At the Limits of Romanticism

D1019222

At the Limits of Romanticism

ESSAYS IN CULTURAL, FEMINIST, AND MATERIALIST CRITICISM

EDITED BY

Mary A. Favret & Nicola J. Watson

INDIANA UNIVERSITY PRESS
Bloomington & Indianapolis

© 1994 by Indiana University Press
All rights reserved

No part of this book may be reproduced or utilized in any form or by
any means, electronic or mechanical, including photocopying and
recording, or by any information storage and retrieval system, without
permission in writing from the publisher. The Association of American
University Presses' Resolution on Permissions constitutes the only
exception to this prohibition.

The paper used in this publication meets the minimum requirements of American
National Standard for Information Sciences—Permanence of Paper for Printed
Library Materials, ANSI Z39.48-1984.

 ™

Manufactured in the United States of America

Library of Congress Cataloging-in-Publication Data
At the limits of romanticism : essays in cultural, feminist, and
materialist criticism / edited by Mary A. Favret and Nicola J.
Watson.
 p. cm.
Includes bibliographical references (p.) and index.
ISBN 0-253-32156-5 (alk. paper). — ISBN 0-253-20853-X (pbk. :
alk. paper)
 1. English literature—19th century—History and criticism.
2. Great Britain—Civilization—19th century. 3. Romanticism—Great
Britain. I. Favret, Mary A. II. Watson, Nicola J., date.
PR457.A8 1994
820.9'145—dc20 93-23001

1 2 3 4 5 99 98 97 96 95 94

CONTENTS

ACKNOWLEDGMENTS vii

Introduction 1

1. Wordsworth and Romanticism in the Academy 21
 JOHN RIEDER

2. Climbing Parnassus, and Falling Off 40
 PETER T. MURPHY

3. A Home for Art: *Painting, Poetry, and Domestic Interiors* 59
 MARY A. FAVRET

4. "A Voice from across the Sea": *Communitarianism at the Limits of Romanticism* 83
 ANNE JANOWITZ

5. The Uneducated Imagination: *Romantic Representations of Labor* 101
 KURT HEINZELMAN

6. Sexual Politics and Literary History: *William Hazlitt's Keswick Escapade and Sarah Hazlitt's* Journal 125
 SONIA HOFKOSH

7. "Why Should I Wish for Words?": *Literacy, Articulation, and the Borders of Literary Culture* 143
 LUCINDA COLE AND RICHARD G. SWARTZ

8. History, Imperialism, and the Aesthetics of the Beautiful: *Hemans and the Post-Napoleonic Moment* 170
 NANORA SWEET

9. Trans-figuring Byronic Identity 185
 NICOLA J. WATSON

10. Butchering James Hogg: *Romantic Identity in the Magazine Market* 207

 MARK L. SCHOENFIELD

11. "An Embarrassing Subject": *Use Value and Exchange Value in Early Gothic Characterization* 225

 ANDREA HENDERSON

12. "Liquidating the Sublime": *Gossip in Scott's Novels* 246

 JAN B. GORDON

13. Romantic Criticism: *The State of the Art* 269

 MARJORIE LEVINSON

 NOTES ON CONTRIBUTORS 283

 INDEX 285

ACKNOWLEDGMENTS

In the process of editing this collection, we have been fortunate in our advisors and sponsors; our special thanks go to Bob Sloan at Indiana University Press, and all those whose expert advice supplemented his own, notably Alan Richardson (Boston College) and Kenneth Johnston (Indiana University). For the ever-ready and much-appreciated supply of "tea and sympathy" we should also like to thank Andrew Miller and Michael Dobson.

At the Limits of Romanticism

Introduction

A *romantic* place is still approved; a *romantic* scheme is not.
—Raymond Williams, *Keywords*

This volume of essays situates itself "at the limits" of romanticism with a feeling of optimism about the possibilities available to romantic studies in the contemporary academic environment. Predicated on the history of readings and institutions that have preceded it, romanticism at the limits reflects upon that history in order to project its own. As the work of Clifford Siskin and others may remind us, our romanticism is necessarily defined by "romantic" theories and histories stretching back to the end of the eighteenth century. But the romanticism available to us now is also informed significantly by the work of cultural materialism and postmodern "historicisms" in the past two decades, and especially by their response to deconstruction. This long and heterogeneous history of investments means that the forms contemporary romanticism takes at its limits will be variously and multiply defined—generically, economically, culturally, ideologically. Its narratives will be both familiar and disruptive; its major figures by turns notable, commonplace, and alien. Indeed, in the collective enterprise that constitutes romanticism in general, and this anthology in particular, we discover that, in Don Bialostosky's words, our "development . . . has taken us places we did not expect to go, put us in the company of people we did not expect to encounter, and confronted us with issues we did not expect to address."[1] These essays, we hope, register the surprise and the challenge of coming upon hitherto (or newly) unaccountable places, people, and issues in the romantic tradition.

To this end, *At the Limits of Romanticism* puts in question one of the limits that the romantic tradition has consistently defined and negated: the line between the material and the theoretical.[2] This division establishes itself under many guises within romantic discourse. As a historical marker, it divides the empiricism of the eighteenth century from the metaphysics of the nineteenth. As a measure of aesthetic practice, it distinguishes what one might too conveniently call a Wordsworthian poetics of "co-operative power," "plea-

sure," and social constitution from a Coleridgean celebration of the unifying symbol and the transcendental imagination (Bialostosky, 23–54).[3] In assessments of genre, it segregates the study of popular, commercial forms (especially the novel) from accounts of the "higher" forms of epic, lyric, and critical essay. In recent critical practice, too, this division separates historicist from rhetorical readings of culture, the proponents of each defining the limitations of the other and invoking (often paradoxically) romantic precedents in their defense. The most visible and intractable register of this dividing line is, finally, that which demarcates the properly "non-romantic" from the "romantic."

The legacy of this opposition has given romanticists a chronic split vision: romanticists have treated male writers in isolation from women writers, for instance; academic romanticism apart from more popular versions; critical argument at a distance from professional and economic concerns. Rather than merely trying to replace the one side of the picture with the other, supplement one with the other, or combine them in a unified representation, this volume aims to join with recent critics of romanticism, such as Jonathan Arac, Don Bialostosky, Marilyn Butler, Alan Liu, and Jerome McGann, who have activated the tensions between these two perspectives and traced their effects on one another and on the romantic tradition in its various manifestations.[4] It aims to establish a dialogic view of romanticism, one capacious enough to recognize the mutual interdependence of the "inside" of the romantic field and its "outside," and of re-articulating them within the field of cultural contention, both then and now.

In rethinking literary and cultural history, the writings of these critics, as well as the essays within this collection, display contentious and even incommensurable representations of romanticisms and romanticists.[5] Given this array, we can extend Bialostosky's model of a dialogic between Wordsworthian and Coleridgean critics in order to recognize the mutual dependence of other seemingly opposed figures in the romantic critical tradition: the theoretical and the material, men and women writers, radicals and reactionaries, lyric poetry and prose novels, the popular and the literary. This is the sort of dialogue we imagine at the limits of romanticism. Here "the question of . . . [the] roles [of these figures] in a contemporary critical tradition will never be a question of displacing the one and replacing the other but always of locating ourselves in the field of their likenesses and differences" (Bialostosky, 29, 34). By continually questioning the tensions produced by romanticism, by awakening not only the differences between Wordsworth and Coleridge, for instance, or between first and second generation romantics, but also between these traditional dialogues and dialogues left unaccounted for, we force ourselves into a new literary history.[6] The determination of crucial questions within romantic studies, and the consequent establishment of authorities, traditions, curriculum choices, and paradigmatic texts, will promote this history only if we continue to probe the shadows and silences produced by each new version of romanticism.

According to Raymond Williams, "it is at the vital points of *connection*" in culture, "where a version of the past is used to ratify the present and to indicate directions for the future, that a selective tradition is at once powerful and vulnerable" (116). Our investigation, then, is less about breaking the hold of past or even recent forms of romanticism than about examining these forms, the possibilities they represent, the itineraries they provide for our critical practice, and the passages they leave uncharted. In a suggestive if not comprehensive way, this collection therefore looks backward and forward at the romantic and romanticist tradition, in the places of its power and vulnerability.

We can begin to put pressure on romanticism as presently constituted by providing a (necessarily partial) history of the romantic tradition inherited by the most recent generation of romantic scholars—a tradition shaped in the United States by the critical methodologies of New Criticism and its demon-image, deconstruction, and recently reformulated by the work of new historicism and cultural studies. However antithetical or inimical to one another these phases have claimed to be, they are recognizably interconnected as the links of a given critical genealogy. And just as deconstruction can be shown to have continuities with New Criticism, which it supposedly displaced, so too have more recent efforts in historicism and cultural studies—which Alan Liu has assembled under the label of "new formalism"—betrayed covert affiliations with supposedly antipathetic precursors. In reviewing this tradition we hope to suggest how the two opposing strands we have identified—the theoretical and the material-historical—intertwine and become codependent. To put it another way, we hope to involve the history of romantic critical theory in the university with a history of its public or, as Bruce Robbins would suggest, its professional role.[7]

The making of a contemporary academic romanticism has been the subject of many studies and need not be fully rehearsed here. But we might note the recurrence of the tension between the theoretical and the material in these studies. For many, the notion of a history of ideas, fundamental to the early twentieth-century debate over the definition or "discriminations of romanticisms," forms the basis for understanding "what we have come to call Romanticism in literature" (McGann, 17). Contemporary romanticism is, by this account, the product of a series of theoretical debates, usually carried on within the academy. For others, what we call romanticism is fully scripted into social and cultural institutions. Jon Klancher, for instance, provides a brief history of the "diverse institutional crises and consolidations" that have constructed romanticism in its late twentieth-century American academic form (83).[8]

Thanks to the work of McGann and Klancher, among others, we have the benefit of both models when we consider what constituted "romanticism" in the United States throughout the 1960s. According to Klancher, "Romanticism" in the early decades of the twentieth century was perceived to be a distinctly European phenomenon, implicated in the political and philosophical

legacy of the French Revolution, the German Empire, and the Russian Revolution. Beginning in the 1940s, American scholars began "disengaging" a distinctly "English" romanticism from a continental context associated with revolution and two world wars. A resolutely American "English" romanticism in the '40s and '50s could assert a "pragmatist commitment to individual responsibility" and individual (as well as national) autonomy from (international) politics (83–84). This trajectory within romantic studies is complicated, as Alan Liu reads it, by a move within the academy to mark disciplinary and administrative boundaries. The demarcation between literary criticism and "the scientist historicism of history of ideas," coupled with a general emphasis on scientific rationalism in education, encouraged English departments to mobilize under the banners of New Criticism, seen as the pursuit of expert, analytical "close readings" unencumbered by consideration of historical subjects and actions ("The Power of Formalism," 740–42, 768n.69).[9] As it developed from distinctly southern roots, New Criticism worked to overcome the conflicting demands of history and create "a Platonic Republic of intellect." This "Fugitive, Agrarian, and at last academic state (a fifty-first state, we might say)" established itself first at Vanderbilt, then in the university seminar, then "in the sublimated state of the 'poem'" (741). Although much of romantic poetry resisted an approach which sought to disentangle "ideas" from the messy claims of "economics, politics, and religion," the romantic lyric did provide new critics with their museum showpiece, the "Grecian Urn."

Relatively neglected under New Criticism, romanticism gained currency in a new political climate, as the United States began pulling away from the isolationism of the fifties. Its value derived once again from the study of the history of ideas, now imagined as a cultural tradition (Western humanism) and as political prophecy. Predictably, new readings of Wordsworth's poems, especially *The Prelude,* were central to this reevaluation. As Klancher notes, M. H. Abrams's paper delivered to the English Institute session "Romanticism Rediscovered" in 1962 proclaimed a "new orthodoxy of English studies" derived from his reading of Wordsworth (78–79). Abrams "brilliantly reconciled French Revolutionary politics with Romantic transcendent imaginations" at the same time that he "evoked a suggestive bond between liberal intellectual formations of the English 1790s and the American early '60s" (85). The clarion call that accompanied the renaissance of romanticism sounded in a number of other registers as well. On one side, romanticism's return to favor in the sixties was marked by the founding of *Studies in Romanticism* (1960), with its deliberate turn away from purely "literary" and nationalistic readings of the period. On another side, it was characterized by efforts to publish "definitive editions" of the works of five major romantic poets, efforts which therefore continued to identify romanticism as essentially poetic, male, and individualized.

Whereas recent scholars of romanticism have situated New Criticism and

the subsequent liberal exegesis of Abrams within both a history of ideas and a history of American culture and its institutions, deconstruction's version of romanticism has been treated primarily as a theoretical rather than a cultural or material concern.[10] The emergence of Paul de Man's potently attractive version of deconstruction should be considered in relation to the specific historical and cultural role played by American critics in the 1970s and early '80s rather than in terms of the personal history, hagiographic or otherwise, of de Man himself.[11] Such attempts both deflect attention from complicated formations in society and the university and fail to address why de Man's deconstructive version of romanticism had such appeal for younger, primarily American scholars on the one hand and such little appeal on the whole for their British counterparts on the other.[12] Reflecting on the seductiveness of de Man's reading strategies, Jonathan Arac calls attention to the opening essay of *Allegories of Reading,* where de Man disparagingly identified the "spirit of the times" (1973) in unmistakably political terms: "With the internal law and order of literature well policed, we can now confidently devote ourselves to the foreign affairs, the external politics of literature" (Arac, 98–99).[13] Against such a rhetoric (which now seems vaguely Nixonian), de Man offered a way of reading that refused authoritarian complacency, asking critics to "scrutinize as closely as possible the texts of our internal 'law and order'" (99). Moreover, deconstruction offered an intellectually serious and nominally un-American method for questioning the timeless truths that were held to govern a compromised political and a fractured university system. Central to deconstruction's appeal was the characteristic turn inward—to the informing structure of texts themselves, to the discipline of literary criticism proper—and the coincident suspicion (or embarrassment?) of efforts to tackle affairs "foreign" to the properly literary.

Along with its evident formalism, de Man's early work bears a phenomenological and Sartrean emphasis on internalization: on modes of consciousness and intentionality and, more particularly, on the inevitable failure of conscious intent ("The Intentional Structure of the Romantic Image"; "Image and Emblem in Yeats"). As Tilottama Rajan has demonstrated, poetry becomes for de Man the privileged record of this failure, even as it permits consciousness to survive its (inherently inadequate) form.[14] If this narrative of sublime intention, conscious failure, and record of failure sounds akin to Wordsworth's experience on the Simplon Pass, it also points to the fact that in de Man's early work, "the problem of intentionality is historically localized in romantic literature" and aesthetically localized in sublime landscapes (Rajan, 455, 462n.). Thus romanticism (associated with the poetry and prose of the poets) and deconstruction (identified with the self-conscious critical essay) became inextricably related to each other, mutually identified as the discourse of critical self-reflection and political belatedness.

It should not surprise us that this disheartened or alienated romanticism would in the 1970s succeed the robust humanism and revolutionary tones of

the prior decade. As the utopian optimism, based on unprecedented wealth and rapid expansion of the university system, gave way to the humiliation of defeat in Vietnam, and as universities experienced newly constrictive budgets, so too did the tone of criticism change. Throughout the sixties influential studies in romanticism, such as Harold Bloom's *Shelley's Mythmaking* (1959) and *The Visionary Company* (1961), Northrop Frye's *Fearful Symmetry* (first published in 1947 but reprinted in paperback three times between 1969 and 1974), and M. H. Abrams's *Natural Supernaturalism* (1971), imagined a powerful merger of revolutionary politics and the poets' "visionary politics," a merger which liberal academics could then ascribe to their own work.[15] In the seventies, however, one detects exhaustion as well as a sense of failure: interest shifted symptomatically to the complicated guilt of Rousseau's *Confessions* and the ironies of his *Social Contract* or to the loss inherent in Wordsworth's "Michael" or the "Essay upon Epitaphs." Originally emphasized by Geoffrey Hartman's *Wordsworth's Poetry* (1964), the fascination with loss and guilt signaled by the Lucy poems gained extra currency in the heyday of deconstruction and fueled the Wordsworth industry for years. (The fascination with Lucy may also have masked the perplexity of romantic scholars newly challenged by feminist critics.) Thus "A Slumber Did My Spirit Seal" might serve as the central poem for a decade of romantic studies dedicated to reflecting upon its own aporia.[16]

Effectively a scholarly confession of empty rhetoric, as Rajan has argued, deconstruction was built on the recognition among the political Left of "the collapse of the logic of representation," specifically, as Catherine Gallagher has noted, political representation (Rajan, 456). Through its emphasis on a politics of de-centering, deconstruction both confirmed New Left tenets and explained the movement's loss of momentum.[17] Although liberal pessimism or apology was perhaps most notably incorporated in the rigors of deconstruction, it was also evident in studies not directly indebted to deconstruction's methodology and relatively miscellaneous in approach: for instance, Bloom's *Anxiety of Influence* (1973), John Barrell's *The Dark Side of the Landscape* (1980), and Thomas McFarland's *Romanticism and the Forms of Ruin* (1981).

And yet, even as deconstruction allowed romanticists to embrace failure, it guaranteed the survival of the text, the survival of critical consciousness, and, thus, the continued viability of a romantic tradition in critical theory. Its formalist strain could be seen, as Rajan argues, as "an attempt to supplement the phenomenological sense of a consciousness which survives the deconstruction of its language, with an emphasis on the text as rhetorically well-wrought and therefore surviving its subversions of itself" (458). Deconstruction may have disfigured and disturbed a romanticism tied with liberal humanism, but it had not replaced it; if anything, it enhanced the importance of romantic literature in the English curriculum. Critics such as Jerome Christensen could thus argue simultaneously that "the predicament of contemporary academic criticism" is anticipated by "the text of romanticism" and that "romantic

criticism" in particular brings an "ethical vitality" to contemporary academic practice ("From Rhetoric to Corporate Populism," 439). This mutual validation was redoubled in the way that deconstructive criticism, like romanticism, generated critical interest in the personalities and stylistic idiosyncracies of its major practitioners. Moreover, deconstruction's insistence that literature inevitably thematizes sites of reading and writing meant that the idea of literature, the work of the classroom, and the routines of academic scholarship could be seen as practically indistinguishable and, most important of all, sufficient unto themselves.

In declining to investigate matters "foreign" to literature, deconstruction therefore paradoxically proposed a criticism in sympathy with the "external" structures of its historical moment; however, this criticism, apparently uprooted from the surrounding culture, easily transplanted, and exiled from history,[18] was to come under pressure from the absences generated by its hermetic logic. Coincident with the critism of self-reflection and guilt grew a criticism of political anger and recrimination. If the failure of (self-)representation was deemed the central object of interest for both critics and their subjects, the romantic poets, the effects of that failure on those denied the power of self-representation would not be measured by a turn inward. The first major work by feminist scholars on women writers in the romantic tradition emerged within and simultaneously at odds with this rhetoric of failure. It is not surprising that both Margaret Homans's study *Women Writers and Poetic Identity* (1980) and Sandra Gilbert and Susan Gubar's *Madwoman in the Attic* (1978) were written under the aegis of and yet in reaction against the so-called Yale School, nor that Mary Jacobus, perhaps the most astute feminist critic of romanticism, drew her power from a dialogue with romantic deconstruction and with its favored text, *The Prelude*.[19] These studies not only based themselves on a romantic model of poetic authority but contested that authority, often by pushing beyond the privileged genres (from lyric and epic poetry to diaries, letters, and novels) and beyond the historical confines of traditional romanticism to eighteenth-century and, later, nineteenth-century British and American literature. For feminists in particular, the failure visible in romantic theory was a historical failure that had not been solved; it was a political wrong that denied self-representation to women. In Gilbert and Gubar's influential work, for instance, literary history (the anxiety of influence) and literary theory (the disjunction between representation and identity) intersected in the woman writer to produce fictions of madness, violence, and death. Romanticism here figured as the recurrent agent of oppression and appropriation; for feminists, romanticism's power echoed still in the structures of the political system and the corridors of the university.

In the United States, romanticism's growing identification with critical theory expanded its influence over other literary periods (most especially and symptomatically nineteenth- and twentieth-century American literature) and

over other disciplines (notably law and film studies). As this identification increased, however, its hold over any definition of romanticism proper loosened considerably. What the rhetorical tropings of deconstruction held at bay—what they constituted as the "embarrassment" of political representation, the "failures" of narrative, the "emptiness" of notions of the local, sentimental, or feminine—came flooding back into the field of romanticism from other quarters. In fact, the high profile given to deconstruction in the seventies and eighties obscured and delayed recognition of significant reinterpretations of the concept of romanticism by scholars in other areas.

On one side, provocative new work by eighteenth-century scholars gave texts from the romantic period a newly prominent position. Interdisciplinary studies in particular, influenced by Michel Foucault, by feminist literary histories, and, more locally, by new approaches to the French Revolution (most significantly the work of François Furet, Lynn Hunt, and Mona Ozouf), drew the attention of eighteenth-century studies to areas excluded from the traditional romantic canon: the jacobin and anti-jacobin novel (John Bender, Marilyn Butler, Gary Kelly, Claudia Johnson); the gothic and sentimental (Francis Barker, Terry Castle, Ronald Paulson, David Punter, Janet Todd); the literature and representation of the working class and poor (John Barrell, E. P. Thompson). On another front, critics of nineteenth-century literature, with a strong tradition of interest in narrative and popular forms, brought that interest to bear on texts from the early part of the century. Thus, for example, conduct books for women, scientific and medical treatises, Orientalist scholarship, journals, and political pamphlets from the romantic period were incorporated into revisionary studies of nineteenth-century culture (Mary Poovey, Nancy Armstrong, Thomas Laqueur, Catherine Gallagher, Leonore Davidoff and Catherine Hall, Edward Said). Clearly, for critics working on either side of romanticism proper, the years between 1789 and 1832 did not represent a discrete or especially privileged critical period in literary history; the romantic was a "place" rather than a "scheme." Yet, at the same time, and in ways quite different from the influence of deconstruction, romanticism as an ideological complex figured centrally in accounts of the dominant ideologies of the emergence and dominance of modern Europe: gendered subjectivity, domestication and professionalization, imperialism, capitalism. In these ways it could be said that the influence of romanticism was being rewritten throughout the late seventies and eighties by scholars primarily "outside" the field.[20]

The adulteration of "pure" romanticism—of lyric by narrative, labor, the feminine, and revolutionary politics—was signaled most influentially by Jerome McGann's publication of The Romantic Ideology in 1983, a study which, along with his subsequent work—The Beauty of Inflections (1985), Social Values and Poetic Acts (1988), and Towards a Literature of Knowledge (1989)—at once questioned what was at stake in the uncritical reproduction of romanticism as a pure space of sublime anxiety, and ultimately subjected the self-consciously romantic to the constrictions of the material. McGann

concentrated in particular on the tortuous itinerary of the romantic lyric through the business of contemporary publication and its concomitant com- modification. McGann's approach would be variously reconfigured by a new generation of critics, who held in common an interest in the "real" of history, to borrow David Simpson's phrase.[21] This "real" owed a good deal to the notions of history as a discursive construct formulated by Hayden White and Foucault, on the one hand, and to the continued vitality of what has come to be known as cultural materialism in Britain, which traces its (broadly Marxist) intellectual inheritance through such thinkers as Althusser, Macherey, E. P. Thompson, Raymond Williams, and, most recently, Terry Eagleton.[22] Claim- ing to fuse deconstructive practice with historical materialism, and indeed to reclaim a political vigor for deconstruction, such critics as James Chandler in *Wordsworth's Second Nature* (1984), Marjorie Levinson in *Wordsworth's Great Period Poems* (1986), David Simpson in *Wordsworth's Historical Imagi- nation* (1987),[23] and Alan Liu in his monumental *Wordsworth: The Sense of History* (1989) made the controversial claim that "history" itself in Words- worth's poetry is registered stylistically as displacement, silence, incoherence, distortion, dislocation—as, in fact, resident within the romantic sublime itself. Literary production (both then and now) could thus be read as intimately linked with the production of social meaning, historicized subjectivity, and systems of power.

Between these (mostly American) proponents of what is now loosely called new historicism and the practitioners and borrowers of the distinctively British variant, cultural materialism, stretches a symptomatic gulf: the difference be- tween those who continue to privilege the centrality of Wordsworth, however de-centered and harassed, and those who wish to expand the view across a wider field altogether.[24] These latter, the most prominent of whom in the romantic period include Marilyn Butler, John Barrell, and Ronald Paulson, prefer to subject Wordsworth (and the romantic tradition his poetry has been taken to construct and underwrite) to history. They do this not by reading history within the symptomatic absences of the romantic sublime, but by re-contextualizing Wordsworth's poetic practices within a lost network of conflicting, contentious, and self-consciously politicized poetic practices— practices traceable to social and material contexts. In this way these critics effectively de-center the privileged term "romanticism" with a more capa- ciouis notion of the romantic period. Butler's method in *Romantics, Rebels, and Reactionaries* (1982), for example, is largely to lay out other territories and representational decisions, an act which in and of itself at once disputes the narrowing of focus in romantic studies to a few "major" poems by Words- worth and implicitly queries the politics of such restriction. Espousing a sort of promiscuity in their interest in genres and writers contemporaneous with the poets Blake, Wordsworth, Coleridge, Shelley, Keats, and Byron, these crit- ics damage claustrophobic schemas by taking into account the varied and conflicting practices of contemporary novelists, journalists, prose writers,

best-selling poets, and dramatists. This promiscuity was encouraged and en-
abled in part by conferences held throughout 1989 to mark the bicentennial
of the French Revolution, which, convened on a strictly historical premise,
brought together for the first time in many years unaccustomed bedfellows.
At these meetings Frances Burney escaped the eighteenth century to rub el-
bows with Mary Wollstonecraft and Edmund Burke; Richard Payne Knight
linked William Wordsworth to Lady Sydney Morgan and Maria Edgeworth;
and Erasmus Darwin proved to have something to say to both Charlotte Smith
and William Blake. Furthermore, the continuing vitality of feminist criticism,
which during the eighties slowly expanded its activities across the critique of
versions of gender within romantic poetry (Mary Jacobus, Gayatri Spivak,
Susan Wolfson, Julie Ellison, Jane Moore), to the reevaluation of such figures
as Mary Wollstonecraft, Dorothy Wordsworth, and Mary Shelley (Mary
Poovey, Marilyn Butler, Mitzi Myers, Margaret Homans, Anne Mellor), and
to the excavation of a much wider range of contemporary women poets and
novelists (Jane Spencer, Stuart Curran, Janet Todd, Beth Kowaleski-Wallace),
also prompted a wider version. Finally, the increased attention within the
academy in both Britain and the United States to issues of cultural diversity—
a response to remarkable demographic changes in the constituency of society
and the university—seems to have rendered a more pluralistic approach ur-
gent, expedient, and attractive.

Influential studies that explore this more open terrain include, for example,
that of Marlon Ross, who juxtaposes an analysis of desire in the high romantic
lyric with a study of the same formations as they are written into non-romantic
versions by contemporary women poets. *The Contours of Masculine Desire*
(1989) breaks new ground in its effort to expose the constitutive limits of
romantic poetry, which he identifies as the "suppression" of female desire,
and to explore "the margins of romantic poetry" in order to recover other
lost histories. In so doing, Ross's aim is, like ours, to question "the ideological
limits of romanticism in history," thereby generating "some critical and his-
torical distance between ourselves and romantic ideology" (186, 5). Similarly,
John Barrell's *The Infection of Thomas De Quincey* (1991) remaps the period,
arguing for a reading of De Quincey not in terms of the romantic imagination
but in terms of the discursive materials—in this case discourses of political
sedition at home and imperialism in the East, among others—which the prac-
tices of that imagination articulate. In a different fashion, Jon Klancher's *The
Making of English Reading Audiences, 1790–1832* (1987) also pays attention
to the more generalized literary milieu—drawing on periodicals, political po-
lemics, travel diaries, and the like—so as to highlight the conditions of literary
reception and thus of production. What characterizes these otherwise dispa-
rate approaches is an attention, as we have already remarked, to a wider
range of genres beyond the romantic epic or lyric; this strategy goes far to
disarm criticism of the extreme new historicist approach, which has displayed

a tendency to formalize and even lyricize the material as either style and anecdote.

In describing alternative and contestatory literary practices, these critics have allowed others to re-situate the canonical romantic lyric (and, increasingly, romantic narrative poetry) within a politicized and gendered field. This latter endeavor, exemplified, for instance, by the work of Karen Swann, is not designed so much to provide context as to illuminate the class and gender politics of the conventionally romantic.[25] This re-situation has also expressed itself as critical interest in the material conditions and constrictions within and against which romantic poetic identities were formed—the seminal work here being perhaps Kurt Heinzelman's *The Economics of the Imagination* (1980), David Simpson's *Wordsworth's Historical Imagination* (1987), Marjorie Levinson's *Keats's Life of Allegory* (1988), and essays by Alan Richardson, Marlon Ross, and Sonia Hofkosh in *Romanticism and Feminism* (1988). Some of these interests—gendered authorial subjectivity, the pressure of "foreign" discourses of, variously, nation, the body, charity, museums—are visible in the recent British *Reviewing Romanticism* (1992) and *Beyond Romanticism* (1992), which have begun to map something of this newly hybridized field. Finally, the dramatic widening of the field of romanticism that these efforts have both entailed and promoted has begun to register at the institutional core of the profession; so long split among a number of single author conferences (the Keats/Shelley conference, the Jane Austen Society, the Wordsworth summer conference, the Byron Society, the Charles Lamb Society, the Scott Society, to list just a few), and so long hovering uneasily at the edges of the American Society for Eighteenth Century Studies (ASECS) or nineteenth-century studies, scholars across the field finally met in 1993 under the aegis of the North American Society for the Study of Romanticism (NASSR), the governing thematic of which was, tellingly, genre.

These very different attempts to make romantic literature accountable to historical contingency are undoubtedly rooted in their own historical moment. In Britain the ever-tightening grip of the Thatcherite state upon the universities resulted first in major cuts in resources and student and faculty numbers, followed by a sharp reversal when the government hit upon the notion of increasing student numbers to disguise unemployment rates while continuing to cut staff. Combined with a general loss of status consequent in part upon the government's demand for "productivity," it was hardly surprising that left-wing critics (based most visibly at Essex) should first have meditated upon the relation of the power of the state to the possibility of writerly subversion (Dollimore, Sinfield, Stallybrass, Barker) and then increasingly upon the material base for intellectual endeavor. In such circumstances, the old playground joke—"What's a Greek Urn?" "Thirty bob a week"—took on a new topicality. Faced also with state efforts to regulate canons and traditions ever more closely, British academics began to invent a theoretical narrative of contestation and legitimation, a myth which endorsed the retrieval of texts which

would put the authority of the canonical into question. Similarly, if less urgently, the academic profession in the United States found itself squeezed for cash, and that in a decade of flaunted materialism (in its more popular sense), a decade in which high romantic arguments seemed to have little market value. At the same time, American universities came under fire from external critics provoked variously by the esotericism of high deconstructive theory and the breakdown of received canons under the stress of feminist and postcolonial criticisms. Romantic literary identity, modeled, as Clifford Siskin has argued, most elaborately in the self-substantiating, generative academic, thus became visibly and extensively subject to interruption by state intervention, social pressures, and material reality ("Wordsworth's Prescriptions," 307).[26] It is hardly surprising, then, that new work in the field should be marked with materialist preoccupations.

Our project here is to expand upon recent endeavors to contest traditional constructions of romanticism, in particular as they are dependent upon notions of gender, of genre, of tradition, and of canon, by invoking the history, politics, and larger literary culture of the period 1789 through 1832, between the French Revolution and the Reform Act. To reiterate, we hope to do this on the one hand by asking what exactly is invested in the maintenance of certain exclusive versions of romanticism and, on the other, by discarding the current model that covertly determines the field, a model premised upon a notion of "insiders" and "outsiders," for a dialogical and contestatory model, in spite of an awareness that contestation is necessarily only a temporary state, bound to generate new orthodoxies. We hope concurrently and by extension to flatten certain familiar vertical axes characteristic of romanticism as we know it, whereby the sublime regularly trumps narrative, lyric the novelistic, masculine the feminine, imagination the body, in order to produce a more accommodating and elastic plane. Modeled in this way, romanticism would then be seen to be composed of multiple (and currently shifting) tectonic plates, alternative generic territories, whose relation to each other is determined by their different modes of negotiating the same historical, political, and cultural anxieties particular to the period 1789 to 1832. If we are interested in enlarging the scope of what has been called romanticism by revalidating a disconcerting and contaminating heterogeneity generally exiled to its borders, we also focus deliberately on those equally troubling and productive blind spots which are just now beginning to appear within the limits of institutional romanticism.

The essays that follow share a general desire to dis-articulate the field as currently constituted, whether by remapping lost terrains at the very heart of modern canonical romanticism or by diverting attention to the borders of romanticism as contemporary sites of discursive struggle.[27] This double and apparently contradictory preference, for the alien on the one hand and the domestic on the other, is dictated by a desire to bring within the field of

reference "lives, events, or texts that do not already signify in direct relation to the plots or structures that determine our sense of history" (Hofkosh); in so doing, we hope to pull the familiar skein askew, in the hopes that reconstructing past challenges to romantic history might allow us at this moment to constitute that tradition differently. Our contributors set out to scrutinize the boundaries that canonical romanticism reproduces: the dividing lines of genre, gender, class, nation; the economies of identity, body, market, and academy; the rhetorics of the sublime and the material. Although deploying an eclectic range of critical strategies, stretching from those inflected by cultural materialism through those indebted more extensively to feminism and post-Marxist dialectics, all our contributors thus inevitably, implicitly or explicitly, share a concern with how romanticism and the culture we have inherited from romanticism (which includes the ways in which academic institutions are currently conceived) are shaped by forms of discursive and material power, then and now.

The opening essays accordingly explore in their different fashions the blank centers of romanticism. John Rieder traces the centrality of Wordsworth to the academic practice of romanticism and argues for a different pedagogical practice. Remarking that the very impulse which may be said to drive this collection, an impulse toward recovery of the lost, the marginal, and the outsider, is in fact a quintessentially romantic, indeed Wordsworthian, motive, Peter Murphy chooses instead to reflect upon the meaning of our virtually complete lack of interest in the work of the man whom his contemporaries rated as the most important poet of the age, Samuel Rogers. Meditating upon the inability of our poetics to discover a glamour in this erased figure, Murphy argues that his disappearance is concomitant with a version of academic labor that models itself upon a thoroughly Wordsworthian poetics. If Murphy is interested in the blankness at the center of romanticism, Mary Favret is concerned with restoring vitality to that which has been reduced to a spectral trace in a romantic logic of interiorization—the domestic, the feminine, and the corporeal. By recovering the language of domestication that supports and threatens cultural institutions, Favret calls into question the place we give to art, especially poetry and painting, in the academy, an institutional setting framed by a critical tradition that includes Coleridge, Hazlitt, and Ruskin. Anne Janowitz similarly attends to exclusions at the center of the canon. Focusing upon Shelley's "The Mask of Anarchy," frequently set aside as anomalous, Janowitz argues that it provides an alternative poetics to those commonly known as romantic: communitarian rather than individualist, interventionist rather than representational, literal rather than metaphoric. In so doing, the poem allows for a different, and recoverable, version of romanticism, one genuinely political and hospitable to constructions of women.

If Murphy, Favret, and Janowitz all take as their subject matter that which has been repressed within the magic circle of romanticism, the essays that follow ask what sort of pressure incorporating "outsiders" might exert upon

current versions of the romantic. Kurt Heinzelman considers what it might mean to make the gesture of incorporating the outsider—in this case, contemporary working-class poets—into romantic discourse as constituted at the time by Southey, Wordsworth, and Coleridge and, nowadays, by modern quasi-Marxist materialisms, critiquing by implication their politics of representation. Like Murphy, Heinzelman queries our current fascination with the rescue of the outsider, asking whether such a practice does not simply recapitulate characteristically romantic notions of intellectual labor. Sonia Hofkosh turns to another type of outsider, the woman, encouraging her to put pressure upon dominant paradigms of romantic literary authority. Her essay asks what would happen to typically homosocial and patrilineal versions of literary history were we to take into account the narratives and bodies of such women as those who punctuate Hazlitt's paradigmatic self-forging. By taking as her subject an "outsider," Hazlitt, and showing that his representation is possible only at the expense of erasing the figure of the woman, Hofkosh's essay, like Heinzelman's, raises questions about the project of constructing any literary history. Lucinda Cole and Richard Swartz are also preoccupied with the detours that attention to contemporary women's strategies for self-representation might introduce into conventional romantic narratives and aesthetics, in this instance, the trope of sublime inarticulation. Through meticulous adumbration of the cultural contexts of literacy in the north of England at the turn of the nineteenth century, Cole and Swartz anatomize the ways in which an aesthetics of the sublime could be appropriated by the working-class poet Ann Yearsley, while being necessarily scrupulously repudiated by the middle-class Hannah More and Dorothy Wordsworth. In so doing, they render the romantic sublime accountable to the conditions of its production, reproduction, and legitimation. As in Hofkosh's essay, the effect is to ask what kinds of dispossession romanticism authorizes and enforces.

By "call[ing] into question the still prevalent notion that women were necessarily 'silenced' by romantic aesthetic discourse" and analyzing the ways in which these women appropriated and negotiated dominant aesthetic discourses, Cole and Swartz's essay also paves the way for Nanora Sweet's excavation of the then successful and only recently salvaged poet Felicia Hemans's political critique of a nationalist and imperialist sublime. Sweet examines Hemans's production of an alternative discourse of the beautiful which reimagines historical narrative under the signs of fragmentation, evanescence, and feminization. Hemans's privileging of the beautiful, Sweet argues, results in her disqualification from the ranks of canonical poets. Putting the figure of the woman, and lower-caste genres associated with her, into dialogue with the canonical is also the project of Nicola Watson's essay, which, in retailing a convoluted series of literary transactions between Caroline Lamb, Byron, and the noted courtesan Harriette Wilson, shows how *Don Juan* is constituted in part through challenging the political implications of the sentimental and gothic genres which Lamb deployed. Their games of literary impersonation

put into question whether it is possible for an "outsider" to do more than shadow or impersonate the dominant poetics available; whether adding oneself in as a woman critic is to lock oneself into an aggressive masquerade of longing replication, however profitable any such masquerade might prove to be; whether, alternatively, masquerade and replication usefully destabilize myths of authentic, inner, masculine, romantic poetic identity. Like Watson, Schoenfield is preoccupied with the salability and concomitant inauthenticity of romantic identities within a free market, invoking the multiple and contested identities of the poet, novelist, essayist, and prominent literary figure, James Hogg. If Watson is interested in identity as constituted through and against generic conventions, Schoenfield similarly points to authorial identity as a function of forms of representation in competition with one another. By considering the production and reproduction of the "Ettrick Shepherd" circulating in the periodical press and related publications, Schoenfield institutes in the same historical territory as the autobiographical sublime of *The Prelude* a counter-sublime of identity marked by a principle of impolite proliferation, subject to appropriation and re-articulation by its consumers.

As such Schoenfield's essay registers something of the professional anxiety of a "romantic" profession subjected to the increasingly oppressive vagaries of the free market. It is perhaps hardly accidental that Andrea Henderson also writes about versions of identity that counter romantic identity in the context of the gothic novel. Henderson sets out to account for the marginalization of the gothic, arguing that it models a mode of identity premised upon exchange rather than upon use-value, and that, as such, it is profoundly subversive of romantic individualism. Similarly concerned with the market value of romanticism, Jan Gordon considers Sir Walter Scott's critique of the romantic sublime as that which cannot transmit value by entering into a system of public consumption. According to Gordon, Scott reinscribes the sublime as a counter-sublime so as to make it pay, representing it in the mobile and always alien figure of the gossip who, in traversing varied social territories, also traverses and cross-fertilizes multiple social identities. In this figure of fluidity we may read yet another version of romantic identity to add to the convalescent identity offered by Favret, the fragile and hysterical identities offered by Hofkosh and Schoenfield, and the cynical if profitable identity offered by Watson—a figure which, by circulating and socializing history and thus giving value to it, "releases for public consumption, heirs, information, and money; all of which become interchangeable 'currencies.'"

The final word goes to Marjorie Levinson, who is preoccupied with the future of materialist criticism, which, she remarks, appears to be able to exert ever-decreasing leverage upon the poetry. Noting that the poetry seems to have retreated into a state of blank immanence which cannot be appropriated to produce consumable, reproducible value, Levinson argues for the reinstatement of a sublime that sabotages the business of making value from the poetry, a sublime associated with a banished autoeroticism. She thus calls for a criti-

cism that specifically refuses to accommodate itself to a market economy predicated upon the reproduction and circulation of cultural commodities. What such a criticism might be is yet to be revealed, but, as Levinson points out, criticism "has no choice but to throw itself into history."

Finally, this volume's enquiry into the state of romantic studies raises a number of important questions regarding the practice of a loosely materialist criticism, questions which it leaves unanswered. It is, for instance, not easy to account for the pronounced turn to the intractably matter-of-fact, for the strong attraction to difference as registered in the detail, for the pervasive nostalgia that seems to drive recent historicisms. This does not quite look like strong interventionist criticism; indeed it looks like a (potentially very profitable) commodification of historical difference by the accidental tourist, literature as theme park. We might well ask, moreover, whether this nostalgia for the real—expressed as a desire for the strangely useless, excessive, and nonspeculative—is actually in practice antithetical to the romantic. Privileging as it does the material over the theoretical, it surely inhabits and is indebted to a strictly Wordsworthian poetic.

A newly down-to-earth romanticism, medicated by a doggedly materialist criticism, also leaves us with the problem of where to locate literary value— to put it bluntly, how to sell it (perhaps even whether to sell it) in the modern context. Pointing out the material conditions that have constituted the literary, revealing those pleasures to be themselves commodities, both in the ways they were produced and in the ways they are (and were) consumed, we perhaps strip them of some large part of what has been understood to be their value, which has in the past inhered precisely in their status as non-commodities, and as non-commodifying practices. On the other hand, to relocate that value in the poetry's very refusal of the logic of productivity—Levinson's blank immanence[28]—is ultimately simply to risk reinscribing the sublime, the very discourse of transcendence upon which the identity, significance, and salability of romanticism has so much depended, and which has so persistently excluded modes which we would wish to revalue: the local, the feminine, the domestic, the sentimental, the novelistic. What is perhaps needed is some sort of theoretics of pleasure, at once sensuously material and yet not held hostage to processes of amorticization. It is, however, neither surprising nor accidental that this tentative and embryonic desire should smack so strongly of Wordsworthianism; whatever else this volume's inquiry into the state of romanticism may suggest, it also effectively demonstrates that, however contested the practices and poetics of romanticism may currently be, a post-romantic criticism is as far off as ever.

NOTES

1. Don H. Bialostosky, *Wordsworth, Dialogics, and the Practice of Criticism* (New York: Cambridge University Press, 1992), xiii.

2. We use "tradition" as Raymond Williams defines it: as "a deliberately selective and connecting process which offers a historical and cultural ratification of a contemporary order" and which can be "directly experienced" through "many practical continuities—families, places, institutions, language." *Marxism and Literature* (Oxford: Oxford University Press, 1977), 116.

3. See also Jonathan Arac, *Critical Genealogies: Historical Studies for Postmodern Literary Studies* (New York: Columbia University Press, 1987), 14–56.

4. See Jonathan Arac's *Critical Genealogies*, esp. pp. 11–113; Don H. Bialostosky, *Wordsworth, Dialogics, and the Practice of Criticism;* Marilyn Butler, *Romantics, Rebels and Reactionaries* (Oxford: Oxford University Press, 1982) and "Repossessing the Past: The Case for an Open Literary History," in Levinson et al., eds., *Rethinking Historicism: Critical Readings in Romantic History* (Oxford and New York: Basil Blackwell, 1989); Jerome Christensen, "'Like a Guilty Thing Surprised': Deconstruction, Coleridge, and the Apostacy of Criticism," *Critical Inquiry* 12 (Summer 1986): 769–87, and "From Rhetoric to Corporate Populism: A Romantic Critique of the Academy in an Age of High Gossip," *Critical Inquiry* 16 (Winter 1990): 438–65; Kenneth Johnston, "The Politics of 'Tintern Abbey,'" *The Wordsworth Circle* 14 (1983): 6–14; Marjorie Levinson, "Introduction," *Rethinking Historicism*, 1–15; Alan Liu, "The Power of Formalism: The New Historicism," *ELH* 56 (Winter 1989): 721–71, and "Local Transcendence: Cultural Criticism, Postmodernism and the Romanticism of Detail," *Representations* 32 (Fall 1990): 75–113; Jerome McGann, *The Romantic Ideology: A Critical Investigation* (Chicago: University of Chicago Press, 1983); and Clifford Siskin, *The Historicity of Romantic Discourse* (New York: Oxford University Press, 1988).

5. Compare, for example, Arac's endorsement of Wordsworth's Preface and Essay Supplementary with Siskin's critique of their role in the "invention" of "Literature" (*Critical Genealogies*, 3–4, 45–46; *Historicity*, 84–96); or the role of rhetoric in Christensen's call for "an ethic of Romantic relexivity that tactically coadunate[s] theoretical statement with professional practice" with its place in Liu's proposal for a "disciplined, high-level study of the evolution of historically-situated language" ("From Rhetoric to Corporate Populism," 450; "The Power of Formalism," 756).

6. The term New Literary History is borrowed from the journal of that name, established by Ralph Cohen in 1969, and specifically referred to by Arac (1, 11), Bialostosky (2–3), and Siskin, *passim*. See also Butler on an "open literary history" ("Repossessing the Past").

7. Robbins carefully warns against the rhetoric that would distinguish between professional and public concerns, a "tendency to believe that all moral and political imperatives arise and all public consequences are felt 'somewhere else'" ("Theory and the Narratives of Professionalization," *Consequences of Theory*, ed. Jonathan Arac and Barbara Johnson, Selected Papers of the English Institute, 1987–1988, New Series, no. 14 (Baltimore: Johns Hopkins UP, 1991), 18. See also Butler, "Re-Possessing the Past," 66–67.

8. See McGann, Siskin, Arac, Bialostosky; also Frank Lentricchia, *After the New Criticism* (Chicago: University of Chicago Press, 1980), and Herbert Lindenberger and Hans Eichner, eds., *"Romantic" and Its Cognates: The European History of a Word* (Toronto, 1972).

9. See also Gerald Graff, *Professing Literature: An Institutional History* (Chicago: University of Chicago Press, 1987), *passim*.

10. Klancher's account, for instance, largely skips over the phenomenon of deconstruction. He comments, almost in self-admonishment, that "de Man demonstrated the way literary texts rigorously resist being recuperated by historicism and other institutional strategems. . . . [His] work both enabled and complicated the effort to forge more materialistic and worldly reading strategies" (79). This resistance is marked by historicist critics' reluctance to account for deconstruction in their materialist his-

tories of romanticism. See also Liu, "The Power of Formalism," and Bialostosky, chapter 6. The most interesting attempt to give an institutional history of deconstruction comes from Jerome Christensen, himself more sympathetic to the strategies of de Man than those of the new historicists ("From Rhetoric to Corporate Populism").

11. *Allegories of Reading* appeared in 1979, but was written primarily in 1972–1973; many of the chapters appeared in journals prior to the book's publication (Preface, x). *Blindness and Insight: Essays in the Rhetoric of Contemporary Criticism* appeared in 1983; *Rhetoric and Romanticism* was published in 1984; both collections gave currency to essays written much earlier.

12. The failure of deconstruction to take anything like a comparable hold on the British establishment may be explained by a number of factors peculiar to British academic institutions. Whereas American universities have historically had a strong tendency toward formalism from the inception of New Criticism through to New Historicism, partly because such non-historicist criticism could be deployed to appropriate pre-World War I British literature as part of American culture, partly as a result of a relative poverty of research resources, the British have consistently maintained a much stronger historicist and materialist tradition fostered by easily accessible research libraries. More locally decisive of the fate of deconstructive criticism was its emergence at a historical moment (the mid-seventies through the early eighties) when there were few jobs, and those competing for them were subject to the favor of an older critical generation who for the most part dismissed deconstruction as dangerous French thinking engrafted upon American nouveau-intellectual aspirations, a discourse of power rather than knowledge. (This is not to deny that there were those who engaged critically with deconstruction in Britain, among others Catherine Belsey, Thomas Docherty, Ann Wordsworth, and Paul Hamilton; rather, it is a general description of the temper of the times.) The pedagogical structures of the "old" universities—invested in author-based tutorial rather than in period-based courses with set syllabi—also did much to discourage any sort of critical orthodoxy, especially one that depended upon general notions of the romantic (however limited to one author's works deconstructive criticism might prove to be in practice).

13. Paul de Man, *Allegories of Reading* (1979), 3.

14. Tilottama Rajan, "Displacing Post-Structuralism: Romantic Studies after Paul De Man," *Studies in Romanticism* 24, no. 4 (Winter 1985): 455–58.

15. See Klancher's analysis of the specific social context of these "visionary politics." "English Romanticism and Cultural Production," 84–85.

16. Aporia—the pathless path.

17. Catherine Gallagher, "Marxism and the New Historicism," in H. Aram Veeser, ed., *The New Historicism* (New York: Routledge, Chapman, Hall, Inc., 1989), 41–42.

18. See Tillotama Rajan, "The Erasure of Narrative in Post-Structuralist Representations of Wordsworth," in Kenneth R. Johnston, et al., eds., *Romantic Revolutions: Criticism and Theory* (Bloomington: Indiana University Press, 1990), 350–70; and Alan Liu's reflections on emigration and post-structuralist criticism in *Wordsworth: A Sense of History.*

19. Most of the essays collected in Jacobus's *Romanticism, Writing and Sexual Difference: Essays on The Prelude* (1989) appeared in various journals between 1979 and 1985.

20. The subsequent changes in our image of romantic studies thus bear witness to Bruce Robbins's insight that "the foundation of professional authority is not unchanging control over one's exclusive expertise," but rather a constant exchange and even competition between alternative disciplines and specializations. "Theory and the Narratives of Professionalization," 16.

21. David Simpson, *Wordsworth and the Figurings of the Real* (London: Macmillan, 1982).

22. See Barrell, who describes this particular brand of materialism as compounded of "historical and cultural context, theoretical method, political commitment, and textual analysis" together with an insistence that culture does not and cannot "transcend the material forces and relations of production." *Poetry, Language and Politics* (St. Martins Press, 1988), vii. We leave aside the vexed question of the relation between romantic studies and Renaissance New Historicism. See Klancher, "English Romanticism and Cultural Production," in Veeser, ed., *The New Historicism,* and Levinson, *Rethinking Historicism,* for a full discussion.

23. David Simpson's work was already proceeding along lines that clearly prefigure McGann's early statements by 1982, when he published *Wordsworth and the Figurings of the Real.* While Simpson has generally continued to concentrate on Wordsworth, he is in many ways the exception that proves the rule that we lay out in our next paragraph, for his critical practice is generously inflected with a British version of Marxism.

24. For an elaboration of this debate, see the essays grouped under the heading, "Romanticism without Wordsworth," in *Romantic Revolutions: Criticism and Theory,* ed. Kenneth R. Johnston, et al. (Bloomington: Indiana University Press, 1990). See also Butler's "Repossessing the Past: The Case for an Open Literary History."

25. See, for instance, Karen Swann's essay "'Christabel': The Wandering Mother and the Enigma of Form," *Studies in Romanticism* 23, no. 4 (1984): 533–54.

26. Herbert Lindenberger effectively argues that the academy is possessed of a romantic identity in *The History of Literature* (1990), 80.

27. We draw here on Ernesto Laclau and Chantal Mouffe's notion of "articulation", as well as their use of Michel Foucault's notion of "discourse" as developed in *The Archaeology of Knowledge.* In brief, Laclau and Mouffe describe articulation as "any practice establishing a relation among elements such that their identity is modified as a result of the articulatory process." Discourse, in this schema, may be described as "the structured totality resulting from this articulatory process" and the discursive formation—such as romanticism—"an ensemble of differential posititons" which "constitutes a configuration, which in certain contexts of exteriority can be *signified* as a totality." *Hegemony and Socialist Strategy: Towards a Radical Democratic Politics* (London: Verso Books, 1985), 105–106.

28. Despite their very public disagreement at the 1992 MLA session on "Green Romanticism," Marjorie Levinson's position here suggestively displays a shared interest with Jonathan Bate's version of eco-romanticism as a potential refusal of productivity and of materialism.

1

Wordsworth & Romanticism in the Academy

J O H N R I E D E R

According to Roland Barthes, "to give a text an Author is to impose a limit on that text, to furnish it with a final signified, to close the writing" (147); or, as Foucault later put it, the author is "the principle of thrift in the proliferation of meaning" (159). What, then, results from the practice of binding together a group of authors in the further coherence of a literary period? If the death of the author is the birth of the reader (Barthes, 148), isn't periodization an even stronger way of asserting critical authority over a group of potentially unruly readers? Periodization seems to be a way of keeping the books in order. Relevance to the period prescribes a hierarchy among the texts, and it elicits and legitimates a determinate set of interpretations. These procedures are called establishing the canon and defining the proper context. But what is the point of such hermeneutic accountancy? What purposes does it serve, and for whom? The argument that will be explored here is that the functions of periodization are academic and pedagogic. That is, periodization is a tool for shaping and governing the responses of a certain kind of reader in a specific place: the student of literature in the modern university. More particularly, this essay will attempt to describe and speculate about some of the professional and institutional functions of the period term *English romanticism,* especially as it applies to the poet who is nowadays usually placed at its center, William Wordsworth.

Insiders and Outsiders

It is worth asking at the outset why English romanticism is a category worthy of serious consideration. Any advanced student of the period knows that the poets and writers who are grouped together under this term recognized no

solidarity or unity of purpose or style among themselves. Even contemporary denominations, such as the Lake School, the Satanic School, or the Cockney School, are all epithets inflicted on unwilling poets by hostile reviewers. As for the term "romantic" as a designation for the major English poets of the early nineteenth century, it is, according to the best scholar of the word, "a comfortable aberration that canonized itself towards the end of the [nineteenth] century" (Whalley, 157). But this "comfortable aberration" has some pernicious effects; Whalley concludes that it "has done widespread (but probably not irreversible) damage to the precise apprehension of the early nineteenth-century poets and their work" (256–57).[1]

Certainly the history of scholarly and critical dissatisfaction with the term might seem impressive enough to justify abandoning it; most recently, for instance, David Perkins, who began his important book on Wordsworth in 1964 with the assertion that "Wordsworth is the central figure of English romanticism" (*Poetry of Sincerity*, 1), has declared in 1992 that "English romantic poetry seems to me a classification that is not well grounded" (*Is Literary History Possible?*, 118). There is a strong temptation to follow the lead provided by Earl Wasserman's arch dismissal:

> We generally lop off a period of time, variously and arbitrarily determined, presuming it to be infused with some identifying quality whose name is "romanticism"; and we then set out, in fact, to constitute the *a priori* phantom by defining it, with little resulting agreement, usually by naming the common features in manifestations of what we assume must be "romantic." The logic is that of the vicious circle: the definition assumes as existent and understood that which is to be defined and proved to exist. Since, like Humpty Dumpty, I'd rather not have the word come round of a Saturday night to exact such heavy wages of me, I ask permission to sack it. (17)

Nonetheless the essay which Wasserman opens in this way is entitled "The English Romantics: The Grounds of Knowledge."

The apparent contradiction between Wasserman's title and his argument is instructive. Whatever the amount of discomfort the term inspires if taken seriously, it remains inescapable as a conventional, professional signal. Wasserman wants his readers to know what critical debate his essay joins, and he may also need the conventional term to conveniently designate an area of professional expertise. His essay was published in the journal *Studies in Romanticism*, and has been read most attentively, no doubt, by many members of the MLA Division called "The English Romantic Period," many of whom earn their living teaching courses with the same or a very similar title. Wasserman's joke about Humpty Dumpty's wages speaks to the real issue, which is not semantics, but rather the economic contingency by which English romanticism delimits the wage-earning activities and the professional certification of a sizable group of university professors. Wasserman's use and abuse of romanticism—that is, his simultaneous promulgation and dismissal of the period

term—can stand as an emblem for the impact of periodization on this group. Each person who aspires to teach English romanticism in an American university will probably at some point feel the need to negotiate between the term's conceptual validity and its institutional necessity. The problem indicated by Wasserman's strategy, then, is not so much the circularity or impossibility of defining English romanticism but rather the professional situation which allows—or forces—this designation to persist in spite of its intellectual and scholarly shortcomings.

The teaching of English romanticism is a decidedly minor moment in the educational mission of the modern American university. If that mission, from the most general point of view, is to reproduce socially useful or desirable skills, then little more than a vague sense of what "romanticism" gestures toward would seem to be as much as the majority of college graduates want or can use. Yet it is precisely at this vague level of generality that the term has its most widespread effect—that is, as a label for a set of commonplaces about literary and cultural history best suited for the necessarily reductive treatments English literary history receives in introductory literature courses or, in a slightly more specialized context, in surveys of English literature. Those who progress beyond this point—English majors, graduate students, and members of the profession—learn both to disregard or at least distrust such commonplaces among themselves and to disseminate them at appropriate times and places (e.g., secondary schools and the lower levels of college training) to neophytes and nonspecialists.

The result is that romanticism takes on two quite different aspects. From the "outside"—on the evidence, for instance, of the title of an article or of a course or of a section in an anthology—it looks unified and coherent, and it commands recognition as a comprehensive, well-established term. From the "inside," its significance becomes a matter of hotly contested debate, as if "Romanticism" were no more than a code word with which to gain entrance to this esoteric dialogue. If this situation is something more important than merely a pragmatic tolerance we "insiders" exercise toward the imperfect educability or dedication of the "outsiders," it makes sense to think that some sort of homogenizing, institutional necessity overrides the conceptual instability of the term "romanticism."

A commonsense explanation of the dual aspects of "romanticism" might be that various uses of the term correspond to and differentiate appropriate levels of acquired knowledge and interpretive skill with regard to late eighteenth- and early nineteenth-century English literature and history. This commonsense observation needs to be supplemented by two additional ones, however. First, the difference between insiders and outsiders may have as much to do with attitudes and values (e.g., opinions about what is interesting and important) as with cognitive skills. Much of what seems to the insider to be a hierarchy of knowledge, sophistication, or taste may seem to the well-educated outsider no more than a difference of opinions and interests largely

based on a horizontal division of labor. To a large extent, the insider's sense of privilege or of belonging to a cultural or intellectual elite manifests a kind of ideological buttressing for the technical necessity of specialization. Second, however, and more to the point in the present context, this horizontal division of insiders and outsiders echoes or redoubles the vertical difference between those outsiders who recognize "romanticism" as a cultural and historical term and those even further outside to whom the academic term has no significance whatsoever. The two aspects of romanticism reflect inside the academy the difference which obtains between those with a college education and those without one; that is, between the inside and the outside of the academy itself. This is not a difference between people who are trained for different specializations, but rather one between different classes of workers, e.g., professional vs. blue collar, managerial vs. manual. Thus, along with the problem of the ideology of specialization comes the problem of the way advanced professional training is implicated in hierarchies of social class.

One of the major theses of Louis Althusser's influential essay "Ideology and Ideological State Apparatuses" is that educational institutions collectively comprise the dominant ideological mechanism for the stable reproduction of capitalist relations of production in contemporary capitalist societies. An Althusserian line of argument would suggest that the dual aspects of romanticism might not merely reflect an ideology and a class division, but rather participate actively in reproducing them. This is not the place to enter into the validity or the shortcomings of Althusser's hypothesis. Its use here is rather that of suggesting a broad conceptual horizon for the question of insiders and outsiders. It suggests that we need to place this specific institutional situation for a moment in the context of the social reproduction of the relations of production, and to ask what function the different uses of the term "romanticism" might serve from this point of view. The problem is to find a plausible way of relating the production and reproduction of knowledge and skills within the academy to the economic reproduction of capital and labor and to the social reproduction of class identities and divisions.

Consider, as a starting point, a simplified version of the circuits of capitalist reproduction elaborated by Marx in volume two of *Capital*. For the capitalist, economic reproduction begins and ends with money. Money buys the means of production (MP) and pays for the labor power (LP) which transforms the raw material into commodities (C) which are then exchanged for more or less money (M') than the capitalist started with:

$$\begin{array}{c} \text{LP} \\ \text{M}\!-\quad -\text{C}\!-\text{M}' \\ \text{MP} \end{array}$$

Note that C–M', the valorization of the capitalist's commodity, is from this point of view the climax and the point of renewal for the whole cycle. From the point of view of the worker, however, things look very different. Workers

sell their labor power for wages in order to buy commodities with which they renew their labor power:

$$LP-M-C-LP$$

The valorization of the commodity in this scheme appears as M–C, that is, the act of consumption, and, far from being the climax of the cycle, it only mediates the more important goal of reproducing labor power. Of course, the renewal of labor power is an enormously complex process, and by no means so abstract as this diagram would make it appear. No laborer strives to reproduce "labor power." Laborers are interested in reproducing children, families, traditions, beliefs, and ways of life.

The clear-cut difference between consumption and valorization gives way to a more ambiguous situation in the context of institutional education. When students and teachers enter their classrooms, students enter as consumers intent on renewing and improving their labor power, while teachers enter as laborers intent on practicing their trade. In diagrammatic terms, the student's use of the commodity, C–LP, coincides in the classroom with the teacher's expenditure of labor to produce the commodity, LP–C. But C–LP and LP–C are not, like C–M and M–C, two ways of looking at the same transaction, and they are not necessarily opposed to one another. It is true that, from a certain point of view, the teacher's labor is a subordinated moment, regulated under a contract for the payment of wages, which may well serve the ultimate goal of reproducing appropriate skills in the labor market and "safe" values in the political and social community. C–LP, however, represents the moment when commodities are put to *use,* so that the value of a commodity therefore appears, not as profit or price, but rather as its effect upon the labor power it helps to reproduce. Thus C–LP could be called the "cultural interlude" in the cycle of production, since this momentary predominance of use over exchange value brings to view, on the one hand, the rich qualitative differences between the ways workers reproduce their families, traditions, beliefs, and ways of life; and on the other hand, the way all of these activities are contained and inscribed within, without being strictly determined by, the quantitative logic of capitalist production and commodification.

From the student's point of view, therefore, education cannot be reduced to a factory-like process in which a teacher expends his or her labor in order to produce as a "commodity" a certain number of well-trained workers to fuel the economy and increase the tax base. University students' motives for acquiring an education are as diverse as their beliefs. Far from considering themselves as a kind of commodity, they are likely to think of the university as precisely an interlude or break from the workplace—especially if, like many of my own students, they carry full- or part-time jobs while they go to school. Education thus often appears to them as an opportunity to enjoy some relative freedom and to explore their ethical, cultural, and intellectual options.

Not that economic interests do not exercise a powerful influence here. That

is, it is generally in the workers' interest to reproduce their labor power, or that of their children, in forms which improve their own condition and promote their own sets of values. In economic terms, then, the worker's interest in getting an education is to make his or her labor power *more expensive*. In this sense the classroom is a muted but extremely important site of the class struggle which, as Marx's great chapter on the working day in volume one of *Capital* narrates most impressively, pits the capitalists' desire for the cheapest available labor against the workers' interest in making their labor as expensive as possible. The teacher therefore works in an ambiguous situation, not only insofar as the students' interests may or may not correspond to those of the institution, but also insofar as each teacher's sense of the students' best interests—and of their implications in political and social struggles—is liable to differ from the goals which emanate from the general direction of those who pay the teacher's wages.

The point of this analysis is to attempt to expose what is at stake in the apparently esoteric problem of the status of "English romanticism" as a historically useful generalization and in the related problems of periodization and canonization in the university curriculum. It suggests that English romanticism (or any similar period term) might usefully be considered in terms of the way it tends to either enforce or to struggle against higher education's institutional propensity to reinforce or replicate stable relationships of social class. Thus, on the one hand, the concept of the period seems to function for "outsiders" in much the same way as Barthes and Foucault say the concept of the author does; that is, as a way of gaining some control over the readerly chaos which tends to dissolve the meaning of any given text—for instance, a "romantic" poem or essay—into innumerable acts of reception and transmission. In an institution devoted, to one degree or another, to the predictable and stable reproduction of skills and attitudes, a "principle of thrift" such as romanticism may serve the important function of normalizing the reception and transmission of a whole group of texts and an entire era of cultural history. On the other hand, the esoteric debate over English romanticism may well articulate a number of the same conflicts and tensions which the period term serves to smooth over at different times and places. And while this much could be said of almost any powerful period term or area of specialization in literary studies, such tensions are certainly exacerbated in the case of romanticism both by the history of scholarly contention over the term and by the volatility of the historical issues themselves (e.g., the French Revolution and its effects, the emergence of industrial capitalism in England, and so on). Since teachers of English romanticism, like scholars of literature in general, are extraordinarily self-conscious about the ideological, political, and ethical ramifications of the terms they disseminate in the classroom, such concerns do more than merely find their ways into critical and scholarly projects. A great deal of contemporary criticism's preoccupation with political and historical

issues probably arises more or less directly from the ambiguous class position teachers occupy in the university scene of instruction.

Romantic Ideology as Institutional Expediency

One of the most notable recent contributions to the esoteric dialogue on English romanticism has been Jerome McGann's critique of the "romantic ideology," "an uncritical absorption in Romanticism's own self-representations" (*Romantic Ideology*, 1), which, he argues, holds sway over most professional scholars of the period. McGann's critique is a prime example of the way the esoteric dialogue on romanticism has engaged itself in political and historical issues, and therefore, if the argument developed so far in this essay has any validity, the university classroom and the wage-earning activities of university professors provide a very important context in which to place McGann's thesis. "Romantic ideology" is not just a set of false ideas, and its critique properly aims at changing not just opinions but also professional and pedagogic practices. What follows here is an attempt to help move the discourse on ideology itself away from too exclusive a concern with ideas and toward the realm of institutions and professional practices.

It begins not with a consideration of McGann's wide-ranging argument, however, but with one cogent objection to McGann's argument which has been raised by David Perkins. Perkins maintains that McGann "wrongly conflates the aesthetic ideology of the end of the [nineteenth] century with the opinions and practices of the Romantic poets themselves" ("The Construction of 'The Romantic Movement,'" 143). While the possibility that McGann has conflated some major poetry (cf. his readings of "The Ruined Cottage," "Tintern Abbey," and the "Immortality Ode" in *The Romantic Ideology*, 81–92) with late Victorian interpretations of it would not automatically absolve the poets from significant complicity in the idealizing and conservative ideology under attack, Perkins's argument implies that there is a strong difference between the poems in their original context and the cultural and ideological significance they acquire when forced to become representatives of English romanticism. Perkins's criticism therefore has a strong bearing not only on our idea of the extent and origins of English romanticism and on our understanding of the poetry of Wordsworth and his contemporaries but also on the question of periodization and our continued promulgation of generalizations about the romantic period in our teaching. His argument needs to be examined in terms of institutional as well as intellectual history.

Throughout most of the nineteenth century the most usual mode of relating Wordsworth to his contemporaries and of explaining his massive impact on English poetry was by recourse to the historical and political context of his achievement. (This very brief account draws freely on the scholarship of Wellek, Whalley, and Perkins, and readers in search of a more detailed narrative should consult these sources.) Wordsworth's poetic revolution reflected the

French Revolution; it expressed "the spirit of the age." Hazlitt's essay on Wordsworth in *The Spirit of the Age* is, of course, an early epitome of this strategy; at the other end of its development stand such books as William Courthope's *The Liberal Movement in English Literature* (1885) and Edward Dowden's *The French Revolution and English Literature* (1897). The major contemporary alternative would be some form of humanist emphasis on the faculty of "Imagination," as exemplified by Wordsworth's 1815 essay or Coleridge's theorizing in *Biographia Literaria*. Toward the end of the century this argument finds its most important proponent in the person of Matthew Arnold. Neither of these arguments, however, is especially tied to the term "romanticism," and the romantic/classic opposition, introduced into England somewhat furtively in Coleridge's lectures and more widely popularized by Germaine de Staël, had little direct impact on attempts to generalize about Wordsworth and his contemporaries—partly because Wordsworth himself seemed more "classical" than "romantic" to some of the reviewers (Whalley, 199–216, 227–28).[2]

In the late nineteenth century, when the word "romantic" entered into the "comfortable aberration" of periodization, the influence of the French Revolution generally gave way to explanations emphasizing cultural continuity with various eighteenth-century trends, such as primitivism, the medieval revival, associationism, and so on. According to Perkins, this shift signals a major institutional realignment of criticism. Instead of being predominantly a way of supporting the critic's political and ideological commitments (the charge leveled against his contemporaries by Arnold in "The Function of Criticism at the Present Time"), criticism now began to reflect an "aesthetic ideology" by which art provides ideal reparation for the ills which the current social order could not heal (*Is Literary History Possible?*, 104–105).

A late version of the older mode of criticism, William Courthope's *The Liberal Movement in English Literature*, for instance, consists of a series of articles reprinted from a politically oriented journal, the *National Review*. Courthope defines the "Liberal movement" as "the writings of those who, in point of time, followed the French Revolution, and who founded their matter and style on the principles to which that Revolution gave birth" (22). His fundamental conceptual—or at least polemical—opposition is explicitly political: Liberalism vs. Conservatism.

Compare to this the definition of romanticism offered by C. H. Herford, a professor of English literature at the University of Manchester, in *The Age of Wordsworth* (1897):

> Primarily, as we have hinted, it was an extraordinary development of imaginative sensibility. At countless points the universe of sense and thought acquired a new potency of response and appeal to man, a new capacity of ministering to, and mingling with his richest and intensest life. . . . Its peculiar quality lies in this, that in apparently detaching us from the real world, it seems to restore us to

reality at a higher point,—to emancipate us from the "prison of the actual," by giving us spiritual rights in a universe of the mind, exempt from the limitations of matter, and time, and space, but appealing at countless points to the instinct for that which endures and subsists. (xiv)

For Herford romanticism offered a veritable secular apocalypse, a "new earth and heaven" (xv) available to all, indifferent of one's political persuasion. Significantly, his claim that romanticism emancipates man from the prison of actuality corresponds to Courthope's sharpest criticism of Wordsworth, that the poet's liberalism stems from and reinforces his narcissism (his "overweening estimate of his own genius"), and as a result Wordsworth "removed the art [of poetry] from the sphere of social action to that of individual reflection and mental analysis" (106–107).

C. E. Vaughan, of the University of Leeds, writes of *The Romantic Revolt* (1907) in a way which makes it clear that the political term in his title is only a metaphor. For him romanticism signifies "that revolt from the purely intellectual view of man's nature, that recognition of the rights of the emotions, the instincts and the passions, that vague intimation of sympathy between man and the world around him—in one word, that sense of mystery which . . . inspires all that is best, all that is most characteristic, in the literature of the last half of the eighteenth century" (4). The sweeping generalizations flung forth in passages like this may read to us now like the ravings of an aesthetic ideologue indeed; and yet even a critic with a strong focus on historical specificity, like Albert Hancock in his Harvard dissertation, *The French Revolution and the English Poets* (1897), prefers to stress a weak kind of period unity over the political differences that were preeminent to Courthope: "The Romantic Movement then means the revolt of a group of contemporary poets who wrote, not according to common and doctrinaire standards, but as they individually pleased. . . . There are no principles comprehensive and common to all *except those of individualism and revolt*" (47; my emphasis). I suggest that if there is an "aesthetic ideology" at work in Herford, Vaughan, and Hancock, it is perhaps less a matter of shared interpretations or beliefs than of a commonly held priority: the task of unifying the period classification. That is, what Perkins calls the "aesthetic ideology" which produced the late Victorian version of romanticism might at the same time also be an emerging academic ideology. This ideology is based on the necessity of elevating and unifying the literature of this slice of literary history; that is, of rendering it a worthy and practical object of pedagogy as well as of serious scholarly inquiry. Its effect is to cause teachers and scholars to invent a quality called romanticism which pervades the age and is reflected in all of its major poetry. The poetry thereby becomes an avenue leading to this essential quality.

Thus the "romantic ideology" may be best understood as the whole matrix of interpretative positions which depend, more or less openly, on the assumption that a select group of poetic texts expresses the essential truth about the

age (including the humanist truth that the age does not finally matter because the spirit is free to transcend it). Even those critics, like McGann, Marjorie Levinson, and Alan Liu, who think that Wordsworth's poetic achievement produced a momentous repression of historical reference in English poetry (cf. *Romantic Ideology*, 90–91, *Wordsworth's Great Period Poems*, 16–17, *Wordsworth*, 447–49) do not necessarily cast doubt on the basic assumption of literature's essentiality. Such criticism will be vitiated if it challenges a set of received critical ideas but leaves undisturbed the institutional practices of periodization and canonization which may well hold more normalizing and replicating power than any given interpretation of Wordsworth.

The connection I am suggesting between "romantic ideology" and the powerful influence of an institutional expediency is speculative, but I hope to show that it is at least a plausible speculation. Certainly there were factors other than purely intellectual ones encouraging the practice of periodization in American universities in the late nineteenth century.[3] In the years from 1870 to 1910, the modern American university as we know it today came into existence: "The numbered course; the unit system for credit; the lecture, recitation, and seminar modes of instruction; the departmental organization of learning; the chain of command involving presidents, deans, and department chairmen; and the elective system of course selection all emerged in an astonishingly short period of time and with relatively little variation from one institution to another" (Veysey, 3, quoted by Graff, 59). Of these changes, two are particularly relevant to the emergence of academic romanticism: the course and the department. Veysey comments that, compared to its British and continental counterparts, the American university was far more impersonal and bureaucratic, far more *rationalized* in Weber's sense of the term. Veysey connects this tightness of structure to a certain insecurity owing to the strong current of anti-intellectualism in American culture; as a result,

> Highly formal organization guaranteed necessary order. In addition, it had the advantage of permitting interchangeability between many of its functioning parts (such as individual courses . . .). As a record of these interchangeable courses accumulated, everyone could know at all times just where everyone stood. (Veysey, 4)

Standardization of course offerings, in other words, assured adminstrators and consumers of getting their money's worth; to recur to the scheme of social reproduction sketched earlier, it appears as an efficient mechanism for subduing or neutralizing the inherent tension between valorization and consumption (for "know[ing] at all times just where everyone stood"). This same standardization also encouraged what Gerald Graff calls the "field coverage model of departmental organization" (Graff, 6–9; see also Veysey, 32–34). The course on English romanticism and the department's desire to train and hire romanticists are dual, linked results of the same institutional and disciplinary structure.

A concomitant development is the undergraduate major with its combination of mandatory and elective requirements. A brief look at these requirements shows the way that the study of romanticism and the English romantic period are liable both to be reified and to flourish in this setting. In 1895 at Berkeley, for instance, the basic requirement for advanced work in English was a survey course, "a synoptical view of English literature . . . based upon a text-book of English history, and the copious reading of authors illustrative of social and literary movements" (Graff and Warner, 56). The advanced courses themselves are devoted to rhetoric, linguistics, and "the historical and critical study of literature: eleven courses in chronological sequence, by *(a)* periods, *(b)* authors, *(c)* literary movements, *(d)* the evolution of types" (Graff and Warner, 57). Periods take their place alongside authors, movements, and types as organizational principles in the curriculum, and therefore some generalization or another must, out of curricular necessity, dominate each manageable slice of literary history. Furthermore, practical and pedagogic considerations would surely militate toward lending sense and coherence to such denominations.

A description of the English major at Indiana University, written the same year by Martin Wright Sampson, provides a clue as to why the romanticism that took hold in this type of institution tended to emphasize intellectual and literary continuities at the expense of political engagement:

> To repeat those truisms that have thus become truisms of theory (not yet of practice—the difference is profound), we have first the truth that the study of literature means the study of *literature*, not of biography nor of literary history (incidentally of vast importance), not of grammar, not of etymology, not of anything except the works themselves, viewed as their creators wrote them, viewed as art, as transcripts of humanity,—not as logic, not as psychology, not as ethics. (Graff and Warner, 53)

The need to organize literary history into movements, to offer advanced courses in periods of English literature, and to do so while presenting literary works as "the works themselves," rather than as logic, psychology, or ethics— i.e., as literary form and "transcripts of humanity" rather than as persuasive statements committed to political or social doctrines—all of these pressures surely encouraged the success of the late Victorian version of periodization in the American university. In fact, we now find ourselves in precisely the opposite of the situation described by Sampson, for nowadays the version of literary pedagogy he advocated is a truism of practice, and it is one that is increasingly embattled by recent developments in theory.

If our teaching of reading is to become more aware of its participation in the reproduction of social practices and values, and to be more articulate and self-conscious in its engagement with the political and economic imperatives which meet in the classroom, then the critique of "romantic ideology" needs to include a reexamination of the practice of periodization. Such a reexamination

would involve, at the outset, de-idealizing poetry, separating the poets' time-bound utterances from the glow of essentializing generalizations, and re-emphasizing the synchronicity of different and conflicting poetic practices and the values which motivate them. The remainder of this essay will attempt a modest beginning of such a project, starting with a look at René Wellek's defense of periodization, moving from there to some more recent efforts to conceptualize Wordsworth's originality in its historical context, and concluding with an all-too-brief suggestion concerning the way this still esoteric contribution to the dialogue on romanticism might have a practical effect in the classroom.

Rethinking Wordsworth's Dominance

In "The Concept of Romanticism in Literary History," Wellek writes that literary periods should be thought of as "not as arbitrary linguistic labels nor as metaphysical entities, but as names for systems of norms which dominate literature at a specific time of the historical process" (129). Wellek devotes a good deal of attention, here and elsewhere, to clarifying what he means by "norms" and to explaining their dependence on notions of value and evaluation. It is only through the exercise of critical judgment that one can decide which norms or conventions are dominant at a given time; that is, which norms "were created or used by writers of greatest artistic importance" (129). Domination therefore means aesthetic superiority, and Wellek is acutely aware of the circularity by which literary history "will be constructed in reference to a scheme of values or norms, but these values themselves emerge only from the contemplation of this process" (*Theory of Literature*, 257). To escape this logical circle would mean applying "extra-literary standards," and would therefore defeat Wellek's whole project of defining the literary period "by purely literary criteria" (*Theory of Literature*, 257, 264). Wellek's argument is clear and internally consistent, but surely it also begs some important questions. What is a "purely literary" phenomenon? Why *not* judge literature by "extra-literary standards"? How could literature be thought of as bearing any sort of value at all if it could really be detached from all other types of norms and values? But what Wellek is defending is the kind of detachment and isolation which enables literary values to root themselves in "the contemplation of this process," that is, in the act of reading and studying literature—or, to put it bluntly, in the professional space cleared for literary study by the disciplinary structure of the modern university. His defense of "purely literary criteria" is meant to argue the correctness of separating the literature department from departments of history, sociology, philosophy, and so on. (Such insulation of literary "contemplation" also tends to erode any strong sense of the relation between the cultural interlude—C–LP—in which education takes place and the rest of the economic circuit which it helps to reproduce.)

It is quite possible, however, to turn Wellek's definition of a period away

from its apology for disciplinary structure. If domination and normalization are taken, not as the results of professorially determined aesthetic superiority, but rather as actions which constitute a distinct moment in the "historical process," then our "names for systems of norms which dominate literature at a specific time" can lead students toward a critical integration of literary study with social history. Periodization might then help literary study become more useful for life, as Nietzsche would say, since periodization would have to begin by questioning the value of literature's truths. Rather than isolating and monumentalizing a set of dominant norms, however, such a study would need to set dominant conventions beside their dominated counterparts. Domination would need to describe a set of values promulgated by both writers and readers, always multiple and always in the process of contesting other contemporary sets of conventions and values. Such extrinsic historical phenomena as the technology of publishing, the censorship and regulation of the dissemination of literature, the cultural hierarchies which predicate various forms and venues of expression, the institutionalization of interpretative practices, and so on, would seem to be pertinent to one's sense of the strength and extent of the domination enjoyed by a given set of norms. An exemplary model of the kind of study just projected would be Jon Klancher's *The Making of English Reading Audiences, 1790–1832*. It is also to the point that Klancher's title echoes E. P. Thompson's most famous work; the revision of Wellek's concept of the period turns upon the decision to read "domination" as the action of a class rather than a quality inherent in a text.

How do romanticism and Wordsworth appear in a literary history which is alert to the social forces supporting the emergence and eventual dominance of a set of literary conventions? Klancher's chapter "Romantic Theory and English Reading Audiences" offers several periodizing statements about Wordsworth which attempt to establish the poet's writing as a watershed in literary history. For instance, he attributes to Wordsworth "the first functionalist view of cultural acts" (137) and says that Wordsworth's theory of language "belongs to a new age in which the writer's language can at most only 'represent' a truly representational language" (143). One finds in Wordsworth's prose

a whole vocabulary with which literary history and the sociology of culture came to distinguish the transmission of cultural works: their "reception" by some readers, their "consumption" by others, and the abyss between serious and mass culture. (135)

Romanticism does not thereby turn into the spirit of Wordsworth's age, however. On the contrary, Wordsworth's poetic theory emerges in direct opposition to what the poet saw as the degenerate reading habits spawned by the burgeoning institutions of the circulating libraries and the periodical press. Wordsworth's experiments with common language attempt to erase the dan-

gerous class divisions being reified in the new institutions (140). The spirit of Wordsworth's theory thus runs directly counter to much of what dominated his age—"he attempts to transform commodified textual relations into an older relation of symbolic exchange" (143)—and it is precisely the fantasy of overcoming class conflict by a symbolic strategy that eventually triumphs in the late nineteenth- and twentieth-century understanding of the "romantic" Wordsworth (150). What makes Klancher's argument persuasive is not just his careful reading of Wordsworth's prefaces but, more crucially, his delineation of the various audiences (middle-class, mass, radical) against which Wordsworth's theory directs itself. To say that Wordsworth's eventual canonization derives from his aesthetic superiority is indeed, by comparison, a circular argument. It is the social triumph of the "high-humanist" (150) classless fantasy that itself establishes the prescriptive role of academic aesthetic values.

A similar attention to the institutional history of writing and reading informs Jonathan Arac's recent attempt to rearticulate Wordsworth's crucial place in English literary history. Drawing upon the historical sense of Raymond Williams and Michel Foucault, Arac writes that "Wordsworth stands at a very special place in history, what might arguably be called the 'end of English poetry' and the 'beginning of English literature'" (47–48; cf. Williams, 45–54, and *The Order of Things,* 299–300). Arac performs a very sensitive psychoanalytic reading of Wordsworth's "Nutting" in order to advance the thesis that "Wordsworth not only defended but also formed a new, literary human nature—the human nature that makes psychoanalysis possible" (49). At the same time Arac gestures briefly toward the decay of patronage, the commodification of publishing, and the alienation of writers from their readers, and avows that Wordsworth's "process of internalization . . . cannot be understood apart from such externalities." The (no doubt deliberate) inadequacy of this gesture is worth examining.

First of all, because the situation Arac alludes to is so general (almost a Marxist version of the spirit of the age), it seems quite insufficient to justify the large claim being made for Wordsworth. To adduce a new kind of selfhood directly from the circumstance of ever more pervasive commodification simply collapses the difference between consumption and what I have called the cultural interlude, that is, the scene of education, of literary pleasure, of cultural reproduction in all its complexity. Second, and by the same token, the particular relevance of such a claim to Wordsworth is open to serious doubt. For instance, Terry Castle makes the same kind of claim about selfhood and psychoanalysis for Anne Radcliffe's *Mysteries of Udolpho* (236–37), with more than enough plausibility to weaken any claim for the special status of either Radcliffe or Wordsworth. It seems that "the emergence of the psychological self" is one of the more powerful interpretive commonplaces of the present generation; and the important question, in any event, may not be whose genius or charisma first produced such a selfhood in literature, but rather why so many texts of the eighteenth and early nineteenth centuries support this inter-

pretation. Thus a periodization based on selfhood might better turn to a study of family structure, like Lawrence Stone's argument that privatized reading habits provide a material support for the development of "affective individualism" (226–29), or to Alan Liu's monumental chapter on *The Borderers* (*Wordsworth*, 225–310), in which he draws on the interaction of family and class structures to explain the development of Wordsworth's characteristic selfhood. It is only at this point, at least, that "romantic" selfhood enters into a recoverable dialogue with contemporary, rival versions of individual autonomy and collective self-recognition, so that Arac's thesis about Wordsworth can begin to be adequately assessed.

I do not offer this criticism of Arac in order to belittle his argument, however. The point, rather, has to do with the context in which he offers his reading of "Nutting." He is engaging in a careful and very useful critical survey of academic interpretations of romanticism, and within that setting it is difficult not to turn Wordsworth's centrality to academic romanticism into an essential feature of social history. Thus Arac's gesture toward economic history confesses the absence of those other voices which might make claims about Wordsworth's historical importance more credible.

Those other voices need not be difficult to present to the average college student. Let me conclude with some pedagogical suggestions, beginning with a rather conservative one that involves only standard canonical texts. A survey of English literary history, or even an introductory literature course, might easily place Wordsworth's claims for the moral and spiritual efficacy of pedestrian tourism in "Tintern Abbey" next to not only Coleridge's identification of the rural landscape as God's language in "Frost at Midnight" but also another tourist's raptures over another landscape: Elizabeth Bennett's appreciation of Darcy's estate in *Pride and Prejudice*. The question is to what extent, and how convincingly, Wordsworth's romantic ambition can share in the ironies Austen brings to bear on Elizabeth Bennett's feeling that "to be mistress of Pemberley might be something!" Wordsworth's poem does, after all, express a longing to establish "a mansion for all lovely forms," and it should prove interesting to compare Wordsworth's husbandry of his mental resources with Darcy's exemplary estate management. But the point is also to ask how well Wordsworth's exalted faith in nature can be understood unless it is held next to the still viable association of land ownership with classical virtue and paternalistic order in Austen. I think it likely that fewer students will reproduce banalities about "Nature" in response to Wordsworth's poem if his glorification of the Wye valley, and his later regard for the freeholding farmers of the Lake District, are made to enter a dialogue with Austen's representation of Pemberley as the basis of a solid, self-justifying social order. Wordsworth's enthusiasm about the rural landscape might at least make more sense to many students if they are presented with a historical situation where economic production outside the capitalist circuit of reproduction, such as subsistence farming or artisanal labor, is still an aristocratic privilege for the

estate owner but is reduced to nostalgia for the pre-capitalist economy in the wandering, marginalized, middle-class poet's fantasies of community.

I am not trying to strip Wordsworth's poetry of its claims to profundity, but rather to advocate presenting those claims to students in a less heroic light than the practice of periodization usually encourages. Restoring to Wordsworth's voice some of the contingency and obscurity of the situation from which he spoke, and setting his aspirations within a dialogue of attitudes between the members of an emergent social class and a well-established one, should help to strip away some of the air of essentiality and inevitability invested in "Tintern Abbey" by a century of curricular canonization. The pedagogical strategy I am suggesting is certainly no less laborious than the humanistic endeavor to train college students in the art of recognizing the value of literature "as literature," but it aims instead to help students think about literature in history and as a social practice. The point is not so much to put literary history, rather than literature "as literature," at the center of literary pedagogy, however, as to take notice of the fact that the problem of what literature *is* and *does* has become a different kind of question, one more likely to be illuminated by historical investigation than by professorial evaluations of aesthetic merit.

The project of understanding the social function of literature predicates a greater emphasis than is usual in current pedagogy upon the contemporaneity of texts which inhabit different places and engage different perspectives within a shared historical moment. Jerome McGann's *New Oxford Book of Verse of the Romantic Period* lends itself to such an emphasis by presenting the period's poems, not grouped by authors, but in chronological order, year by year from 1785 to 1832 (see McGann, "Rethinking Romanticism," 743–47). An advanced course in English romanticism might be organized, if not by years, then by decades or half-decades. Whatever problems such an organization might throw in the way of a student trying to understand a given author's organic development would be compensated for by the way this organization would help direct students' attention to the historical specificity of a given poem's or volume's composition and publication.

For instance, the tone and polemical implications of Wordsworth's representations of the poor in the 1798 *Lyrical Ballads* would be more easily understood by students who were also asked to read Hannah More's "The Riot, Or, Half a Loaf Is Better Than No Bread . . . Written in 1795, a Year of Scarcity and Alarm" (More, 2:86) alongside Joseph Fawcett's *Art of War*, published in the same year of scarcity; or the *Anti-Jacobin*'s "The Friend of Humanity and the Knife-Grinder" (November 27, 1797) alongside Southey's "The Widow" (1796), which it parodies (see *Poetry of the Anti-Jacobin*, 17–21). At the same time, the comparative subtlety and indirectness of any didactic intention in Wordsworth's poems could lead to the question of how literary response was detached, in precisely these years, from political intervention. Here might be the place to return to the "Lines Written a Few Miles above

Tintern Abbey, upon Revisiting the Banks of the Wye during a Tour, July 13, 1798," by placing it alongside a blank verse poem with a strikingly similar title, John Thelwall's "Lines, written in Bridgewater, in Somersetshire, on the 27th of July, 1797; during a long excursion, in quest of a peaceful retreat" (Thelwall, 126–32). Thelwall, one of England's most prominent radical writers, announces quite explicitly in this poem his desire to retreat from politics into the rural landscape, domestic tranquillity, and "high poetic rapture" (132). The point of such an exercise would be to confront and perhaps change the situation described by Marilyn Butler in *Burke, Paine, Godwin, and the Revolution Controversy,* a prose anthology of the 1790s which ends with Wordsworth's "Preface to the *Lyrical Ballads.*" Butler says that it is difficult for us to read the political prose of the 1790s well "because we are ourselves Romantics or post-Romantics; we have been taught the primary aesthetic values adopted by literary men after their political defeat" (16).

Much of my point in this essay, however, is that, if we have indeed learned to read as romantics or post-romantics, this has at least as much to do with a late nineteenth-century transformation of the institutional context of literary pedagogy as with the late eighteenth-century transformation of literary values Butler describes. If emergent theory is to triumph over ingrained practice in the late twentieth century, as it did in the late nineteenth, the period course needs to become the site of a critical dialogue where competing class goals, both those represented in the literature and those which meet in practice in the classroom, become audible and can be deliberated upon. In order for this to happen in a course on English romanticism, it seems to me that Wordsworth's voice must first cease being represented as that of the spirit of his age, and that we must restore to it, instead, the pathos of an individual struggling to make himself heard.

NOTES

1. Whalley's acerbic judgment is worth quoting at slightly greater length because it is so well informed: "By the end of the [nineteenth] century the phrases *romantic poets, romantic school, romantic movement,* and *romantic revival* had slid into respectable academic currency as affirmations of historical conclusions drawn from vaguely specified evidence and no better than casual analysis. . . . Historical generalizations about the alleged uniformity of romanticism in the early nineteenth-century poets have established a complex and opaque set of conditioned critical reflexes which have—until less than 25 years ago—induced systematic distortion and misreadings of the writings themselves" (160).

2. In Henry Beers's *History of English Romanticism* (1897–1901), where the term *romantic* "implies its opposite, the classic" (I:3) and refers to a type of writing rather than to a literary period, Beers judges Wordsworth "romantic neither in temper nor choice of subject. . . . Though innovative in practice and theory against eighteenth-century tradition, [Wordsworth] is absolutely unromantic in contrast with Scott and Coleridge" (II:14, 51).

3. A fuller treatment of the topic would have to include developments in British education as well as the problem of the American reception of British critical thought. What is offered here is, obviously, suggestive rather than comprehensive, and I can only hope that it will help to encourage (or provoke) a more thorough account.

WORKS CITED

Althusser, Louis. "Ideology and Ideological State Apparatuses (Notes Toward an Investigation)." *Lenin and Philosophy and Other Essays*, trans. Ben Brewster. New York: Monthly Review Press, 1971, 127–86.

Anonymous. *Poetry of the Anti-Jacobin*. With explanatory notes by Charles Edmonds. 2nd ed. London: G. Willis, 1854.

Arac, Jonathan. *Critical Genealogies: Historical Situations for Postmodern Literary Studies*. New York: Columbia Univ. Press, 1989.

Barthes, Roland. "The Death of the Author." *Image, Music, Text*. New York: Hill & Wang, 1977, 142–48.

Beers, Henry A. *A History of English Romanticism in the Nineteenth Century*. Two volumes. New York: Henry Holt and Company, 1897–1901.

Butler, Marilyn, ed. *Burke, Paine, Godwin, and the Revolution Controversy*. New York: Cambridge Univ. Press, 1984.

Castle, Terry. "The Spectralization of the Other in *The Mysteries of Udolpho*." *The New Eighteenth Century: Theory, Politics, English Literature*, ed. Laura Brown and Felicity Nussbaum. New York: Methuen, 1987, 231–53.

Courthope, William John. *The Liberal Movement in English Literature*. London: John Murray, 1885.

Foucault, Michel. *The Order of Things: An Archaeology of the Human Sciences*. New York: Vintage, 1973.

———. "What Is an Author?" *Textual Strategies: Perspectives in Post-Structuralist Criticism*, ed. Josue V. Harari. Ithaca, NY: Cornell Univ. Press, 1979, 141–60.

Graff, Gerald. *Professing Literature: An Institutional History*. Chicago: Univ. of Chicago Press, 1987.

———, and Michael Warner, eds. *The Origins of Literary Studies in America: A Documentary Anthology*. New York: Routledge, 1989.

Hancock, Albert Elmer. *The French Revolution and the English Poets: A Study in Historical Criticism*. 1899; rpt. Port Washington, NY: Kennikat Press, 1967.

Herford, Charles Harold. *The Age of Wordsworth*. 1897; rpt. London: G. Bell and Sons, 1934.

Klancher, Jon P. *The Making of English Reading Audiences, 1790–1832*. Madison: Univ. of Wisconsin Press, 1987.

Levinson, Marjorie. *Wordsworth's Great Period Poems*. New York: Cambridge Univ. Press, 1986.

Liu, Alan. *Wordsworth: The Sense of History*. Stanford: Stanford Univ. Press, 1989.

McGann, Jerome. *The Romantic Ideology: A Critical Investigation*. Chicago: Univ. of Chicago Press, 1983.

———. "Rethinking Romanticism." *ELH* 59 (1992): 735–54.

More, Hannah. *Works*. 11 vols. London: T. Cadell, 1830.

Perkins, David. "The Construction of 'The Romantic Movement' as a Literary Classification." *Nineteenth-Century Literature* 45 (1990): 129–43.

———. *Is Literary History Possible?* Baltimore: Johns Hopkins Univ. Press, 1992.

———. *Wordsworth and the Poetry of Sincerity*. Cambridge, MA: Belknap Press of Harvard Univ. Press, 1964.

Stone, Lawrence, *The Family, Sex, and Marriage in England, 1500–1800.* New York: Harper & Row, 1977.

Thelwall, John. *Poems Written Chiefly in Retirement.* 1801; rpt. Oxford: Woodstock, 1989.

Vaughan, Charles Edwyn. *The Romantic Revolt.* 1907; rpt. London: William Blackwood, 1922.

Veysey, Laurence. "Stability and Experiment in the American Undergraduate Curriculum." *Content and Context: Essays on College Education,* ed. Carl Kaysen. New York: McGraw-Hill, 1973, 1–63.

Wasserman, Earl. "The English Romantics: The Grounds of Knowledge." *Studies in Romanticism* 4 (1964): 17–34.

Wellek, Rene. "The Concept of Romanticism in Literary History." *Concepts of Criticism.* New Haven: Yale Univ. Press, 1963, 128–98.

———, and Austin Warren. *Theory of Literature.* Third Edition. New York: Harcourt Brace Jovanovich, 1977.

Whalley, George. "England/Romantic—Romanticism." *"Romantic" and Its Cognates: The European History of a Word,* ed. Hans Eichner. Toronto: Univ. of Toronto Press, 1972, 157–261.

Williams, Raymond. *Marxism and Literature.* New York: Oxford Univ. Press, 1977.

2

Climbing Parnassus, &
Falling Off

PETER T. MURPHY

Students of British romantic culture have always known that their canon of
major writers is and has been for a long time an unusually revisionary one.
We know that the list of the "big six" excludes all the popular and important
women writers (like Felicia Hemans and Charlotte Smith), but the proper way
to put it is that it quite simply excludes *all* of the most popular poets of the
period, with the exception of Byron. We know many of their names (in addi-
tion to Hemans and Smith): Walter Scott, Thomas Moore, Robert Southey,
Samuel Rogers, Robert Burns, Thomas Campbell. Even as late as 1879, Mat-
thew Arnold (a powerful force in the construction of the twentieth-century
canon) includes Burns, Scott, Campbell, and Moore on the roll of "our chief
poetical names" (40–41). Mid-century anthologies distribute favor similarly;
Palgrave's enormously influential *Golden Treasury*, for instance, has more
Campbell than Byron, more Moore than Coleridge.[1] Stepping closer—closer,
in fact, to the forces involved in conferring popular favor in the period—
Leigh Hunt makes a similar list in 1831 that mentions Campbell, Moore,
Lamb, Scott, Rogers, and Crabbe before getting to Coleridge (390–91). Step-
ping still closer, Francis Jeffrey, who played a role in the reception of most
major romantic poems, was one of the most vocal supporters of the contem-
porary canon. Writing in 1829 (at the end of a review of Felicia Hemans's
poems), Jeffrey notes with melancholy the lapsing of poetic reputations:
Wordsworth, Byron, Keats, and Shelley (among others) are all faded. He
goes on:

> The two who have the longest withstood this rapid withering of the laurel, and
> with the least marks of decay on their branches, are Rogers and Campbell . . .
> both distinguished rather for the fine taste and consummate elegance of their

writings, than for that fiery passion, and disdainful vehemence, which seemed for a time to be so much more in favour with the public. (478)

Jeffrey is always a fastidious reader, and a less general figure than we sometimes imply, so I will introduce another voice, with a different sort of authority. Writing in his journal in November 1813 (220), Byron constructs a "triangular 'Gradus ad Parnassum'":

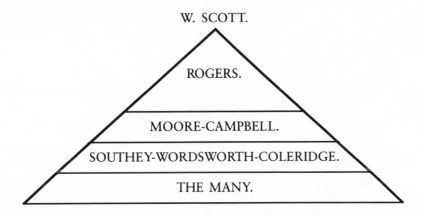

With typical Byronic diffidence, he then claims (to himself) that he has ordered them according to "popular opinion," rather than his own, but certainly this ordering is quite in keeping with his opinions voiced in other places and contexts.

The poets at the top of Byron's pyramid (Scott, Rogers, Moore, and Campbell) represent for us the deadest of the dead, and Samuel Rogers (my subject) is the most thoroughly dead of these the deadest. I want not so much to reanimate these writers as to think about what their death might mean: reanimation could conceivably be a consequence of such a meditation. In a critical period when reference has returned as a source of poetic interest, boredom—a name for the critical state which might cause a poet's death—might well return in the form of the interesting. Why do poets (or poems) which were once interesting become boring? As critics we are now typically quite skeptical of the assertion of low quality that such a shift can sometimes seem to express; but we have not, I think, dealt very thoroughly with the decisions about quality that such skepticism seems to brush aside. Do we think that all poems are in fact interesting, in their own way? Do we find Samuel Rogers's poetry boring for a good reason, or for some contingently bad reason?

This is a polemical way of expressing Rogers's fate, but both the plural and the judgment ("we" and "boring") can be made at least functionally precise. I will use the figurative "we" as a stand-in for "written criticism," as defined by the writing indexed and cataloged by the MLA *Bibliography*. "Boring" is

simply a plain term for the writer who is either badly represented in this bibliography or simply not represented at all. There are other critical contexts (such as teaching) and other "we"s, but my focus here is on the kind of work and interest written criticism represents. An informal survey of the years 1988 to 1990, inclusive, of the MLA *Bibliography* produces the following numbers of entries for selected poets: Wordsworth 277; Blake 161; Keats 103 (the other of the familiar six lie between); Moore 3; Scott 4; Rogers and Campbell 0.[2] As a mathematician would say, the distance between zero and 277 is infinite. Even outside this sampling period, the critical silence over Rogers is nearly perfect: in the twentieth century, the number of serious essays on Rogers himself can be counted on one hand.

As Byron and Jeffrey show, this silence is a development, not a primary fact. Rogers's reputation always rested primarily upon his first real effort: *The Pleasures of Memory,* published in 1792. Between its publication and about 1830 nearly 30,000 copies of this poem were sold: serious numbers, reached by very few in the period. Rogers was also an eminent figure, enormously long lived (1763–1855) and thoroughly well connected. He was rich, generous and sociable, and he knew everybody (everybody literary). His family history was liberal, but his politics were neither loud nor insistent. By all accounts he was not an easygoing person (he was famously sarcastic), but his presence in history is very much so. There are no sharp edges to his literary and political legacy, no Byronic drama, no Coleridgean psychology, Wordsworthian enigmas, or Keatsian death. The poetry of *The Pleasures of Memory* is easygoing too: we can imagine the pleasant sigh of familiar pleasure that would issue from all but the crankiest of romantic readers upon reading its opening lines:

> Twilight's soft dews steal o'er the village green,
> With magic tints to harmonize the scene.
> Hushed is the hum that thro' the hamlet broke,
> When round the ruins of their ancient oak
> The peasants flock'd to hear the minstrel play,
> And games and carols clos'd the busy day.
> Her wheel at rest, the matron charms no more
> With treasur'd tales of legendary lore.
> All, all are fled; nor mirth nor music flows,
> To chase the dreams of innocent repose.
> All, all are fled; yet still I linger here!
> What pensive sweets this silent spot endear?

This most pleasantly untaxing poetry good-naturedly refers to its literary precedents with an easy familiarity. We remember Goldsmith, Gray, Collins, Warton, Akenside, and some others, but we are not asked to work hard at tthis remembering: Rogers's literary memory is as broadly and sweetly brushed as the specific memories in this passage. Our description of his literary reference

might indeed be a negative one. Rogers has none of the social/personal agendas of Gray and Goldsmith, none of the formal inwardness of Collins, none of the quirky psychology of all three. *The Pleasures of Memory* seems to have read just enough to make it come into being, but not so much that it has become anxious or ambitious. None of the poems we are reminded of are relaxed in this way. Here we might see at least some of the interest in including Rogers in our critical discussions. Do we find him boring because of his lack of edge? Because of a lack in general? Is there good stuff in other writers that is simply not there, in *The Pleasures of Memory?* Part of the problem in speaking positively of Rogers is what we might call a grammatical one: because we are so used to discussing lyrics in a context of struggle, we will say "lack of anxiety" before we will say "happy," or "calm." This is not only our problem. A retrospective review of Rogers in the *Edinburgh Review,* generated by the *Poems* of 1812 and written by Sir James Mackintosh, describes *The Pleasures of Memory* as appearing

> without paying court to the revolutionary tastes, or seeking distinction by resistance to them. It borrowed no aid from either prejudice or innovation. It neither copied the fashion of the age which was passing away, nor offered any homage to the rising novelties. . . . It was patronized by no sect or faction. It was neither imposed upon the public by any literary cabal, nor forced into notice by the noisy anger of conspicuous enemies. (38–39)[3]

It is important to note that this was written in 1813, after Wordsworth, and after Jeffrey's combat with Wordsworth's "revolution." It is, we might say, post-romantic. Byron (also in 1813) has the same difficulty of finding praise for Rogers that is not in some way the noting of an absence:

> I have been reading Memory again, the other day, and Hope together, and retain all my preference for the former. His elegance is really wonderful—there is no such thing as a vulgar line in the book. (107)[4]

Note that Byron's praise is not totally negative; at least, the lack of vulgarity is associated with an epithet, "elegance." This is the same word that Jeffrey applies in 1829 (quoted earlier), in order to describe what has exempted Rogers and Campbell from oblivion.[5] This term still has a sort of negative interest: it is not, for us, a critical term. Whatever Byron and Jeffrey mean by this word, it most certainly does not describe the quirky, disjunct, and interpretively vexing features of poetry that dominate our interests. I will return to this interest later; here, a list of positives from a review of the original publication of *The Pleasures of Memory* in 1792 might help us fill elegance out:

> correctness of thought, delicacy of sentiment, variety of imagery, and harmony

of versification, are the characters which distinguish this beautiful poem, in a degree that cannot fail to ensure its success.[6]

Correctness, harmony, variety, and delicacy (and beauty too) are also terms, I would argue, that we find critically empty. That is, we no longer have any real way of absorbing this list except as a list of negatives. We might use these words, but not critically: as I will argue somewhat later, the things such words describe do not seem to offer us opportunities for critical work. We inherit this incapacity (which Mackintosh's list of negatives, above, shows in embryo) from the romantics we do read, like Byron and Wordsworth, and we aggravate it by comparing Rogers, as I have done in part, to the sources of our incapacity. Rogers, hypothetically, has "elegance," "refinement," "taste," and his contemporaries thought these things worth purchasing. What shall we say about elegance? What is it, for us?

Some of the negatives need only be turned slightly to make them positives. Rogers's verse is remarkably easy, remarkably smooth, without catch or sharp contrast, line after line, even when addressing less easy subjects:

> Say why the pensive widow loves to weep,
> When on her knee she rocks her babe to sleep:
> Tremblingly still, she lifts his veil to trace
> The father's features in his infant face. (I:253–56)

This kind of simplicity of tone and pace is, as critics have often said in reference to Goldsmith, easier to enjoy or dislike than it is to accomplish. Compare it to some well-known lines, from Wordsworth's "An Evening Walk," another and almost exactly contemporary poem in couplets:

> I love to mark the quarry's moving trains,
> Dwarf pannier'd steeds, and men, and numerous wains;
> How busy the enormous hive within,
> While Echo dallies with the various din! (141–44)

Wordsworth's couplets are active, straining; not bad couplets, but energetic ones. In Rogers, the constricted form produces smoothness, connection, flow; in Wordsworth, it produces ends, stops, and sparks (Wordsworth's couplets are those of a poet who will eventually write strong blank verse). At this level of detail, "elegance" describes the metrical happiness of Rogers's verse. It doesn't want to be anything else, and it fits smoothly into the pattern marked out for it. Rogers is, we might say, well behaved: his aim is to naturalize the inherently unnatural imposition of form. Wordsworth so clearly does not want to do this. He wants his couplets to struggle, to call attention to themselves, to generate energy and emphasis by making the form a sort of (poetic) imposition. From the list of positives, Rogers's good behavior is "harmony." Artificiality, the first consequence of the easy couplet, becomes harmony through

assiduous and happy polishing.[7] The easily cultured literary atmosphere of the poem fits into this category too. Rogers lets us enjoy the predictability of the poem without taking us or that predictability to task. He recalls other poetry because he likes it.

The smooth metrical and literary surface of *The Pleasures of Memory* is crucial to its eventual effect. It is there to do work. What plot the poem enacts comes to us in the mixed form typical of this type of poem: a mixture of anecdote, episode, and "thought." All of these snippets are brought into the general field of Memory, and Memory always appears with a pure compensatory force that makes it the deep match to the smooth surface. The sad reflection on the losses of time that opens the poem, a close relative of the sadness in so many great romantic lyrics, is potentially painful, potentially disruptive, but the poem both acknowledges this and waves pain away with the pleasures of memory:

> Childhood's lov'd group revisits every scene,
> The tangled wood-walk and the tufted green!
> Indulgent MEMORY wakes, and, lo! they live!
> Cloth'd with far softer hues than light can give. (I:81–84)

As the poem goes on, we realize how simply and thoroughly Rogers means this: Memory compensates us for the loss of the past, pure and simple. He will insist on this in even the most extravagant circumstances:

> Go, view the captive barter'd as a slave!
> Crush'd till his high heroic spirit bleeds,
> And from his nerveless frame indignantly recedes.
>
> Yet, ev'n here, with pleasures long resign'd,
> Lo! MEMORY bursts the twilight of the mind. . . . (II:53–58)

One might speculate that if lack of harmony and vulgarity were to creep into this poem, if its elegance and correctness were to be violated, that it would happen at a moment like this, where the extremity of the subject matter puts pressure on the general policy of polish. The compression of the episode this passage ends also challenges smoothness: we are asked to plunge into suffering and then emerge by the path of memory at high narrative speed. The harmony Rogers achieves is thus double, both psychological and narrative. The loss and suffering of the expiring slave is to be integrated into a compensatory economy that makes him feel better, and might make us feel better; his story is to be integrated into *The Pleasures of Memory*, which values smoothness and harmonious progression above all else.

The Pleasures of Memory contains and enjoys episodes of this sort with interesting and noticeable ease. It does not seem right, at least initially, to describe this containment negatively, to ascribe it to some incapacity on

Rogers's part. Rogers does not assume that the poem will right itself after encountering the slave. He works hard, and openly, at describing his compensation. He pictures the slave re-creating the world he has lost within him, and this assertion ends with these warm and satisfied verses:

> Ah! why should virtue dread the frowns of Fate?
> Hers what no wealth can win, no power create!
> A little world of cloudless day,
> Nor wreck'd by storms, nor molder'd by decay;
> A world, with MEMORY's ceaseless sunshine blest,
> The home of Happiness, an honest breast. (II:72–77)

Memory grants the slave all he has lost, and so the poem can move on, having filled the depths it might otherwise fall into. "Memory" is a vast reservoir, equal to the drain of all possible loss. In exactly the same way, Memory provides the narrative harmony for the episodic collection of the poem as a whole. Memory absorbs all loss, and also all plots. The speaker of the poem is not involved in a narrative, and so there is nothing to interrupt. In Wordsworth's "An Evening Walk," by way of contrast, the topographical plot of the poem means that imagined suffering will be an interruption (since it is always happening "now"), and that the I/eye of the poem will have to recover in order to go on. The plan of *The Pleasures of Memory* is purely abstract, and movement is produced by opening one cupboard after another, all located in the spacious room labeled "Memory." Rogers's psychology floats above narrative, and so does not need to "recover" in order to get past the slave; the slave's story is in one place, and the poem can simply shift to the next. Memory cancels loss and dislocation by gently holding everything in its grasp, and so the poet need only keep going.

The way in which "memory" is a poetic activity, rather than ignorance, poetic incompetence, or some other lack, is well illustrated by the largest narrative episode in the poem, the story of Florio and Julia, which appears late in Part II. As we might expect, this story ends in disaster, like the parallel episode of Celadon and Amelia in Thomson's *The Seasons* ("Summer," 1169–1222). The hero, Florio, loses his lover in a storm on "Keswick lake," after which her father "strew'd his white hairs in the wind" and followed her in death. The bereft Florio wanders the woods in proper romantic fashion, "in sweet delirium of romantic thought!" (II: 364). In so much of the literary history behind this poem, this kind of narrative ends with a literal or figurative epitaph; think of Gray's "Elegy," for instance, or the exodus in *The Deserted Village*. Here, the sweet melancholy of Florio's wandering is left simply sweet, because Florio is left alive, and we do not see his death. In the simplest, most direct of ways, Rogers gives us not plain loss but, through memory, presence:

> For ever would the fond enthusiast rove,
> With JULIA's spirit, thro' the shadowy grove;

Gaze with delight on every scene she plann'd,
Kiss every floweret planted by her hand. (II:355–58)

Rogers closes the story with a typically calm couplet of compensation:

Her charm around th' enchantress MEMORY threw,
A charm that soothes the mind, and sweetens too! (II:371–72)

Florio wanders the woods, but this is an activity rather than the mark of loss; he is remembering Julia. This is a general quality: *The Pleasures of Memory* is a very active poem. It is happy and smooth not because Rogers does not recognize the possibility of loss but because he so clearly, actively, and immediately compensates us for it. His elegance is not, in a simple way, an absence of poetic work, but rather a particular *kind* of poetic work.

The clarity and immediacy of *The Pleasures of Memory*'s compensations are, I think, what we find boring in it. I also think that this is a more complicated assertion than we might at first assume. Behind it lie the reasons for our largely unarticulated attribution of goodness and badness to romantic (and perhaps all) poems; behind these reasons, in turn, is the way we define the work of the critic and the way that definition conditions and defines what poetry we find worth writing about. As a way of showing this to be true, and of describing how Rogers's poem of smooth compensation differs from what we want to write about, I will compare it to a poem we do in fact talk about, and which (as I have noted) is very similar to *The Pleasures of Memory,* in many ways: Wordsworth's "An Evening Walk." Wordsworth's poem was published within a year of Rogers's; it is anthological, though in a different way; it is written in couplets; like *The Pleasures of Memory* it is also part of the first book-length publication of an ambitious young poet; it is uneven in tone and quality; it produces a melancholy speaker who meditates on loss. It is also a related poem, whatever that might be worth; Wordsworth had clearly read *The Pleasures of Memory* before he assembled his poems for the press. In fact, the opening lines of "An Evening Walk" remember very clearly lines from the beginning of Florio and Julia's story.[8] It provides a good comparison because while Rogers has fallen into utter neglect, "An Evening Walk" has played and continues to play a part in critical discussion. Of course, critics do often qualify discussion of both "An Evening Walk" and "Descriptive Sketches," but all the same critics do talk about them; in the terms of my figure of critical consensus, we find "An Evening Walk" interesting. If we feel tempted to dismiss Rogers on the basis of the uneven conduct of his poem (for it is uneven), we would have to do the same for Wordsworth, since his poem is uneven in very similar ways. What "An Evening Walk" has that makes it interesting to us, I would argue, is quite precisely an anti-elegance, a quality best described by a word bestowed upon it by both Geoffrey Hartman and Alan Liu: "edginess." Indeed, I think edginess is *the* property of

interest to us as critics, and that Rogers's quite purposeful avoidance of it renders his poem boring to us. Without edginess, we literally have nothing to say, nothing to do.

The roving eye of "An Evening Walk" produces both the narrative continuity of the poem and its anthological collection of "scenes." Contemporary reviews of the poem generally liked this quality, and simply praised the poem, in a mild way, for the beauty of its scenes. Here is part of the review in the *Analytic Review:*

> This descriptive poem is so nearly of the same character with ["Descriptive Sketches"] that it is only necessary to remark in general, that it affords distinct and circumstantial views of nature, both inanimate and animate, which discover the eye of a diligent observer, and the hand of an able copyist of nature.[9]

The review then quotes a lengthy passage which begins with the well-known lines "Sweet are the sounds that mingle from afar . . ."(301), well known for being immediately *after* the death of the beggar and her children. The presentation of "scenes" is exactly what modern critics feel the need to look past in order to find the interest of the poem. This is Geoffrey Hartman:

> "An Evening Walk" is still a gallery of discrete pictures, and to consider it as an anthology of images from nature is therefore persuasive or at least prudent.
> I believe, however, that a greater theme is present, and that nature's variety is not depicted for its own sake. (93)

This "however," the argumentative pause that notes the actual (critical) interest of the poem, is echoed by later critics, and made into the very substance of interest in the exemplary reading of Alan Liu, which I will turn to shortly. This pause ushers in the possibility of critical narrative, the "greater theme," what is in the poem that is more interesting than a prudent anthology of images. This narrative is of two sorts, one of which rises out of the other. The first is the narrative of the poem's progress, the troubled I/eye that stumbles across (among other things) the suffering beggar. Out of this trouble we often read Wordsworth's nascent poetic strength and interest, expressed as narratives of the "growth" of Wordsworth the poet or of literary history. In these narratives the trouble in Wordsworth's poem shows that both Wordsworth and literary history are beginning to move "beyond" the topographical mode.[10]

The assertion that the "greater theme" exists, in the form of narrative, seems to me to be quite true. "An Evening Walk" is a sketchbook, but the tour of the sketchbook is conducted by an invented speaker. "Memory," an abstract, personified presence, performs this function in Rogers, which allows the speaker to remain elegantly observant and calm. The presence of the invested speaker in "An Evening Walk" renders the episodic form of the poem problematic: it makes smoothness harder to achieve. The problem in Words-

worth's poem is a parallel to the hypothetical challenge of the suffering slave in *The Pleasures of Memory.* If the speaker is going to get caught, upset, at the same time that the poem is trying to describe the upsetting episode, then the poem will need to work all the harder to right itself and progress to the next "image." When Wordsworth's speaker becomes fascinated by what he sees, the challenge is to find a way to tear himself away in order to get on with the progress of the eye. The episode of the dying beggar, which perhaps surpasses Rogers's suffering slave in both extremity and quickness, is the most well-known example of the speaker's fascination and the attendant difficulties. Nothing illustrates better the fact that Wordsworth and Rogers are in the end examples of different poetic kinds, defined by a very different sense of poetic activity, than the different ways in which they save themselves from their narrative challenges.

That the difference illustrates, in turn, something of broader interest to us as critics is emphasized by the fact that modern readings invariably light upon the death of the beggar as *the* place to find critical interest. In Alan Liu's virtuosic and entirely convincing depiction of the "loco-descriptive" moment, the seams between this narrative of disaster and the rest of the poem are the essential source of the critical narrative: that is, our interest attaches not so much to the story itself as to its uneasy, abrupt placement in the topographical anthology. The eruption of the story creates the poem's "edginess," encountered again and also tamed later in the poem with the coming of night and the rising of the moon. The seams or edges, the "craquelure," indicate poetic power, poetic interest, as it rises to the surface of the uninteresting topographical anthology:

> In "An Evening Walk," in sum, nascent stories exert such a torsion upon the picturesque canvas that the craquelure—the cracks in the paint—widens to show traces of the *istoria* underlying all description. Or rather, what shows through the cracks is at last not so much any particular narrative as the generative basis of narrative. (131)

In Liu's reading, then, the crucial passage is not the beggar's story but the astonishing and beautiful passage that succeeds it, extracted by the *Analytic Review,* above.[11] In this passage, the typical picturesque "silence," typical of poems like Gray's "Elegy" and Collins's "Ode to Evening," which is made up of unheard noises, the "save but" formula, is made by Liu to pay dividends as the nervous fade of the suppressed narrative. "An Evening Walk" refers to this literary history much more actively and aggressively than *The Pleasures of Memory* does; such is the content of the commonly described narrative concerning Wordsworth and literary history. But inside this narrative is the smaller narrative of the poem itself, the conduct of which is sharply different from that of *The Pleasures of Memory.* I cite the relevant passages in Wordsworth to emphasize this difference:

No tears can chill them, and no bosom warm,
Thy breast their death-bed, coffin'd in thine arms.
Sweet are the sounds that mingle from afar,
Heard by calm lakes, as peeps the folding star. . . . (299–302)[12]

No warm day of compensation here: all is cold death and suffering. In Rogers, this kind of transitional moment is quite precisely that which both calls up Memory and puts the powers of memory to work. Instead of an uncontextualized and naked line between different psychological states, Rogers's poem gives us a conceptual framework onto which we can cling as we step away from suffering. Providing us with the ability to step away is, indeed, the very heart of the business of *The Pleasures of Memory;* Rogers talks us out of our problem instead of demonstrating symptoms and falling silent. What interests critics in Wordsworth's poem is that it behaves as a suffering person might, denying or ignoring symptoms which are obvious to the outside observer. Ten lines after the transition the speaker admits his upset in the smallest of ways ("the breast subsides . . ."), but the beggar's narrative must largely speak for itself.[13] The speaker cannot deal with the energy of suffering in any direct way; the structural corollary is that the poem has no way of moving on except by turning away. Thus Hartman and Liu's term, "edginess," in which the hard, strange line between the suffering of the beggar and the topographical progress of the poem turns into a psychological quality. Edginess, what we enjoy in "An Evening Walk," describes the action in a picture of struggle; most generally, Wordsworth's struggle to include the possibly infinite nature of human suffering in some compensatory scheme. In the larger critical narrative, the disruption or dis-harmony in the poem reflects and expresses this struggle. It is played out both in the poem (soothed, finally, but partially, by the rising of the moon) and in the career of Wordsworth the poet, who will go on to write (for example) "The Ruined Cottage" and the "Immortality" ode.

We like these moments of disruption and struggle because they literally give us something to talk about: most importantly, something to say which is something more or other than what the poem has already said. In a struggling poem the reader needs the sturdy arm of the critic if he or she is to leap across the crack. Or, to change the metaphor, the cracks are where the critic can get a hold on the smooth surface of the topographical poem, which otherwise seems to ask only for us to admire what it shows us, to look but not speak. Once we have a fingerhold, we can pull and pull, as Liu does, and expose what is inside. Critical narrative appears to supply what is lost, what is repressed: a struggling poem needs critics because it is in some ways telling a story that it doesn't know. Speaking (again) most broadly, what "An Evening Walk" doesn't know is that the trouble it experiences is part of an ongoing struggle, the growth of a great poet, William Wordsworth. The eruption of history, the approach of apocalypse, the transformation of pastoral, will all be worked out "later," and the critic can see this Wordsworthian narrative because the

critic can see more than just this poetic moment: the critic sees the seams, the progress. Speaking of the struggle over the beggar specifically, the critical narrative fills what otherwise looks like an actual crack in the poem itself (the interruption of topographical progress) with the stuff of critical interest. The crack shows us the "inside"; the crack, indeed, is an indication that there is an inside, that the poem is interesting. "An Evening Walk" cannot talk about its author's encounter with "history," or his numbing fear of solipsism. All it can do is crack, stumble, suffer. We like this because for us poetic work *is* struggle; we do not like *The Pleasures of Memory* because it does not struggle, and it does not crack; it is not under torsion. When we leave Florio's story, he is not dead but active, remembering, and the poem is not nervous but calmly active, opening the next abstract closet. "Memory," the compensatory filler, is what the poem has instead of struggle, what allows it to be calm.

Calm, elegant poetry is a kind of poetry that we rarely see today; history is overflowing with it and similar types, but we do not generally read this poetry. One purpose or focus of this kind of poetry is described in the sonnet which Rogers placed before *The Pleasures of Memory* in 1793:

> Yet should this verse, my leisure's best resource,
> When thro' the world it steals its secret course,
> Revive but one generous wish supprest,
> Chase but a sigh, or charm a care to rest . . .
> Blest were my lines, tho' limited their sphere,
> Tho' short their date, as his who traced them here.[14]

This humility is in many ways conventional, but I think it is fair to say that not one of the "Big Six" would say this about their poetry, even in the humblest of moods; it is far away, for instance, from the intense and committed world of Wordsworth's "Preface" to the *Lyrical Ballads*. Such "humble" poetry may have high ethical purpose, and may be very serious, but it takes clarity and stability as its primary goal. It wants to tell us things; it wants to talk about its accomplishments, and it wants them to be clear and steady. Rogers's achievement of unproblematic poetry is (was) his claim to fame, and the clear surface of his achievement, his smooth compensation and its smooth couplets, earns him his reward: "elegance." Elegance, though, leaves us out; elegance is, quite precisely, a slippery critical surface. As Byron says, making a parallel point: elegance is the lack of the vulgar word, the edge which is the opening for criticism. In *The Pleasures of Memory* there is no linguistic loss, no crack for the critic to fill, no struggle to detect and explicate by the disturbance it causes. In other words, the busy activity of *The Pleasures of Memory* preempts the work of the critic. We have nothing to say because the poetry is so busy saying things itself.[15]

The critical narrative which the crack creates an opening for is what the critic knows, and telling it is not only the work of the critic but also justifies

the work of the critic, the practice of "close reading," and the allied "interpre-
tation." If we might generally say that our work, which institutions value and
for which we are paid, is describing the work the poem does, then it is both
identical with and supplemental to (as Derrida would say) the work of the
poem itself. As descriptions of the kind of poetic place or structure that gener-
ates our critical work, "edginess" or "craquelure" are further installments in
the modern critical vocabulary, modern being dated, say, from the "paradox"
of *The Well-Wrought Urn*. The crack is what Cleanth Brooks would call the
poetic "problem," a difficulty that is the source of critical activity and also
the source of poetic quality (they go together). This is Brooks noting what
makes Tennyson's "Tears, Idle Tears" a good poem:

> If the poem were merely a gently melancholy reverie on the sweet sadness of the
> past, Stanzas I and II would have no place in the poem. But the poem is no such
> reverie: the images from the past rise up with a strange clarity and sharpness that
> shock the speaker. . . . If the past would only remain melancholy but dimmed,
> sad but worn and familiar, we should have no problem and no poem. (171)

Wrestling with this problem is the work of the poem, what it does that we
value and want to talk about. Brooks will go on in this essay to distinguish
between "Tears, Idle Tears" and "Break, Break, Break," which he thinks is a
bad or in any case an uninteresting poem. It is uninteresting because it does
not "recognize"(176) that memory is itself ironic, that the recall of memory
is also an admission of loss.[16] In vague analogue to Clifford Siskin's (1988)
descriptions of the Wordsworthian imposition of the modern "lyric turn," I
would argue that this structure, the poetic problem and the supplement of
critical discourse, is a Wordsworthian or at least romantic imposition.[17] It is,
for instance, what Coleridge noticed and valued in Wordsworth's early poetry:

> The language was not only peculiar and strong, but at times knotty and contorted,
> as by its own impatient strength; while the novelty and struggling crowd of images
> acting in conjunction with the difficulties of the style, demanded always a greater
> closeness of attention, than poetry (at all events, descriptive poetry) has a right
> to claim. (77)

More tellingly, we could note that Wordsworth himself produces the same
ratio between the poem and the critical work of prose by pairing his difficult
and enigmatic poems with fussy explanations. In the plainest of ways, the busy
professional work the modern critic does is called up by the Wordsworthian
insistence on difficulty:

> What more I have to say is short,
> I hope you'll kindly take it;
> It is no tale; but should you think,
> Perhaps a tale you'll make it. ("Simon Lee," 77–80)

Rogers tells the tale himself; we, the readers, listen to it. He hopes that we will listen and feel better about the world, that this wisdom will soothe us. Our response, as readers, is primarily one of argument or agreement; we are asked to enjoy and value a certain way of thinking about the world. Judgment of Rogers is judgment indeed: we are asked to describe him as right or wrong. We might well feel that *The Pleasures of Memory* is horribly wrong when it claims that the dying slave feels happy because he is ministered to by the Muse of Memory. The necessity for making such a decision might constitute a problem, but we do not perceive it as a *critical* problem: should we be paid for saying that a poet writing in 1792 was wrong? Whatever we do say, we first formulate a definition of our work that will produce what we see as "work," what we can value as work and not simply the reactions involved in reading.

Our critical work—the work not called out by Rogers—is Wordsworthian in several ways. The plainest is, again, the provision of a moral sense like that Wordsworth asks for in "Simon Lee." Simon Lee himself is also important to us, in the same way that the beggar in "An Evening Walk" is important to us. When Wordsworth asks us to read our own moral sense out of Simon Lee, he is reminding us to think in general, but he is also reminding us that we have forgotten to think about Simon Lee in particular. And so when we tell the story we tell a moral story of loss (about suffering); and we tell that story because we have been told a story of loss by Wordsworth. The critical work of recovering the moral sense is paralleled by the critical/poetic recovery of the minor, forgotten, lost, or marginal figure, whose story provides the opportunity for the contemplation of loss. Such a recovery counts, for us, as work. Such indeed is the source of energy behind a collection such as the present one, the work of which is either the recovery of those outside the "limits" or the contemplation of that recovery. This kind of work is just that proposed in the preface to *Lyrical Ballads,* which proposes a revolution in reading habits based upon the recovery of forgotten "real" poetry and language. We do not, in other words, step outside the limits of *romanticism* when we recover the lost or marginal literary figure; our current fascination with revision is produced in part by the persistence of romantic ways of reading. The story of loss is the site of critical work.

Because we practice romantic or Wordsworthian criticism, Samuel Rogers, and poets like him, lose our interest in several ways. We tend to fall silent in the presence of the energetic talking found in these poems, their lack of symptom. But if we are silent because *The Pleasures of Memory* (in my specific example) does not have cracks in it, we are also silent because it does not feel the need to crack. We are told not to crash when contemplating the suffering of the dying slave, and we are told why we should not. *The Pleasures of Memory* wants to reconcile us to the world, to rescue us from loss, and it does so again and again. We do not believe in this compensation; or, if we do, "criticism" no longer has a place for the statement of this belief. A criticism of

admiration, in which the critical work is to catalog exactly where in our reading we feel better, could include Rogers, and in fact his disappearance from the canon roughly parallels the disappearance of the strain of admiration (of judgment generally) from critical practice. Above all, elegance asks us to admire it, but we no longer think it worth the while of the publishing scholar to admire, or, for that matter, not to admire elegance. Rogers loses out because of this, in the very specific ways I have outlined. Other poets lose out here too, for allied if slightly different reasons. Campbell, who was known to the nineteenth century as a writer of stirring patriotic verse, resembles Rogers very much: he tells us too much, and also things we do not wish to hear. Moore is an interesting variant. The *Irish Melodies* are songs that ask us to enjoy singing them. The terms of elegance (harmony, purity, and so on) are often applied to his lyrics, and those terms are easily recognized as praise for a pleasant song. But as with *The Pleasures of Memory*, we have not shown any desire to talk about our admiration, if we feel it. Walter Scott is perhaps the most complex of the group, but, as I have argued elsewhere, he too takes the avoidance of "edginess" as the very essence of his project.[18]

Samuel Rogers (and perhaps Campbell and Scott) is also boring to us in a more general Wordsworthian way. Because his popularity has disappeared, because he is forgotten, we might find critical work in his recovery: the recovery of such figures counts for us as work. But Rogers's particular kind of obscurity is a non-romantic one. He is hidden inside what we might call an interior limit; he does not in himself offer the marginalized and excluded figure romanticism helped us to become fascinated by. He represents, in his time, the power that did the excluding. Romantic interest in marginalization, and the parallel critical interest in rescue, have caused, in the most interesting of ways, the center of the romantic period to grow a blank. Samuel Rogers, the prosperous, charming banker-poet, and his fellows are not beyond or outside of what we have thought of as the major writers but rather before or within them. Recovering Rogers might seem oddly useless because, especially today, what we have when we are done is in some ways what we feel we started with: orthodoxy, visibility, centrality. In his valuation of those outside the limit Wordsworth eventually stole the energy of such poets, whose popularity and centrality becomes the very reason we ignore them. Interestingly, I think the same forces have largely kept poets like Rogers from appearing as figures in the more thoroughly historical narratives many critics have been interested in recently. Reference can, in principle, rescue anything: poems are part of the world, and the world is always interesting. *The Pleasures of Memory* was written in 1792 by a well-to-do liberal in London, and the calm it contains can only be thought of as a balm for the pain of the French Revolution and its disappointing violence.[19] There is no question that this poem and others like it would supply material for such analysis. Still, this kind of reading has not been practiced, and I think it has not because (again) it generates no "problems." When we are through, we would get (again) what we started

out with: orthodoxy. We would get back, in particular, the ideologically and politically dominant culture that we often hope historical analysis can rescue us from. Asymptomatic poetry will only support a reading that indicates the lack of symptom. Even when described as responding to the deep uncertainty generated by the revolution, the poetry still is not asking us to help it make it through its troubles; it only asks us to agree, and to feel better. The deeply revisionary, deeply romantic energy behind most contemporary historical analysis is not likely to appear in response to such material. Do we wish to rescue from history a poem that we can admire because it contains "not one vulgar line"? We might well decide that the critical world defined by "close reading" has no place for this poem. The reward for rescuing it, from this perspective, is a poem that doesn't want us to practice our method on it (it is already doing what we might do).

Still, I think *The Pleasures of Memory* has lessons to teach us. It can help us remember that if pleasure, feeling better, and finding a poet "wise" are not part of the modern critical history of poetry, they are in fact part of the history of poetry and exert their influence on the function and creation of poetry. The recovery of Rogers—his forced inclusion in critical discourse—would inevitably contaminate the purity of our critical rhetoric, and that contamination would be the sign of contact with historical truth. Even if we recover Rogers only to forget him again, his presence might force us to voice our largely repressed or forgotten foundation of judgments about literary worth and quality. We write about the poetry we like; we like troubled and problematic poetry and poets. This is neither bad nor good, in itself. It is only bad if we think that in valuing the problematic we have passed by or risen above the encounters with wisdom and judgment that "elegant" and talkative poetry presents us with. We have made judgments, and they live in our revisionary and continually revised canon. Our loss of Rogers as a *romantic* poet, our refusal to look at the center of the period, emphasizes that we value revision itself, since it marks the story of romantic loss. In the end, his lesson is simply that we *have* forgotten him, and that we have forgotten him because we want to, even now.

NOTES

1. Other anthologies have similar proportions; Emerson's collection *Parnassus*, published in 1875, has more Moore and Campbell than it does Coleridge, Keats, or Blake. *Parnassus* is distinguished by the enormous amount of Wordsworth it includes, though Palgrave had begun the trend. It is also worth noting that the nineteenth century was better at remembering women poets, especially by anthology. Two quite large anthologies that I know about are Alexander Dyce's *Specimens of British Poetesses* (London, 1825) and George Bethune's *The British Female Poets*, which I have seen in a Philadelphia edition of 1848.

2. I simply counted the number of entries devoted to each author in vol. I of the "Classified Listings," under "English Literature, 1800–1899."

3. J. R. Watson quotes parts of this passage (289). The whole of the essay is extracted in the "Memoir" attached to Epes Sargent's edition of Rogers's poems (1871, 13–27).

4. From a letter to Thomas Moore, September 5, 1813. The "Hope" referred to is Thomas Campbell's *Pleasures of Hope*, written in 1799, and often bound together with its parent after that date.

5. The *Monthly Review*'s article on the *Poems* of 1812 notes that *The Pleasures of Memory* "everywhere afforded evidence of a highly cultivated and elegant mind" (207).

6. From the *Monthly Review* for June 1792 (1). The *OED* gives the following fascinating opinion about the modern history of this word: "Formerly used somewhat vaguely as a term of praise for literary style; from the 18th c. it has tended more and more to exclude any notion of intensity and grandeur, and when applied to compositions in which these qualities might be looked for, has a depreciatory sense" (under meaning 4 for "elegant"). The writer of this note might have been reading Hazlitt: "The epithet *elegance* is very sparingly used in modern criticism. . . . Mr. Rogers was, I think, almost the last poet to whom it was applied as a characteristic compliment. At present it would be considered as a sort of diminutive of the title of poet, like the terms *pretty* or *fanciful*, and is banished from the *haut ton* of criticism. It may perhaps come into request at some future period" (vi, 222). Hazlitt also has a brief but interesting discussion of Rogers at the beginning of the Campbell-Crabbe section of *The Spirit of the Age* (iv, 343), in which "pretty" and "fanciful" have become "effeminate."

7. In fact, Rogers was known to have polished *The Pleasures of Memory* excessively; he exhausted himself, and then turned "to his friends . . . demanded their opinions, listening to every remark, and weighing every observation." See the "Memoir" attached to Sargent (11). Additional and fuller information about this period can be found in P. W. Clayden, *The Early Life of Samuel Rogers*.

8. From Wordsworth:

> His wizard course where hoary Derwent takes
> Thro' craggs, and forest glooms, and opening lakes,
> Staying his silent waves, to hear the roar
> That stuns the tremulous cliffs of high Lodore. (2–5)

From Rogers:

> . . . the rapt youth, recoiling from the roar,
> Gaze'd on the tumbling tide of dread Lodoar;
> And thro' the rifted cliffs, that scaled the sky,
> Derwent's clear mirror charm'd his dazzled eye. (II:229–32)

9. Quoted from Reiman (5). The *Analytic* gave separate reviews for "Descriptive Sketches" and "An Evening Walk." Having dealt with "Descriptive Sketches" first, which was praised for its imagery and lightly criticized for extravagance, the review begins with this passage.

10. In Hartman and Liu (1989) the narrative of Wordsworth's progress is in the plan of the books, discussions of "career." In John Williams's *Wordsworth: Romantic Poetry and Revolution Politics*, we get the larger literary history mixed with the personal. He says that his argument about the poem will "establish how the traditional pastoral mode is present in the poem, both through landscape description and the depiction of figures in the landscape; and secondly, there will be a consideration of how the difficulties encountered began to shape Wordsworth's later, more mature

poetry along lines which nevertheless preserved a fundamental continuity with the eighteenth-century political implications of pastoral" (19).

11. In Hartman, the same dynamic is described, but there the focus is on the later scene, when the moon rises and saves the eye/I from darkness and solipsism, from apocalypse. John Williams "independently" focuses on the passage that Liu does, with very similar thoughts (33).

12. According to the layout of the Cornell edition, Wordsworth did not separate these passages in the 1793 edition (66); they are pulled apart by one blank line in the 1836 edition. In the 1793 edition the lack of separation is made noticeable not only by the transition itself but also by the frequency with which Wordsworth uses the blank line in other parts of the poem; there are two such pauses within the beggar's story itself.

13. Both Liu (1989) and Williams note this line, for similar reasons.

14. Quoted from Sargent (60); since this sonnet was attached after the first edition, it is not included in Jonathan Wordsworth's Woodstock facsimile.

15. Avery Gaskins gives wonderfully clear proof of our lack of interest in smoothness even while writing of Rogers. Summing up his essay, he says that "his 'smoothness' has been overemphasized . . . and he is capable of telling a powerful and polished story" (148). Smoothness is what we look past, what we get around.

16. "New Historicism" does not, it seems to me, lose the focus on the problematic. Jerome McGann, for instance, even while deriding Cleanth Brooks, depends upon the language of paradox: his paradoxes are reproduced in the struggle that the later reader engages in when authentically reading older material. The value of history is a function of "our hostility" to it. See "Tennyson and the Histories of Criticism" (202). His engagement with Brooks is fascinating and knotty, and produces this interesting valuation of struggle: "because human experience in its historical passage is at all points marked by struggles . . . because this is so, and because poetry's subject is human experience in time, poetry inevitably reproduces the conflicts and contradictions which it is itself seeking to deal with, and even perhaps seeking to resolve" (181–82).

17. Choosing from the many recent works on this subject, Alan Liu's essay "Local Transcendence" (1990) also works on the notion of our critical dependence on romantic ways of reading.

18. In my book, *Poetry as an Occupation and an Art in Britain, 1760–1830*.

19. Rogers was loosely involved in liberal politics; he was, for instance, "Joseph Priestley's host on the night before he emigrated to America" (Jonathan Wordsworth's introduction to the Woodstock Facsimile).

WORKS CITED

Arnold, Matthew. "Wordsworth." In *The Complete Prose Works of Matthew Arnold.* Ann Arbor, 1973. Volume IX, 36–55.

Brooks, Cleanth. *The Well-Wrought Urn.* New York, 1973.

Byron, George Gordon Baron Byron. *Byron's Letters and Journals,* ed. Leslie Marchand. Cambridge, MA: Harvard University Press, 1973. Volume 3.

Claydon, P. W. *The Early Life of Samuel Rogers.* London, 1884.

Coleridge, Samuel. *Biographia Literaria,* ed. James Engell and W. J. Bate. Princeton, 1983.

Gaskins, Avery. "Samuel Rogers: a Revaluation." *Wordsworth Circle* (Summer 1985): 146–49.

Hartman, Geoffrey. *Wordsworth's Poetry.* New Haven: Yale University Press, 1971.

Hazlitt, William. *The Collected Works of William Hazlitt, in Twelve Volumes,* ed. A. R. Waller and Arnold Glover. London: J. M. Dent, 1902.

Hunt, Leigh. "Mr. Moxon's Publications." In *Leigh Hunt's Literary Criticism,* ed. L. H. and C. W. Houtchens. New York: Columbia University Press, 1956.

Jeffrey, Francis. "*Records of Women* by Felicia Hemans." *Edinburgh Review* (October 1829). In *Contributions to the Edinburgh Review.* New York, 1860, 473–78.

Liu, Alan. "Local Transcendence: Cultural Criticism, Postmodernism, and the Romanticism of Detail." *Representations* (Fall 1990): 75–113.

———. *Wordsworth: The Sense of History.* Stanford: Stanford University Press, 1989.

MLA Bibliography. New York, 1989–1990.

MacKintosh, James. "*Poems,* by Samuel Rogers." *Edinburgh Review* (October 1813).

Murphy, Peter. *Poetry as an Occupation and an Art in Britain, 1760–1830.* Cambridge: Cambridge University Press, 1993.

"*Poems,* by Samuel Rogers." *Monthly Review* (March 1813): 207–18.

"*The Pleasures of Memory* by Samuel Rogers." *Monthly Review* (June 1792): 1–9.

Reiman, Donald ed. *The Romantics Reviewed.* Volume 1, Part A. New York: Garland Publishing, 1972.

Rogers, Samuel. *The Pleasures of Memory,* ed. Jonathan Wordsworth. Oxford: Woodstock Books, 1989.

———. *Poetical Works,* ed. Epes Sargent. New York, 1971.

Siskin, Clifford. *The Historicity of Romantic Discourse.* Oxford: Oxford University Press, 1988.

Thomson, James. *The Seasons,* ed. James Smabrook. Oxford: Oxford University Press, 1972.

Watson, J. R. "Samuel Rogers: The Last Augustan." In *Augustan Worlds,* ed. J. C. Hilson et al. Leicester: Leicester University Press, 1978, 281–97.

Williams, John. *Wordsworth: Romantic Poetry and Revolution Politics.* Manchester, U.K.: Manchester University Press, 1989.

Wordsworth, William. *William Wordsworth: The Oxford Authors,* ed. Stephen Gill. Oxford: Oxford University Press, 1984.

———. *An Evening Walk,* ed. James Averil. Ithaca, NY: Cornell University Press, 1984.

3

A Home for Art

Painting, Poetry, and Domestic Interiors

MARY A. FAVRET

In his recent book, *The History of Literature: On Value, Genre, Institutions,*
Herbert Lindenberger asks how "the aura exercised by romanticism [has]
come to color and change the image of the literary and cultural past that had
existed in preceding centuries" and "what communicative mechanisms" have
allowed "certain attitudes associated with romanticism . . . [to remain] institu-
tionalized within the university" (32–33). Lindenberger begins to address these
questions by introducing a distinction, first sketched in romantic texts, later
filled in by the New Critics, and fully outlined by scholars from Northrop
Frye to the present day: that is, the separation of "public" from "academic"
criticism.[1] In marking this gap, Lindenberger sidesteps the public/private di-
vide; but I would like to suggest that, in discussions of literature and "high
culture" at least, the "academic" and the "private" seem to share a space
apart from "public" concerns, and that this shared space, too, is a product of
romantic discourse. In fact, I propose that romantic discourse often imagines
both the academic and the private within a domestic framework, and yet
ignores that framework. Here we will discuss some of the ways in which both
the academy and the private individual are encouraged to provide a "home
for art" apart from the vicissitudes of the public domain. At the same time, we
will analyze how the image of the home serves as one of those "communicative
mechanisms" that continually write romantic values into our cultural and
educational institutions—into what we might call the academy. I focus on "a
home for art" in hopes of releasing from that expression its contradictory as
well as its doubly legitimating energy—as both a domestic and an aesthetic
space. But I also intend a quiet subversion by suggesting that it is the domestic
rather than any purely aesthetic point of view (Lindenberger's "aura . . . color

... image") that places aesthetic objects within romantic discourse.[2] In periods such as the early nineteenth or the late twentieth century, when the viability of the home as a determined and determining space is thrown into doubt—and when, as both Dove Cottage and our own professional habits attest, the places where we reside and where we work are not easily distinguished—we need to ask what significance the home holds and why we resist it.

To begin to locate the figure of the home in a history of institutions, we can turn to Coleridge's "Fears in Solitude" (1798), which exploits the image of the home to justify the poet's "stately songs," only to replace that image with the "sole and most magnificent temple" of his art. The "home" first appears as England, the poet's "native isle," imagined as a corrupt, crowded, public house:

> Meanwhile, at home,
> All individual dignity and power
> In courts, committees, institutions,
> Associations and societies,
> A vain, speech-mouthing, speech-reporting guild,
> One benefit club for mutual flattery,
> We have drunk up, demure as at a grace,
> Pollutions from the brimming cup of wealth. (*Coleridge*, 94)

With the fervor of a prophet, Coleridge demands that the public house be purged, and that the boundaries between public and private, foreign and domestic, masculine and feminine, be maintained:

> Sons, brothers, husbands, all
> Who ever gazed with fondness on the forms
> Which grew up with you round the same fire-side,
> ... make yourselves pure!
> Stand forth! be men! repel an impious foe. . . .
> Render them back upon the insulted ocean. . . . (*Coleridge*, 96)

Coleridge explicitly forces an opposition between public institutions (in this case, the political forms of the nation—courts, committees, clubs) and the domestic; in doing so, he reveals the fears underwriting this opposition and the violence necessary for its maintenance. This defensive gesture saves the nation and redeems the poet in the process, himself now identified as "a son, a brother, and a friend,/ A husband, and a father!" (97). Now he can "walk with awe" and sing his "stately songs" in the "magnificent temple" (formerly "my Mother Isle") that he has built. But it is a vacant temple, far from the noise of "drunken triumph" and the weight of "all his human brethren" (96, 93). For as much as his fear of any French invasion, Coleridge's aversion to the crass sensuality of the public house, to the potential for "uproar" and "strife," "carnage and groans," fuels the poem. The home, therefore, must be

cleansed of its social, profane, and finally material associations. Ideally, for Coleridge, the home should recall "nature's quietness/ And solitary musings," not gothic "fears." In the concluding lines of the poem, the home itself vanishes from view; but it remains the imaginary guarantor of peace—and poetic production:[3]

> And now, beloved Stowey! I behold
> Thy church-tower and, methinks, the four huge elms
> Clustering, that mark the mansion of my friend;
> And close behind them, hidden from my view,
> Is my lowly cottage, where my babe
> And my babe's mother dwell in peace! With light
> And quickened footsteps thitherward I tend. . . . (98)

I would like to restore the contours to the mansion and cottage that Coleridge erases in the service of poetry and patriotism, in order to make visible the presence of the home in romanticism and the institutions it buttresses. At issue here are the procedures and habits by which we establish and evaluate national canons and artistic genres, as well as the material and political consequences of constructing a home for art.

The notion of "a home for art" allies itself fairly readily with a number of familiar institutional spaces—museums, galleries, classrooms, libraries—that give us occasion to locate and classify works of art in our society. What Lindenberger and other scholars point out is the skill with which high romantic art in particular accommodates and classifies itself as art, so that romanticism is always at home within art, and art within romanticism (70–73).[4] In the process, the home itself can be converted into a museum or an emblem of artistic genius, as in this description of Walter Scott's residence, Abbotsford:[5]

> In all ages the favoured spot of seclusion, selected by men of genius . . . has been an object of particular curiosity. . . . To particularize the variety of curiosities and the different relics of antiquity to be found in this place, would occupy more room than we can possibly devote to the subject. Abbotsford may be said to comprize a museum within itself. (Neale, V: n.p.)

As a mediating figure, enabling the institutionalization of certain romantic attitudes, the home nevertheless risks occlusion; even as it figures the mind of its owner, it can appear immaterial, invisible, even ghostly. I borrow here from Terry Castle's work on "the spectralization or 'ghostifying' of mental space" in her essay "Phantasmagoria" (29). Castle argues that the romantic imagination shifted "something external and public [i.e., specters]" into "something wholly internal or subjective: the phantasmic imagery of the mind" (29). That shift guaranteed the autonomy and creative power of the individual imagination. By extending Castle's notion to include the domestication of mental space, we are faced with the two-way shift articulated in Cole-

ridge's "Fears" and in Scott's Abbotsford: the figure of the home externalizes
and commodifies our understanding of specifically artistic production or "ge-
nius," and yet that production works to internalize and idealize—even spec-
tralize—the home.

To reverse that shift, to "externalize" the home and make its presence more
visible in our institutional practice, we can look to the outer cover of *The
Norton Anthology of Poetry,* which bears a reproduction of a romantic paint-
ing, J. M. W. Turner's *Interior at Petworth* (1837), also known as *The Apo-
theosis of Lord Egremont* (figure 1). This painting is the last of a remarkable
series of domestic scenes painted at the country seat of one of Turner's patrons,
Lord Egremont, a renowned collector of works by Old Masters and contempo-
rary English painters. Elegiac (note the coffin on the right) and apocalyptic,
Interior at Petworth marks the passing of Lord Egremont and the cultured
society he fostered at Petworth; at the same time, it invades the domestic
space with the romantic storm characteristic of Turner's landscapes.[6] Viewed
on the cover of *The Norton Anthology of Poetry,* Turner's *Interior* becomes
an emblem for poetry; but it also announces the American literary academy's
efforts to mimic (or replace) the aristocratic English collector by selecting and
securing in one location "a wide and deep sampling of the best poetry written
in the English language." Its presence on the anthology's cover situates poetry
and painting together as the high arts that legitimate academic study of the
"Old Masters." But it also reminds us of the "sister arts," a pairing which
simultaneously invokes and resists the material constraints associated with
women, family and the home. This cover, in other words, allows us to investi-
gate how specific romantic themes—in this case, the idealization and dissolu-
tion of the home—when used to identify English poetry in particular and a
"cultural tradition" in general (*Norton,* xi), contain figures that continue to
haunt the academy. By giving a shape and a history to this haunted house,
we may make the cover less transparent, more resistant to our readings.[7]

I

> The institution of Academies in most countries
> has been coeval with the decline of art; in ours,
> it seems, it is the harbinger and main prop of
> its success.

> —Hazlitt, *Complete Works*

Reflecting on the British Gallery in 1822, William Hazlitt proposed that
"Pictures are a set of chosen images, a stream of pleasant thoughts passing
through the mind. It is a luxury to have our rooms hung around with them,
and no less so to have a gallery in the mind" (*Table Talk,* 173). Beneath the
fluid images, we see in Hazlitt's deliberations, here and elsewhere, the desire
to infiltrate public galleries and private homes, to plunder their treasures and
house them instead in the individual mind. The student of painting, Hazlitt

1. J. M. W. Turner, "Interior at Petworth (Apotheosis of Lord Egremont)" (c. 1837). Courtesy Tate Gallery.

confesses, "makes a pilgrimage" to the country seats of the wealthy, "eyes [these houses] wistfully at a distance," and demonstrates "an interest in them of which the owner is scarce conscious":

> he . . . passes the threshold, is led through the wainscoted rooms, is shown the furniture, the rich hangings, the tapestry, the massy services of plate—and, at last, is ushered into the room where his treasure is, the idol of his vows—some speaking face or bright landscape! It is stamped on his brain, and lives there henceforward. . . . He furnishes out the chambers of the mind from the spoils of time, picks and chooses which shall have the best places—nearest his heart. He goes away richer than he came, richer than the possessor. . . . (*Table Talk,* 14)

For Hazlitt, this mental gallery "henceforward" replaces public galleries and showpiece homes such as Petworth, for it allows any student to own the art of his choice.[8] It also defines the student of art as both interloper and interior decorator, furnishing a country estate within his brain and imagining the regions of his mind as a country estate. But it is a house where art replaces bodies; both mind and home, like the museum, become "tenantless mansion(s) of god-like magnificence" (*Table Talk,* 16).[9]

Hazlitt's class associations are characteristically ambivalent here. Despite the Robin Hood-like thievery he performs amidst the impressive collections of art throughout the English countryside, no property appears more secure than the place of art in Hazlitt's imagination. If the mental mansion is not quite a home, it is also more than a home: more private, more exclusive, and more protected from acquisitive visitors. In Hazlitt's private gallery of the mind, even the impoverished student can view masterpieces "bound up 'within the book and volume of the brain, unmixed . . . with baser matter!'" (*Table Talk,* 173). The interchangeable walls of museum, mansion, and mind are reinscribed in the image of the book, the bound volume which secures both masterpieces and masters from the taint of "baser matter." Given this material security and this security from material, the viewer of art (as well as the reader) disappears and becomes, in Hazlitt's words, a "visionary and abstracted [and classless] being" who dwells in a "happy, noiseless dream." "I lived in a world of pictures," Hazlitt writes. "Battles, sieges, speeches in parliament seemed mere idle noise and fury, 'signifying nothing,' compared with those mighty works . . . that spoke to me in the eternal silence of thought" (*Table Talk,* 14).

Three movements, relevant to our understanding of the academy, are implicit in Hazlitt's discussion of the place of art: he locates art in interior spaces—simultaneously mental and domestic—while removing it from other material possessions within the home; he turns both domestic and mental interiors into "tenantless mansions" occupied by "Old Masters"; and he displays the coordination of cultural institutions and romantic subjectivity in housing art while displacing conflict and human bodies. Moreover, we notice the network of metaphors by which Hazlitt identifies "art" with both painting

and poetry; these metaphors will, in turn, link his image of the "bound . . . volume" (borrowed from Shakespeare's *Hamlet*) with Turner's "Interior" and *The Norton Anthology of Poetry* I have already mentioned.[10] As Roy Park has pointed out, despite a romantic insistence on its limitations, "painting still remained the dominant analogy in the critical writings of the romantic period, and was still employed as illuminative of the essence of poetry" (159).[11] The complexities of this analogy between picture and essence will be explored later.

Hazlitt's imaginary raids on English art collections and his subsequent metamorphosis into a "visionary and abstracted being" form one response to questions raised in nineteenth-century England about the place of art in national and individual identity.[12] From the 1820s to the 1870s, debates in England over the construction of a national gallery and the efficacy of the Royal Academy jostled with questions of England's artistic "character" and of the appropriate audience for great works of art. Like Coleridge in "Fears in Solitude," Hazlitt makes the home responsible for reconciling public and private views of art. But writing twenty years later, in the midst of this national debate, Hazlitt clearly has a harder time than Coleridge distancing himself and his view of art from the home.

The Royal Academy of the Arts was founded by George III in 1768. In accord with eighteenth-century ideals of civic humanism, the Academy sought not only to make public the art of the nation but also to represent and thereby cultivate public virtues, public activity, and public-minded citizens.[13] Painters such as Joshua Reynolds would not be wasted "painting portraits to place over a chimney or the door of a private cabinet," but would be employed "by the public in some great work that would do honour to our country."[14] This neoclassical humanism merged with a desire to locate England and its Royal Academy as "the principal seat of the arts" in Europe; consequently the wars against France brought the urge "to demonstrate the mastery of English art, as well as English armies" (Barrell, 37; Gage, 110). Art, its admirers, and its practitioners in England all participated in a project of national definition, and that definition was transcendent, sublime, and clearly out-of-doors. Thus Turner, in his exhortation to the Academy's students in 1811, could echo the civic-idealism of Reynolds and wed it to the rhetoric of Napoleonic campaigns:

> To you, therefore, young gentlemen, must the nation look for the further advancement of the profession. All that have toiled up the steep ascent have left, in their advancement, footsteps of value to succeeding assailants. . . . To you, therefore, this Institution offers its instructions and consigns their efforts, looking forward with the hope that ultimately the joint endeavours of concording abilities will . . . irrevocably fix the united Standard of Arts in the British Empire. (Gage, 142)

England's Royal Academy, in other words, secured its place somewhere on a mountaintop in the Alps.

But the heroic nature of the Academy and its ability to ensure the public

good were increasingly called into question in subsequent decades. The Academy's status as a locus for art met competition from the growing private collections of wealthy patrons; its role as the center of artistic activity and instruction was compromised by the establishment of rival societies that explicitly challenged the authority and assumptions of epic-scale, heroic, public painting.[15] After the demise of Joshua Reynolds, the Academy did not speak univocally in the public sphere: political rifts divided members and undermined any semblance of disinterested civic authority (Shane, 40–45).[16] In 1836, the British House of Commons appointed a Select Committee to investigate corruption and incompetence in the Royal Academy, a result of pressure from reform groups that had been building since 1832. The same year—the year before Turner began his *Interior*—saw the opening of a new national gallery and with it the first in a series of public debates about this institution that would extend through the 1860s. These debates and investigations demonstrate a dramatic shift in the public perception of the role of the Academy and its members, who were now placed at odds with the welfare of the nation (Sandby, II:75–131). With the move to Trafalgar Square in 1836, the Academy established itself as a private residence—a home, in fact—apparently set apart from the demands of Parliament and the public. (To emphasize its domestic aspirations, the new building's library was dominated by a bas-relief of Michaelangelo's "Holy Family," placed over the fireplace.) In 1837, when Parliament proposed that the Academy open its doors to the public *gratis,* the Academicians refused, insisting they owed "nothing to their country" and the building was the queen's "private property" donated for their use.[17]

In his essays criticizing the Royal Academy, Hazlitt bluntly diagnosed its perceived failure: as a "Corporate Body," it was too private and partial, promoting its own interests; as a feminized body, it was too public and corporeal. "Profligate" and shameless, the prostituted Academy "loses all the delicacy . . . of nature in one undistinguished bloom of florid health": its annual exhibition (*Complete Works,* XVIII:42). In place of Reynolds's notion of an "ornament to Britain's greatness" and a "repository for the great examples of . . . Art"; in place of Turner's imperial army, Hazlitt's Academy stands as

a kind of *hospital and infirmary* for the obliquities of taste and ingenuity—a *receptacle* where enthusiasm and originality stop and stagnate. . . . The air of an academy, in short, is not the air of genius and immortality; it is *too close and heated,* and *impregnated with notions of the common sort.* (*Table Talk,* 269–70; emphasis added)

In this hot, claustrophobic, feminized space, artistic debates were "considered a personal quarrel, not a public question" (269–70). The institution "dandled and swaddled" and thereby corrupted artists; it was both a devouring "vortex" and an "antiquated coquet" (270, 268).

It is easy to read Hazlitt's attack on the academy as an attack on domestic

space, and to see the place of heroic, civic art surrendering to the demands of a feminized domestic culture. Hazlitt's characterization of academic art thus reflects his bitter view of the contemporary audience and artist as well:

> give me the gentleman and scholar, with a good house over his head and a handsome table. . . . Fill up the sparkling bowl, heap high the desserts with roses crowned, bring out the hot-pressed poem, the vellum manuscripts, the medals, the portfolios, the intaglios—this is the true model of a man of taste and virtu—. . . . Look in, and there amidst silver services and shining chandeliers, you will see the man of genius . . . a poet, framed, glazed, and hung in a striking light. (*Table Talk*, 211)

A review in *The Atheneum* in 1838 extends Hazlitt's remarks, lamenting that Academy exhibitions have taken on all the features of the bourgeois home, where art, artist, and audience are commodified: "the vast majority of works are made to suit medium taste, and wealth, and tenements: pretty, petty things, which display domestic scenes, 'bits' of nature, or colour, or effects, or portraits of dear non-entities" (Barrell, 360n.). The bourgeois home had swallowed the academicians as well as their public.

What then do we make of Hazlitt's student of art, who retreats from public exhibitions into gentlemen's residences and from them to the well-appointed chambers of his own mind, where paintings can be appreciated in private without the interference of a "herd" of "common" bodies?[18] Why is this mental gallery not another feminine, threatening, sensual, commodifying space? Perhaps because Hazlitt's student wants to appropriate a nobleman's mansion, a "privileged sanctuary," and with it the nostalgia for a masculine era of "true patrons and true critics" when art did not consort with the public. But given his disdain for the gentleman-patron with his "good house and . . . handsome table," Hazlitt has trouble reserving even this sacred space (analogous to Coleridge's "magnificent temple") from the threat of domestication. To ward off this possibility, his mental chamber of art metamorphoses into the book and volume of the brain, "unmixed . . . with baser matter"—unmixed, in other words, with the feminine, the corporeal, the vulgar.

The move from gallery to book replicates Hazlitt's biographical (and vexed) turn away from a career in painting to a career in writing. Writing, Hazlitt confides elsewhere, does not "exercise the body" as painting does; painting "embodies" and "gives the object itself," whereas writing (most especially poetry) "implies" and "suggests." Painters "in general mix more with the world than authors"; they are capable of producing "bodies [that] seem to feel"; they are "wedded to [their] art, the mistress, queen and idol of [their] soul" (*Table Talk*, 10–12; *Selected Writings*, 319, 266–67).[19] The painter, though more worldly, is also in a sense more domesticated than the writer, more subject to feminine rule. When Hazlitt finally retreats through metaphor to the world of books, rather than the riskier and more material realm of

painting, we see him fleeing a world of common, especially female, bodies. We see him running from history—and, more strikingly, from home.

He does not run very far; in fact, by turning to the metaphor of the book, the man of genius writes himself back into the Academy, the too private, too public corporate body he found so oppressive. Not only is the book already recognized as a commodity (along with "the hot-pressed poem, the vellum manuscripts"); it is also, like the academy, associated with the domain of the feminine.[20] By invoking the "book and volume," Hazlitt ironically identifies the student in his retreat with the debased academician: the man of the Academy loses "'the Raphael grace, the Guido air'" of genius because "the commands of the Academy alone"—that "antiquated coquet"—"'must live within the book and volume of his brain, unmixed with baser matter'" (*Table Talk,* 270). In his cloistered appreciation of the masters, in his silent appropriation of the privileges of patronage, the student/reader, like the academician, closes his doors to the public and finds himself nonetheless in a book, on the shelf, under the rule of the queen's "private residence." Occupying Hazlitt's frame of mind is a series of eternal substitutions—national academy replaced by feminized home, home replaced by gentleman's gallery, gallery replaced by book, book replaced by academy, and so on—in an economy that presumably keeps art safe and off the streets.

II

> And, instead of Cathedrals, Castles or Abbeys, the Hotel, the Restaurant, the Station, and the Manufactory must, in days to come, be objects of her [England's] artists' worship. In the future England and Wales series, the Salisbury Terminus, the Carnarvon buffet, the Grand Okehampton Hotel, and the United Bolton Mills will be the only objects thought deserving of portraiture. But the future England and Wales will never be painted by a Turner.
>
> —Ruskin, *Complete Works*

More than the work of any other nineteenth-century painter, J. M. W. Turner's landscapes have been used to ground the English School of painting and to bind together discussions of the sister arts, poetry and painting.[21] It is probably John Ruskin's work that has taught the nineteenth century and us to read Turner's productions (and painting in general) as a species of poetry, to identify "the whole soul of a nation" as a creature represented in its art, and to locate art not in the transience of a commercial world or in the movement of human bodies, but within the enduring edifices of a nation.[22]

As the image of the "soul" suggests, however, Ruskin extends Hazlitt's notions of genius in such a way that a nation's art and its poetry remain exceedingly interiorized, disembodied works. Ideally they are private works,

privately viewed: Turner's greatest and fundamental accomplishments, by Ruskin's account, were landscapes never meant for public view, but painted only for the eyes of the artist.[23] Hugh Honour, for instance, echoes Ruskin by insisting "Not only did [Turner] paint . . . for his eyes alone, he became increasingly reluctant to part with the pictures he exhibited and took every opportunity of buying back those he had sold" (*Romanticism, 95*). Yet at the same time, Honour is forced to acknowledge that Turner's influence in the nineteenth century derived almost entirely from the circulation of "his commercially successful paintings and book illustrations" (102).[24] Indeed, it appears difficult to fix Turner—an artist who drew crowds to his performances at the Academy's public "Finishing Days," an artist whose gallery on Queen Anne Street was part gentleman's home, part museum, part shop—as an artist essentially removed from public view and commercial interests.

In contrast to Ruskin's intensely private and simultaneously nationalistic view of Turner's work, we might place the characterizations against which Ruskin felt compelled to defend Turner's genius. Those characterizations, which became increasingly popular in the late 1820s and early 1830s, situated the artist's efforts not in the regions of the soul but in the realm of the body, the domestic, and the unmistakably consumable. The critic for *John Bull*, viewing *Mortlake Terrace* in 1827, declared that Turner "is in painting, what a cook would be in gastronomy, who, fancying he could make a good curry, curried everything he could get a hold of, fish, meat, fowl, and vegetables: MR TURNER, indeed, goes further, for he curries the rivers, and the bridges, and the boats upon the rivers, and the ladies and gentlemen in the boats . . ." (Gage, 3). Turner's work is reduced to domestic service, his art to victuals. Above all, they are not gentlemanly; nor are they English.

Other critics found Turner's canvases to be similarly perishable, if more refined—"a confectionary's Sugar Candy Jellies," mere "patisserie," indistinguishable from a tray of smashed crimson and gold jam tarts (Gage, 3–4). But a prevalent response was less lighthearted. Picking up on the alimentary metaphors, *Blackwood's Magazine,* in its 1836 review of *Juliet and Her Nurse,* roughly deposited Turner in the kitchen, as a working-class ignoramus likely to contaminate the status of national art:

> This is indeed a strange jumble. . . . Amidst so many absurdities, we can scarcely stop to ask why Juliet and her nurse [from Shakespeare's *Romeo and Juliet*] should be in Venice. . . . [T]he scene is a composition . . . thrown higgledy-piggledy together, streaked blue and pink, and thrown into a flour tub. Poor Juliet has been steeped in treacle to make her look sweet, and we feel apprehensive lest the mealy architecture should stick to her petticoat and flour it. (Wilton, 187)

In response to this review Ruskin pens his famous vindication of Turner, which becomes the seed for *Modern Painters*. In this work, Ruskin further abstracts Hazlitt's notion of a mental gallery, insisting that "the greatest art"

"conveys to the mind of the spectator" not Hazlitt's "speaking faces and bright landscapes" but rather "the greatest number of the greatest ideas" (I: chap. 2). The value of art is measured in terms of an inventory of the "higher faculty" of the mind, which has been cleansed of any dependence on mimesis of the physical world, on sensory pleasure or utility (*Modern Painters,* I: chap. 2; see Vaughan, 12). This is a far cry from the labor of the kitchen or even the cluttered drawing room of the bourgeois gentleman. And yet Ruskin's ideal (and infinitely reproductive) art has more in common with the contents of those interior spaces than with Joshua Reynolds's notion of a civic art. For Reynolds, only the lesser genres of painting, those "private images" that "were kept by artists and collectors in a portfolio; or—if occasionally hung—not in the showrooms of the house, but in the private apartments," could depart from the "determined forms" of nature, in particular the form of the human body, and from social responsibility. And such "private images," meant only for individual viewing, were "fleeting, unstable, transient, quickly produced and quickly enjoyed, taken out and put away, and not . . . 'on permanent exhibition'" (Barrell, 112–16, 120–23).

At Ruskin's request, the "suggestive" sketches and drawings of the essential Turner were sequestered in specially designed cabinets in the National Gallery, accessible only to "true critics" and students. Whereas the general public could crowd into the permanent exhibitions of the National Gallery with benefit or else buy engravings of the painter's work, Ruskin imagined an elite gallery for specialists (never built), where Turner's finest work, the fugitive "soul of a nation," would be divided among separate rooms and locked in individual cabinets to be opened exclusively for solitary viewing—a library, as it were, full of ghostly books and volumes waiting to be read or illuminated. As the editors of Ruskin's *Complete Works* suggest, Turner's "drawings were, in a sense, [Ruskin's] stock-in-trade; or, to vary the metaphor, his sacred books, which it was his mission to interpret, to illustrate, to reveal to a blind generation" who, themselves, could never be at home with Turner's art (XIII:xlvi).

III

> [T]he dissolution of an autonomous sphere of culture is rather to be imagined in terms of an explosion: a prodigious expansion of culture throughout the social realm, to the point where everything in our social life—from economic value and state power to practices and the very structure of the psyche itself—can be said to have become "cultural" in some general and as yet untheorized sense.
>
> —Fredric Jameson, "Postmodernism"

Hundreds of Turner's landscapes now reside in the Clore Gallery, in cabinets very similar to those proposed by Ruskin. Amid these landscapes one encoun-

ters the series of interiors, painted primarily in body color, that Turner produced at Petworth in the years between 1828 and 1836. For the most part these unpolished paintings, though interiors, correspond to Ruskin's evaluation of the essential Turner: as the artist meditates on his art, quotidian details are consumed by color and light. In this series, Turner takes domestic genre painting to its painterly extreme, encompassing and defying the practice of Rembrandt and Watteau.[25] Human forms grow less and less substantial in the works, eventually ceding presence altogether. At the same time, what animates these interior spaces is clearly art itself: the music filling the rooms, the collection of works mounted on Lord Egremont's walls, the paintings crowding Turner's studio in (remarkably) the Old Library, and, finally, the very paint from Turner's brush (see figures 2, 3, and 4). Turner appears to transform Petworth into one of Hazlitt's "tenantless mansions of god-like magnificence."

Looking again at *Interior at Petworth,* now reproduced on the cover of *The Norton Anthology of Poetry,* we might pause and acknowledge the connections implied between Coleridge's, Hazlitt's, Ruskin's, and this late twentieth-century representation of the "academy" as a home for art that distances art from the taint of the home. But we also ought to sound the differences: our academicians are not painters and sculptors but scholars, critics, and teachers. We see our students not as future practitioners but as potential consumers of art. The architecture of the academy is more often that of the state or corporate university than of the private mansion (though these may not be absolutely distinct); the exhibition gallery has become the classroom. And yet our academic practice often perpetuates the romantic logic of interiorization and the coincident denial of the feminine and material that we have traced throughout the nineteenth century. If nothing else, our teaching of poetry, as represented by the book and volume of *The Norton Anthology,* promotes the aesthetic study of canonical, dead, Old Masters and yet remains haunted by the neglected claims of living bodies. Our repressed "deep embarrassment about the marginality of literary history now" can be located in the image of a domestic interior on the exterior of the poetry anthology: how often do books of poetry actually find their way into the home (Liu, "The Power of Formalism," 722)?

Because of this embarrassment, we might be inclined to continue the critical legacy of Hazlitt and Ruskin, to repeat the move from image to text, and read the last of the Petworth interiors, *Interior at Petworth (The Apotheosis of Lord Egremont),* as domestic genre painting replaced by the poetic genre of elegy. With the hapless dogs in the foreground, we gaze at the coffin and ask "where are the masters of yesteryear?" Marking the death of Turner's patron, the loss of the "informal academy" at Petworth, and perhaps Turner's sense of alienation from public acclaim, *Interior at Petworth* might participate in a lament for the displacement of art and artist in a commercial world crowded with vulgar bodies.[26]

If we take this elegiac reading of *Interior at Petworth* to *The Norton Anthol-*

2. J. M. W. Turner, "Petworth: The Square Dining Room" (c. 1828). Courtesy Tate Gallery.

3. J. M. W. Turner, "Petworth: A Recital in the White Library" (c. 1830). Courtesy Tate Gallery.

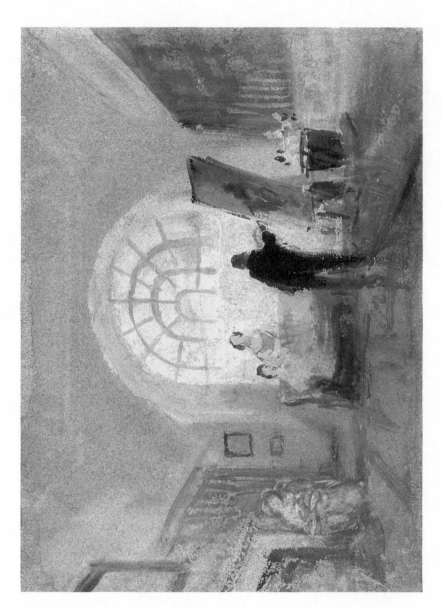

4. J. M. W. Turner, "Petworth: The Old Library" (c. 1828). Courtesy Tate Gallery.

ogy of Poetry, we might imagine the anxiety of its editors and teachers as they confront classrooms that cannot be so easily evacuated of vulgar bodies. In fact, it appears that poetry itself is the corpse in the corner, mourned in its passage from the interior spaces of the academy and the mental storehouses of students. The third edition of this anthology seems deeply concerned with the place of poetry in the contemporary American classroom, repeating obsessively that these are the "most teachable poems written in English," that "new elements . . . will materially facilitate the anthology's use in the classroom" and make it "more suitable for introductory courses," as if poetry would have trouble finding its way into the classroom or into the student's chambers without these aids. "Teachable," one suspects, indicates the ease with which a poem may be internalized by students or dissolved into ideas. A similar anxiety marks the status of the "Old Masters" in this collection, as the editors simultaneously apologize and congratulate themselves for including in their survey "pedagogically useful and stimulating poems" by the likes of "Twenty-five women poets," "a generous selection of Afro-American poems" "Canadian poets . . . and poems written in English in other countries" (xi–xii). As elegy, Turner's *Interior at Petworth* makes visible the lament written into the revisions of *The Norton Anthology of Poetry*. It holds up a masterful but finally impotent shield against intrusions which have been visited upon the place of poetry in the literary academy. Poetry, it confesses, is history.

Yet *Interior at Petworth* might also signal a joyous dissolution of structure that only artistic vision (Ruskin's "illumination") can restore. Rather than a mausoleum, the painting may describe a place where "classicisms . . . are at last rejected—or rather . . . fully incorporated in the vision of gyring storms and serene pools of light" (Lindsay, 186). The domesticating vortex that threatened Hazlitt's genius is now the natural/supernatural vortex of the artist, "a demonstration of the way a paradigm of pictorial and metaphoric space is replaced and transformed" (Mitchell, "Metamorphoses of the Vortex," 150). Art has no (more) place in the home; it enters only to dissolve the home into a barely residual, or nostalgic, idea. According to this apocalyptic reading of the cover, both the anthology and the classroom within which it is read invite students into a destabilizing realm of "vision" and "light"; it asks them to become, like Hazlitt's student, "visionary and abstracted beings." First transporting the American reader to the English gentleman's drawing room, the anthology then promises a force that will obscure the outlines of home, convention, nation, and history, eventually pulling the carpet out from under the reader's feet. This apocalyptic reading nonetheless assumes that art and its audience need to be rescued from the immediate, material, domestic sphere and restored, by the genius of the artist (or the teacher?), to the elemental—and abstract—forces of nature. Understood in this reading is the sense that poetry is not about the domestic, the quotidian, or the historical; that it resists structure and institutions. Poetry then resides not with the corpse in the sepulcher but with the spirit of "light, air and space."[27]

Both the elegiac and apocalyptic readings of the anthology cover insist, either with mourning or exultation, that art is not safe in the home; at the same time, they maintain that the contemporary academy provides an appropriate home for art. We reinforce this claim when we make the painting a sign of professional, academic, and intellectual transitions: when we note that Turner executed *Interior at Petworth* in a year of displacements—the year his last great patron died, the year the Royal Academy moved to Trafalgar Square, the year a vicious attack in *Blackwood's* signaled Turner's fall from popularity and prompted the first essay in modern art criticism. But these readings are complicated when we recall this as the year the Select Committee began to interrogate the procedures of the Royal Academy and demand free public access to Academy exhibitions and the year a woman ascended the throne of England. They become even more complicated when we recall that two years earlier Turner had begged off his lecturing duties at the Academy in order to devote himself to (more lucrative) book publishing, and had established his own residence in Margate with his mistress Mrs. Booth, thereby defying his public role as a "gentleman" of the Academy. (Ruskin tried to defend his idol from this association: though he lived "practically, in modern Margate," Turner lived "in imagination, in ancient Carthage.") We might say that the context surrounding the production of *Interior at Petworth* suggests an ironic reading of the very notion of a (gentlemanly) home for art which tries to maintain its distance from public concerns, commercial demands, and the pleasures of the body.[28] Maybe institutional and institutionalized art, this last Petworth interior seems to say, belongs with ghosts and Old Masters.[29] Maybe too, sublime events do take place at home, within feminized spaces.

Yet even a historicist's view of this painting, while draining it of artistic "vision," nonetheless risks dissolving the home under the light of historical fact, filling the space with matters of academic interest. In a debate with those who read the *Interior* by invoking "emotion" (nostalgia) or "the transcendental," Andrew Wilton argues that the *Interior* suggests "a fairly violent domestic drama" ("The 'Keepsake' Convention," 27). But in that drama he sees public and historical concerns about the place of art, not domestic troubles:

> This could perhaps be the sacking of a house. Charles Landseer was to execute two such subjects in the 1830's [set in the reign of Richard I]. . . . It is striking that items connected with both Judaism and Christianity, together with sculptures from pagan antiquity, occur (or appear to) in the "Interior." [These items are extremely difficult to verify.] Turner may well have been contemplating the destruction of a connoisseur's collection, but he would have conceived the subject as a historical set-piece rather than as a cryptic reference to a private relationship. (27)

Wilton's reading of *Interior at Petworth* is deliberately iconoclastic. He not only proposes a new title for the work, "Study for the Sack of a Great House (Interior at Petworth)," and a new date, c. 1830; he also argues that Turner

painted *in competition* with his contemporaries, that his work was shaped by what sold: "fashion" and "currently popular mode[s]" ("Picture Note," 56–58). Wilton enlists the aid of science—an X ray of the painting—in order to locate the "real" interior of the *Interior* and to erase other critics' elegiac or apocalyptic claims; but he actually casts those claims back into the painting. According to Wilton, the X ray reveals at least two interior scenes painted beneath the present surface, one of several men and women listening to music (in which case the sarcophagus becomes a piano), one "a scene of rioting or looting in a seventeenth-century baronial setting" ("Picture Note," 56). His scrutiny of these anterior interiors produces another version of competition in the painting: in Wilton's schema, *Interior at Petworth* paints over the very alternative that perplexed Hazlitt—a domestic interior defined by art or a domestic interior where the cultural heritage, the "connoisseur's collection," risks looting or destruction. In this struggle, the critic clearly allies himself with the image of Turner he favors: a "professional" and "Academician before anything else," Wilton sets about destroying the notion of a home for art by embracing the forces of history and economics that (pre-)occupy the contemporary academy.

We might try to detach ourselves from the romantic and academic content whirling around *Interior at Petworth* by admitting how its present, postmodern situation casts a backward light on this logic of interiorization. Its appearance on the cover of *The Norton Anthology of Poetry* announces the painting's transformation into reproducible image—the "final form of commodity reification" (Debord, quoted in Jameson, 67)—whose glossy surface turns the series of domestic interiors back upon itself. This image decorates a book that will be sold and resold in countless universities and high schools; it gives a pretty face to classwork and homework. As commodity, the painting loses its interiority and its cultural past: interior becomes cover; depth—with its suggestion of anteriority—becomes packaging. The reflective surface of this postmodern image provides the mirror by means of which we see, retrospectively, that Turner's work was and is, necessarily, commodified both in and out of the academy; it was reproduced then and continues to be reproduced today; it decorated and still decorates domestic interiors.[30] The image chosen by the publishing company borrows from a history of aesthetic discourse, promoting a distinct aesthetic style—"British Romanticism at Home"—and thereby colonizing under its sign the history of poetry written in English.

This postmodern analysis of the image finds us, finally, not at variance with the nineteenth-century logic of interiorization but at its apotheosis. By means of a visual image of an unmoored past, this aesthetic colonization "endows present reality and the openness of present history with the spell and the distance of a glossy mirage" (Jameson, 67). In similar fashion, *Interior at Petworth* paints over, with "a strange occultation," our encounters with poetry in the present (Jameson, 68).[31] As literary history becomes more imagi-

nary, its readers become more ghostly. The image on the anthology cover serves, in fact, as a nineteenth-century gloss on Jameson's "dissolution of an autonomous sphere of culture" in late capitalism: "our now postmodern bodies are bereft of spatial coordinates and practically (let alone theoretically) incapable of distantiation" (87).[32] As the "visionary and abstracted beings" of the postmodern academy, we can neither live within nor remain outside of the historical dimensions of *Interior at Petworth*.

What does the presence of Turner's *Interior at Petworth* tell us about the home we construct for art and the activity carried on within? If nothing else, this image should force us to question the economy of interiors and institutions that keeps both painting and poetry away from the pressure of human bodies, locked in safe cabinets, at an imaginary distance from the noise of history. Turner's *Interior* on the cover of a poetry anthology reveals the history of artistic academies, with their reliance on and fear of the home, all written beneath the claims of romantic genres: are we teaching elegy, apotheosis, or gothic novel?

NOTES

I would like to give special thanks to Professors James Heffernan, Nicola Watson, and Andrew Miller for their valuable assistance to me as I worked on this essay.

1. Lindenberger describes the public critic as one who, like Matthew Arnold, imagines himself as a spokesman for the general community and a guardian of cultural values, and imagines his subject (the artist, or art itself) as a distinct cultural force (29–32). The academic critic, by contrast, speaks to a much more restricted and familiar audience and speaks from "a body of knowledge" rather than a set of values. Thus academics shy away from the broad evaluative gestures "that might bring about too rapid a change in the way we enshrine and consume the great works of the past" (36). Note the emphasis on the familiar and on a known "body," in a place of "enshrinement" and "consumption."

2. I borrow loosely from Pierre Bourdieu's critique of an aesthetic intention that "makes the work of art." Bourdieu's analysis of the "aesthetic disposition" shares much with Lindenberger's idea of the "academic" critic. See *Distinctions*, 28–35, 44–50. Bourdieu's characterization of the "aesthetic disposition" is especially helpful in locating its affiliations with the domestic: "it presupposes the distance from the world . . . which is the basis of bourgeois experience. . . . [Thus,] the bourgeoisie has established the opposition between what is paid for and what is free, the interested and the disinterested, in the form of the opposition, . . . between the place of work and the place of residence, working days and holidays, the outside (male) and the inside (female), business and sentiment, industry and art, the world of economic necessity and the world of artistic freedom that is snatched, by economic power, from that necessity" (55).

3. For a similar reading of this poem that emphasizes "the topos of the family" instead of the home, see Julie Ellison, *Delicate Subjects*, 118–23.

4. Other scholars who address this question are, notably, Alan Liu, *Wordsworth: A Sense of History*, Jerome McGann, *The Romantic Ideology*, Marlon Ross, *The*

Contours of Masculine Desire, and Clifford Siskin, *The Historicity of Romantic Discourse.*

5. See Wainwright's *Romantic Interiors,* which describes the nineteenth-century impulse to turn romantic interior space into museum-like space—sites for the display of medieval, Renaissance, or exotic art, acquired or imitated. His discussion of Walter Scott's Abbotsford or William Beckford's Fonthill Abbey is especially interesting in terms of the conversion of living space to showplace. One should also point out the late eighteenth- and early nineteenth-century vogue in England for visiting the homes of "noblemen and gentlemen," and especially of renowned writers. Pope's Villa at Twickenham, Walpole's Strawberry Hill, and Beckford's Fonthill Abbey not only served as popular stopping points for a growing national tourist industry, they also actively promoted themselves as objects of interest (Wainwright, 148–50, 285–87). Books of engravings "by the most eminent Artists," notably Watts's *The Seats of the Nobility and Gentry* (1779) and Neale's *Views of the Seats of Noblemen and Gentlemen, in England, Wales, Scotland, and Ireland* (1824), presented the private property of these gentlemen as aesthetic objects—engravings—which the middle-class purchaser could, in turn, bring home to his or her own drawing room. The collusion of authorial identity, aesthetic value, domestic property, and national property (these books always mapped the kingdom as a collection of eminent homes) is pronounced in these books.

6. Lord Egremont died in November 1837, the year Turner finished working on this painting. John Gage, Patrick Youngblood, and other Turner scholars propose that the *Interior* was meant to commemorate the earl's funeral, but was left unfinished (Gage, *Turner,* 167). Andrew Wilton has recently contested the dating and content of the painting; his arguments will be addressed below. *The Norton Anthology* in its attribution, dates the painting "c. 1837."

7. I position the cover of *The Norton Anthology of Poetry* as a material rather than a metaphorical link between a historical discussion of a "home for art" and a discussion of the current practice of teaching poetry in the university. In so doing, I hope to avoid the "embarrassment" of New Historical criticism, most effectively voiced by Alan Liu: "what now substitutes for history of ideas between context and text is the fantastic interdisciplinary nothingness of metaphor." "Where history of ideas straightened the world pictures, . . . New Historicism hangs those pictures anew—seemingly by accident, off any hook, at any angle . . . ("The Power of Formalism," 743, 722).

8. John Barrell develops this point in *The Political Theory of Painting* (315–38). According to Barrell, Hazlitt counters the civic theories of art proposed by Sir Joshua Reynolds and his followers by advancing "a complete separation of the republic of taste from the political republic." Instead Hazlitt insists "that the satisfactions offered by painting are offered to us as we are private individuals, not public citizens" (315).

9. Hazlitt is referring specifically to the French National Gallery at the Louvre, formerly the residence of kings, where he "strolled and studied" for four months as a young man. In a later essay, Hazlitt represents the collections in British country homes—Blenheim, Burleigh, Grosvenor—as successors to the Louvre, the "privileged sanctuary" that had been "stripped of its triumphant spoils [by collectors!]" since the fall of Napoleon (*Table Talk,* 174). In this way, he imagines both the student/art-thief and the noble collector as heroes on a national scale.

10. See *Collected Works* (X:185–89) for Hazlitt's discussion of English character in terms of the "two sisters," painting and poetry.

11. For the interconnections of romantic theories of poetry and painting, see also Heffernan, *The Re-Creation of Landscape,* and Steiner, *Pictures of Romance.* Steiner concludes that "[t]he nineteenth century seems not to be a hiatus in the painting-

literature connection, but a critical and artistic laboratory for a redefinition of the relationship" (57).

12. See also Hazlitt's *Sketches of the Principal Picture Galleries in England* (1824) and the series of essays, "Fine Arts. Whether They Are Promoted by Academies and Public Institutions" (1814).

13. See Sir Joshua Reynolds's first Discourse, delivered in 1769, in his *Discourses on Art* (13–21). On art's civic humanism, see Barrell, 1–63.

14. Quoted from John Robert Scott, "A Dissertation on the Progress of the Fine Arts" (1804) in Barrell (36).

15. The increase in private collections in England was the result, in part, of the dispersal of French collections after the Revolution. The movements to watercolor and landscape paintings, in which Turner was intimately involved, and the founding of the Watercolour Society, are indicative of the challenge to the Academy's centrality. See Gage, 110–24, and Sandby, I:270–79.

16. See also Sandby (I:252–82; II: 74–129, 226–76) on West's turbulent presidency and subsequent strife in the institution.

17. Sir Martin A. Shee, "A Letter to Lord Russell . . . on the alleged claims of the Public to be admitted *gratis* to the Exhibition of the Royal Academy," quoted in Sandby, II:107.

18. See *Complete Works* (XVIII:37–51, X:49) for extreme instances of Hazlitt's desire for private viewing.

19. Compare Heffernan's discussion of Percy Shelley's resistance to the pictorial in *Defense of Poetry*, where poetry is imagined as both less material and more internal than its "sister" (*Re-Creation*, 43).

20. Despite his efforts to keep them in "the pure, silent air of immortality," books, in Hazlitt's remarkable essay "On Reading Old Books" (1821), keep sliding into commodification (especially through metaphors of food and consumption) and revealing their feminine and material associations.

21. Against a critical history that validates Turner's painting as "poems of light," see Vaughan, "Reconstructing Late Turner." Heffernan's *Re-Creation* and "Painting against Poetry" discuss Turner's resistance to the prominence of poetic over painterly power.

22. See Ruskin's testimony to Parliament, "Picture Galleries—Their Functions and Formations" (1857), Appendix I, *Complete Works*, XIII:545–50.

23. For excellent critiques of this approach, see Vaughan, "Reconstructing Late Turner," *Turner Society Notes* no. 55 (August 1990); John Parker, "How Should Turner Studies Progress?" *Turner Studies* 7, no. 2 (1989); and Barry Venning's reply, "How Should Turner Studies Progress?" *Turner Studies* 10, no. 2 (1990). Lawrence Gowing, in *Turner: Imagination and Reality*, extends Ruskin's elevation of the "late Turner," finding the exhibited works marred by the artist's attempts "to complete the product"; the unfinished works, by contrast "isolated an intrinsic quality of painting" (quoted in Vaughan, 11).

24. See Vaughan, 11, for a critique of this prejudice on the part of twentieth-century Turner scholars. On the public's detrimental effect on Turner's work, see Ruskin, *Complete Works*, XIII:433–38.

25. For Turner's adaptation of genre painting, see Lindsay, 180–86; and Gage, 105, 166. Heffernan describes the romantic poets' general disdain for genre painting, for the "dutchified" particularity of detail which marked (for them) a submission of the mind to the material world (*Re-Creation*, 38–40). Wilton notes that Turner also adapts the popular form of the "keepsake" painting in the "Interior," most explicitly through "the absence of any large-scale [human] figures" ("The 'Keepsake' Collection," 24).

26. This seems to be the reading suggested by Gage: "With its busy atmosphere

and bohemian life-style Petworth, as it is presented by Turner, came, indeed, to have something of the character of an informal academy" (165–66).

27. This phrase is taken from Turner's friend C. R. Leslie, who wrote that Turner "is the painter of light, air, and space. . . ." Quoted in Honour, *Romanticism* (102).

28. Turner's letter responding to Ruskin's uninvited defense suggests that, contrary to assumptions, he rather liked "invad[ing] the flour tub." See his *Collected Correspondence* (202).

29. Turner's *Transcept of Ewenny Priory* (1797) makes just this sort of ironic commentary. This watercolor has the same structural design as *Interior at Petworth*, but here a flood of light invades a dilapidated priory. The painted tiles of the foreground are littered with fowl, chicken coops, and rustic implements. Illuminated by the light is the figure of a woman, and behind her, a sarcophagus sculpted with the figure of a knight.

30. For instance, in the late 1820s he was commissioned by Egremont to paint landscapes of the estate to decorate the Carved Dining Room at Petworth (Gage, 157).

31. Compare Jerome Christensen's reading of "a theory of literature accommodated to scenic representation" which echoes the romantic discourse of the domestic interior. In his account, the authority of the image in the present is established "by a device that renders past and future as phantomized adjacencies . . . other pictures, other rooms" ("Rhetoric," 456).

32. The home for art thus finds its apogee in Jameson's postmodern hotel, a commercial and fully abstracted home, which "achieves a peculiar and placeless disassociation from its [urban] neighborhood," and whose "very real pleasures" are found everywhere but in its residential sections ("one understands that the [bed]rooms are in the worst of taste") (82–83).

WORKS CITED

Barrell, John. *The Political Theory of Painting: From Reynolds to Hazlitt.* New Haven: Yale UP, 1986.

Bourdieu, Pierre. *Distinctions: A Social Critique of the Judgement of Taste,* trans. Richard Nice. Cambridge, MA: Harvard UP, 1984.

Castle, Terry. "Phantasmagoria: Spectral Technology and the Metaphorics of Modern Reverie." *Critical Inquiry* 15, no. 1 (Autumn 1988): 26–61.

Christensen, Jerome. "From Rhetoric to Corporate Populism: A Romantic Critique of the Academy in an Age of High Gossip." *Critical Inquiry* 16 (Winter 1990): 438–65.

Coleridge, Samuel Taylor. *Samuel Taylor Coleridge,* ed. H. J. Jackson. Oxford and New York: Oxford UP, 1985.

Ellison, Julie. *Delicate Subjects: Romanticism, Gender, and the Ethics of Understanding.* Ithaca, NY: Cornell UP, 1991.

Gage, John. *J. M. W. Turner: "A Wonderful Range of Mind."* New Haven and London: Yale UP, 1987.

Hazlitt, William. *The Complete Works of William Hazlitt,* ed. P. P. Howe. 23 vols. London: 1930–1934.

———. *Table Talk, or Original Essays.* London: J. M. Dent & Sons, Ltd., 1911.

Heffernan, James A. W. *The Re-creation of Landscape: A Study of Wordsworth, Coleridge, Constable and Turner.* Hanover N.H.: UP of New England, 1984.

———. "Painting Against Poetry: Reynolds' *Discourses* and the Discourse of Turner's Art." *Word & Image* 7 (July–September 1991): 275–99.

Jameson, Fredric. "Postmodernism, or the Cultural Logic of Late Capitalism." *New Left Review* 146 (July/August 1984): 53–92.

Lindenberger, Herbert. *The History in Literature: On Value, Genre, Institutions.* New York: Columbia UP, 1990.

Lindsay, Jack. *J. M. W. Turner: His Life and Work.* London: Cory, Adams & McKay, 1966.

Liu, Alan. "The Power of Formalism: The New Historicism." *ELH* 56 (Winter 1989): 721–71.

——. *Wordsworth: The Sense of History.* Stanford: Stanford UP, 1989.

McGann, Jerome. *The Romantic Ideology: A Critical Investigation.* Chicago: University of Chicago Press, 1983.

Neale, John Preston. *Views of the Seats of Noblemen and Gentlemen, in England, Wales, Scotland, and Ireland.* Second Series. 5 vols. London: Sherwood, Jones & Co., 1824.

Park, Roy. "Ut Pictura Poesis: The 19th Century Aftermath." *Journal of Aesthetics and Criticism* 28, no. 2 (Winter 1969): 155–65.

Reynolds, Joshua. *Discourses on Art,* ed. Robert Wark. New Haven: Yale UP, 1975.

Ross, Marlon. *The Contours of Masculine Desire: Romanticism and the Rise of Women's Poetry.* New York: Oxford UP, 1989.

Ruskin, John. *The Complete Works of John Ruskin,* ed. E. T. Cook and Alexander Wedderburn. London: George Allen, 1904.

Sandby, William. *The History of the Royal Academy of the Arts from Its Foundation in 1868 to the Present Time.* 2 vols. London: Longman, Green, Longman, Roberts, & Green, 1862; facsimile rpt. London: Cornmarket Press Limited, 1970.

Shane, Eric. "Dissent in Somerset House," *Turner Studies* 10, no. 2 (1990): 40–45.

Siskin, Clifford. *The Historicity of Romantic Discourse.* New York: Oxford UP, 1988.

Steiner, Wendy. *Pictures of Romance.* Chicago: University of Chicago Press, 1988.

Turner, J. M. W. *Collected Correspondence,* ed. John Gage. London: 1980.

Vaughan, William. "Reconstructing Late Turner." *The Turner Society News* no. 55 (August 1990): 10–12.

Wainwright, Clive. *The Romantic Interior: The British Collector at Home, 1750–1850.* New Haven: Yale UP, 1989.

Wilton, Andrew. "The 'Keepsake' Convention: 'Jessica' and Some Related Pictures." *Turner Studies* 9, no. 2 (Winter 1989): 14–33.

——. "Picture Note." *Turner Studies* 10, no. 2 (Winter 1990): 55–58.

——. *Turner in His Time.* New York: Harry N. Abrams, Inc., 1987.

Youngblood, Patrick. "Letter to the Editor." *Turner Studies* 10, no. 1 (Summer 1990): 51.

4

"A Voice from across the Sea"

Communitarianism at the Limits of Romanticism

ANNE JANOWITZ

The remarks which follow comprise three linked arguments. I first offer a "unified field" theory of romanticism; I then take the elements of that theory and use them to make some observations about Shelley's "The Mask of Anarchy," a poem whose academic status has been one of anomaly rather than straightforwardly one of inclusion or exclusion from the canon; and finally, I bring those observations to bear on a problem within feminist criticism of romantic poetry.

I draw on Shelley's canonically borderline poem in order to raise a question about the currently awkward relationship between the traditions of romanticism as they have been described and modified since the middle of the nineteenth century and our more contemporary interest in the exclusions of the period.[1] This newer and more diffracted network of historical paths within the corpus of texts written between 1780 and 1830 has principally resulted from the combined influence of the 1960s and 1970s labor history project, the power of feminist scholarship, and the historicized versions of both structuralism (Althusserian Marxism) and post-structuralism (Foucauldian analysis). I wish to displace the critical inclusion/exclusion model for poetic texts of the period 1789 to 1830 and invoke instead a dialectical model of a dynamic debate argued through texts we now consider to be canonically included and excluded.

I am therefore principally concerned to reopen the "unified field" debate within romantic criticism, invoking Shelley's poem where appropriate, and using the discussion to respond to feminist critics' recent rejection of the "orthodox" poets of romanticism. These notes participate in the project of offer-

ing an explanatory framework within which to investigate the plurality of those "romantic exclusions" which the editors of this volume say "would appear properly to belong within the period."[2] For without such a comprehensive framework, study of these disparate materials fragments into a market economy of reified critical commodities.

The "Unified Field" Theory of Romanticism

To combat the fragmenting implications of a "free market" of romanticisms, my "unified field" theory argues that the term "romantic" ought to be used to describe neither (1) a set of literary functions (paradigmatically debated in discussions by Arthur J. Lovejoy and Rene Wellek about the reducibility or irreducibility of structures and preoccupations such as imagination, nature, myth, and symbol) nor (2) a set of ideological mystifications (the literary method derived from the work of Althusser).[3] Rather, we should consider romanticism to be the literary form of a struggle taking place on many levels of society between the claims of individualism and the claims of communitarianism. For a central contest within British society as a whole, beginning in the later decades of the eighteenth century, reaching its height between 1790 and 1848, and persisting in various forms (as romanticism has persisted in various forms), was between individualism and communitarianism as grounding social theories of the constitution of personal and political identity.

If we provisionally suspend the inclusion/exclusion model, we can see more clearly how self-divided British romantic poetry has always been in its intentions. That self-division is evinced in the way that romantic poetry offers at times a poetic of transcendence, lyric solitude, and private meditation—what we have come to call the ideology of aesthetic autonomy; while, at other times, romantic texts polemically invite political activism and militant poetic revolution, and the integration of intervention and rhetoric: for "Poetry fettered fetters the human race."[4] Some romantic poems stumble back from the urban and industrial fray, and from the increasingly hectic pressure of other consciousnesses. These poems, like "Tintern Abbey," breathe more freely in the countryside, providing aesthetic spas, locations within which to cultivate an individual private poetic of transcendence. But poems such as Blake's *Jerusalem* and Shelley's "The Mask of Anarchy," on the contrary, offer transpersonal voices that originate in collective desire and seek to intervene in the world as collective agents.

The analytical categories I am using here derive in part from contemporary critiques of liberalism which counterpoise to the liberal conception of the individual as an "unencumbered" self formed anterior to its ends in lived social reality the alternate notion of a communitarian self intelligible by and through common goals and aims.[5] When contemporary critics take on liberalism by way of a communitarian critique, they invite a return to the origins of

liberalism in order to discover the sources of a predicament in contemporary political philosophy. In *After Virtue,* Alasdair MacIntyre outlines a prolonged crisis from the middle of the eighteenth until the middle of the nineteenth centuries, in the breakup of moral presuppositions, a loss which, he argues, was conceived by moral philosophers not as *loss* but as what he calls "self-congratulatory gain" in the emergence of a freed but, as we have increasingly discovered, impoverished individualism, the one we live with now.[6] Though MacIntyre is discussing the history of moral philosophy, not of either social life or literary texts, his claim resonates with the complexity of intentions within romanticism.

Our present ability to critically elicit the double intention within romantic poetry has, of course, been deeply hampered by the outcome of the contest in the larger regions of intellectual and political life. Because individualism won the larger debate, it has shaped the history of literary criticism, which now either approvingly reads the romantic period backward as a poetic of autotelic aestheticism or disapprovingly exposes a "romantic ideology" which claims it is without ideology, but which in practice enacts the individualist ideology of bourgeois universalism. At present, this latter critical activity needs to be supplemented by a history of the dynamic struggle through which that bourgeois hegemony was achieved.

As a result of the victory of individualism, a whole set of exclusions have proliferated, making large numbers of textual materials out of bounds for the customary literary-historical study of romanticism. These include popular periodical poems, poetry written by working-class and agrarian poets, women's poetry, and, crucially, poems which attempt to *intervene in* rather than *represent* political and social movements. For "high" romanticism, with its obsessive focus on the self as voluntaristic and on the individual imagination as a source of self-representation, must perform the massive act of suppressing its own contestatory history in order to preserve its triumph.

It is within this debate between individualism and communitarianism that the anomalous status of Shelley's "The Mask of Anarchy" becomes exemplary. For though "The Mask of Anarchy" has been included in the Shelley canon, it is regularly treated as a special kind of romantic poem because it is, as Shelly himself named it, "of the exoteric species"—i.e., addressed to the populace at large rather than to a set of initiates.[7] Leavis, for example, though he liked the poem, called "The Mask of Anarchy" "little more than a marginal throw-off."[8] In *Shelley's Major Poetry,* Carlos Baker praised the poem, but because of its popular appeal placed it in an independent category from Shelley's personal lyrics. Earl Wasserman, whose *Shelley: A Critical Reading* set the standard for the 1970s and early 1980s in philosophical and rhetorical interpretation, does not include any reference at all to the poem in his study.[9] On the other hand, critics who elect to take on the explicitly political issues within Shelley's work do address "The Mask of Anarchy" but maintain the division between this kind of popular Shelleyean work and the "esoteric" categories

of skepticism, idealism, and Hellenism. For example, Marilyn Butler, whose *Romantics, Rebels, and Reactionaries* did an enormous amount to open up new areas within romantic literary criticism by attending more fully to cultural and political context than had been the case for decades, writes that "Shelley's greatest poetry *rises above* the simplification entailed in his call to the masses."[10]

Because twentieth-century critics have discussed the poem as an experiment in popular culture within Shelley's predominantly high cultural project, and as a practical political experiment within his prevailingly politico-philosophical poetic, the critical reception of "The Mask of Anarchy" as an anomaly attests to prevalent conceptions of what constitutes the romantic; namely, conceptions that confine acceptable texts to either (1) those that foreground philosophical, aesthetic, and individual psychological problematics or (2) those that *appear* to problematize philosophical, aesthetic, and psychologial issues. We need to be clear that it is not the political but the popular character of the poem that gives it its anomalous position, for the "Ode to Liberty" and "Prometheus Unbound" are both political and canonical. What is perceived as unusual is Shelley's intended poetic purpose to go into the world, "to publish a little volume of popular songs wholly political, & destined to awaken & direct the imagination of the reformers."[11]

The two related aspects of Shelley's popular intention in this poem of interest here are his use of a communitarian, transpersonal voice and his intention to intervene in, rather than to represent, a mass social event, the insurrectionary possibility of the post-Peterloo period. Because this communitarian modality is yoked to an interventionist rather than a representational poetics, "The Mask of Anarchy" is considered anomalous by both orthodox and Althusserian romanticists. But because Shelley was not only an atheist and philanthropist but also an aristocrat, the poem is not of much interest to those who practice a version of literary "history from below" or those who have been recovering forgotten and marginal poets of the period.[12]

But though the poem appears to be unusual among romantic texts by reason of its production of a communitarian interventionist voice rather than the individualized voice of romantic meditation, the poem nevertheless has not been vigorously excluded from the narrow critical construction of romanticism. "The Mask of Anarchy" does, after all, exhibit features common to Shelley's more aesthetic-lyrical productions and to general trends within the romantic corpus. For example, while the ballad measure Shelley uses in the poem is intended to address an audience which can be roused to political intervention, such a popular form was experimented with extensively and nonthreateningly throughout the period. More particular to Shelley, the transient romantic force, or Power, that subtends the appearances of the world in "Mont Blanc" and "Hymn to Intellectual Beauty" equally inhabits this poem and is called to action in the world. In "The Necessity of Response: How Shelley's Radical Poetry Works," Robert Hendrix argues that "The Mask of

Anarchy" is best read as a meeting place of romantic and radical poetics. That is, he finds that the poem includes "sharp public satire and realistic polemic; but it is also a self-conscious attempt to engender ethical and philosophical attitudes, more ambitious than working-class poetry and more obscure." I find his formulation both interesting and inadequate, for while he is right to sense in this poem some kind of encounter between distinct poetic impulses, his definition of the two categories are easily canceled by examples from the range of poetic texts written in the period. "Radical literature," he argues, "differs from romanticism by prizing explicitness over submerged meaning, public allusions and shared abstractions over personal symbolism and the process of self-discovery."[13] This characterization is deceptive, for both "radical" and "romantic" texts experimented with generic forms and with levels of explicitness. Clarity, after all, was the program of the *Lyrical Ballads,* as was probably the intention of James Ogden in his radical epic *The Revolution,* published by Johnson in 1790.[14] And certainly the communitarian commitment to social responsibility and mutuality is productive of philosophical categories and responsible to "ethical attitudes." This suggests to me that Hendrix's category of "radical" poetry is better interpreted as a subset of romantic poetry. But this point goes beyond tautology only if we wish to positively characterize the affinities among romantic poems, rather than multiply the number of "romanticisms," a contemporary project in the tradition of Lovejoy.

Though I am tempted to enlist "The Mask of Anarchy" as exemplary of a significant "romantic exclusion"—which we can call the nineteenth-century tradition of communitarian interventionist poetry—the term exclusion is historically insufficient. The communitarian tradition is so intertwined with, because historically interpreted *within,* the tradition of aesthetic autonomy and individualism that it is most meaningfully understood as an element in an overarching contestatory history, as an aspect of the engagement between traditions. And we should note that within the popular communitarian tradition, Shelley's poem was only one of many images of the Peterloo Massacre; moreover, it missed its intended audience, since Hunt would not publish the poem in 1819 when Shelley posted it to him from Italy.

In "The Mask of Anarchy" the "selves" of political upheaval are generated from and come to know themselves through their experience of oppression. In the individualist mode within romantic poetry, by contrast, most often the self is pre-given and extremely vulnerable: the possibility of development, though inherent in each self, is understood in Wordsworth's poetry after "Salisbury Plain" to be "in most [people] abated and suppressed" by society.[15] "Tintern Abbey" and "The Mask of Anarchy" might well be placed as the two extreme positions of a debate between a theory of identity construction which places the voluntaristic self in the ever-new and challenging contexts of a social world or one which theorizes a self constructed by a set of social

goals and expectations. The two versions of Wordsworth's "Animal Tranquillity and Decay" exemplify Wordsworth's own move toward an individualist grounding. The first version of the poem suggests quite explicitly the social determination of the old man's consciousness, while a second, truncated version gives an *extreme* example of an unencumbered self.

Generations of students have been taught by Palgrave and his successors to think of the first half of the nineteenth century as "The Age of Wordsworth." But when we turn back to the cultural discourses of the 1840s, when the outcomes of the contest between classes and between individualist and communitarian conceptions of identity were as yet undecided, it was the communitarian and interventionist aspect of Shelley's poetry that was most apparent to readers as the central aspect of his *entire* work. Ernest Jones, a Chartist poet and leader, wrote in an 1847 article that "Shelley had the happy power of never swerving from a practical [i.e., interventionist] aim *in his most ideal productions.*"[16] Charles Kingsley was eager to point to the social dangers of poetry, and he blamed Shelley as one who had done Chartist poets "most harm . . . and one can imagine how seducing [such a] model must be, to men struggling to utter their own complaints."[17]

As we can better identify the communitarian impulse (and "The Mask of Anarchy" exhibits explicitly its usually, to our eyes, more recessive characteristics), so may we be better able to understand poems whose foregrounding of the individualist aspect of the debate veils but does not entirely destroy communitarian concerns. We can then locate the roots of romantic poetry in the origins of this debate and follow its history into the twentieth century. Considered through the matrix of communitarian and individualist identity formation, a poem like "On First Looking into Chapman's Homer" expands into a historical genealogy of a social self. Keats's "chameleon poet" can be understood as a category of dialectical exchange between the unencumbered self and a socially constituted one. By paying closer attention to Coleridge's pantisocratic conception of community, and his use of the Indic elements that generate the notion of "The One Life," we can watch the workings of the debate within his version of the romantic poetic. A study of nineteenth- and twentieth-century romanticism, from the early political poems of Coleridge through the romantic Anglo-communism of W. H. Auden, will tell a compelling story of the interweaving of individualist and communitarian purposes in British poetry.

A volume on the "limits of romanticism," then, one that seeks to "map neglected hinterlands onto the well-worn contours of the field,"[18] may find that by suspending the inclusion/exclusion model, we are brought back to places we have been before. But we may find there a partially obscured set of contestatory meanings that in turn invite within their scope other exclusions: textual materials belonging to a communitarian vision of identity leading to progressive social and political interventions and ends.

Communitarian Elements in "The Mask of Anarchy"

"The Mask of Anarchy" is a good example of a limit-case for romantic communitarianism, both insofar as the text itself fashions a transpersonal theory of identity and as it taps into a larger communitarian current in the period. The argument of the poem is unabashedly clear: the "vast assembly" (LXXIII) coming "From the corners uttermost/ Of the bounds of English coast" (LXVII) can "Rise like lions" (XCI) because they establish their identity through their act of solidarity. Identity is clearly established as a plural and a social mode. The act of solidarity produces action dialectically out of passive resistance, as the mass demonstration will provoke the State to intervene and propel the demonstrators toward a revolutionary retort: "And that slaughter to the Nation/ Shall steam up like inspiration,/ Eloquent, oracular,/ A volcano heard afar" (LXXXIX). The language of the poem will occupy and then transform oppression into resistance, the words, "Like Oppression's thundered doom,/ Ringing through each heart and brain,/ Heard again" (XC). "These words" (XC), moreover, do not belong to the represented "I" of the text, for his voice is that of a scribe; nor do they unambiguously belong to Earth, for they are so attributed through an act of similitude, "As if her heart had cried aloud." The source of that language is unfamiliarly fluid and social in the context of a romantic individualist poetics of the self.

In twentieth-century critical discussions, Shelley's political poetics have most often been linked to the traditions of radical liberalism learnt from Godwin and Paine, traditions which dovetail nicely with the domination of liberal individualism.[19] But "The Mask of Anarchy" does not only suggest the social sources of the self; it also draws upon an already established mythology and imagery of a communitarian traditionalism, one which is closely linked to that movement of the laboring poor known as "agrarianism." This strand within Shelley's poetic is distasteful both to proponents of the individualist interpretation of romantic poetry and to leftist critics in the Painite rationalist tradition. While Shelley certainly was crucially linked personally and philosophically to Godwinism, his work shows the link as well to plebeian communitarianism.

As I implied above, because Shelley was a poet, an aristocrat, and an intellectual, "The Mask of Anarchy" does not conform precisely to any absolute divide between high and popular culture. And the poem's occasion—the Peterloo massacre—itself was an event which predated the split into middle-class and working-class political movements. The pre-Reform Bill radical movement was one in which elements of plebeian and middle-class ideas of social change were jostled together. The men, women, and children who peopled St. Peter's Fields were themselves a mix of full-time cotton operatives, agricultural workers, those who mixed the two activities in pursuit of sustenance, and middle-class radicals. Communitarian texts are not always congru-

ent with those that we associate with popular working-class culture (which
often will emulate the genres of high culture), nor are individualist texts only
drawn from middle-class or aristocratic high culture (by mid-century a large
region of working-class culture had assimilated the values of individualism
into popular textual genres).[20] But for the most part, the political and cultural
aspirations of the developing autonomous working-class movement between
1800 and 1840 were embodied in utopic versions of society which derived as
much from communitarian agrarian traditions as from Enlightenment values
and notions of natural right.

So, though it may at first appear odd that Shelley would commemorate an
event in an industrial city with a vision of an agrarian utopia, in fact, he was
writing right out of the mixture of visions that characterized the radicalism
of the first four decades of the nineteenth century. The image of "the comely
table spread" (LIV) that Shelley produces within his imagined community
would have been part of the traditional fantasy of a good life for a laboring
class very newly arrived in the cities and slowly being turned into the industrial
proletariat, and not simply the idealized feudal fantasy of a landed aristocrat
expatriated to Italy and filled with ressentiment about new industrial and
financial wealth.

Malcolm Chase, the historian of agrarianism, makes the point that the issue
of agrarianism is not primarily about agricultural labor at all, but about the
developing industrial working class. Agrarianism is about their response "to
economic, social, and political dislocation which sought solutions in and on
the land." He insists that "for such people 'nature' retained a profound mean-
ing, not sentimental or Arcadian in character, but ingrained, realistic and
born of continuing proximity (spatial and psychological) to the land."[21] The
aesthetic linked to this version of nature would be very unlike that idealized
landscape of the picturesque, i.e., unlike the aesthetic ideology.

Agrarianism was a crucial tradition and rhetoric for industrial workers still
deeply tied to their history in the countryside, and the single most significant
vehicle for urbanized agrarian radicalism was the ideology of the followers of
Thomas Spence, whose "land plan" articulated an early version of land reform
that would later be taken up by the Chartists.[22] In his analysis of the vicissi-
tudes of Spenceanism in London radical circles between the 1790s and 1820,
Iain McCalman has not only demonstrated the links between Spence's agrar-
ianism and Paine's rationalism, providing one salient instance of the communi-
tarian-individualist debate in action within the radical world, but also suggests
that Shelley must have had some intellectual relationship with the Spencean
movement. *Queen Mab* was first published in a journal run by "Erasmus
Perkins," the pseudonym of George Cannon, an important second-generation
Spencean.[23] Spence was an intellectual bricoleur, and it is easy to see how
appealing his notions might be to Shelley: "[Spence] had absorbed the rhetoric
of truculent political anti-clericalism which was so much a part of the popular
dissenting outlook. He was heir to the strange blend of social prophecy, popu-

lar materialism and skepticism which had surfaced in the writings and utterances of plebeian sectarians like the Ranters and Seekers. And he had ingested elements of enlightenment rationalism through his reading of philosophes like Volney."[24] This is the matrix of romanticism: the difficult and confused meeting of communitarian and individualist aspirations. Both Spence and Shelley open their texts to that flux.[25]

Agrarian elements in working-class culture are often criticized by radicals in Painite and Marxist traditions for being a reactionary strain in the class-consciousness of the working-class. Organic or traditional aspirations get shifted onto a Burkean paradigm, and so appear to be responsible for holding back the growth of industrial class consciousness.[26] It is usual as well for Marxist critics to invoke the category of the "radical aristocratic" when describing Shelley's revolutionary poetics. Readers such as Edward Aveling and Eleanor Marx in the past, and more recently Paul Foot of the British Socialist Workers' Party, have stressed the ways in which Shelley's radicalism inflected his aristocratic position. They argue that the aristocrat is as excluded from the main zones of economic power as the laborer, and therefore has access to insights not available to the bourgeois poet who is too attached to the interests of this own class position.[27]

It is interesting then to read Donald Reiman's forceful argument that Shelley, however much it may embarrass his leftist admirers, *was* linked closely to "reactionary agrarianism." Reiman looks at the ways in which Shelley's links to the estate system made it impossible for him to break with the aristocracy, and argues that *this* inflects "The Mask of Anarchy." Reiman presses his point by outlining the antagonism between Shelley's positions and those of the "new" financial interests, whose wealth "was newly created by the need to fund the national debt, the issuing of paper money and credit, and the expansion of governmental bureaucracy during the American and French Wars, 1775–1815."[28]

But most of the aristocratic targets in "The Mask of Anarchy" (abolition of the slave trade and the Court of Chancery; criticism of the church hierarchy, lawyers, the House of Lords, spies, agents provocateurs, the standing army, royal prerogatives, the Bank of England, the Tower of London, the unreformed Parliament, the practice of hiring workers at subsistence wages; hatred of paper currency; and the inculcation of a thirst for revenge!) are equally those that would have been shared by the radical agrarian movements that helped to secure the industrial working class in a sense of an inherited and shared tradition, and so buttressed the growth of working-class consciousness.[29] For example, Shelley's attitude toward paper money in "The Mask of Anarchy" was shared by the agricultural aristocracy and popular radicals. Thomas Evans, another of the second-generation promoters of Spence's "Land plan" for the "people's farm" of England argued that it was the parasitism of the privi-

leged classes which led to the poor being mired in debt and financial bondage.[30]

When Shelley writes "The Mask of Anarchy" in the discourse of agrarian radicalism, he links himself to the plebeian political tradition that runs outside and athwart Godwinian rationalism. This enables him to redirect his sense of what it is that poems can do: namely, it allows him to shift from a representational to an interventionist project in the poem. And here we can begin to address the question of feminism and the study of romantic poetry, for Shelley's engagement with communitarianism produces in his poem an encounter with women and with the problem of the representation of women that is markedly different from his address to this question in other poems, and instructive for our contemporary study of the romantic period. The communitarian poetics in "The Mask of Anarchy" link Shelley to plebeian feminism. The Spenceans were not only the historical link between the revolutionaries of the 1790s and the radicals of 1818, but they are also the link on the question of women's oppression. Though the intellectual circle around Wollstonecraft, Godwin, and Blake had been interested in the cause of sexual liberation, Spence was one of the only English Jacobins to explicitly address women from the laboring classes.[31] Spence's *Rights of Infants* (1797) calls for women to have full political rights. Using a female voice, he writes: "Our sex were defenders of rights from the beginning. . . . You shall find that we not only know our rights, but have spirit to assert them."[32]

Interventionist Poetics and Feminist Criticism

If "The Mask of Anarchy" has appeared anomolous within the Shelley canon for reasons of its explicitly political topic, it is anomolous as well in its representation of women. It is quite stunning to find that the Shelley who is the author of an idealized self-projection of the female in "Alastor," the essay "On Love," and "Epipsychidion" is, in "The Mask of Anarchy," equally the author of a fierce and autonomous female interventionism. That Shelley uses the image of an articulate and female Earth to be the spokesperson for radical change in "The Mask of Anarchy" enacts the productive links between communitarianism and women's liberation. For it is noticeable that, in the case of Shelley's usual presentation of women, femaleness is linked to solipsistic individualism, while, in "The Mask of Anarchy," femaleness is linked to interventionist communitarianism.

The middle-class response to the involvement of women in the Peterloo Massacre had been divided. One strand of response to the massacre of women and children was an indignant sense of an assault on innocents. One Cruikshank engraving, "Massacre at St. Peter's or 'Britons Strike Home'" depicts the slaughter of women and children by the Loyal Manchester Yeomanry, their banner reading "Be Bloody, Bold, & Resolute" (*Macbeth* IV:i).[33] But this benevolent patriarchal response was matched among the pro-government

forces by an equally severe condemnation of the women themselves. The women reformers of Peterloo were labeled as prostitutes, and Dr. Stoddert, editor of *New Times,* argued that legislation should be passed so that women might not attend popular meetings.[34] It makes sense that the depictions of women in the press in the immediate aftermath of Peterloo (which Shelley read in the papers which reached him in Italy) would have raised for him the question of how to link the philosophical rights of women to the actual interventions of women activists. In a letter to Hunt dated November 3, 1819, Shelley refers to the troop of "master manufacturers" who "cut off women's breasts & dash the heads of infants against stones."[35] The presence of an interventionist representation of women in Shelley's work in concert with his communitarian voice in the poem suggests that there may be a strain within romanticism which links the debate between individualism and communitarianism to that between the oppression and the liberation of women.[36]

It is a credit to the work of many feminist literary critics, but principally to the work of Margaret Homans, that we now accept as repressive that romantic image of a silent or silenced woman. One need think only of Leila's body in Byron's *The Giaour,* or Dorothy's unexpected presence at William's side at the end of "Tintern Abbey," or the reduction of Christabel's speaking voice to a brute hiss to experience again the violence done to women's voices in romantic poetry.[37] Moreover, when a female representation *is* allowed to speak, she may be, like Keats's Belle Dame, unintelligible, or, like Coleridge's Maid of Mount Abora, necessarily forgettable.[38]

It is not surprising, then, that the recent inquiry into the crushing of women's voices in romantic poetry would locate that suppression as one of romanticism's most tenacious and damaging "limits." Nor is it surprising that the exposure of the ways in which male romantic poetry relies upon a landscaped femininity should bring about a hemorrhage of feminists interested in those poems by Blake, Wordsworth, Coleridge, Byron, Shelley, and Keats that describe poetic fecundation as a consequence of female suppression. Interestingly, gay studies, also an emancipatory discipline, has found within the same textual terrain a wealth of materials to work on. This is the result of both the centrality of individualist masculinity to the self-definitions of romantic poetics and its focus on homoeroticism.[39] But critics who take a feminist approach to the period have increasingly turned to more "feminine" genres—the romantic novel—or to recovering "lost" women poets of the period 1789 to 1832.

Both these projects raise new questions about what constitutes the very field of "romanticism" and motivate the question of whether "high" romanticism as we have customarily defined it is reducible to patriarchal ideology. These new chapters in literary history narrate the productive poetic labor of women poets; the male solitary wandering the countryside is being crowded now by an urban social network of readers and writers comprised mostly of women.[40]

From within the relatively circumscribed field of romantic literary criticism, we can see how both the demystifying analysis of the masculine construction of a female subjectivity in romantic poetry and the recovery of forgotten voices relate to more general trends within contemporary literary criticism. On the one hand, we have seen the coming to dominance of one literary method which is almost entirely deterministic: selves understood as ideologically constructed and agency often undermined to the point of nonexistence as a category. Often misdeveloped from the complex (and certainly not congruent) heritages of Althusser and Foucault, this analysis of the social construction of subjectivity can be frighteningly incapacitating, and is perhaps a scary postmodern version of the communitarian vision of social intentionality within identity formation. And it is, of course, very uncertainly related to the excavatory impulse in much new literary history, which bears the impress and exigencies of the activism of feminism and of the method of "history from below."

The work of these two trajectories within literary studies, however, have not been without mutual influence. After the ideology critic has analyzed the apparently ineluctable determinations through which literary subjects are formed, and cultural institutions created, for regulative ends, she may have just enough strength left to listen for and then begin to hear the voices of those who refused to obey the cultural hegemony, and so hear what sound like the more authentic or liberating voices of the period in question. And the critic who has been influenced by the possibilities that arise from the new social movements has a particular interest in analyzing the ways in which those possibilities are retarded or appropriated by the culture at large.

Furthermore, enthusiastic rediscoverers of women's poems from the margins of the early nineteenth century are able, through the force of the "Romantic ideology" argument, to invoke new evaluative criteria, distinct from those associated with the tradition of the aesthetic ideology. They can do so not only because the romantic aesthetic ideology often builds upon the exclusion of the female voice but also because the invention of new criteria suggests a *hopeful* imagining of some agency recoverable beyond the determination so exhaustively taxonomized in much Foucauldian, Lacanian, and Althusserian analysis.

One other happy result of this dialectic between constructivist and activist models of analysis may be a turn to the problem of poetic production as intervention rather than representation. A poem which most insistently does *not* belong to the tradition of the aesthetic ideology, "The Mask of Anarchy" enacts the problems of silence and intervention through the mediating figure of a female Earth who speaks *for* and *as* the silenced and excluded laboring classes. "The Mask of Anarchy" offers itself as a very interesting place to name a tradition, since the very subject matter of the poem is about how best to intervene in the struggle for political reform in Britain. The poem also

engages quite actively in the development of a communitarian "people's" voice discursively built from materials of an insurrectionary rage imaged as female. The poem makes a good limit-case then, not only for romantic canonicity, but for the mutual interdependencies of romantic "exclusions," for the communitarian poetic is linked to a progressive representation of woman while individualism is linked to the romantic repression of the female voice.

Homans theorizes the fabrication of the feminine in the nineteenth century as a discourse of and an anxiety about the *literal*. "For the same reason that women are identified with nature," she writes, "women are also identified with the literal. . . ." Literal meaning, she goes on to argue, "would hypothetically destroy any text it actually entered by making superfluous those very figures. . . ."[41] Within the individualist poetry of aesthetic autonomy, this is a very grave problem indeed, since the translation of the unrepresentable into the figural is a main stimulation for poetic production itself. One might invoke this insight as the source of the not surprisingly female "Maid of Mount Abora," in "Kubla Khan," whose song (luckily for the poetic speaker) *cannot* be recreated. If it could, it would thereby usurp the place of Coleridge's own presumptive poem, which is forecast from within the text as the as-yet deferred product of the poem's invoked male manic poet.

Feminist critics have seen this spirit at work among all the romantic poets; for example, in "Tintern Abbey," Wordsworth "addresses Dorothy in the manner of an address to nature, as if conflating her with nature."[42] And Shelley is not usually exempted from this discussion of the figure of the female: Meena Alexander, in her survey *Women in Romanticism*, sees Shelley as transforming women's otherness into a figment of his own imagination. The feminine as a "purest symbol is intoxicating, fiery and finally in Shelley's vision a catalyst for the longed for self-combustion."[43] And Anne Mellor points out that "for a woman to write in such a language [of figuration], then, is tantamount to the denial of being female."[44]

But when we foreground Shelley's interventionist poetic, a poetic fused not to aesthetic autonomy but to poetic and political collective agency, we see how the usurpation of the figurative by the literal turns into an asset, not a liability. This opens up a space for a construction of the feminine as an articulation rather than a suppression. Imagine now the passionate qualities of the manic poet of "Kubla Khan"—he who stands inside the holy circle and cannot be touched—merged with the singing Maid of Mount Abora. Such a merged agent *would be* the "maniac maid" of "The Mask of Anarchy," who can turn her body into the source of a spirit of active change and invoke the voice of the earth itself. In such a way words *do* "rise up like things," as they did in Coleridge's reverie before he sat down to write "Kubla Khan." Unlike the ill-matched relation between the Maid of Mount Abora and the manic poet within Coleridge's text, the "maniac maid" in "The Mask of Anarchy" is invoked in order to participate in social processes. Nor does Shelley appear anxious that the fulfillment of deferred desire (namely, human liberation) will

lead him out of his poetic reverie and into the diminished literality of the world (the usual charge against romantic poets), for in this case he is attempting to legitimate the literal, which leads him easily to present this through the vehicle of the female.

To literalize figures, then, is a central intention of "The Mask of Anarchy," and I would argue that this rhetorical step bears a necessary relation to the occasion upon which the poem was written. For it is in the very nature of mass demonstrations that symbolic actions are transformed into literal, engaged ones. When a public demonstration (a mass of people symbolically representing by their mass appearance on St. Peter's Fields their demand for political representation) is intruded upon by external authority (the Loyal Manchester Yeomanry), it shifts from having a symbolic meaning to having a literal and potentially insurrectionary meaning. John Berger argues, "Almost invariably, authority chooses to use force. The extent of its violence depends upon many factors, but scarcely ever upon the scale of the physical threat offered by the demonstrators. This threat is essentially symbolic. But by attacking the demonstration authority ensures that the symbolic event becomes an historical one. . . ."[45] This is precisely the structure of the Peterloo massacre. A mass symbolic demonstration in support of political representation was literalized by the actions of the authorities, who swept into the crowd to "Slash, and stab, and maim, and hew" (LXXXIV).

We are authorized to read the "maniac maid" of "The Mask of Anarchy" as a strong riposte to the various maids who people romantic lyric poems. Not only does she speak, but she also acts, reversing the relation between figural and literal in a manner which completes the linkage between the worlds of poetic and social intention. Her passivity, "Expecting with a patient eye,/ Murder, Fraud, and Anarchy" (XXV) is the ground upon which the symbolic life of demonstration, of the masque which inhabits the realms of the representational, is transformed into the world of action and combat. And contrary to the contention that for the male romantic poet the literal is always an inferior mode to the figurative, this poem invokes the literal as its own triumphant conclusion.

Significantly, it is when the maid is freed from her mania and "walking with a quiet mien" (XXXII), a transpersonal, communitarian voice rises from the unspecified spot. Now figuration is reintroduced, but in such a way as to entirely efface the boundary between the representational and the literal: the transpersonal voice arises, "As if their own indignant earth,/ Which gave the sons of England birth,/ had felt their blood upon her brow,/ . . . Had turned every drop of blood. . . . To an accent unwithstood,/ As if her heart had cried aloud. . ." (XXXV, XXXVI). The power to speak here is directly linked to a gendered power: the widespread voices of the people are assimilated to the female voice. The poem invites us to infer the structural analogy between women and all those who are voiceless. Voicelessness, then, shows itself to be

not the condition of a biological marker but a relation between oppressed and oppressive agents.

We should notice as well the extent to which Shelley's plebeian Earth differs from those versions of natural fecundity invoked by Wordsworth as nursemaid and schoolmarm. Wordsworth's Nature is a teacher whose major charge is to spur on the individual to locate his autonomous yet integrated imagination, which will then lead to a love of humankind. Shelley's "indignant earth" in "The Mask of Anarchy" is a voluble peasant, defending her children against the social injustice that is judged to be inextricable from the manage of the soil. Wordsworth's Nature is peculiarly withdrawn from, though catalytic within, human affairs, while the Earth of "The Mask of Anarchy" knows that it is the process by which humans dominate nature that determines the quality of people's lives.

The poetic "I" who gives voice to both "maniac maid" and Earth is himself a very different kind of "I" from the individualist one of "Alastor" or "Tintern Abbey." Shelley makes the point that the "I" is *not* the point of origin for his poem: "As I lay asleep in Italy/ There came a voice from over the sea,/ And with great power it forth led me/ To walk in visions of Poesy" (I). The voice of the mass activity for political change is the source of poetical vision. The process Shelley outlines is dialectical: action gives rise to poetry, and the inspired poem will, in turn, give rise to action of a particular sort; namely, to the literalization of its figures in mass passive resistance. The poem re-symbolizes the event in order to then be drawn into an intervention.

The meanings intended in this "exoteric" poem dovetail immediately with issues of the aesthetic ideology, for if the poems written in the aftermath of Peterloo were meant to "awaken & direct the imagination of reformers," they were meant to subvert the function of a representational aesthetic of the figural, and to enter into the literalization of figures in the minds of reformers. The links between poetry and action are explicit in this intention, an intention utterly different from the one enshrined in the aesthetic ideology, which demands and depends upon the separation of the literal and the figural.

Margaret Homans describes two major aspects of women's exclusion from the romantic tradition: "her association with nature and her exclusion from a traditional identification of the speaking subject as male."[46] When linked to individualism, women are bound to suffer exclusion. "The Mask of Anarchy," however, as it foregrounds communitarianism, calls upon the resources of female figuration to both transform the romantic meaning of that figure and link it to the collective agency of the laboring classes. Agency is here positively linked to literalness, which is traditionally linked to the representation of women. The aesthetic ideology, the aesthetic of figuration, is thus the site of representation and patriarchy. Communitarianism, feminism, intervention, and a poetic of the literal are all interdependent. The ideology of the aesthetic, patriarchy, representation, and individualism are similarly interdependent. Romanticism is the theater of their contest.

Conclusion

The issues I have discussed here are intertwined. First, I have argued that by refusing the inclusion/exclusion model in favor of a unified field model of romanticism, we are in a better position to watch the self-development of romanticism itself, a modality which has reproduced itself in criticism as much as in literary texts. Because this has been a dialectical and dynamic development, in which the competing claims of an individualist and a communitarian theory of identity were decided in favor of individualism, we are usually presented with a history of romanticism which reads the triumph of the individualist ideology backward, and with it the triumph of the ideology of aesthetic autonomy over a poetics of intervention. By formulating the excision of other texts from that tradition as a set of exclusions of difference, we are less able to understand their structural relationships within the claims of (1) communitarianism and (2) the conflict between individualism and communitarianism.

The example of Shelley's agrarianized poem as a limit-case of romanticism points to a third issue: Shelley's imaging of the female is significantly inflected by the communitarian grounds of his poem, suggesting that the suppressive image of the silenced female is closely linked to solipsistic individualism. This, in turn, suggests that the dismissal of "agrarianism" as "reactionary" misses its place within a much larger social and cultural conflict. Radical agrarianism was not simply the dross of an outdated modality of oppositional consciousness, about to be superseded by Painite rationality. Rather, it was a fabric of both traditions and possibilities.

NOTES

1. The best recent survey of what those traditions have been is given by Jon Klancher in his article "Romantic Criticism and the Meanings of the French Revolution," *Studies in Romanticism* 28 (1989): 463–91.

2. Letter from Nicola Watson and Mary Favret to contributors, September 25, 1991.

3. For the orthodox statement of (1) see Arthur J. Lovejoy, "On the Discrimination of Romanticisms," *Essays on the History of Ideas* (Baltimore: Johns Hopkins University Press, 1948), 228–53; rpt. in *English Romantic Poets: Modern Essays in Criticism,* ed. M. H. Abrams (New York: Oxford University Press, 1960), 3–24; René Wellek, "The Concept of Romanticism," in *Concepts of Criticism* (New Haven: Yale University Press, 1963). For examples of discussions of romantic ideology, see Jerome McGann, *The Romantic Ideology* (Chicago: University of Chicago Press, 1980); Marjorie Levinson, *Wordsworth's Great Period Poems* (Cambridge: Cambridge University Press, 1986).

4. See Terry Eagleton, *The Ideology of the Aesthetic* (Oxford: Blackwell, 1990); for its meaning in the specific context of English romantic poetry, see my *England's Ruins: Poetic Purpose and the National Landscape* (Oxford: Blackwell, 1990); Blake, *Complete Writings,* ed. Geoffrey Keynes (Oxford: Oxford University Press, 1972), 621.

5. Proponents of the critique include Alasdair MacIntyre, Michael Sandel, and Charles Taylor. See MacIntyre, *After Virtue* (London: Duckworth, 1981); Sandel, *Liberalism and the Limits of Justice* (Cambridge: Cambridge University Press, 1982); Taylor, *Sources of the Self* (Cambridge: Cambridge University Press, 1990).

6. MacIntyre, *After Virtue*, 32.

7. *The Letters of Percy Bysshe Shelley*, edited by Frederick L. Jones. 2 vols. Oxford at the Clarendon Press, 1964. Volume Two: *Shelley in Italy*, 152.

8. F. R. Leavis, *Revaluation* (London: Chatto & Windus, 1936); rpt. Harmondsworth: Penguin, 1964), 190.

9. Carlos Baker, *Shelley's Major Poetry: The Fabric of a Vision* (Princeton: Princeton University Press, 1948), 159; Earl R. Wasserman, *Shelley: A Critical Reading* (Baltimore: Johns Hopkins University Press, 1971).

10. Marilyn Butler, *Romantics, Rebels & Reactionaries: English Literature and Its Background, 1760–1830* (Oxford: Oxford University Press, 1981), 148; my emphasis.

11. Shelley, *Letters*, II:191.

12. See, for example, Donna Landry, *The Muses of Resistance: Laboring-class Women's Poetry in Britain, 1739–1796* (Cambridge: Cambridge University Press, 1990); Stuart Curran, *Poetic Form and British Romanticism* (Oxford: Oxford University Press, 1986).

13. Richard Hendrix, "The Necessity of Response: How Shelley's Radical Poetry Works," *Keats-Shelley Journal* 27 (1978): 47, 66.

14. Stuart Curran, *Poetic Form and British Romanticism* (Oxford: Oxford University Press, 1986), 161.

15. Shelley, *The Mask of Anarchy*, ed. Donald H. Reiman (New York: Garland, 1985). All further references to the poem will be from this edition and given in the text by stanza number; William Wordsworth, *The Prelude*, ed. Ernest de Selincourt (Oxford: Oxford University Press, 1926), II:278.

16. Cited in Paul Foot, *Red Shelley* (London: Bookmarks, 1984), 241; my emphasis.

17. Cited in Brian Maidment, *The Poorhouse Fugitives: Self-taught Poets and Poetry in Victorian Britain* (Manchester: Carcanet Press, 1987), 305.

18. Nicola Watson and Mary Favret, letter to contributors, September 25, 1992.

19. P. M. S. Dawson, *The Unacknowledged Legislator: Shelley and Politics* (Oxford: Oxford University Press, 1980), 40.

20. See Trygve R. Tholfsen, *Working Class Radicalism in Mid-Victorian England* (London: Croom Helm, 1976).

21. Malcolm Chase, *"The People's Farm": English Radical Agrarianism, 1775–1840* (Oxford: Clarendon Press, 1988), 3, 15.

22. I am grateful to Dr. David Worrell of Twickenham College, Strawberry Hill, for first introducing me to the importance of Spence and his followers.

23. See William St. Clair, *The Godwins and the Shelleys: The Biography of a Family* (London: Faber and Faber, 1989), 394; McCalman, *Radical Underworld: Prophets, Revolutionaries and Pornographers in London, 1795–1840* (Cambridge: Cambridge University Press, 1988), chapter 4, "Cannon and Rationalist Philosophy."

24. McCalman, *Radical Underworld*, 92.

25. Marilyn Butler argues that Shelley's best poetry avoids the simplifications of "The Mask of Anarchy" and "holds in striking dual perspective the natural cosmos, fluid, destructive, impassive, and the fragile, delicate bloom of individual consciousness" (148). I would argue that much of the most interesting poetry of the period holds in dual perspective the competing claims of individual and community.

26. See Chase, *"The People's Farm,"* 188.

27. Eleanor Marx Aveling and Edward Aveling, *Shelley's Socialism* (West Nyack: Journeyman Press, 1975); Paul Foot, *Red Shelley*.

28. Donald H. Reiman, "Shelley as Agrarian Reactionary," *The Keats-Shelley Memorial Association Bulletin* 30 (1979): 9.

29. Reiman, "Shelley as Agrarian Reactionary," 12.

30. McCalman, *Radical Underworld,* 101.

31. E. P. Thompson, *The Making of the English Working Class* (Harmondsworth: Penguin, 1968), 178.

32. Chase, *"The People's Farm,"* 57.

33. M. D. George, *Catalogue of Political and Personal Satires* (London: British Museum, 1949), IX:13258.

34. Iain McCalman, "Females, Feminism and Free Love in an Early Nineteenth Century Radical Movement," *Labour History* 38 (1980): 10.

35. Shelley, *Letters,* II:136.

36. The most compelling theoretical modeling of the individualism/communitarian debate with respect to nineteenth-century women is Ruth L. Smith and Deborah M. Valenze, "Mutuality and Marginality: Liberal Moral Theory and Working-Class Women in Nineteenth-Century England," *Signs* 13 (1988): 277–98.

37. Margaret Homans's two volumes on nineteenth-century literature were the pioneering discussions of the silenced romantic woman. See Margaret Homans, *Women Writers and Poetic Identity* (Princeton: Princeton University Press, 1980), and *Bearing the Word: Language and Female Experience in Nineteenth-Century Women's Writing* (Chicago: University of Chicago Press, 1986). Both Homans and Susan Wolfson have done considerable work on the problems faced by Dorothy Wordsworth. For a fascinating response to Homans, see Wolfson's "Dorothy Wordsworth in Conversation with William," in *Feminism and Romanticism,* ed. Anne K. Mellor (Bloomington: Indiana University Press, 1988), 139–65.

38. See Karen Swann, "Harassing the Muse," in *Feminism and Romanticism,* 81–92.

39. The issue of the masculinity in romanticism has been interestingly explored by Alan Richardson, "Romanticism and the Colonization of the Feminine," in *Feminism and Romanticism,* 13–24. Louis Crompton's *Byron and Greek Love: Homophobia in 19th Century England* (London: Faber, 1985) is a crucial intervention in gay studies/romantic studies.

40. For a wide-ranging survey of such poets, see Stuart Curran's "The Altered Eye," *Feminism and Romanticism,* 185–207.

41. Homans, *Women Poets and Poetic Identity,* 4.

42. Homans, *Women Poets and Poetic Identity,* 26.

43. Meena Alexander, *Women in Romanticism: Mary Wollstonecraft, Dorothy Wordsworth, and Mary Shelley* (London: Macmillan, 1989), 34.

44. Anne Mellor, "On Romanticism and Feminism," *Feminism and Romanticism,* 6.

45. John Berger, "The Nature of Mass Demonstrations," *Selected Essays and Articles: The Look of Things* (London: Penguin, 1972), 249.

46. Homans, *Women Writers and Poetic Identity,* 3.

5

The Uneducated Imagination

Romantic Representations of Labor

KURT HEINZELMAN

We are, in a great degree, what our institutions make us.
—Robert Southey[1]

Completed in 1831, near what we usually take to be the chronological limit of the romantic age, Robert Southey's *Lives of Uneducated Poets* hearkens back to an abiding concern of the romantic writer since George Crabbe's *The Village* in 1783 and Wordsworth and Coleridge's *Lyrical Ballads* of 1798: how to represent the lives and voices of working-class people. "Uneducated" is the late romantic code word Southey uses to designate that very group, ranging from John Taylor, the bargeman and contemporary of Ben Jonson, to John Jones, an "Old Servant" who had petitioned Southey's help in securing a subscription for the publication of his own poems. Southey's 170-page *Uneducated Poets* was originally published as a preface to Jones's collected poetical works, but it also serves as a kind of valedictory address to the very history it introduces: "Mr. Jones would in all likelihood be the last versifyer of his class."[2] This apparently optimistic assertion requires careful reconstruction of its rhetorical context, for the Poet Laureate was not prophesying, like a Marxist *avant la lettre*, an end to class struggle. On the contrary, he was imagining just such a struggle, possibly for the first time, and offering to ameliorate it by way of newly historicizing the imagination so as to include writers previously occluded by or invisible to both social and literary historians.

Southey defines Jones's "predecessors, the poets in low life," as precisely a class—that is, as writers with a common history (even if they actually lived 200 years apart). Their commonality depends not just upon their social origins

but also on the artisanal quality of their writing, which is as much a function of how they write—that is, how they actually compose their works, and for whom—as it is a function of what they write about. "Artisanal" is not always or even usually a literary compliment at this time (witness Hazlitt's critique of the Reverend Crabbe or Byron's scathing reference to Southey himself as a cobbler and tinker),[3] and yet Southey's essay is the first serious and sympathetic critical assessment of poetry written by men and women (he includes both) from this socioeconomic stratum. Underlying Southey's essay is his personal fear that this commonality of laborer-poets might augur a political solidarity of laborers as such. Nevertheless, the essay offers an alternative or supplemental, though not quite oppositional, narrative of literary achievement, one that fosters the emerging nineteenth-century belief in English literature as a distinctive body of work, a material practice with its own tradition and canon.

Southey himself thought he was "contributing something towards our literary history" (*LUP*, 12). I take it that Southey's "our" has a genuinely collective antecedent (although not necessarily, as I will show, a pluralistic intent), and I take it that the "history" he has in mind would promise a variegated perspective embracing writers of both educated and uneducated imaginations alike (if not embracing them equally). Whatever the collaborative intent of his rhetoric, however, the exact sense of Southey's "our," reaching out as it does toward those of us who are still later contributors to that same historicizing process, is difficult to position. We know, for instance, that Southey's own attempt at literary history in *Lives of Uneducated Poets* was in his own time mildly received and is in our time virtually forgotten. We also know that the most immediate beneficiaries of Southey's new faith in the valorizing power of history-writing as sustained through literary criticism and biography would turn out to be the canonical writers we now call romantics, whose work in their own time "dominated neither the cultures of the aristocracy, nor those of the middle classes and even less of the laboring poor."[4] This subsequent history tends to keep Southey's collective "our" ironic and to leave us skeptical of his intent. It is, then, the burden of that constitutive "our" which is my subject here. The full weight of that burden is misunderstood, however, and its belated, poignant irony lost, if we do not see how Southey's *Uneducated Poets* is virtually the last attempt by a romantic writer, marginally canonical himself, to assert the importance of the laborer's voice in his own social and aesthetic program.

Later, I will turn directly to Southey's text. It is necessary, first, to survey the discursive modes by which "labor" and "laborer" were able to be represented at all, for Southey had to alter the conditions of this representability if he wished to teach the public how to read the cultural possibilities of the uneducated imagination.

Uneducated Poets attempts to inscribe a place for the laborer within the culture of belles-lettres. To do so, I will argue, is to enact the specifically

georgic plot within romantic historiography and thus behind the making of "our" literary history. Such a plot finds in poetry-writing a culturally safe haven for the laborer's sense of social aspiration and personal aggrandizement. But it also allows the poet to abstract and thereby appropriate to himself the work of cultivation.

A recurring dilemma of georgic writing in the Georgian age was located in the social complexities of that rhetorical arc: who is speaking to whom, and for whom? By the end of the Georgian period, historical commentators and social theorists were coming to understand, perhaps for the first time, how these aesthetic or rhetorical issues entailed political implications. Southey and many of his contemporaries, including virtually all of the canonical romantics, understood not only that a new "manufacturing system," as they called it, was unalterably at work but also that a newly fashionable discourse, which Southey himself called "statistic economy," was dominating the way in which social institutions were defined and represented.[5] In this newly codified rhetoric of economics, the actual lives of laborers were of less importance than the fungible product they generated—their own sweat and toil. Workers were being reduced to mere "operatives," as Coleridge sarcastically put it, and yet at the same time the very success of capitalist production was enticing them to believe that they owned their own labor, that labor was theirs to sell.[6] For a later thinker like Karl Marx, of course, this misguided way of representing one's productivity as a product was precisely the apparitional effect of classical political economy. Marx, writing in private and with little hope of publication almost exactly at the time that Wordsworth was succeeding Southey as Poet Laureate (1843), attempted to disclose the dispossessed status of the laborer and to interpret critically how the text of economics inscribes "work" as the alienated concept of "labor."

One recurring aim of Marx's 1844 manuscripts is to wrest "labor" from the dominant text of political economy. Marx's primary strategy (insofar as these manuscripts have a sufficiently sustained method to warrant being called a strategy) is to refigure labor—to bestow upon it a new biography—within the "human" configuration of social life, just as Southey was trying in his *Lives* to effect by means of biography a transformation of laborers into cultural agents. Marx's starting premise is that "the individual *is the social being*."[7] What Marx is trying to break down—to transcend or annul—is the "*external, mindless, objectivity*" of wealth" (128) that creates a spurious literalism in how we connect desire and the object, wanting and having, imagination and value. "Private property," Marx says, "has made us so stupid and one-sided that an object is only *ours* when we have it—when it exists for us as capital, or when it is directly possessed, eaten, drunk, worn, inhabited, etc.,—in short, when it is *used* by us" (139). This imaginative one-dimensionality is maintained within the text of political economy thanks to the apparently commonsensical notion that property is the principal embodiment of

value and thus the necessary condition for what he deprecates as modern (i.e., private) selfhood, which relies upon "*immediate, one-sided gratification*—merely in the sense of *possessing,* of *having,*" rather than in any sense of social being (138).

The British romantics had access, of course, to the same classical texts of political economy that Marx was trying to rewrite. (Many of these were written in their own native English.) Being poets and not economists, however, they were trying to renegotiate not political economy per se but the texts which they perceived to underlie their own discipline, the texts from which they derived their own educational mastery. The most important of these is Virgil's *Georgics,* for just the reasons Southey gives in his *Quarterly Review* article of March 1834, where his subject is the manufacturing system itself:

> It carries in itself the sure cause of its own terrible destruction. That physical force which it has brought together as an instrument of lucration—a part of the machinery—will one day explode under high pressure; and the words of the poet will then have a new and appalling interpretation—
> *Labor omnia vincit*
> *Improbus, et duris urgens in rebus egestas.*[8]

Throughout the eighteenth century, two passages from Virgil's *Georgics* were often quoted out of context and used as tags or mottoes: the first, a passage in which the poet speaks of the happiness to be discovered in seeking out "the causes of things"; the second, the lines quoted above, which speak of how labor, unrelenting toil, subdues or masters all, and of the pinching necessities of a hard life.[9] Southey, I believe, has both references in mind in this learned quotation of "the words of the poet," a poet no educated reader of Southey's social class needed to have named. What Southey here "seeks out" is a new cause of things that produces only fear—specifically, a fear that labor unrest would act as a "physical force," like the "high pressure" storms in the first book of Virgil's four-book *Georgics,* and unhinge the tectonic structures of both nature and culture.

Southey's quotation from Virgil's learned text is symptomatic of what the educated reader must dread from the success of capitalism. A culturally monumental text would be turned upside down, subjected to "a new and appalling interpretation" by the uneducated but dangerously understandable actions of the labor force. In this appalling interpretation, Virgil's *labor* would be no longer a kind of metonymy for the work of men's hands nor, by extension, a complex metaphorical representation of the competing claims of self-mastery, societal well-being, gratification, and the love of possession:

> even so, if we may compare small things with great, an inborn love of gain spurs on the Attic bees, each after its own office. The aged have charge of the towns, the building of the hives, the fashioning of the cunningly wrought houses. But the young betake them home in weariness, late at night, their thighs freighted

with thyme. . . . All have one season to rest from labor, all one season to toil.
(*Georgics* IV:176–81, 184; Loeb translation)

Virgil is here speaking honorifically of bees, but his apiarian discourse also foreshadows Marx's derisive description of man's one-dimensionality under the conditions of capitalism. Labor is here divided among worker-bees according to their ages and abilities. Whereas each worker is motivated by the same innate love of private possession *(innatus amor habendi)*, all labor together as a single institution and all find a common, collective rest from labor. The potential libidinal energies implied by that "love" *(amor)* are sublimated into the successful communal activity of making (or literally "generating") honey. As is often the case in Virgil's text, *labor* is a metaphorical passion that annuls the "love of having," the self-interest out of which it originates, and thus attains a larger social function, almost as if it had been translated into a form of patriotic service.[10] *Labor* results in cultural improvement even as individualistic, self-serving *amor* is tamed—eighteenth-century theorists of the passions and the interests would say "softened" or "feminized"—into civilized manners.[11] This is the master-text that Southey fears will be reinterpreted.

Labor, updated, will become a personification, a class: it will represent *laborers* acting collectively together against this metonymic sense of labor as national productivity. *Improbus* in Southey's Latin tag will be pared of any honorific sense—that is, the sense of difficulty which fascinates and is even pleasurable to confront. It will no longer speak of honorable persistence and relentless piety but instead will suggest only a lack of probity, the absence of rectitude: evil. *Urgens* will no longer have its expansive Protestant sense of sublimating spiritual enlightenment from good works but will acquire the unleashed sexual energy it possesses in, say, a usage like Walt Whitman's "procreative urge." *Urgens* promulgates the French disease—jacobin upheaval and orgies of political violence—not to mention Malthusian catastrophe. Devising his argument by means of classical quotation, keeping the terms of discussion beyond the reach of "uneducated" laborers, Southey reveals that the appalling new interpretation of *labor* would equate it simply and wholly with uncontrollable power.

We need to look more closely, however, at Southey's master-text, Virgil's *Georgics,* because the reasons for that work's popularity in England throughout the early Georgian period tended to obscure some of the social and cultural contradictions in Virgil's text, contradictions which later georgic-like productions, such as Southey's *Uneducated Poets,* perpetuated.

To start with, Virgil's *Georgics* never imagines a crossing of class barriers. At least that is one reason why slave-laborers, for instance, are not represented in his poem or in his vision of Roman society. Virgil uses as his principal representative of the laborer the figure of the farmer, who is variously called

colonus, arator, and *agricola,* three words that connote a wide spectrum of cultural values and social attitudes ranging from the derogatory to the patronizing to the nearly heroic. Virgil's poem, however, is not spoken in the voice of any one of these "farmers" and is not even addressed to them; rather, it is told by another speaker altogether, a poet, who exclusively addresses first his patron Maecenus (who is, in eighteenth-century terms, a gentleman-farmer) and then Octavian ("whom he complements with Divinity," as Dryden put it in the "Argument" to Book I of his well-known translation [1697]).[12] There is, in short, a rhetorical distance maintained by the different (social) positions of speaker, audience, and the agent of labor.[13] Although the society Virgil apparently envisions is collective and collaborative, it is not pluralistic: all labors are not equally valued. Whatever personal virtues a farmer may metaphorically glean from the literally hard work of husbandry, he is still a rustic, without any taste for the cultural achievement and with little understanding of the mythopoesis that Virgil's very poem represents. And if cultivation of the fields underlies acculturation of the society, then both still rely upon the adventurous militarism of Caesar that is celebrated in nearly millenarian tones at the end of Book IV.

Some sense of how Virgil's class divisions were understood in the eighteenth century can be witnessed in Joseph Trapp's praise of Virgil over Hesiod. Writing in Latin in 1742 and addressing specifically "the Schools of Natural Philosophy at Oxford," Trapp explains how Virgil transcended his ancient Greek model:

> The good old Man of *Ascraea* [Hesiod] is at best but a downright Yeoman, where *Virgil* appears with the Learning of a Scholar, and the Elegance of a Gentleman.[14]

As a commentary on a text which sometimes celebrates menial labor, Trapp's terms inappropriately align Virgil with the "elegance" of a higher social class. And yet the snobbism by which Trapp identifies Virgil as "our" kind of writer, part of the academic institution of "us," is not inconsistent with a tone sometimes found in Virgil's own poem, one eliding the social differences between patron and poet.

On other occasions in its reception history the Virgilian georgic has been transmitted by collapsing the rhetorical distance between the farmer (i.e., the laborer) and the poet, representing them as politically analogous and culturally allied, thus further obscuring the differential of class. Wordsworth's poetic program circa 1800, with its claim for "real language" as the constitutive bond between the rustic/farmer and the socially conscientious poet, may have been aided and abetted by Dryden's Englishing of a tonally critical passage in Virgil's Latin text. Early in *Georgics I,* Virgil petitions Caesar in his heavenly-aspect-to-come *(quidquid eris)* to "grant a propitious course and assent to bold undertakings and pitying, with me, the farmers who are ignorant of

the way, come forward and accustom yourself even now to be addressed as a god":

> da facilem cursum, atque audacibus adnue coeptis,
> ignarosque viae mecum miseratus agrestis
> ingredere et vobis iam nunc adsuesce vocari. (I:40–42)[15]

The syntactical problem here is whether *mecum* modifies the participial clause that follows it or the one that precedes it. If the former, as virtually all modern commentators believe, then the line has the tonal effect of distancing the poet from the rustics by means of his pity for them: "pitying as I do the farmers who are ignorant of the way." If *mecum* modifies the preceding clause, however, as Servius said it could, then the speaker is effectively put in the same pitifully ignorant boat as the farmers: "pitying the farmers who are ignorant of the way, as I am."[16] We can see how socially important tone is here, for the syntax will indicate whether the speaker primarily aligns himself with the party addressed (Octavian) or with the party referred to (the ignorant rustics), and upon that alignment depends the moral quality of his representation of agricultural interests to Caesar. Dryden, however, did more than simply follow Servius's reading: he closed off any possibility of ambiguity by affirming through repetition of the institutional word "our" the vital link between farmer and writer:

> But thou, propitious *Caesar*, guide my Course,
> And to my bold Endeavours add thy Force.
> Pity the Poet's and the Ploughman's Cares,
> Int'rest thy Greatness in our mean Affairs,
> And use thy self betimes to hear and grant our Pray'rs. (I:59–63)

By grafting poet and plowman together under the rubric of "Cares," Dryden also takes us back to the very subject of the poem itself—"The Care of Sheep, of Oxen, and of Kine" (I:3)—here implicitly putting the whole under the custodial care of the "great" statesman's overarching pity.

Wordsworth had nearly defined this dilemma of the poet's rhetorical position vis-à-vis laborers—defined it, that is, as a *georgic* dilemma—in a passage composed at about the same time as the 1800 preface to the *Lyrical Ballads* and incorporated in the manuscript poem we now call *Home at Grasmere*. There, Wordsworth wonders if "an art, a music, and a stream of words" could be fashioned which would speak more "truly" about labor and the laborer than do the idyllic forms of pastoral. Although Wordsworth went on for many years hence to write poems which he himself called "pastoral," he identifies here in 1800 an idea of poetry which is "more" than "the idle breath of sweetest pipe attuned to pastoral fancies," a more-than-pastoral "That shall be life, the acknowledged voice of life, / Shall speak of what is done among the fields, / Done truly there. . . ."[17] Wordsworth himself has no name

in 1800 for this literary idea except the language of supplement—the *more-than-pastoral*—and perhaps it is that uncritical supplementarity which makes Wordsworth's ideal seem, in retrospect, less like a term of difference *from* pastoral and more like an uncomfortable idealization *of* pastoral.

I would suggest, however, that we identify Wordsworth's "more-than-pastoral" by the traditional term "georgic." Georgic is the one literary genre traditionally understood as representing rural labor—the work, as Wordsworth says, that "is done among the fields, / Done truly there." But this aesthetic issue of how to portray labor is increasingly complicated through the first three decades of the nineteenth century by the question of how to represent oneself as a writer who is not a laborer *to* laborers (who, most likely, are not even able to read). The still greater problem is the one explicit in Wordsworth's phrase "the acknowledged voice." The question is not just how to enable laborers to speak in their own voices, which is a problem in aesthetic representation, but how the laborer's voice is to be heard—how, when it *does* speak, is it to be *acknowledged*? This becomes a problem in political representation.

Wordsworth's georgic vision often underscored the mutuality of the husbandman's and the poet's affairs.[18] Dryden's literal translation of Virgil's *vobis vocari* as "our Pray'rs" finesses, however, the more pressing dilemma behind Wordsworth's quest for what he called in 1800 "the acknowledged voice" of labor. Over thirty years later, after passage of the Reform Bill, Wordsworth was still trying to "do" the voice of the laborer, and with disastrous results, owing I think to Wordsworth's failure to acknowledge how the widening differences between aesthetic and political representations had made the very concept of "voice" in the 1830s irreconcilable with turn-of-the-century sociopoetics.[19]

Wordsworth's lyric "The Labourer's Noon-Day Hymn," composed in the mid-thirties, makes painful reading, although it is a more understandable (if still unsuccessful) piece of work when read in its historical context.[20] The laborer who speaks this poem is a kind of pilgrim in a spiritual allegory of redemption through service and good works, more closely related to Adam and Eve in their morning orisons in *Paradise Lost* (Book V) than to members of the third estate for whom William Cobbett said *he* wrote. This laborer's noonday idleness is more nearly tied to the scholastic idea of *acedia,* which is traditionally linked to creativity, than to any sense of actual fatigue that follows hard labor. More precisely, the laborer's "hymn" is Virgil's *vocari* (prayers spoken, in Virgil's fiction, by both knowing poet and ignorant farmer) but here further mediated by a John Bunyan-like sense of a spiritual vocation (a word that derives, of course, from this same *vocari*) that progresses along an ascending sine-curve of work/rest, struggle/praise, dejection/delight. What I mean is that the fictional voice of Wordsworth's poem does not represent a speaking person so much as it embodies ideas about labor. The Virgilian allusions, being available to learned readers only, place "labor" in one literary

tradition, whereas the *Pilgrim's Progress* subtext, drawing on "one of the two foundation texts of the English working-class movement,"[21] supplies a class orientation for the hymn's classical structures. It looks very much as if Wordsworth is trying, as Dryden's translation of Virgil tries, to bind the poet's and the day-laborer's cares into one sheaf of georgic pity for *labor improbus*.

Whatever Wordsworth's intent in composing his "Noon-Day Hymn," he was partially satisfied a decade later (in 1843) when he described to Isabel Fenwick how the poem had served as an instrument of education:

> Often one has occasion to observe Cottage children carrying, in their baskets, dinner to their Fathers engaged in their daily labors in the fields and woods. How gratifying would it be to me could I be assured that any portion of these stanzas had been sung by such a domestic concert under such circumstances. A friend of mine has told me that she introduced this Hymn into a Village-school which she superintended, and the stanzas in succession furnished her with texts to comment upon in a way which without difficulty was made intelligible to the children, and in which they obviously took delight, and they were taught to sing it to the tune of the old 100th Psalm.[22]

Wordsworth here derives pleasure from his poetic text by observing how easily ("without difficulty") the writing had been enfolded first into history (through the biblical song of praise) and then into voice (the Protestant practice of "pointing," using psalmic singing to generate "texts to comment upon"). His 1831 anthology of poems compiled especially for the use of children served the same purpose (although he debated with himself for many years about the advisability of such anthologies, repeatedly rejecting Alan Cunningham's overtures circa 1825–1829 to arrange a Wordsworthian edition for the working classes). This homiletic and celebrative use of his fictional speaker's discourse by real children seemed to confirm Wordsworth's long-standing sociopoetic faith that the imagination, if carefully executed, is capable of becoming real—a source of delight and instruction—for others who are not at all "like" the author.

What is enacted in Wordsworth's recollection of his poem's reception might be named an allegory of superintendence, a word that I adapt from Wordsworth's own oral history of the poem's transmission where it means, essentially, the work of teaching. John Wesley had designated his bishops in the United States as superintendents, but by Wordsworth's later years, in early Victorian England, the word was losing its primary ecclesiastical sense and coming to have a wholly secular and more pervasive use in defining the kind of managerial roles required by the newly bureaucraticized organizations of business, industry, and education. Three acts of superintendence—in this latter sense of labor-management, which replaces the idea of pastoral guidance— occur in the inception and reception of Wordsworth's poem. First, by speaking collectively, on behalf of all who labor (including most immediately, one supposes, his fellow field-hands), Wordsworth's laborer-speaker superintends the

celebrative purpose of his song in a way that partakes of both the older and newer sense of superintendence: "Then here reposing let *us* raise / A song of gratitude and praise" ("Noon-Day Hymn," 11. 7–8; emphasis mine). Second, insofar as this "us" is expansively collective—encompassing the laborer's own lay-creator, the poet, as well—one might also say that the uneducated laborer's rhetorical mission is superintended by the educated romantic poet. Finally, the education of the children, represented in their use of the poem, is under the superintendence of Wordsworth's friend, the teacher, who supplements Wordsworth's poetic fiction with the corroborative music of the psalm. Superintended by this biblical and didactic authority, the poem's writing of a fictional "voice" becomes actually voiced by the village children. By means of this threefold process of repeated superintendence and mediated educational mastery, the text is "made intelligible to the children" and their response to the text is made culturally useful. We might say that for Wordsworth the whole experience of writing, reading, and textual transmission—of representation, expression, and communication—becomes in this way institutionalized.[23]

But Wordsworth is not entirely satisfied with this process, as he makes clear in the exclamation that immediately precedes the story of the village school: "How gratifying would it be to me could I be assured. . . ." What Wordsworth wants to be "assured" of, apparently, is that his poem, like the dinner that the cottage children carry to their fathers in the field, might become an *actual* part of the work-process—that it might be sung *by the laborers themselves* even as their dinner is consumed by them. "Gratitude," of course, is precisely the subject of Wordsworth's "Hymn," and gratification is here what the poet seeks for himself in the assurance that the "voice" he has created could be wrested from the practice of artistic representation and thus become the laborer's own—in short, transforming Wordsworth's poetical fiction into a real work-song. What Wordsworth's exclamation reveals, therefore, is Wordsworth's need to have his *own* voice acknowledged as one that might bestow the very respite it bespeaks:

> What though our burden be not light
> We need not toil from morn to night;
> The respite of the mid-day hour
> Is in the thankful Creature's power. ("Hymn," ll. 9–12)

Perhaps a poet living on a combination of inheritance, royalties, and a civil-service sinecure "need not toil from morn to night," but it is uncertain how far the arc of antecedence for that "we" can travel.

If the political implications of this moving arc were finessed in Virgil's learned master-text, and continued to be finessed in early Georgian understanding of that text, the attempt to address them in the later Georgian (i.e., romantic) age was understood to depend upon new approaches to education and learning and upon substantially new definitions of what was taught, by

whom, and to whom.[24] Finally, the problem was not Virgilian but modern, not a matter of antiquarian scholarship but a measure of present polity, embracing pedagogical, governmental, and economic practices. This holistic comprehension of how the idea of "representation" crossed the entire curriculum of interests, from rhetoric and poetics to political economy and natural history, was a defining moment for what we now call romanticism.

Southey's *Uneducated Poets* bases its call for expanded national education upon its testimony to how much even a little learning can produce. It is a tonally complex work because its avowed double-purpose is (1) to explain the power of working-class writers to a middle-class public "who will not feel the touches of nature" in their writings but who "*will* feel the rudeness and the faults" (*LC*, 103), while at the same time (2) to keep that power firmly in perspective: "touches of nature," after all, are not the smooth finish of the educated imagination. Written in the wake of the large Whig victory of 1830 and just in advance of the most heated Parliamentary debate over the Reform Bill of 1832, Southey's *Uneducated Poets* uses literary criticism as a way of reencoding the political issue of how to acknowledge the laborer's voice. The purpose of this series of biographical studies in the guise of a new literary history is not, however, literary appreciation alone. Indeed, Southey is trying to save the uneducated imagination from what he calls "the epidemic disease of criticism" (*LUP*, 13).[25]

Southey borrows the format of Dr. Johnson's *Lives of the* [Educated / Canonical] *Poets:* he uses authorial biography to introduce the poetical works and then illustrates them by means of generous, in the sense of ample, quotation from the individual poet. Unlike Dr. Johnson, however, Southey is generous in the other sense also; he is loath to criticize directly the poetical texts he quotes, for that, he implies, is what the gentle reader is already too inclined to do. Instead, Southey wants to find room in his "long introduction, [which is,] in fact, a chapter, of the history of English poetry" (*LC*, 103), for "affording some gratification" to readers "who, having escaped the epidemic disease of criticism, are willing to be pleased, and grateful to those from whose writings they derive amusement or instruction" (*LUP*, 12–13). Whatever the aesthetic value of this perspective, it is possible that Southey is also arguing for a social virtue—specifically, for a *polis* of fair, openminded, tolerant citizens; for a kinder, gentler nation.

Because this audience would still be socially apart from the writers whom Southey studies, his literary history has to manage a delicate act of brinksmanship. As Southey goes on to show, "we" live in a world of (social) difference. The division of language along social lines, producing discrete languages "of high and low life," is a relatively recent historical phenomenon, which Southey dates from the Elizabethan period when "the mother tongue of the lower classes ceased to be the language of composition; that of the peasantry was antiquated, that of the inferior citizens had become vulgar" (*LUP*, 13). What

happens at the level of language replicates the improvement of intellect and manners, and both of these necessitate a new kind of literature: as "the minds of the great grew . . . more expansive and more reflecting, . . . something more was required than the minstrels afforded in their lays, whether of ribaldry or romance" (*LUP*, 14). What Southey is sketching here is a familiar genre, a georgic narrative of cultural progress, but one used for an unfamiliar end— not to graph mythic shifts between golden-age and iron-age dispositions but to explain the differentiation between high and popular cultures.

Southey's view of a historical fissure within a culture, which significantly distances the language of the uneducated classes and their artistic productions from the mainstream voices that possess the power to acknowledge and so to legitimize cultural works, is an orthodox depiction (in the romantic period) of the effects of the Reformation in Britain. Coleridge deduced this same historical crux in his earlier discussion in *Biographia Literaria* of linguistic change and variation; however, Coleridge posits a narrative of the transmission of cultural values that is at odds with Southey's. It is also at odds of course with the narrative enunciated by Wordsworth, Coleridge's nominal antagonist. The *Biographia Literaria* maintains, *contra* Wordsworth's view of the connection between colloquial language and creativity in the 1800 preface to *Lyrical Ballads,* that the language of the lower classes could never be adequate to the demands of the literary imagination. Coleridge's famous pronouncement about the connection between language skills and the life of the mind makes social difference testify to the presence or absence of imagination itself:

> The best part of human language, properly so called, is derived from reflection on the acts of the mind itself. It is formed by a voluntary appropriation of fixed symbols to internal acts, to processes and results of imagination, the greater part of which have no place in the consciousness of uneducated man; though in civilized society, by imitation and passive remembrance of what they hear from their religious instructors and other superiors, the most uneducated share in the harvest which they neither sowed or reaped. If the history of the phrases in hourly currency among our peasants were traced, a person not previously aware of the fact would be surprized at finding so large a number, which three or four centuries ago were the exclusive property of the universities and the schools; and at the commencement of the Reformation had been transferred from the school to the pulpit, and thus gradually passed into common life.[26]

Coleridge is here refuting Wordsworth's claim that rustic language either constitutes "the real language of men" or is capable of greater imaginative truth than learned (or any other) discourse, while at the same time he is asserting hierarchical kinds of knowledge—imitative versus constitutive, passive versus acquisitive—and projecting an implicit goal for education. Modern scholars universally judge Coleridge's argument the victor over Wordsworth's, at least on sociolinguistic grounds, especially when Coleridge goes on to point

out that there is no one "uneducated" language but that "the language so highly extolled by Mr. Wordsworth varies in every county, nay in every village, according to the accidental character of the clergyman, the existence or non-existence of schools," and so on (*BL,* II:56). One must notice, however, that Coleridge is also implying that there is considerably less variety after the Reformation, especially where the trickle-down effects have been accelerated by school and pulpit. The basis for this trickle-down theory is, to alter a well-known Coleridgean axiom, that we receive what only a few give. The uneducated man can be responsive to certain cultural stimuli, but the burden of and responsibility for creating those stimuli fall upon those who possess the language of cultural ownership. That so much has already been passed down, which Coleridge emphasizes by saying how "surprized" an unsuspecting observer would be, indicates that Coleridge's whole argument is composed under the sign of a progress myth, based upon an already decided vision of what constitutes a "civilized society" and of how that civilization is made manifest, how culture is cultivated.

Culture for Coleridge is a "harvest" in which the uneducated "share" although they neither reap nor sow it themselves. Considering that Coleridge's "uneducated man" is clearly in this context a rural laborer and that agricultural laborers made up the largest segment of the work force until well into the nineteenth century, this notion of cultural sharing as a harvest depends upon a strange displacement. Whereas Coleridge may be refuting Wordsworth's dulcet "pastoral" notion that the poet can modify or adapt the language of rustics to his middle-class aesthetic agenda, Coleridge, like Adam Smith before him, writes the laborer out of the cultural formula altogether.[27] That is, Coleridge's biblical metaphor silently draws its full social significance from the textuality it does not acknowledge—the georgic crossing of cultural achievement with agricultural improvement. Or rather, Coleridge's language retains a residual georgic entailment (in the use of the word "harvest") but the beatific overlay of the lilies of the field strips the georgic concept of labor of *any* meaning and, in effect, buries the laborers themselves beneath the (now) biblically idealized concept of the imagination. The allusiveness of Coleridge's own metaphor demonstrates his point about imaginative mastery. It is impossible to read the "harvest" as literal in any way, for either the harvest is devoid of reaping and sowing or these "labors" are accomplished by wholly symbolic workers, men sensitive "to the processes and results of imagination." In short, Coleridge's one word—"harvest"—epitomizes his entire argument. Like "the best part of human language," this "harvest" is a consummate reflection on and of "the acts of the mind itself." There are no laborers, really, who need to be politically assuaged: they've gone to flowers every one.

We are not witnessing here just a rhetorical sleight of hand but a logical displacement as well. Coleridge's implicit progress-myth depends upon the conjunction of three agents, whereas his text appears to rely on only two. The antonym of the uneducated man, for instance, is not one who is educated but

one who is well-educated. Take Coleridge's concluding statement about what is anterior to culture and read it antithetically to determine what is posterior to culture: "Anterior to cultivation the lingua communis of every country, as Dante has well observed, exists every where in parts, and no where as a whole" (*BL*, II:56). Like television in the late twentieth century, then, "cultivation" here has the effect of effacing regional linguistic peculiarities and generating some sort of standard pronunciation and even common vocabulary. Such "cultivation," however, is not Coleridge's *final* desideratum any more than his "harvest" was a melding of economic practice with social activism. Anterior to this picture of a precultural world is Coleridge's depiction of a culturally exemplary man in the figure of Algernon Sidney, the seventeenth-century political activist and man of conscience who was fraudulently condemned and executed for treason. Sidney's language-use is part of Coleridge's extended comparison with Wordsworth:

> The language of Algernon Sidney differs not at all from that, which every well educated gentleman would wish to write, and (with due allowances for the undeliberateness, and less connected train, of thinking natural and proper to conversation) such as he would wish to talk. Neither one or the other differ half as much from the general language of cultivated society, as the language of Mr. Wordsworth's homeliest composition differs from that of a common peasant. (*BL*, II:55–56)

What is natural about the language of a well-educated gentleman like Sidney (or indeed like Wordsworth) is not that it is the same as the general language of cultivated society but that we can see—we can readily acknowledge—how the two are mutually informed by and derive from each other. Wordsworth's homeliest composition is twice as hard to derive from uneducated language. The tacit point is that "cultivated society" is not a middle ground between the discourses of common peasant and well-educated gentleman, for that would make it the terrain of the merely educated and would imply that education is a sufficient end in itself. But simple education is much more like what Coleridge called in his *Essays on Method* a landing-place—a respite, not a terminus.

We can now pose a question about Coleridge's argument that his omissive rhetoric does not permit but that will be important to Southey. How much trickling down of language and values would be enough to enable the rustic to accumulate, however passively, sufficient verbal weapons to be a fully participatory member of the culture? How many such arms would it take to make a man? In some sense this is the question Southey's *Uneducated Poets* poses by reframing the question of cultural participation not in terms of whether the laborer can vote or hold office (a question still unthinkable in 1830) but of whether he can write poems. The question is not germane to Coleridge because his goal is not culture in this enabling sense but culture as preeminence, distinction, excellence. The heroic arc in Coleridge's projected trajec-

tory for culture is not upward, as the uneducated are assimilated into the educated ranks, but downward, in the dissemination made possible by the *well*-educated, culture's true superintendents.

Southey is not entirely free of a trickle-down theory of his own, for he believes that patronage of laboring-class artists by those who have the means to do so is culturally required. Each of the biographies in *Uneducated Poets* is emplotted around an act of patronage that rescues the uneducated poet from a life of "hard and hopeless labor" (*LUP*, 139). At least this is Southey's own analysis of the internal structuration of his various narratives. He also understands each of these acts of patronage to have been undertaken "not with the hope of rearing a great poet, but for the sake of placing a worthy man in a station more suited to his intellectual endowments, than that in which he was born" (*LUP*, 165–66). That is, the effect of this patronage is never merely or primarily to secure a socioeconomic situation in which the laborer-poet can be freed of vocational worries and live wholly as a writer, the way Calvert's bequest of money and Beaumont's gift of property were intended toward Wordsworth; rather, the beneficence of the patron simply changes the kind of labor required of the poet—usually from manual or arti-sanal labor to something more genteel, as in the case of John Frederick Bryant, who was "enabled . . . to give up a miserable occupation [i.e., pipe-making], in which his eyes suffered from exposure to the fire, and to set up as a stationer, bookbinder, and printseller in London" (*LUP*, 156). Finally, all the acts of patronage narrated by Southey are in some measure financial except the last one, the wholly figurative act of patronage which is Southey's writing of this very history (or series of histories) as a way of introducing John Jones's work. The money-name for Southey's introduction is "advertisement," pitching a product he wants us to buy. But the work comes to us under the more commu-nal spirit of georgic in which writing is signed as labor. Just as Bryant's "most effectual benefactor" in turn "introduced Bryant to . . . many persons who liked to do good, and were wealthy enough to gratify their bountiful inclina-tions" (*LUP*, 156), so Southey's *Lives* will introduce *all* these writers, some for the first time, to readers. To subscribe to this edition is an act of cultural patronage, and the patronage thus enacted by "us" readers extends and cor-roborates the patronage narrated inside Southey's historical writings.

Let me focus in more detail on Southey's story about John Frederick Bryant, because this biography is emplotted with greater specificity and suggestiveness than most of the others, because historically his life is the most contemporane-ous one (Bryant died in 1791), and because structurally Southey makes this life the climactic one of his *Lives*.

Bryant's story begins with his father who, having given up the pipe-making business followed by his "grandfather and all his family," goes to London as a journeyman house painter and ends up marrying a servant-maid. For the first five years of John Frederick's life he is farmed out to her parents, "poor

honest hard-working people at Sunbury" (*LUP*, 135). After Bryant returns to his father's household, now relocated in his native Bristol and again engaged in the family trade of pipe-making, Bryant idyllizes Sunbury as his true home. His Bristol schooling is desultory and piecemeal, although he does become a little acquainted with Pope's Homer and Dryden's Virgil through their being quoted in other books of mythology. Grown deaf because of a childhood illness, Bryant is put to work "packing up tobacco pipes for exportation" (*LUP*, 136) in his father's now prosperous business that employs ten journeymen (*LUP*, 139). Bryant however longs to see once more his maternal grandparents and finally does so in what Southey, melding Bunyanesque and Wordsworthian language, calls a "pilgrim's progress" undertaken out of "a feeling of natural piety" (*LUP*, 142).

The journey to Sunbury, like John Clare's later journey out of Essex, is circumscribed by writing. As prelude to the walking trip, Bryant writes his father "the first letter that he ever penned" (*LUP*, 141) explaining his purpose in going, and he then sets off with "the whole of his worldly wealth" which he gradually sells off in the course of reaching Sunbury. After a visit of nine days, Bryant returns home "in health and spirits," having been gone a total of three weeks. His return unleashes a run of misfortune—mother's death, decline of business, father's death, grandparents' death—the end of which leaves Bryant homeless and vocationless. Southey then chronicles Bryant's long series of unsatisfactory employments, from foundation digger for the barracks at Woolwich to jobber in the rope-grounds to longshoreman, his lot emblematic of the horrendous unemployment situation throughout the war years.

What punctuates this work record, however, is the evolution of Bryant's talent for "stringing together rhymes," which always "made him a favorite with most of his comrades" (*LUP*, 147). Once, he was refused a shop in Bristol to set up pipe-making because he had lampooned the daughter of the house's owner (*LUP*, 148). But much more often the economic repercussions of his poetry-making were salutary. "It was his good hap," writes the Laureate-narrator, and

> contrary to general experience, to find that theirs [i.e., the Muses'] is no thankless service; and his first proof of this was that by making songs for some convivial meetings which he frequented, and singing them himself, he procured friends and customers, and occasioned moreover a consumption of his own tobacco-pipes. (*LUP*, 151)

At every juncture in Bryant's career—and this is representative of all Southey's "lives" in this volume—aesthetic progress is a function of the uneducated poet's social relations. The conviviality described here is more than just an effect of good songs to sing and good things to smoke: it is the cultural sign of the integration of what Southey calls "good nature and . . . social

talents" (*LUP*, 154). More than the craftsmanship or intelligence of his verses, it is this integration, as signified by the performative communality of Bryant's art, which represents the poet's acculturation and "earns" him the beneficence of the gentleman whom he meets while waiting for a ferry. The gentleman overhears him entertaining a kitchenful of passengers in the Passage House and then offers Bryant a seat in his boat. Whereas Bryant's earlier journey back to the Sunbury past had been circumscribed by writing, this journey, which turns out to be a passage into the future, is infused with Bryant's singing, including some songs that Bryant himself had composed—"for he was a poet himself," as he tells the gentleman (*LUP*, 155). The gentleman did not laugh, as Bryant had expected, when he said this. Instead, he "listened attentively." The rest is history.

Or rather, what remains is to graph that history as a sequence of discrete but culturally apposite biographies. What Southey says about Bryant's published verses might also describe Southey's own *Lives:* they "were intended for the perusal of those who might be desirous of seeing the gradual progress of natural poetical genius, unassisted by education" (*LUP*, 157). To read this progress-narrative well depends upon seeing how social relations take the place of education in inculcating cultural values. Those social relations extend beyond the narrative limits of the *Lives* to the very act of reading this history. Southey's educated readers are told that they must overcome their autotelic sense of excellence; they must lay their own education aside and read *through* the superficial imperfections and artisanal irregularities in these uneducated verses to the importance of the cultural process that underlies their composition. We are "observing," says Southey, "the growth of a poetical spirit" (*LUP*, 157). To read and "find no amusement," to peruse without ridicule, requires what one might call anthropological curiosity. Indeed, Bryant, the man of damaged sight who was also at one time in his life nearly deaf, resembles an anthropological case study of the sort that proved so provocative to men of letters during the period of Bryant's own lifetime.[28]

Southey's history has all the virtues and the vices of its premise. We see his own anthropological fascination, as a literate man, with the artisanal idiosyncrasies and non-inscriptive methods by which these uneducated men and women compose, but Southey also immediately recognizes what Wordsworth, for instance, never quite seems to notice—that the writing of poetry by working-class poets is an oppositional activity. Real laborer-poets do not write about the kind of noonday rest that Wordsworth describes: for them, the act of writing poetry is already a form of respite claimed *in spite of* the labor demanded of them. The writing is a way of breaking out from the social expectations (or absence of expectations) others would have for them, and the failure to write or compose throws the would-be poet back into the unrelenting world of *labor improbus*, as John Clare delicately describes it: "I felt and shunned the idle vein / Laid down the pen and toiled again."[29] That "toil" is no metaphor and is not equivalent to the "work" of writing. To understand

this helps us explain why so many working-class poets have "amusing" artisanal idiosyncrasies as they try to solve the problem of getting "in a position to write," as William Carlos Williams put it.[30] Either these writers have to steal time from real work in order to write or their very way of composing has to be physically in accord with the work-processes they live by and contribute to the value of what that work produces. Southey portrays John Taylor the Water-Poet as a kind of Evel Knievel showman, expert at improvisations and "flytings," especially glib when composing against a monetary wager or for an occasion when he would be paid. James Woodhouse, the poetical cobbler, "used to work with a pen and ink at his side, while the last [i.e., a shoe] was in his lap;—the head at one employ, the hands at another; and when he had composed a couplet or a stanza, he wrote it on his knee" (*LUP*, 115). Had Southey expanded his list he might have added Cobbett's usual practice of dictating his "writings"; the way Robert Bloomfield, "the farmer's boy," would compose a whole poem in his mind before writing any of it down; and John Clare's habit of making notes to himself, which he stuck in the brim of his hat as he worked.

As anthropologist, Southey is not hamstrung by the need to "do" the laborers' voices, to make the language of their lives the poetry of his own. On the contrary, Southey's very success at describing an extant literary practice that has largely escaped public acknowledgment depends upon his maintaining a certain narrational distance from it. His claim for its value depends upon the objectivity of his documentation, just as the poet's claim for the sociocultural values of agriculture in Virgil's *Georgics* depends upon his not being a farmer himself. Southey opposes the "maxim of philosophical criticism that poetry ought never to be encouraged unless it is excellent in its kind,—that it is an art in which inferior execution is not to be tolerated,—a luxury, and must therefore be rejected unless it is of the very best . . ." (*LUP*, 164). His is not an argument in support of aesthetic mediocrity, though, but a plea on behalf of a metanarrative of civic progress: these uneducated poets are not mute, inglorious Miltons but figures of capable imagination, many of whom found, in their own day, an enviable number of supporters for their work and who not only negotiated their own lack of education with some success but even, in a few cases, gentrified themselves and their immediate families. These latter poets are essentially middle-class success stories, whose pilgrims' progresses led to an earthly city of genteel well-being from (usually) rural poverty.

Perhaps the greatest limitation of Southey's narrative could also be ascribed to its anthropological spirit of inquiry. Southey wants to keep his subjects as he found them, and this means maintaining if not a social differentiation then at least the aesthetic distance that has made Southey's history possible. In establishing the class identity of these uneducated writers as laborer-poets, "brethren in the art," Southey tends to sentimentalize their community as a collegial world apart from the enmity, jealousy, and competition of those learned poets (like himself) who suffer the anxiety of knowing the influences

with which they are (and are not) crowned. Indeed, under the ramparts of their nonprofessionalism, the uneducated are safe from the jockeying and caviling associated with the frenzy of renown:

> If, indeed, a poet feels in himself a constant craving for reputation, and a desire of depreciating those who have been more successful than himself,—if he looks upon them as his competitors and rivals, not as his brethren in the art,—then verily it is unfortunate for such a man that he possesses the talent of versifying. (*LUP*, 165).

Cordoning off the profession of letters from the uneducated poet and reserving it for professional writers only, Southey again makes paramount the implications that the word "uneducated" has always carried, at least since Plato: it signifies a lack of proprietary rights. Mainly though, Southey wants to spare these working-class writers, some of whom have risen to bourgeois status thanks to their endowment of imagination, the psychic ravages of participating in an actual market economy.[31] Southey wants to maintain the uneducated writer, the laborer-poet, as a self-educable amateur who is not entrepeneurial in his aspirations and whose gentrification, even if sustained by patronage, nevertheless symbolizes at the social level his autogenesis as an aesthetic producer. As I have suggested, this construction of the "uneducated poet" grows in part out of the georgic strategy that equates writing with material means of improvement. Be that as may be, it is certainly a "romantic" construction, or, more precisely, a construction of romanticism. Especially in a life like Bryant's, we see represented the biography of what is often taken to be an emblematic romantic producer—one who was once "immured" but is now, thanks to his art alone, "free, enfranchised, and at large."[32] At the end of the romantic age, and ironically in the figure of a laborer, Southey sketches the first romantic poet.

Southey, who dedicated his entire professional life to earning enough income to maintain the large house and household at Greta Hall, knows the workings of real markets, and he reminds himself of this again at the end of his treatise by warding off a certain kind of prospective (or prospecting) reader. Southey says that his intervention on behalf of John Jones must be the last superintendent act of this kind that he will undertake to close the fissures between the uneducated and the educated. Southey's way of bowing out of "the progress of civilization" (*LUP,* 164), however, entails a peculiarly self-conscious, hyperbolic awkwardness as he endeavors to extricate himself from further philanthropies:

> I, Robert Southey, Poet Laureate, being somewhat advanced in years, and having business enough of my own fully to occupy as much time as can be devoted to it, consistently with a due regard to health, do hereby decline perusing or inspecting any manuscript from any person whatsoever, and desire that no application on that score may be made to me from this time forth; this resolution,

which for most just cause is taken and here notified, being, like the laws of Medes and the Persians, not to be changed. (*LUP*, 167–68)

What makes this facetious is that the testamentary language of last wills, while it certainly in one sense spells out severances, does so in order to secure continuities and to entail legacies. Southey must know, of course, how difficult it will be to detach himself from what he fancies and even actively hopes will be the market-success of this very project. Southey told one correspondent that he hoped this ending would "amuse" her (*LC*, 103). What keeps it unfunny is that it is inappropriate in *this* context to call attention to his own labor and to his own authority under the law, for it is precisely this authority (as official Laureate) that is withheld *by definition* from these uneducated poets.

That which is unfunny, however, turns arch when Southey goes on to say that he has "entered into a society for the discouragement of autograph collectors; which society will not be dissolved till the legislature in its wisdom shall take measures for suppressing that troublesome and increasing sect" (*LUP*, 168). Southey's "society" here is a collective of one—himself—and yet this collective apparently has at its disposal the power to persuade legislatures to action. But what are we to make of that so-called sect of autograph hounds who, in wanting Southey's patronage, might need "suppressing"? Is this sect being allusively associated with all "troublesome and increasing" groups—from fundamentalist religious factions to collective-action political clubs and corresponding societies, all of which tended to attract their members from the laboring classes and were often seen as merely glorified mobs? If so, Southey's fanciful way of terminating his own historical writing would seem to imagine the legislative suppression of some of the acknowledged public voices of labor, even as his own narrative unearths, presumably for the first time, the imaginative and poetic voices of that same class. After Southey has concluded his conceit of fantasizing a proclamation of Parliament, introduced by "my county member" and circulated "by the reporters, inserted in all the daily newspapers, copied into the weekly and provincial ones, and finally recorded in the Parliamentary Debates," one struggles to remember that what is being circulated to the countryside, in this overdetermined daydream, is word of what Southey will not read. Surely this is bizarre. For Southey to end his humanitarian appeal on behalf of those who, for social reasons, have struggled against all odds to learn how to write and who, with amazing luck, have sometimes had their writing read by the "right people," by saying that he will not read any of this any more for whatever reason has all the bluffness of a rhetoric that refuses to concede its own tacit acceptance of the absolute differentiating power of social class.

And yet, if Southey signs off as a Maecenas or an Octavian—a society of one—thus relinquishing any further role as patron and sponsor, he still sustains the georgic strategy of making writing a means of social improvement—

at least for others. By seeing these uneducated laborer-poets as "brethren in the art"—a fraternal order or artisanal guild removed from the professional competition of the moneyed interests (and indeed from his own "business"), but also removed, thanks to their art, from the crushing economic conditions that were driving fellow members of their social class into "troublesome and increasing" groups—Southey makes these writers seem to be social mediators between those who labor and those who legislate. Southey grants these poets, in other words, precisely the cultural status of the Virgilian georgic poet, although he makes them emblematic of a social harvest in which they have neither sown nor reaped. We notice, however, that in his daydream those who write *for a living,* as Southey does, are aligned not with those who labor but with those who legislate, not with the spirit of artisanal cooperation among brethren but with the power of the law and the control of the public media.[33] In this way, Southey's narrative accomplishes diametrically opposed ends. It promulgates the georgic fiction of a social union through writing (specifically through writing poetry) but, by simultaneously trying to extricate Southey himself from that narrative of progress, it also seeks to render this social union culturally marginal—that is, applicable only to others. Such praise of uneducated poets is entirely safe, politically speaking, for it leaves them socially obsolescent even while giving them their aesthetic due.

Perhaps Southey's elaborate self-exit from his own enterprise of writing indicates that he sees more clearly than makes him comfortable the historical implications: how, in declaring for a new society based upon legislative reform, he might become identified with the very group he is trying to set at a distance from his own interests. The irony is that he *has* become thus identified, in the sense that institutionalized romanticism, at least as commonly perceived and understood, has more often imagined the romantics as a sentimental community of writers like Southey's laborer-poets—"brethren in the art" whose self-justifying art is independent of the marketplace—than like entrepeneurial professionals. And just as Southey almost had to apologize for presenting these socially obsolescent laborer-poets to his genteel audience, so the teaching of poetry at the present time (of romantic poetry, say—of Southey's in particular) now needs to be justified to students more concerned with employment career prospects than with writing and to a society firmly persuaded that writing is a polar extreme of real work. Southey's whole historicizing project, and perhaps even the very logic of the georgic upon which it depends, has come round to inscribe the patron (and indeed Virgil's master-text) within the same dismissable "sect" he once sought, however reluctantly, to promote. Who, except for the very specialized, now reads *any* of the texts this essay is about—whether Virgil, the uneducated poets, or Southey? Their dismissal at the present time, however, is not because of differences in social class but—and this is profoundly ironic for a man like Southey who wanted to be his nation's education-Poet Laureate—on the grounds of educational relevance.

NOTES

1. Cited in R. W. Harris, *Romanticism and the Social Order 1780–1830* (London: Blandford, 1969), 281.

2. Robert Southey, *Lives of the Uneducated Poets: To Which Are Added Attempts in verse by John Jones, an Old Servant* (London: H. G. Bohn, 1836), 12. All citations are from this edition, hereafter *LUP,* and are given parenthetically by page number in the text.

3. William Hazlitt, "Mr. Crabbe," in *Selected Writings,* ed. Ronald Blythe (Harmondsworth: Penguin, 1970), 247–48. Hazlitt does not use the word "artisanal" but implies it in belittling Crabbe's "literal fidelity," his attention to "matters of fact," and the "microscopic minuteness" of his "elaborate descriptions." See also Lord Byron, *Don Juan,* Dedication, st. 14, in *Byron,* ed. Jerome McGann (Oxford: Oxford UP, 1986), 376.

4. E. J. Hobsbawm, *The Age of Revolution: 1789–1848* (New York: New American Library, 1962), 319.

5. Cited in Harris, 270.

6. Samuel Taylor Coleridge, "Table Talk," in *Selected Poetry and Prose,* ed. Stephen Potter (London: Nonesuch, 1962), 476: "It is not uncommon for 100,000 *operatives* (mark this word, for words *in this sense* are things) to be out of employment at once in the cotton districts."

7. Karl Marx, *The Economic and Philosophic Manuscripts of 1844,* ed. Dirk J. Struik, trans. Martin Milligan (New York: International Publishers, 1964), 138. Further references to this edition are cited parenthetically in the text.

8. *Quarterly Review* 51 (March 1834): 279. Geoffrey Carnall in his *Southey and His Age* (Oxford: Clarendon, 1960) cites this passage to show that, from Southey's perspective, "happily, reformers were at work" to "avert this catastrophe" (190).

9. The first passage is from *Georgics* II:490ff.; the second, quoted by Southey, is from *Georgics* I:145–46. the text of Virgil used throughout the present essay is *Eclogues, Georgics, Aeneid 1–6,* trans. H. R. Faircough, Loeb Classical Library, rev. ed. (Cambridge, MA: Harvard UP, 1978). The paraphrase of I:145–56 given above is my own.

10. Note that in this usage, *labor* acts like Adam Smith's invisible hand to promote a harmony of interest.

11. See, for instance, A. O. Hirschman, *The Passions and the Interests* (Princeton: Princeton UP, 1977), 56–63, a brilliant reading of this entire phenomenon that never acknowledges the Enlightenment's most important classical source, Virgil.

12. *The Poems of John Dryden,* ed. James Kinsley (Oxford: Clarendon, 1958), II:918; hereafter cited parenthetically in the text.

13. The best short discussion of this distance is Christine G. Perkell, *The Poet's Truth: A Study of the Poet in Virgil's Georgics* (Berkeley: U of California P, 1989).

14. Joseph Trapp, *Lectures on Poetry: Read in the Schools of Natural Philosophy at Oxford* (London: n.p., 1742), 194.

15. The translation given here is by Gary Miles in his *Virgil's "Georgics": A New Interpretation* (Berkeley: U of California P, 1980), 69.

16. See Miles, 69–70.

17. See *William Wordsworth,* ed. Stephen Gill (Oxford: Oxford UP, 1984), 189 (the whole passage referred to here is *Home at Grasmere,* ll. 620–28). Gill, following Jonathan Wordsworth, dates the poem's composition as 1800 and reprints the earliest complete text of *Home at Grasmere*—MS. B.

18. In his later years Wordsworth literally acted out this apparent mutuality of interest by his willingness to go into the fields to help the field-hands make hay, by his unfashionably rustic clothing, and by the notoriously frugal domestic economy at Rydal Mount. While the dress and manners of Wordsworth as a sixty-year-old smiling public man merely looked old-fashioned to his contemporaries, had he adapted this semiotics of costume and *mores* thirty years earlier, at the turn of the century, he might have been thought to be fashionably antiquarian—Roman. See Mary Moorman, *William Wordsworth: A Biography (The Later Years 1803–50)* (London: Oxford UP, 1968), 577–78.

19. We see this irreconcilability dramatized, with 1830 as the calendrical crux, in George Eliot's most Wordsworthian novel, *Middlemarch*.

20. See Wordsworth, *Poetical Works,* ed. Thomas Hutchinson, rev. ed. Ernest de Selincourt (London: Oxford UP, 1969), 396–97.

21. E. P. Thompson, *The Making of the English Working Class* (1963; New York: Vintage, 1966), 31.

22. Cited in *The Poetical Works of William Wordsworth,* ed. Ernest de Selincourt and Helen Darbishire, 2nd ed. (Oxford: Clarendon Press, 1949), IV:428.

23. Southey perhaps grasped the power of that institutionalization more quickly and more bluntly than Wordsworth did. The success of Wordsworth's volumes for children motivated Southey to compile a similar volume of his own poems, with a logic that equates the "good" done for the readers with sound economic policy: "and if this [i.e. Southey's volume] succeeds, as it may *almost* be expected to do, there will be a companion to it of prose selections. In this way I may derive some little profit, now that the sale of the works themselves is at a dead stop. And in this way some good will be done, as far as the selections circulate." See *The Life and Correspondence of Robert Southey,* ed. Charles C. Southey, 6 vols. (London: Longman, 1850), VI:161. All subsequent references to Southey's letters are to this volume of this edition, hereafter *LC,* and are given parenthetically in the text by page number alone. On the financial success of Wordsworth's anthology see Lee Erickson, "The Egoism of Authorship: Wordsworth's Poetic Career," *JEGP* 89 (1990): 45.

24. See John William Adamson, *English Education, 1789–1902* (Cambridge: Cambridge UP, 1930), 1–42; and more recently, Olivia Smith, *The Politics of Language: 1791–1819* (Oxford: Clarendon, 1984), esp. Chapters 1 and 6; and Jon Klancher, *The Making of English Reading Audiences, 1790–1832* (Madison: U of Wisconsin Press, 1987).

25. The Jones project goes hand in hand with the writing of another biography, the life of John Bunyan, intended to accompany John Murray's "handsome edition" of *Pilgrim's Progress*—"a task," Southey says, "not of lucre but of love" (*LC,* 85). By inserting the histories of individual laborers into a recognized cultural identity, Southey's *Lives* attempted to bridge the economic turbulence threatening to upend the social strata of national life.

26. Samuel Taylor Coleridge, *Biographia Literaria,* ed. James Engell and W. Jackson Bate (Princeton: Princeton UP, 1983), II:54—hereafter *BL,* followed by volume and page number and cited parenthetically in the text.

27. "But though the interest of the labourer is strictly connected with that of society, he is incapable either of comprehending that interest, or of understanding its connection with his own. His condition leaves him no time to receive the necessary information, and his education and habits are commonly such as to render him unfit to judge even though he was fully informed" (Adam Smith, *The Wealth of Nations,* ed. R. H. Campbell and A. S. Skinner [1976 Glasgow edition; rpt. Indianapolis: Liberty, 1981], I:266).

28. See Alan Bewell, *Wordsworth and the Enlightenment* (New Haven: Yale UP, 1989), 71–81.

29. *John Clare,* ed. Eric Robinson and David Powell (Oxford: Oxford UP, 1984), 158. One might usefully contrast Clare's noon sonnet with Wordsworth's "Noon-day Hymn," cited above.

30. "The writing is nothing, the being / in a position to write (that's / where they get you) is nine-tenths / of the difficulty," in *Paterson* (New York: New Directions, 1963), 137.

31. Many of the so-called self-educated poets of later Victorian years, whom Martha Vicinus describes in *The Industrial Muse: A Study of Nineteenth Century Working Class Literature* (London: Croom Helm, 1974), 140–79, lived out Southey's desideratum—social improvement without recourse to market economics—not as pleasing paradox but as damning dilemma. If "poetry was, in their eyes, an honourable means of improving their economic and social situation," they also found that "their work was often valued only as a curiosity" (142). If Vicinus is right that "all working-class poets of this period [roughly the last half of the nineteenth century] shared the same definition of poetry, its powers and the role of the poet in society" (141), I would argue that such definitions, powers, and roles arose not from the actual practices and experiences of working-class people writing poetry, but *ex post facto,* from institutive histories like Southey's.

32. I am relying here on Marilyn Butler's germinal formulation: "it may be that the search for 'Romanticism' is not so much the quest for a certain literary product, as for a type of producer," *Romantics, Rebels and Reactionaries* (Oxford: Oxford UP, 1981), 70. The socioeconomic meanings of Wordsworth's adjectives in this quotation from the 1805 *Prelude* (1:8–9) are precisely what the verse glosses over by not disclosing precisely what actions, besides the inspiring breath of nature ("Oh there is blessing in this gentle breeze" [1:1]), have made Wordsworth "free" or "enfranchised."

33. My point, though, is that Southey can also have the alignments work exactly the other way, if the occasion warrants. In a letter to Lord Brougham ("one who is a statesman as well as a man of letters"), written at just about the same time as *Uneducated Poets* (February 1, 1831), Southey says, "There are literary works of national importance which can only be performed by co-operative labour, and will never be undertaken by that spirit of trade which at present preponderates in literature" (*LC,* 133). He is talking specifically here about the making of etymological dictionaries and other such committee ventures, but his terminology is equivocal, not specific; Southey would find a species of "co-operative labour" among the uneducated poets, but they did not—and, I believe, Southey's *Lives* is implying never could—produce "literary works of national importance," no matter how good the writing might be for *them.*

6

Sexual Politics & Literary History

William Hazlitt's Keswick Escapade
and Sarah Hazlitt's *Journal*

SONIA HOFKOSH

oh! fearful lapse of time, pregnant with strange mutability
"On Consistency of Opinion"[1]

I

At midnight in early December 1803, William Hazlitt appeared on the doorstep of Dove Cottage, on the run from an angry crowd of Keswick villagers. His unwanted advances to a village girl had turned into violence. He "narrowly escaped being ducked by the populace, and probably sent to prison," Crabb Robinson would later recount (Baker, 137). Coleridge would recall "not less than 200 men on horse in search of him" (Griggs, II: 735). Hazlitt retreats over the mountains the next morning, wearing Coleridge's shoes and Wordsworth's clothes, the poets' money in his borrowed pockets; thus rescued, he sets out initially for his father's house at Wem and then for London, where he soon launches his literary career with the publication of *An Essay on the Principle of Human Action* in 1805. Hazlitt will proudly remember this first effort as a book "no woman ever read, or would ever comprehend the meaning of" (*Works*, VIII: 237). Pointedly establishing his own exclusionary territory with this work, he rewrites his violent expulsion from Keswick. Having foundered there professionally as well as amorously, as a portrait painter as well as in love, Hazlitt redeems his Lake District failures in his

appearance as an author. The rejected youth, *resartus,* is father to the (literary) man.

Thus construed, the escapade at Keswick dramatizes with a certain economical concreteness Harold Bloom's observation that "from Wordsworth, Hazlitt received a new consciousness of how a writer could begin again" (4). Thomas McFarland has recently remarked that this episode in particular "served the purposes of [Hazlitt's] larger development": his evolution into the "finest pure critic of literature that English culture has brought forth" (81, 57). Nevertheless, the story of the author's progress does not easily or simply resolve even in retrospect into a narrative of natural birth or rebirth. Emerging in the years that follow, indirectly in his own writing and as the occasion of private gossip and public vilification, the story of his rejection at Keswick punctuates Hazlitt's career, complicating his rise as an influential writer and critic of drama, art, and literature, an influential (if anxious) consciousness.

His three-part review of *The Excursion* in *The Examiner* (1814), notably, has been read to allude to the episode in Hazlitt's bitter remarks on the inadequacies of "common country people": "there is nothing good to be had in the country, or, if there is, they will not let you have it" (*Works,* IV: 122). Mary Wordsworth, writing to Dorothy about the review ("a curious piece, but it must benefit the sale of the book"), glosses these observations by recalling Hazlitt's own experience in the Lakes: "A pretty comment upon these opinions would be to relate the story of the critics *[sic]* departure f[rom] this unaccommodating country" (Burton, 24). It is quite soon after this review, though a decade after the event, that her husband does indeed relate the story to Crabb Robinson, R. B. Haydon, and John Wilson, among others. The "lapse of time," as Hazlitt notes in his essay "On Consistency of Opinion," yields strange changes. Ten years later, possibly with the feeling that Hazlitt had inappropriately repaid his loan at Keswick, William Wordsworth's position on the event is charged with an addition, a shift, of interest. Like Robinson, Haydon records the poet's account in his diary: "Some girl called him a black-faced rascal, when Hazlitt enraged pushed her down & because Sir,' said Wordsworth, 'she refused to gratify his abominable & devilish propensities, he lifted up her petticoats & *smote* her on *the bottom.*'" (Pope, II: 470)

Following these Wordsworthian revelations, the story is circulated publically in 1818 in the pages of the Tory *Blackwood's Magazine,* where John Wilson deploys its acquired currency in his vituperative "Hazlitt Cross-Questioned":

> Is it, or is it not, true that you owe all your ideas about poetry or criticism to gross misconceptions of the meaning of [Wordsworth's] conversation; and that you once owed your personal safety, perhaps existence, to . . . that virtuous man, who rescued you from the hands of an indignant peasantry whose ideas of purity you, a Cockney visitor, had dared to outrage? (*Blackwood's* 3:551)

Though Hazlitt ostensibly escapes from the Lakes in 1803, Wilson's literary

inquisition remands him to render (poetic) justice. The *Blackwood's* interrogation is so punishing precisely because it links Hazlitt's transgression at Keswick (outraging "ideas of purity") to questions at once of authorial integrity (misconceiving "ideas about poetry") and individual identity ("personal safety, perhaps existence"). Violations of propriety are associated with trespasses on (literary) property, making the essayist a stranger in his own land. Rhetorically forged, the association indeed turns on Hazlitt's position as the outsider, "a Cockney visitor," an urban interloper, whose very being in the Lakes is a distortion of the natural boundaries—social and moral—mapped by the parallel lines of virtuous poet and pure peasantry. Replicating the Keswick expulsion with a turn of phrase, Wilson deports Hazlitt to the periphery of the very territory wherein the professional writer locates his own identity and his power. No originary author, no primary consciousness, Hazlitt is "a mere bookmaker; one of the sort that lounge in third-rate bookshops, and write third-rate books" (550–51).

Seeking to confirm what is or is not true—to explain and evaluate Hazlitt's status as a writer—modern reconstructions of the episode in romantic criticism and biography account for what happened at Keswick by focusing on the political context of the event itself and by elucidating the political incentives underlying the early reports of it, such as Wordsworth's and Wilson's. In her 1943 biography, for example, Catherine Maclean argues that in the Lakes Hazlitt was the scapegoat of popular prejudice, attacked by the Keswick villagers, as later by his political enemies, as much for his Napoleonic sympathies as for his particular treatment of the village girl. Michael Foot, defending Hazlitt in a debate in the "Letters to the Editor" columns of the *Times Literary Supplement* in 1968 and again at Dove Cottage in 1982, modifies Wordsworth's story by explaining that "Wordsworth and Coleridge could never separate their detestation of Hazlitt's politics and, in particular, his exposure of their own apostasies from their estimate of his character and literary capacity" *(TLS)*. In David Bromwich's discussion of Hazlitt's reputation, Wordsworth's circulation of the Keswick story, in "deliberate revenge" for the *Excursion* review, is indicative of the "malice behind the scenes" (264) which conditioned Hazlitt's critical practice. Like most modern readers, however, Bromwich accepts the basic authenticity or "accuracy" of the Wordsworthian account as it was "retailed" to Haydon, "without trusting its more extravagant implications: 'Devils!' was also what Wordsworth said on being shown a picture of Cupid and Psyche." Bromwich revises out Wordsworth's moral squeamishness to offer a description of the incident as it must have ("doubtless") happened: "Hazlitt . . . had been so far discountenanced by the girl's refusal that he struck her, and soon found himself pursued by a small but determined mob, doubtless more aroused by his Jacobin politics than by the girl's offended honor" (265).

These discussions of the Keswick episode implicitly address the question— "what did actually happen at Keswick?"—in the effort to provide just such

an economical rendering of "the facts" (Grant, *TLS*), to present an incontrovertible sequence of cause and effect, a balanced and coherent history of Hazlitt's career unalloyed by "extravagant," that is, extrinsic, mutations. I rehearse these discussions at some length here, though, not to endorse any claims about the "accuracy" of a certain version of the story, nor to offer my own understanding of "the facts," but to suggest that the many narratives generated out of this episode instantiate the problematic process of historical reconstruction itself. Invoking politics—national and literary—as the unembellished ground of explanation, these arguments reveal that there are always situations "behind the scenes" that motivate events and individuals, rendering texts and lives meaningful. As they do so, however, they also exemplify the way the very effort to reconstruct history—what is or is not true—resists reflecting on the politics of its own formulation. Whether condemning Hazlitt as a rapist at Keswick, a charge intimated by Wilson and Lockhart in a letter to Murray (Jones, 299) and leveled more explicitly by one of the correspondents in the *TLS* debate (Mallaby), or exonerating him as simply "maladroit" in romance (Baker, 138), an idealistic Saint-Preux (Jones, *TLS*), as Hazlitt's twentieth-century biographers do, these various formulations illuminate the inevitable selectivity of historical discourse. In the interests of presenting a consistent narrative of literary history, and of validating aesthetic standards and judgments on the basis of that narrative, readers of Hazlitt and the Lake poets disagree about the answers to the questions posed in such virulent form by Wilson: Was Hazlitt merely derivative? His behavior outrageous? Was Wordsworth fastidious, apostate, malicious? However, they do not contest the significance or implications of the questions themselves, questions embedded with assumptions about the priority of authorial identity and the relation of power to value, which still inflect the conception of romanticism from which we, like Hazlitt leaving the Lakes in the poets' attire, only seem to have escaped.[2]

At stake in current readings of the Keswick episode are questions about the place of a writer such as Hazlitt in a romantic tradition described in terms of a Wordsworthian paradigm. To what extent and to what effect does the prose writer—even "one of the very great prose writers . . . in all English literature" (Reiman, 298)—define the character or spirit of what has been called the age of poetry, indeed, the age of Wordsworth? (Johnston and Ruoff). Does Hazlitt's power as an essayist, conforming to an Oedipal model of literary continuity, derive from a critical misprision or "misconception" of either Wordsworthian poetics or Coleridgean philosophy? (Bloom; McFarland). Yet crucial also are questions about the relation of margin to center implicit in these that remain unasked in the positing of a tradition that can rescue a failed portrait painter, lending him the means of his own romantic refashioning, impelling him to recuperate his claim to power or prestige through language, but at the expense always of what else must be left behind or out, what cannot be represented, if the story is to be told. That Hazlitt's apologists and accusers

alike treat the Keswick episode primarily as an incident in the history of the transaction between Hazlitt and Wordsworth—between men—highlights how partial that history must be. The younger artist, itinerant, awkward ("brow-hanging, shoe-contemplative, *strange*" [Griggs, II: 990]), hovers, emulative, in the established poet's neighborhood; the poet, peevish, resents the influential incursions of the maturing critic's qualified praise. From either perspective, situated at the center of an enabling domestic circle such as the one at Dove Cottage or merely on the threshold seeking the salvation within, the frame of reference, the structure of inquiry, the desire, remains fundamentally the same. The dialectic, Marjorie Levinson might say, is "rigged."[3] What gets displaced from either perspective is the pertinence of some other vantage, some other direction or shape for this history's unfolding, and, of course, the girl, about whom we know and can know so little that she very nearly disappears from view in modern descriptions of the salient features of the Keswick episode.

For some readers, Hazlitt at Keswick is a "trusting victim," his language of passion misunderstood and undervalued (Jones, 10; Kinniard, 92–93); for others, it is Coleridge and Wordsworth who are subject to "unfair representation," the victims of "unjust description" (Moorman, *TLS*) in discussions of the Keswick affair. But this debate occludes another victimization, in fact and in language: that of the girl who gets "struck" (Bromwich), "smacked" (Grant), or "spanked" (Kinniard) in the Lakes. "Some girl," a "local girl," anonymous, objectified, her position is unrepresented, unvoiced in the opposing accounts of the incident, except as a trace, a fragment, approximated and at multiple removes, such as in Haydon's record of Wordsworth's conversation. She figures, in many modern descriptions, merely as the faded background or the excuse for Hazlitt's professional and political (mis)adventure, his author's progress. In this way, she embodies the blank spaces and silences in literary history that we cannot account for by reading either Wordsworth or Hazlitt, that, moreover, we cannot account for by any reading that neglects to look at its own structuring assumptions, its choices about what signifies and on what basis value is determined (Simpson, 28).

Yet the girl's virtual erasure from histories of the episode leaves a residual mark which signals a rough spot—in Hazlitt's time certainly, but in our own as well. This is a spot of contention, a site of dispute, of assertions and denials, of assertion construed, as if naturally, out of denial. Her diminishment is telling, for it does precipitate action and reaction, making narrative possible: it forces Hazlitt's enraged hand to writing and thus to a career; it inspires the villagers' outrage in the tradition of charivari, an "expressive symbolic vocabulary" of popular culture (Thompson, 478); it evokes, too, our own critical rage for a certain order of historical explanation, a continuity, a knowable truth (McGann, 197; Siskin, *passim*). Thus propelling narrative, though, her diminishment by Hazlitt and later commentators alike also resists advance, disclosing the limits of our intentions, the difficulty of representing lives, events, or texts that do not already signify in direct relation to the plots and

structures that determine our sense of history (Liu, 32–51). Even in the context of our interests in the political motivations of literature, in history's expression and repression, how do we situate the specificities of the sexual politics that inform this episode and the narratives construed to explain it? How do we imagine the particular position of a young woman in a village who tries to say no?

The opposing accounts we have of the episode offer a number of possibilities for imagining such a position, such a woman, such words. For Wordsworth and his followers she inspires a chivalric scenario, in which the girl, passive, is rescued and avenged by those 200 men on horseback; or, perhaps, an allegory of innocence, purity, of truth itself, threatened by "devilish" lust and unrestrained ambition. In the versions of Hazlitt and his defenders she bespeaks feminine duplicity and entrapment: she is false, a tease, "some pretty village jilt" (Patmore, III: 141), "some flirtatious girl" (Grant, *TLS*), a "local hoyden" (Jones, 10), La belle dame sans merci. These are all familiar stories, pre-texts. Even Lamb's rendition, apparently taking no sides, passing no judgment one way or the other, mythologizes the event:

> The "scapes" of the great god Pan who appeared among your mountains some dozen years since, and his narrow chance of being submerged by the swains, afforded me much pleasure. I can conceive the water nymphs pulling for him. (Marrs, III: 125)

In this parodic pastoral, the man is deified, while the woman, no nymph, drowns, disappearing as she does in effect in all these imaginary conceptions; she slips through the cracks of the opposition between men—gods and swains, writers and peasants, a strong poet and a critic of power—and in her absence is constructed a story we already know, a story that works as explanation precisely because its contours and its characters are so familiar.

When Hazlitt's recent, expert biographer reconstructs the episode, he appeals to a series of such familiar stories. In his contribution to the *TLS* debate, Stanley Jones adopts the woman's words, that trace that Haydon records, but only in the process of dispossessing her of a vocal, subject position, of any claim to presence: "when this black-faced rascal approached one of their women-folk with his queer romantic talk, a Saint-Preux stooping to conquer a Rosetta in love in a village, a Burleigh paying homage to the farmer's daughter of Hodnet, he was bound to be laughed at and made a fool of." In *Hazlitt: A Life* (1989), Jones argues that Hazlitt's conduct at Keswick "conformed to the quixotic pattern . . . in which he was at once the Don and Sancho Panza" (49). But as Jones's accumulation of references and mixed allusions suggests, such narratives are overdetermined. Driven by the force of their own necessity ("bound to"), by the assumption of natural continuity and conformity, these familiar stories consolidate a tradition that subsumes detail and suppresses

difference. They all function as versions of the same master plot and this plot minimizes, dismisses, or appropriates the woman's side of the story.

That the effort to tell a coherent story, construct a veritable history, involves such occlusion of the woman's position, her body and her voice, is not simply a consequence of our lack of knowledge or evidence; at stake here is not merely that we have no direct testimony from the girl herself, no documentary record of her side of the story—as if that written record would finally reveal the whole truth of the episode. Rather, what is remarkable about the stories of Hazlitt's Keswick escapade, as diverse as they seem, is the way they together so insistently demonstrate where our efforts of recovery have been focused and to what end: we look for confirmation of what we already know. I am less concerned to denounce or correct those efforts than I am to suggest how much more complex the story might be, not quite so familiar, not quite so coherent, were we to consider another focus, other ends. We do not have the girl's story, and that we don't might itself speak volumes about the conditional access to the power of language, personal or collective, in its privileged or even popular forms. The circumstances which dictate what a young peasant woman in rural England at the turn of the nineteenth century feels she can and cannot say to whom, and how her utterance (her desire) might ramify, could well bear, in other words, on the determination and regulation of identities and values in high literary culture. Local knowledge, here gendered and class-bound, however incomplete or inconclusive, could well deepen our understanding of, as it challenges us to reflect on, the priorities and interests implicit in our own claim to know.[4]

II

The girl Hazlitt harrasses at Keswick in 1803 has been effectively reduced to a silent, displaced body—whether by Hazlitt who pushes her down, the laws governing sexual violence which inhibit her from speaking of her experience,[5] or the logic of literary history in its priorities of subject and material. Used by Wordsworth as a vehicle of his own antipathy or by Stanley Jones to redeem the essayist from Wordsworthian persecution, her words issue from a body not her own; she is merely a figure of speech and, as such, can apparently be incorporated into the language of tradition without substantially altering its content or its shape.

Such might also be said of Sarah Walker, the young woman Hazlitt worships and abuses in *Liber Amoris; or, the New Pygmalion* (1823). She, too, has no voice in her own story, except insofar as it is ventriloquized in the text to produce Hazlitt's effect (Butler, 216; Ready, 49). But also like the Keswick girl, Sarah Walker puts up some significant resistance to Hazlitt's passion, contradicting his desire for (self-)mastery and (self-)possession. It is precisely

Hazlitt's project in *Liber Amoris* to explain or resolve the "contradiction" (184) she personifies for him:

> That a professed wanton should come and sit on a man's knee, and put her arms round his neck, and caress him, and seem fond of him, means nothing, proves nothing, no one concludes any thing from it; but that a pretty, reserved, modest, delicate-looking girl should do this . . . without intending any thing by it, is new, and, I think, worth explaining. (186)

Writing through her body (her actions, her gestures, her looks) toward meaning, proof, a conclusion—toward his own satisfaction ("My seeing her in the street has gone a good way to satisfy me" [*LA*, 191])—he announces, "I will make an end of this story; there is something in it discordant to honest ears" (*LA*, 166). We hear the discord that reverberates in Hazlitt's story: it is her voice, silent echoes of the woman's presence ("lovely apparition" [*LA*, 186]) contained within, or, rather, *as,* the narrative limits, the beginning and the end, of Hazlitt's explanation.

We do not have the girl's story. And if we did, it would most likely differ from that of the Keswick villager in many respects: in particulars of time and place as well as in the social, personal, and economic factors acting upon their responses to Hazlitt. But the situations of these women can be considered together, not because they are in some *essential* way the same, but because of the function they (or, rather, their absences) have served in perpetuating the masculine narrative of romantic tradition.[6] In this tradition they are either dismissed as meaningless, like the "professed wanton," or their silence, their reserve, "without intending any thing," is taken as the impetus of the man's story of authorial recuperation. In both instances, their own speech, perhaps with "something in it discordant to" that story, is conclusively suppressed. Without straining all women's voices into one voice, reducing all their bodies to one form, I want to argue that the very absence of the woman's voice and body in narratives of Hazlitt's Keswick escapade and of his affair with Sarah Walker provides the pattern for the displacement of sexual politics from the discourse of literary history generally. What Hazlitt did, and what we have done with Hazlitt, is to make a tradition of that displacement. For he does it again and again. And so do we. As "strange" as Hazlitt may seem, especially in his mutable relationships with women, literary history shows him to be less idiosyncratic than representative of the spirit of the age.[7]

And while we can know so little about what really happened at Keswick or what Sarah Walker really did intend when she sat on Hazlitt's lap, we can trace in the circumstances of another woman's document of her displacement at Hazlitt's hand our own critical replication of that spirit. We do have Sarah Hazlitt's *Journal of My Trip to Scotland,* which recounts her experience of her divorce from the prose writer in 1822. Sarah Hazlitt cannot and does not speak for all women in her *Journal.* She does not speak for the Keswick girl,

a nameless peasant, nor for Sarah Walker, daughter of an innkeeper and a tailor, incipiently middle class; she does not speak for the prostitute her husband hires to provide grounds for his divorce, nor for the turbaned Mrs. Knight, "a woman of color" who runs the James Street brothel in Edinburgh where William goes to commit adultery (*Journal*, 213). Reading the journal does not take the place of these other stories, unrecorded or unrecovered; it does not substitute for an exploration of the way social, economic, national, or racial relations are enacted in particular sexualized situations: in rural England in 1803, in a London lodging house, or in a Scottish brothel. But it does provide another side to a familiar story, another perspective on the subject of female displacement. For example, when she describes the Irish women working in the peat bogs whom she sees on her way to Dublin, Sarah Hazlitt notices that their legs

> are tremendously swollen and discoloured by the nature of their situation and employment; standing in a bog half full of water, busied at a laborious employment, enough to kill them with fatigue and damp. Yet the deplorable figures they cut were matter of sport and laughter to the men on the outside of the coach. [S]uch brutality is quite disgusting. (*Journal*, 232)

As an interjection in the midst of an otherwise bland, guidebook entry about her trip to Dublin—the towns she passes through, the layout and architecture of the city—Hazlitt's comment on the brutal way these women's bodies are disfigured inflects her account, itself disturbed, interrupted, by the male appropriation of women as "matter" for their own narratives. Though from the privileged perspective of an English tourist, on the inside looking out, Hazlitt's *Journal* nonetheless enacts its identification with the situation of the working women in the distance. Hazlitt remarks both those women and the men looking at them, to articulate the conditions of gendered subjectivity: her "figures"—her language and her body—are also subject to the definitions of a culture which, with a forceful consistency of opinion like that voiced by the men on the outside of the coach, makes her into a distant object of others' observation.

III

Sarah Stoddart marries William Hazlitt in London, in May 1808. Fourteen years later Sarah Hazlitt follows her husband to Edinburgh to be divorced under Scottish jurisdiction. Until the passage of the first divorce law in 1857, English marriages could be dissolved only by an Act of Parliament and, with a very few extreme exceptions, only by reason of a wife's adultery. Referred to in law as "criminal conversation," adultery was a transgressive speech-act, a form of trespass on the husband's private property—the woman's body and her language—and so an English divorce also involved a civil suit for damages

against the wife's "correspondent." Such a process was time consuming and expensive, effectively reserving divorce as an aristocratic or upper-class, male privilege. The only option for a professional writer with an irregular salary, unhappily married, other than popular culture's customary wife sale,[8] was to arrange a trip to Scotland.[9] Unlike the rigidly exclusive English law, exclusive by gender and by class, Scottish divorce law at least allowed as tenable grounds a husband's adultery as well, and the proceedings, involving no civil trial, cost substantially less than in England.[10] It is thus to Scotland that Sarah Hazlitt's husband turns when he wants to divorce his wife so that he can marry Sarah Walker, with whom he had been in love since early 1821 when, separated from Mrs. Hazlitt, he moves into her mother's lodging house and she sits on his lap there.

While on his way north in January 1822 to establish the forty-days of residency required by Scottish law and a relationship with a "woman of the town" that can later be presented as evidence against him, William starts anatomizing his passion in what he calls "my book of conversations" (Sikes, 248) with and about Sarah Walker, *Liber Amoris*. Arriving in April, having resistantly agreed to pursue the divorce—she records, "to oblige him . . . I did not want to come, but quite the contrary, was very unwilling" (*Journal* 236)—Sarah Hazlitt, too, has already begun writing a book, a journal that she starts when she leaves England aboard the Leith Smack Superb en route to Edinburgh and in which she records the details of *her* conversations during the three months she lives in Scotland to accomplish the divorce.

Critical attention to this period of William Hazlitt's personal and literary history has rarely been directed to the issue of the divorce itself, though it was an issue of much public interest and controversy at the time, especially in the months following the king's attempt to divorce his wife in 1820 and Queen Caroline's subsequent death in 1821.[11] Rather, it has been focused on questions about the production of *Liber Amoris:* its motivations, its generic definition, how it fits into a romantic aesthetic and canon. Since its publication in 1823, *Liber Amoris* has been described, as Marilyn Butler notes, "as an uncomfortably artless example of the Romantic compulsion towards self-expression" (Butler, 214): "a necessary cathartic" (Baker, 427), the story "of a writer struggling to come to terms with an unfulfilled dream of destiny" (Kinnaird, 266). Butler rereads the book as a satire, and, following her, Stanley Jones calls it "an exercise in romantic irony, a conjuror's trick" (320). But whether considered an authentic autobiography (spontaneous overflow of powerful feeling), or, conversely, as a form of fiction, a masterful manipulation of literary conventions, the opposing views of the book preserve the priority of the authorial self, whether inside as the motivating subject of discourse or outside, above, as its controlling creator. In this way, although viewed by many as "eccentric" (Butler, 214), "an abberation" (Salvesen, 40), "anomalous" (Bromwich, *NYRB,* 53), Hazlitt's story of desire and disappointment can nonetheless be understood as "a classic instance" of romanticism (Butler, 214),

"a parable of the entire Romantic period," visionary though flawed (Lahey, 15).

Gary Kelly has recently remarked the critical contradictions in *Liber Amoris,* observing that in refusing to "divulge its identity," it "exposes the inadequacies of our concepts and canons of Romanticism" (169). Indeed, if Hazlitt's elusive text continues to pose a problem of definition for readers of romantic writing, as Sarah Walker seems to have posed for him, Sarah Hazlitt's journal, which registers her pleasures and her pains during the same period, has been, like the woman herself, dismissed as of only limited interest or importance for our reading of romanticism and its discontents. If, that is, William's prose work is situated "uncomfortably" in an age of masterful poetic achievement—the age of Wordsworth—displaying in its flaws and failings the awkwardness of the age, it is nonetheless positioned within its history and, crucially, taken as a measure of its range. Sarah's writing, however, relegated to the outer edge of *his* story, is off that map. Beyond the borders of romantic discourse, her text is testimony to the dislocations that constitute romanticism's progress and its persistent power.

Published initially as an appendix to a limited edition of *Liber Amoris* in 1894 (Le Gallienne) and republished in 1959 in *The Journals of Sarah and William Hazlitt* (Bonner), Sarah Hazlitt's journal has been read as a footnote in the chronicle of William's life, as a marginal gloss to his experience rather than a record or a revelation of her own. It has in this way been read only partially, when it has been read at all, deployed to explain or justify the character and career of "the best familiar essayist in the language" (Reiman, 298). My brief discussion here involves a consideration of the journal, not just as it illuminates the singular history and writing of that romantic essayist, but in view of the broader implications of the "concepts and canons" that govern standards in literary history, those authoritative formulations, such as Reiman's above, of Hazlitt, that establish and perpetuate tradition, determining what we read and how we read it. What I want to suggest is that the very judgments which comprise that tradition and claim for it a historical order and consistency are informed by (among other things) a sexual politics that is as embedded in literary history as it is emphatic in other overlapping cultural institutions—in this instance, in early nineteenth-century English divorce law, which proclaims in the interests of patrilinear inheritance, in the interests, that is, of the continuity of real and symbolic power, the status of the woman and her conversation as the husband's possession. Reading the journal this way calls attention to some of the ideological premises operative in the making of tradition, and begins to reconstruct, with gendered specificity, the challenges and disruptions to romantic history—those trespasses—that urge us to constitute that tradition differently.

Sarah Hazlitt's journal engages many of the defining concerns and practices of the romantic tradition—the rhetoric of the natural sublime, for example, or the walking tour, or an interest in social reform; at the same time, it

represents another possible approach to that tradition, implicitly offering a critique of its assumption of unified identity as the source and directive of meaningful experience. Conforming in many ways to paradigms of romanticism as we understand it, the journal also calls attention to the conventionality of those paradigms precisely by reproducing them and by doing so on and with a slight edge. Recent work on women's autobiographical writing has argued that writing from the edge "bears witness both to repressive inscription under the law . . . and to the freedom and dispossession of existence outside the law" (Benstock, 2); such writing "allows alternative discourses of 'experience' to erupt at the margins," at once perpetuating conventional definitions and "threatening to disrupt or transform them" (Nussbaum, 149).

In his autobiographical work, William tries to write himself out of such a double stance, such self-contradiction, such divorce. "I can scarce make out the contradiction to myself" (LA, 184). "He had two opposite opinions of Sarah Walker," his wife remarks, and "he said he was determined to ascertain the real state of things" (Journal, 247). Desiring "absolute certainty" (Sikes, 257), he claims to recuperate a unified position, to possess an authorial identity, containing opposition through narrative mastery: "It is all over and I am my own man" (LA, 188). Sarah Hazlitt's autobiographical writing in Journal, however, tells a never-ending story. It develops into no such certain shape; its end is in its beginning: the divorce ("it") accomplished, Sarah remarks, "my situation in my own opinion, was pretty much the same as it had long been" (251). In the heterosexual economy within which she, single, married, or divorced, is situated, the woman may never conclude that she is her own except in contesting the very oppositions with which she is essentially aligned. Contradiction is built in, one way or the other; for her, contradiction, discord, and divorce are "the real state of things," not to be written or resolved away, never "over" like a simple story, but recognized as the dense matrix of her own desire, as the only available way she has to express herself. The binaries Sarah Walker embodies for William to be imagined into subjection, authored into ownership—into his book—Sarah Hazlitt articulates as a self, a body, acting in and out of its own dispossession.

It is in exhibiting the dynamics of this dispossession in her language and on her body that Sarah Hazlitt approaches a revision of the conventions that delimit the field and direction of her authorial identity, her voice. English divorce law encodes the close regulation of the woman's body and her language: her power to act on her own desire, to speak on her own behalf, about and to whom she pleases. In Scotland, Sarah does not escape that supervision exactly—she must, after all, return to England a divorced woman, with all the social ambiguities and tensions attached to that position there (Stone, 340); but she does locate up north, in effect, in exile, a place to confront these constraints on self-expression in order to give a local habitation and a name to her experience.[12]

For example, in Edinburgh she must according to the law swear an oath

she knows to be untrue—that there has been no collusion in the divorce proceedings. She expresses her concern repeatedly, stating her "scruples about taking the oath" (188), copying various versions of it into the pages of her journal, and recording the multiple rationalizations and threats that are used to talk her into what amounts to perjury as a mere formality. The day before she takes the oath, she writes, "In the evening, walked to the meadows, to prepare for the next day's trial, as I seemed to fear I should not be able to go through with it" (225). Herself on trial, she bespeaks in that tentative "as I seemed to fear" an implicit sense of alienation: her feelings and her language, foreign to her, belong to a subjectivity not her own. Sarah's expression is oblique and uncertain; but her journal also documents how such uncertainty, such divisive self-doubt, is compelled by the law itself, which for her renders perjury, like divorce, a practical necessity of her compromised condition. Revealing herself in her personal writing, in other words, she reveals herself already legislated into exile, a self already ventriloquizing its own compromises to conventional scripts. She is active in her acquiescence, and all the writing and the walking she does around issues such as taking the oath outlines the circumscribed sphere of her activity.

When she does not get a response to her repeated requests for the money her husband owes her, Sarah relates, "after some hesitation, went to Mr. Hazlitt myself for an answer": the tension between assertion and deferral she records suggests that the self that goes to question his account of their transactions is a self divided, a self that shows itself to be divided by "necessity." She is vulnerable to his method of accounting, and thus her presence in his domain, though here that domain is itself just a rented room in a foreign city, exposes at once her alienation—"I had no friends, or means of earning money here, as he had"—and the imperative, dictated by his desire, to conceal the disruption that alienation embodies. To get what she should own, to come into her own (though being there at all is "against her will"), she must "come in the dusk of the evening and in a veil" (195–96).

In its characterization of Sarah Hazlitt and her writing, literary history reinscribes the constraints on women's self-expression figured by the veil, the veil of a woman's modesty and of a woman's shame. One of William Hazlitt's biographers characterizes Sarah "as we see her in the journal," as "shrewd and unpretentious, annoyed but not heartbroken by her husband's scandalous behavior, concerned about her bowels, indefatigable in taking exercise, frugal, sensible, and blunt" (Baker, 260). Another recent scholar remarks, "there was never a more sensible, clear-sighted, and realistic journal than Sarah's during the divorce" (Jones, 53). But reading Sarah Hazlitt and her writing as "sensible"—that is, prosaic, passionless ("there is no hint of any emotional involvement" [Barker, 65])—neutralizes the conflict, both painful and productive, that her writing represents. Her concern about her bowels, for instance, like her minute reports of what she eats and drinks ("a nice roast chicken . . . with two glasses of Port"), how many miles she walks, her perspiration, her

sprained ankle and swollen feet, are not simply "matter-of-fact" (Barker, 65), transparent indications of a "crude" (Jones, 10) "candor" (Baker, 415), an "unsentimental" "bluntness" (Birrell, 173). Rather, it is through the details, sometimes excruciating details, of these daily, bodily functions that she conveys the conflict she cannot otherwise express, that is, the conflict within tradition that literary history, with its normative aesthetics and values, has refused to acknowledge.[13]

After a particularly disturbing conversation with William's friend Adam Bell, she reports what he drunkenly tells her:

> I was a pitiful, squeezing, paltry creature. . . . That I did not deserve such a man as Hazlitt: that it was false that he owed me the money I claimed . . . that it was my own fault that Mr. Hazlitt could not be happy with me. *[sic]* that he wondered what could ever have attracted him in me, that he thought my face very ugly, with a particularly bad expression.

Without directly responding to him, Sarah registers her experience of this abuse in body language; "Mr. Bell's behaviour agitated and made me very ill": the doctor "administered three doses of Castor Oil, before my bowels could be at all opened" (222–23). To talk about her digestion, her body, tradition suggests, is to say what she ought not, moreover, what she cannot, say. Her expression, good or bad, is inherently subject to discipline and punishment. "I wished to have said much more, but am not likely to have an opportunity." "Seemed so restless; as if I should go mad; and could not swallow I was so choked" (228). "I was rather flurried at meeting him, and totally forgot many things I wished to have said which vexed me afterwards" (241).

But if Sarah Hazlitt expresses her vexation in corporeal terms, this is not to say that such body language is the natural or necessary form of female utterance; rather, here it is the voice of cultural constraint. Yet, without being an empowering "écriture féminine," her body language also provides a vocabulary for presence, articulating the vital energy of her experience. Returning to her lodgings in Edinburgh after walking 170 miles in one week, she "made," she notes,

> a thorough ablution, and the comfort of that, and clean clothes, after being choked with dust; is more refreshing than can be imagined by those who have not undergone the previous ordeal: it invigorated me so much that I seemed to have nearly overcome my fatigue, and, it being but one o'clock when I arrived, I sat down to writing in the afternoon. (208)

Like the journal she writes that afternoon, in which she records both the frustrations of compliance and the satisfaction of confronting ordeals, her body at once manifests her subjection ("being choked") and affirms her subjectivity ("invigorated me"). And there is no contradiction here; or, rather, the contradiction is operative—her body its site, her writing its expression. The

point is that Sarah Hazlitt's body does not and cannot be made to disappear into writing, into history, without registering its difference: a certain felt consciousness of violence, whether of pain or of pleasure. Her body does not so much define her experience as it represents the way definitions of experience, of consciousness itself, depend both on such violence and on the suppression of the differences that would violently distort a normative aesthetic.

A journalist both private and public, Sarah Hazlitt offers a model of identity that recognizes and incorporates its own vulnerability to other bodies and other voices. Indeed, she does herself in different voices, transcribing various languages—the loud talk of a coachman, the discourse of guidebooks and the law, Adam Bell's abusive rhetoric—as a way to perform a self disowned by her husband and by the romantic tradition he was so instrumental in characterizing and institutionalizing. The conversations she copies into her *Journal* do not confirm a stable, unified subject position from which she can speak, first and foremost, but instead reiterate that conflicting stories are an integral part of her history (Ammons). Recording a conversation with a Highland cottager in which she is asked to give an account of herself ("An what for hae ye been travelling aboot the countra at this gate?"), Sarah notes that "as it was near the time when the Scotch change their servants . . . some conjectured I was a ladies maid going to my place" (215). The woman's story, never completely told, includes such conjectures, such possible changes of place and of identity. It is a story, like history ("fearful lapse of time"), "pregnant with strange mutability," with *in*consistencies of opinion that tell of the differences within tradition, tradition's difference from itself, its ongoing displacements that we can begin to recognize in another body of writing, enabling us to see the limitations of our own construction.

NOTES

1. *The Complete Works of William Hazlitt,* 17, 26. Cited in the text as *Works.*

2. Marjorie Levinson, for example, recognizes "the presence of the Romantic ideology" in her own critique and in the historicist project generally ("Introduction," 17). I am also thinking here, though, of the canonical focus, especially on poetry and especially on Wordsworth, in much recent and compelling historical work on romanticism: Levinson finds in Wordsworth "the very form of our own literary criticism" ("Historicism," 49). Clifford Siskin explains his use of Wordsworth as a necessary, transitional step in the analysis of "the discursive power of the Romantic past" that would begin to write "to an end" that past's power over us (13–14). I can't help feeling, despite Siskin's caveats, the institutional pressure this focus brings to bear on definitions of the field. Treating the poet as exemplary whether in his expressions or his evasions, such a focus "lends a certain contemporary fascination to his work" (Lindenberger, 41) and thereby sustains Wordsworth's priority of place in the developmental narrative of literary history and as the informing presence of our own critical practice. Alan Liu's "Epilogue," framing its personal reflection as mock dialogue and citing as "precedents" Hartman, Foucault, and Greenblatt, invokes its Wordsworthian

lineage as well (500–502). See also Jonathan Arac's discussion of the romantic geneal-
ogy of contemporary criticism.

3. Levinson, "Introduction," 2. See Levinson's characterization of Tony Bennet's
"either/or formulation" of Marxist criticism, which, like the Wordsworth/Hazlitt de-
bate at issue here, "puts us in fact in a single box" ("Historicism," 21). Also see Nancy
Miller's apposite discussion of "the set of references that through the either/or of its
logic . . . constitutes the canon of a national literature" (41).

4. See Clifford Geertz on the limits of local knowledge and Natalie Zemon Davis
on stories and microhistory.

5. See Clark on the double bind of the victim of sexual violence in the early
nineteenth century: If she talks, she is condemned as immodest or malicious and thus
not *legally* violable; if she remains silent in deference to prevailing attitudes toward
female chastity, she cannot bring her attacker to justice nor collect damages. *Women's
Silence*, 1–20, 59–75.

6. See Homans and Ross for sustained arguments on the disappearances of women
that constitute the shape of romanticism's masculine tradition.

7. As James Chandler suggests when he calls the notion of representativeness into
question in his discussion of the "cultural contradiction" built into Hazlitt's *The Spirit
of the Age* (Chandler, 131).

8. See Thompson, 404–66.

9. Brougham comments on this expediency in *The Edinburgh Review* 47 (1828):
"The journey to Scotland is plainly a mere fraud upon the law of England—an escape
from its penalties—an evasion of its authority" (109). Augustine Birrell contends that
Hazlitt's divorce would not in fact have been legal in England.

10. See Stone, 231–367 *passim,* and Phillips, 120–63.

11. See Clark, "Queen Caroline," for a discussion of the political and social signifi-
cance of the royal divorce proceedings. It may not be purely coincidental that Sarah
Hazlitt repeatedly remarks her bowel ailments in her *Journal,* for the queen's death of
a bowel obstruction in March 1821, rhetoricized by some as a direct consequence of
her victimization by her husband, prompted riots involving both middle class and
working people.

12. On the variety of women's writing that negotiates the repressions and displace-
ments of exile with its liberatory potentials, see Broe and Ingram, 1–15.

13. See Schor on the associations among detailism, the feminine, and aesthetic valua-
tion. Following Schor, we might say that the excruciating detail Hazlitt records in her
journal "becomes a camouflage allowing repressed contents to surface" (71), but also
that in itself it constitutes an alternative aesthetic, the return of a cultural repressed.

WORKS CITED

Ammons, Elizabeth. *Conflicting Stories: American Women Writers at the Turn into
 the Twentieth Century.* New York: Oxford University Press, 1991.
Arac, Jonathan. *Critical Genealogies: Historical Situations for Postmodern Literary
 Studies.* New York: Columbia University Press, 1989.
Baker, Herschel. *William Hazlitt.* Cambridge, MA: The Belknap Press, 1962.
Barker, John R. "Some Early Correspondence of Sarah Stoddart and the Lambs."
 Huntington Library Quarterly 24 (1960): 59–69.
Benstock, Shari, ed. *The Private Self: Theory and Practice of Women's Autobiographi-
 cal Writings.* Chapel Hill: University of North Carolina Press, 1988.
Birrell, Augustine. *William Hazlitt.* New York: The Macmillan Company, 1902.
Bloom, Harold, ed. *Modern Critical Views: William Hazlitt.* New York: Chelsea
 House, 1986.

Bonner, Willard Hallam, ed. *The Journals of Sarah and William Hazlitt. The University of Buffalo Studies* 24 (1959).

Brodzki, Bella, and Celeste Schenck, eds. *Life/Lines: Theorizing Women's Autobiography.* Ithaca, NY: Cornell University Press, 1988.

Broe, Mary Lynn, and Angela Ingram, eds. *Women's Writing in Exile.* Chapel Hill: University of North Carolina Press, 1989.

Bromwich, David. *Hazlitt: The Mind of a Critic.* New York: Oxford University Press, 1983.

———. "Review of Jones, *Hazlitt: A Life.*" *New York Review of Books* (April 11, 1991).

Burke, Peter, ed. *New Perspectives on Historical Writing.* University Park: Pennsylvania State University Press, 1992.

Burton, Mary E., ed. *The Letters of Mary Wordsworth.* Oxford: Clarendon Press, 1958.

Butler, Marilyn. "Satire and Images of Self in the Romantic Period: The Long Tradition of Hazlitt's *Liber Amoris.*" *English Satire and the Satiric Tradition,* ed. Claude Rawson. Oxford: Basil Blackwell, 1984, 209–25.

Chandler, James K. "Representative Men, Spirits of the Age, and Other Romantic Types." *Revolutions,* 104–32.

Clark, Anna. *Women's Silence/Men's Violence: Sexual Assault in England, 1770–1845.* London: Pandora Press, 1987.

———. "Queen Caroline and the Sexual Politics of Popular Culture in London, 1820." *Representations* 31 (1990): 47–68.

Foot, Michael. "Letter to the Editors." *Times Literary Supplement* (August 15, 1968): 873.

———. "Hazlitt's Revenge on the Lakers." *Wordsworth Circle* 14 (1983): 61–68.

Geertz, Clifford. "Local Knowledge and Its Limits: Some *Obiter Dicta.*" *The Yale Journal of Criticism* 5 (1992): 129–35.

Grant, Douglas. "Letter to the Editor." *Times Literary Supplement* (September 19, 1968): 1062.

Griggs, Earl Leslie. *Collected Letters of Samuel Taylor Coleridge.* 6 Vols. Oxford: Clarendon Press, 1956–71.

Hazlitt, William. *Liber Amoris; or, the New Pygmalion.* New York: New York University Press, 1980.

———. *Complete Works of William Hazlitt.* 20 vols, ed. P. P. Howe. London: J. M. Dent & Sons, 1930.

———. *The Letters of William Hazlitt,* ed. Herschel Moreland Sikes, et al. New York: New York University Press, 1978. Cited in text as Sikes.

Homans, Margaret. *Women Writers and Poetic Identity.* Princeton: Princeton UP, 1980.

Houck, James A. "Hazlitt's Divorce: The Court Records." *The Wordsworth Circle* 6 (1975): 115–20.

Johnston, Kenneth R., et al., eds. *Romantic Revolutions: Criticism and Theory.* Bloomington: Indiana University Press, 1990. Cited as *Revolutions.*

Johnston, Kenneth R., and Gene W. Ruoff, eds. *The Age of William Wordsworth: Critical Essays on the Romantic Tradition.* New Brunswick: Rutgers University Press, 1987.

Jones, Stanley. "Letter to the Editor." *Times Literary Supplement* (August 29, 1868): 928.

———. *Hazlitt: A Life.* Oxford: Clarendon Press, 1989.

Kelly, Gary. "The Limits of Genre and the Institution of Literature: Romanticism between Fact and Fiction." *Revolutions,* 158–75.

Kinnaird, John. *William Hazlitt: Critic of Power.* New York: Columbia University Press, 1978.

Le Gallienne, Richard. *Liber Amoris, or the New Pygmalion by William Hazlitt.* Priv. Print, 1894.

Levinson, Marjorie. "Introduction." *Rethinking Historicism: Critical Readings in Romantic History,* ed. Marjorie Levinson. Oxford: Basil Blackwell, 1989.

———. "The New Historicism: Back to the Future." Levinson, 18–63.

Lindenberger, Herbert. *The History in Literature: On Value, Genre, Institutions.* New York: Columbia University Press, 1990.

Liu, Alan. *Wordsworth: The Sense of History.* Stanford: Stanford University Press, 1989.

Mallaby, George. "Letter to the Editor." *Times Literary Supplement* (July 25, 1968): 789.

Marrs, Edwin W. *The Letters of Charles and Mary Anne Lamb.* 3 Vols. Ithaca: Cornell University Press, 1975–78.

McFarland, Thomas. *Romantic Cruxes: The English Essayists and the Spirit of the Age.* Oxford: Clarendon Press, 1987.

McGann, Jerome. "History, Herstory, Theirstory, Ourstory." Perkins, 196–205.

Miller, Nancy. "Men's Reading, Women's Writing: Gender and the Rise of the Novel." *Yale French Studies* 75 (1988): 40–55.

Moorman, Mary. "Letter to the Editor." *Times Literary Supplement* (September 12, 1968): 997.

Nussbaum, Felicity A. "Eighteenth-Century Women's Autobiographical Commonplaces." Benstock, 147–71.

Patmore, P. G. *My Friends and Acquaintance.* 3 Vols. London: Saunders and Otley, 1854.

Perkins, David, ed. *Theoretical Issues in Literary History.* Cambridge, MA: Harvard University Press, 1991.

Phillips, Roderick. *Untying the Knot: A Short History of Divorce.* Cambridge: Cambridge University Press, 1991.

Pope, Willard B. *The Diary of Benjamin Robert Haydon.* 5 Vols. Cambridge, MA: Harvard University Press, 1960–63.

Ready, Robert. "The Logic of Passion: *Liber Amoris.*" Bloom, 47–61.

Reiman, Donald H. "Review of Sikes, *Letters of William Hazlitt.*" *Wordsworth Circle* 10 (1979): 298–303.

Ross, Marlon B. *The Contours of Masculine Desire: Romanticism and the Rise of Women's Poetry.* Oxford: Oxford University Press, 1990.

Salvesen, Christopher. "A Master of Regret." Bloom, 29–46.

Schor, Naomi. *Reading in Detail: Aesthetics and the Feminine.* New York: Methuen, 1987.

Simpson, David, ed. "Introduction: The Moment of Materialism." *Subject to History: Ideology, Class, Gender.* Ithaca, NY: Cornell University Press, 1991.

Siskin, Clifford. *The Historicity of Romantic Discourse.* New York: Oxford University Press, 1988.

Stone, Lawrence. *Road to Divorce: England, 1530–1987.* New York: Oxford University Press, 1990.

Thompson, E. P. *Customs in Common: Studies in Traditional Popular Culture.* New York: The New Press, 1991.

Zemon Davis, Natalie. "Stories and the Hunger to Know." *The Yale Journal of Criticism* 5 (1992): 159–63.

7

"Why Should I Wish for Words?"

Literacy, Articulation, and the Borders of Literary Culture

LUCINDA COLE & RICHARD G. SWARTZ

Literacy, Gender, and the Writing of Culture

Near the end of his life William Wordsworth argued that the humbler ranks of society could not "benefit" from the natural landscapes of the Lake District because "the perception of what has acquired the name of picturesque and romantic scenery is so far from being intuitive, that it can be produced only by a slow and gradual process of culture . . ." (*Guide,* 157). Significantly, he does not say that the poor would fail to enjoy the impressive prospects of this area, but that because they lack the ability to "name" what they see, the positive effects of picturesque and romantic (as well as sublime) scenery would be lost on them. Underwriting Wordsworth's comment, then, is first a view of the aesthetic as a carefully refined vocabulary, as a system of classifications which identifies certain phenomena as objects of a particular knowledge. From this perspective, the cultivated spectator or tourist who gazes luminous with sensation at a striking view is doing nothing more than reading back the cultural significations which produce the aesthetic object, scene, or sight in the first place. The humbler ranks, alternatively, who have not had access to this aesthetic vocabulary, can neither interpret nor articulate the meanings invested in romantic or any other kind of scenery. Second, implicit in Wordsworth's remark is a nascent and ideologically loaded theory of acculturation that complicates this view. On the one hand, he represents aesthetic discourse as an official language, as a sort of national wealth to which anyone may potentially have access, if only "through a slow and gradual process of culture." On the other hand, Wordsworth's representation of culture as the pro-

cess of passionate and long-continued attention to the forms of nature advances the idea that aesthetic competency is more a product of private experience than of the technical vocabularies toward which he previously gestured. The symbolic appropriation of sublime or picturesque landscape, in other words, now seems to take place largely at the level of consciousness, unconditioned by any specific, socially and historically situated cultural idiolect. Any apparent contradiction between these two dimensions of aesthetic acculturation disappears, however, when one recognizes that for Wordsworth the possession of the aesthetic idiolect is above all a form of distinction: as such, it confers prestige on those who have acquired it precisely because it appears to be a form of natural experience available to all who can see, feel, and imagine. In this quiet promotion of what, altering a phrase from Bourdieu, one might call the illusion of aesthetic communism, William Wordsworth represents aesthetic competency as a universal possibility available to all, but only by obscuring the concrete, socially conditioned forms of dispossession that such an aesthetic education necessarily implies. Much like certain theories of language, then, he converts "the immanent laws of legitimate discourse into universal norms of correct . . . practice" but, in so doing, deftly avoids addressing questions of the economic and social conditions under which "acquisition of the legitimate competence and of the constitution of the market" take place, and in which, according to Bourdieu, any such definition of "legitimate and illegitimate" language is necessarily "established and imposed" (44).

Taking seriously the idea that *aesthetic* communism—like Bourdieu's *linguistic* communism—is in fact an illusion, or, more precisely, an imaginary construct with real social effects, we attempt in this essay to expose some of the conditions of its production, reproduction, legitimation, and potential disarticulation during the romantic period. Although Wordsworth raises the issue of aesthetic competency, the conditions we seek to isolate here are, perhaps not surprisingly, most visible in the comparatively marginalized work of late eighteenth-century women. Critics have noted in the writing of Dorothy Wordsworth and others a double-edged appropriation and subversion of aesthetic discourse, an apparently gender-specific ambivalence that has been valued in different ways. Our essay turns on the assumption that any such discomfort or resistance is less a sign of gender, as such, than it is a symptom of gender-specific (pre)occupations that eighteenth-century women both inherited and helped to promote. Readers of Nancy Armstrong will recall, for example, that certain "cultural functions" increasingly attributed to and promoted by women were "instrumental in bringing the new middle classes into power and maintaining their dominance" (26). Among these was the role of teacher, particularly, teaching that contributed to the moralization of the laboring poor. As we shall see, Hannah More, Dorothy Wordsworth, and Ann Yearsley—the uneducated "milkwoman poet" of Bristol—share with William Wordsworth an understanding that aesthetic discourse is a specialized vocabulary that is "far from being intuitive." But because that awareness is coupled

with a concern—indeed, a moral duty—to moralize the laboring poor as well, they will often differ from him in contesting the value of particular literary idiolects. Their attempts to negotiate the relationships among literacy, aesthetics, and literariness can therefore tell us more about the forms of dispossession involved in a romantic aesthetic education than, arguably, can "purely" romantic writing itself.

This is particularly true in reference to the sublime, which, by the late eighteenth century, has become an index of one's position in the market of official aesthetic and literary discourse. This market is organized to a considerable degree by gender- *and* class-inflected strictures governing who could and who could not assume the voice of sublime grandeur. Women writers were thus compelled to situate themselves in relation to an increasingly consolidated, if increasingly contested, set of literary practices. Hannah More, in response to this challenge, argued in 1799 that the sublime, properly speaking, was a mode of writing (and feeling) best practiced by men. In her "comparative view of the sexes," she claims that women are endowed with distinct conceptual, moral, and aesthetic capabilities: they "do not so much generalize their ideas as men," she writes, "nor do their minds seize a great subject with so large a grasp" (*Works,* VI:146). Given this, she continues, and because women are blessed by Providence with an "intuitive" penetration into character, they are naturally more suited to "polite letters." Although this is a commonplace of eighteenth-century writing, More's attempt to institutionalize a doctrine of gendered literary practices is clearly related to her larger project, which is to contribute toward the moralization of the laboring poor. Thus elsewhere in her writings, More argues that because only the elite could grasp the sublime, poets who soared in its regions were evading their duty:

> Their taste and their pursuits have familiarized them with the vast, and the grand, and the interesting: and they think to sanctify these in a way of their own. . . . These elegant spirits seem to live in a certain lofty region of their own minds, where they know the multitude cannot soar after them; they derive their grandeur from this elevation, which separates them with the creatures of their imagination, from all ordinary attributes, and all associations of daily occurrence. In this middle region, too high for earth, and too low for heaven; too refined for sense, and too gross for spirit; they keep a magazine of airy speculations, and shining reveries, and puzzling metaphysics; the chief design of which is to drive to a distance, the profane vulgar. . . . (*Works,* IV: 328)

In comments that are derived from Anglican precepts but that nevertheless seem to mirror the insights of Bourdieu, More exposes the notion of distinction upon which practitioners of the official literary language must depend. In her words, poets attempt to "sanctify" matters of "taste" and habit from which the "multitude" are excluded. Indeed, she represents this "distance" from the "profane vulgar" as the source of "their grandeur." Taken together, these passages demonstrate that More willingly abdicates the sublime to men,

but not without challenging the value of both the practice and its practitioners. Her conflicted relationship to the sublime thus appears as a by-product of the socially sanctioned, class-based gender roles that More advocates with other late eighteenth-century women, a list that includes Mary Wollstonecraft, Sarah Trimmer, and Anna Barbauld.

It also includes Ann Yearsley and Dorothy Wordsworth, the subjects of our essay. Both were deeply interested in the particular mode of social reform and moralization that sought to bring benefits of literacy to the laboring poor. Dorothy Wordsworth, for example, established a Sunday school in 1789, where she taught her young charges to read and spell and to memorize hymns and their catechism. Years later she continued to uphold the charitable ideal of limited education for the laboring poor, as evidenced by her actions on behalf of the orphaned children of John and Sarah Green, a poor family from Grasmere.[1] This ideal is also manifest in her *Recollections of a Tour Made in Scotland* (1803), which not only remarks on scenes of touristic interest, but continually inquires into the status of literacy and literary education in the Lowlands. She writes, for example, of children who "went to school and learned Latin, Virgil, and some of them Greek" (*Journals,* I: 206); of proud miners whose village has acquired a library "that had all sorts of books— 'What! Have you Shakespeare?' 'Yes, we have that. . .'"—(I: 209); of a young guide who "said she would buy a book" with the sixpence Dorothy gave her (I: 220); and, with uneasy satisfaction, of some young children apprenticed to a cotton factory who, she was told, "were well instructed in reading and writing" (I: 225). Although Yearsley's active promotion of the Sunday school movement is perhaps less overt, it surfaces throughout her works, partially through frequent references to members of lower ranks in terms often borrowed from educated literary culture. "Untaught, unpolish'd is the savage mind," she writes in "Brutus: A Fragment," but such "error will decay," allowing edifying "Visions" to "arise from interchange of thought,/With dear refinement and instruction fraught."[2] To this end Yearsley praises Sunday schools for giving aid to the "race" of illiterate poor, who, oppressed by circumstances, "sink in vulgar toils" and therefore neglect the soul."[3] Without such learning, Yearsley avows in a poem in favor of the establishment of such institutions, the "savage," working world will be a morally and socially incapacitated one, a "poor unlettr'd tribe" (68) wandering in its own darkness (24–25). As writers themselves, however, Dorothy Wordsworth and Ann Yearsley were also participants within a peculiarly intellectual culture whose specific values they both internalized and partially reproduced. Yearsley's poetry and Dorothy's *Journals* are partially organized around episodes in which, as poet or tourist, they gaze at scenes, sights, or objects of aesthetic interest. These embedded moments belie their efforts to define themselves as possessors of the cultural capital that, for them as for William Wordsworth, aesthetic knowledge increasingly affords.[4] In this sense, Ann Yearsley and Dorothy Wordsworth occupy a complicated, if familiar, subject position. They are

members of literary culture, but members (like most of us) who have internalized a culturally given imperative to regulate and control the practices of reading and writing itself.

Their works, correspondingly, directly pertain to the historical problem that we examine here: how literary culture is formed in relationship to struggles over the meaning and value of literacy, linguistic competency, and cultural distinction. Such relationships, we maintain, are most visible in the vastly overdetermined trope of inarticulation. At one end of an implicit cultural continuum of meaning this trope signifies a basic linguistic incompetence, and at another, a moment of sublime genius. William Wordsworth's poetry, for example, often dramatizes a "higher" linguistic breakdown—a poetic failure of language—which marks the poet's access to truths that cannot be spoken. (Kant defines this provisional failure in cognitive terms as a "negative presentation" which "expands the soul" [127].) Yet William often merges the two aspects of inarticulation into a single narrative in which *another's* silence marks, by a kind of transfer, the *poet's* access to a sublime beyond of language. One thinks, in this regard, of the Blind Beggar and Discharged Soldier episodes of *The Prelude;* or, more immediately, of "Tintern Abbey," where Dorothy's expressive silence serves simultaneously as a mode of distinction (for William) and dispossession (for his sister). It is not surprising, given this situation, that Yearsley and Dorothy Wordsworth both attempt to demystify the idealizing impulses implicit in the literary culture by which, in different ways, both were dispossessed: in Dorothy's case, as a decorous and therefore often self-censoring woman, and in Yearsley's, as a servant whose improvised education marks her as a member of the inarticulate laboring poor. This demystifying tendency, moreover, is intimately related to their interest in the discourses of literacy, where articulation and inarticulation are, it would seem, more pedestrian and "purely" descriptive terms. At the same time, however, as we shall see, both writers partially replicate the tendency of aesthetic discourse to create an inarticulate and sometimes savage other, subject to and subject of their reformist discourse. Yearsley, for example, compares her own, presumably innate aptitude for aesthetic vision to the coarse pleasure of a "noisy crew" of working men, whose "clumsy music crowns the rough delight" they seem to prefer. Let "Yours be the vulgar dissonance," she writes, "while I . . . stretch the ardent eye/O'er Nature's wilds. . . ."[5] This negative description of laboring-class speech dramatizes the ways in which aesthetic discourse, with its increasing emphasis upon the civilizing power of the printed word, created "new lines of demarcation within the working classes" (Vincent 1982, 36, 42). Dorothy Wordsworth's unflattering descriptions of Gaelic speakers in her Scottish *Tour* of 1803 serve a similar function (although one pressed in the service of extending the borders of Englishness itself). Such dividing practices, we suggest in our conclusion, are often simply replicated in an American critical industry that, having inherited a purified notion of literariness, continues to maintain it in splendid isolation. From our perspective, alternatively,

to explore articulation in its full range of meanings during the romantic period is to map the internal and external borders of romantic writing, and therefore to begin to explore the constructive limits and constitutive exclusions of romanticism as such.

Yearsley's Sublime (In)Articulations

Yearsley's work marks a transitional moment in the cultural history of literacy, one that affects both the production and reception of her verse. A major vehicle for the spread of literacy (and with it, propriety) was the complex of institutions and practices associated with middle-class women's charity, some of which were organized by More. But by the late eighteenth century, the idea of a national language purified of the grossness of local pronunciation and usage—what Yearsley refers to as a "vulgar dissonance"—as well as the taint of local customs and manners, was closely connected with the idea that the basis of proper English was to be found in that rich treasure of linguistic propriety, the great texts of English literary culture (Barrell 1983, 135).[6] In this sense, literacy and the values and idioms of a national literary culture must be seen as linked. Sarah Trimmer makes the connection between them explicit when she claims that because "literature has made such advances in the kingdom, the poor men seem to have a just claim to more liberal instruction than was formerly allotted to them" (Trimmer 1792, 4). Here the word "literature" hovers between an earlier sense, where it refers to the minimal condition of being literate, and its more recent connotations, where it refers to a distinct and intrinsically valuable body of texts which form the basis of liberal knowledge as such (Williams, 45–54). Much of the literacy movement, correspondingly, is characterized by (comparatively) progressive and conservative opinions regarding what constitutes proper skills and texts for the poor. In Trimmer's avowedly conservative view, for example, a "more liberal instruction" meant that poor children ought to gain the ability "to read with fluency and propriety" (41). Generally speaking, however, these debates were premised upon the thoroughly ideological assumption that to be poor and uneducated was to be utterly without the means of acquiring the civilizing values associated with the printed word. Their collective effort was thus to obscure or devalue the fact that the laboring classes had developed indigenous educational practices and institutions which, while less pervasive than those associated with middle-class schooling, nevertheless functioned independently of charitable institutions.[7]

Prior to meeting More, for instance, Yearsley had already largely internalized the values of literary culture, including those associated with the aesthetic, in ways that typified laboring-class tactics for developing and sustaining the reading habit. Yearsley was taught to read by her mother. This reproduces a distinctive pattern of eighteenth-century laboring-class life, where the family was one of the chief sources of literacy skills, and women in particular tended

to gain these skills from a literate female parent (Levine, 375). More indicates a second way in her report that Yearsley had gathered "two or three classical allusions in one of her Poems" from "little ordinary prints hung in a shop-window" ("Prefatory Letter," xiii); this practice was typical of laboring-class readers, for whom shop windows were among the many resources that could transform the streets into "a sort of poor man's library" (Webb, 24). In championing the Sunday school movement, then, Yearsley neglects the quite different set of values embodied in her own relatively improvised and so typically laboring-class manner of acquiring literacy.[8] Indeed, she dismisses the existence of the kinds of private, unofficial schooling that were actively supported by a significant proportion of the laboring poor for whom Sunday schools represented either an unwelcome imposition from above or a failure in their own terms, since children frequently left them still unable to read (Stephens, 564).[9] In Yearsley's case, however, to erase or obscure her early (unofficial) education serves an immediate purpose intimately connected to her poetic ambitions.[10] In so doing, Yearsley is able to accept and promote a definition of herself as a poet who *intuitively* grasped the moral, aesthetic, and literary imperatives of middle-class culture—as, that is, a natural genius overcoming the disadvantages of her impoverished background—even while she represents herself as a milkmaid who, deficient in relation to these very systems of value, required the patronage of More and her friends.

"Night. To Stella," which opens her first published collection, dramatizes this simultaneously self-divided and self-promoting strategy.[11] As the title suggests, the poem alludes to *Night Thoughts,* the only work by Young, More reports to her friends, that Yearsley had read ("Prefatory Letter," ix). In strains clearly borrowed from that enormously popular poem, Yearsley begins with a meditation—prompted by the death of her mother—on the topics of solitude, melancholy, and mortality. Yet, after demonstrating her presumably intuitive capacity for sublime feeling, Yearsley apologizes to "Stella" (More) for her "wilder'd thought,/Uncouth, unciviliz'd and rudely rough" (138–39). Indeed, the poem as a whole enacts a disavowal of the formative influences outlined above and, with those, an implicit occlusion of the reading practices upon which Yearsley's myth of natural genius clearly depends. Thus shortly thereafter Yearsley attributes her former mode of thinking and writing not to Young but to a moral and psychological condition: she rejects the "gloomy joy" that once seemed "the nobler choice," but that now, thanks to her patroness, "has lost its relish" (156–58). Indeed, later she attributes this same disposition to what she calls "iron lore," or to forms of knowledge that characterize an oral rather than a print culture (200). In the end, Yearsley declares herself a "convert" to More's "mild rhetoric," but reasserts her own "rusting powers" which are now similarly "tun'd . . . to the bright strain of joy" (211, 206, 211–12). Half a child of nature, half an Anglican proselyte, Yearsley concludes with a wish that More will accept her "wild and untaught rapture" but also "teach" her "honest heart to feel more faint,/More moderate" (221, 213–14).

This brief description shows Yearsley mirroring the efforts of her patrons to represent their charge as a kind of ignorant, inarticulate, but noble primitive tamed—or not, depending upon whom one reads—by More's gentle hand. Yearsley even praises More for teaching her "to scorn the savage virtues of untutor'd minds" (201). It would be a mistake, however, to regard such gestures solely as a symptom of Yearsley's assimilation to a culture that, prior to More's intervention, she did not understand. Rather, as the intertextual relationship with Young attests, the poem turns upon an extended occlusion of her own reading, which had provided her with the rhetoric of sublime aspiration, natural genius, and "wild and untaught rapture." Given this, Yearsley appears as a poet caught between two cultures, or, more precisely, as a poet thoroughly saturated with culture, if by that one means a knowledge of and sensitivity to the tensions between the moral and literary imperatives that characterize both More's social circle and Yearsley's early life.

Yearsley's complicated negotiations of literary culture are perhaps more overt in "On Mrs. Montagu," a recognizably proto-feminist companion piece to "Night." Whereas Yearsley formerly represented herself as a "savage," she now appropriates the comparatively more genteel identity of the merely inarticulate, a trope that also serves a double function. As we shall demonstrate, it both refers to Yearsley's (assumed) inability to speak—that is, her inability to assume the discursive idioms of literary culture—and asserts, at the same time, by pointing to a blockage which is a correlative of the literary sublime, her innate powers as a poet. Thus Yearsley begins, more boldly, with an injunction against "arrogant, imperious man" who falsely assumes that he can "soar nobler flights, or dare immortal deeds,/Unknown to woman, if she greatly dares/To use the powers assigned her" (5–7). These lines set up her celebration of Elizabeth Montagu, whose much-hailed vindication of Shakespeare against Voltaire, the reigning literary dictator of Europe, exemplifies how a woman employing "the soul's energies . . . o'ertakes *his* Muse." Yearsley's panegyric, however, quickly gives way to a retrospective of the poet's condition before the "soft humanity" of Montagu and More "reached over the low vale where mists of ignorance lodge" (34). "Oft as I trod my native walls alone," Yearsley writes,

> Strong gust of thought would rise, but rise to die;
> The portals of the swelling soul, ne'er op'd
> By liberal converse, rude ideas strove
> Awhile for vent, but found it not, and died.
> Thus rust the Mind's best powers. Yon starry orbs,
> Majestic ocean, flowery vales, gay groves,
> Eye-wasting lawns, and Heaven attempting hills
> Which bound th' horizon, and which curb the view;
> All those, with beauteous imagery awak'd
> My ravish'd soul to extacy untaught,

> To all the transport the rapt sense can bear;
> But all expir'd, for want of powers to speak. . . . (51–63)

Referring, again, to her former self, Yearsley narrates her failure to achieve what, presumably, Montagu had. Because her "rude ideas" were not opened by "liberal converse"—or, in Trimmer's words, "liberal instruction"—they could not "find vent" and died. Correspondingly, when the sensuous world of "beauteous imagery" awakened her to a spontaneous "extacy untaught," it expired, she writes, "for want of powers to speak."

Yet Yearsley's claim to inarticulation—her assertion that "liberal converse" might have preserved her vision from its own demise—is at odds with what her writing actually performs.[12] The passage enacts another drama central to a more typically romantic sublime which both evokes and thwarts a desire for access to, and therefore the power to name, worlds beyond the limits of "sense." What rises from the ashes of this failure is the recognition that consciousness or imagination is not determined by the sensuous world but is a law unto itself. The passage is therefore organized around the contrast between higher and lower regions, where the higher world is a metaphor of spiritual transcendence, and the lower of physical confinement and the limits of ordinary perception. The speaker's eyes move downward from the stars to distant prospects of the ocean, and then lower still to "eye-wasting lawns," before they finally rise again to the "heav'n attempting hills." These, however, "curb" her view, limiting the imaginative vision that they also invite. The carefully crafted imagery of imprisonment and blockage therefore compels another reading that must accompany the obvious one. These images refer not only to Yearsley's incapacity to say what she feels, or name what she has seen; they also refer to a fundamental condition of the transported soul, which cannot help but fail, trapped as it is within the bonds of the material world, but still capable of recognizing that its true home, destiny, and law is the spiritual. Read in this way, Yearsley aggressively assigns herself the ability to recognize the transcendent reality that lies beyond ordinary perception, and therefore beyond the limits of articulation. Her collapse into silence, from this perspective, is a predictable and intrinsic feature of the sublime itself, in which failure, silence, and loss become signs of a higher meaning inaccessible to ordinary minds, and beyond the reach of words.

Yearsley's sublime inarticulation will, of course, be familiar to readers of romantic poetry and criticism: for both Thomas Weiskel and William Wordsworth, the inadequation of sign to meaning in the sublime is itself taken to be a signifier for another order of signification. Like Wordsworth, moreover, Yearsley's sublime moments tend to appear as "spots of time" within larger narratives of self-development. What may be less familiar, however, is that, in these poems, her sublime inarticulations are represented as signs of antisocial nature that, fortunately, More's vision of "social love" and benevolence had served to correct. We have so far explained this strategy by focusing upon

Yearsley's position as a member of the laboring poor, who, as an aspirant to literary fame (together with a literary livelihood) simultaneously reveals and obscures the specifically cultural conditions of her possible success. Yet it is perhaps worth reinforcing that, precisely because she is a *woman* poet, Yearsley's ambitions to enter middle-class culture make her both the object *of* and spokesperson *for* the cultural injunctions that More directs at women who write. Given this, Yearsley's moments of sublime inarticulation not only expose the social and cultural conditions of poetic production, they may also subtly resist them. Many of Yearsley's comments, for instance, seem to reinforce More's prohibition against women writing in the sublime mode; in one place she refers to this disposition as "the grand mistake of fools/In sullen self absorbed!" ("Night," ll. 58–59). But, insofar as she casts these (failed) efforts at writing the sublime as one moment in a larger narrative of self-development, as she does above, Yearsley is simultaneously able to perform the operations that More, as we have seen, was beginning to deny women of her own class. At a certain point in her career, in short, Yearsley's sublime verses are both enabled and contained by the very association between poetic ambition and useless self-absorption through which, in More's books, the poetic efforts of middle-class men and women alike are (re)directed and valued according to their moral utility.

Upon leaving the patronage of Montagu and More, however—an act that created quite a scandal in late eighteenth-century social and intellectual circles—Yearsley's implicit awareness of the close relationship between reading, writing, and literary practice seems to play a more explicit role in her verse. Thus in the following lines from a later poem, the economies of literacy and literariness that underwrite Yearsley's inarticulate sublime are neither suppressed nor cast into a hierarchy of value, but neatly counterpoised:

> These feeble sounds
> Give not my soul's rich meaning; or my thought
> Rises too boldly o'er the human line
> Of alphabets (misused). Why should I wish
> For words to form a picture for the world
> Too rare?[13]

This passage, like the ones we have already seen, represents the struggling Yearsley as deficient in the very medium of her most intense self-definition as a poet; it also asserts a counter-theme in which inarticulation appears as a figure of the sublime poetics Yearsley successfully takes as her own. From the latter perspective, the failure to articulate her "rare" vision becomes a sign of meanings which lie beyond the power of any language to articulate. Language is reduced to the merely arbitrary signifiers of social convention, empty "alphabets" which fall short of but for this very reason call attention to her "soul's rich meaning." In contrast to the much-celebrated tradition of roman-

tic writing, however, in which what we have been calling *sublime* inarticula-
tion is a matter only of the poet's individual struggle with language, Yearsley's
tropes of inarticulation, her collapsing of poetic language into alphabets mis-
used, refers, however fleetingly, to the social and cultural conditions of articu-
lation itself. At this point, it seems, she has so successfully negotiated (or
thoroughly internalized) the imperatives of literary culture that, in her work
at least, the shadowy borderline between the discourse of literacy and that of
literariness is nearly erased.

Dorothy Wordsworth's English(ness)

The moralizing ideal that both animates and confounds much of Yearsley's
poetry was the basis of Dorothy Wordsworth's own considerably more official
form of education. Having learned the cultural function of the charitable and
sympathetic woman at an early age, Dorothy came virtually to embody it, or
at least to practice the cultural functions of true womanhood that More
worked so hard to construct. Upon meeting Dorothy, William Wilberforce (a
crucial supporter of More's philanthropic enterprises) was so impressed by
her activities that he gave her a copy of Trimmer's *The Oeconomy of Charity*,
plus ten guineas a year to distribute to the poor.[14] Wilberforce recognized in
the young Dorothy a kindred spirit who would seek to bring the benefits of
learning to the multitude. And without embracing More's version of Tory
evangelicalism, Dorothy did seem to accede to this vision. Not only does she
demonstrate throughout her life a commitment to the spread of literacy, she
seems to have internalized the corresponding prohibition against women writ-
ing poetry as well. "I have no command of language, no power of expressing
my ideas," Dorothy wrote of herself (*MY*, I:25). She did not, however, accept
this lack of power without occasional shows of resentment. In a poem of
1829, for example, she writes that although she "*reverenced* the Poet's skill,"
as a child she "had Stifled ambition" of this kind out of a combination of
"bashfulness," "shame," and regard to domestic authority, or the "fear that
elder heads might blame—Or something worse."[15] Dorothy's near-ironic por-
trayal of her own intimidation (in Bourdieu's sense of the term)[16] expressed
in the very mode of writing that, she admits, she was not supposed to practice,
attests to both her intense and sometimes uneasy attachment to precepts defin-
ing the proper role of middle-class women who, bolstered by a keen sense of
duty that directed them to "the paths of usefulness," also abdicate poetry to
men. Given this complicated reaction, it is surprising neither that Dorothy
Wordsworth turned to prose nor that her journals display another kind of am-
bition.

In addition to providing expected descriptions of striking scenes, sights, and
incidents, these also deliberately explore the discursive idioms and practices
of the aesthetic. So well do they perform this task that her highly coded nature
descriptions often appear as instinctive expressions of her soul, and thus as

signs of a "natural" genius. Indeed, for reasons that shall be explored later, this is a representation of Dorothy Wordsworth that her brother and others were eager to promote. But if one recognizes, with Ian Hunter, that the aesthetic is a "special kind of ethical work," then it is possible to see how Dorothy's descriptions contribute to "shaping a distinctively aesthetic self through the successive intensification and neutralization of capacities for feeling and thought" (Hunter 1992, 353). Whatever their immediate intention, then, Dorothy's skillful descriptions of persons and places attest to her internalization of a specific set of disciplinary practices and the vocabularies which shape them, and, in so doing, have the added effect of normalizing the presumably "natural" basis of her aesthetic responses. Yet Dorothy does more than "naturalize" the practices, protocols, and vocabulary of aesthetic self-cultivation; she relies on these practices to normalize the ideas of feminine duty and polite letters that More felt compelled to assert. As we have mentioned, in her 1803 *Recollections of a Tour Made in Scotland* Dorothy searches for signs of literacy and reading habit among the Scottish working class. This interest in the civilizing function of reading and education accompanies Dorothy's equally pervasive interest in reaffirming the value of an increasingly national literary tradition: Chaucer, Spenser, Drummond, Jonson, Milton, Thomson, Ossian, her brother's poetry. Such authors provide Dorothy with a tissue of intertextual and cultural associations to construct a given sight as an object of aesthetic interest, even as they signify her possession of a linguistic treasure that, according to Trimmer and others, both enabled and obligated women to spread the benefits of limited literacy to the poor. Dorothy's frequent citations, in this view, are not simply allusions or ornamental references but constructive tropes in her ongoing efforts to refine the articulation of the aesthetic self in ways that reinforce both the social function and values associated with literary culture.

Dorothy's is therefore an exercise in *practical* aesthetics inescapably tethered to ideological assumptions foundational to that late eighteenth-century cultural formation. Not surprisingly, these assumptions emerge most forcefully around the tropes of inarticulation, tropes that become particularly common when, in the Scottish tour of 1803, the Wordsworths approach the Gaelic-speaking Highlands. We quote from the following episode at length:

> It rained, but not heavily; the mountains were not concealed from us by the mists, but appeared larger and more grand; twilight was coming on, and the obscurity under which we saw the objects, with the sounding of the torrents, kept our minds alive and wakeful; all was solitary and huge—sky, water, and mountains mingled together. While we were walking forward, the road leading us over the top of a brow, we stopped suddenly at the sound of half-articulate Gaelic hooting from the field close to us. It came from a little boy, whom we could see on the hill between us and the lake, wrapped up in a grey plaid. He was probably calling home the cattle for the night. His appearance was in the highest degree moving to the imagination: mists were on the hillsides, darkness shutting in upon the

huge avenue of mountains, torrents roaring, no house in sight to which the child might belong; his dress, cry, and appearance all different from anything we had been accustomed to. It was a text, as William since observed to me, containing in itself the whole history of the Highlander's life—his melancholy, his simplicity, his poverty, his superstition, and above all, that visionariness which results from a communion with the unworldliness of nature. (*Journals*, I: 286)

On first glance, it appears that Dorothy is simply providing a staple of travel literature, the picturesque image, which, as critics have long since noted, often figures the poor laborer in the landscape as an object of aesthetic interest for the consumption of onlookers, tourists, and readers (Barrell 1972; Berming-ham).[17] Dorothy, in this view, seems simply to embellish and reinforce the more poetic vision of her brother for whom, she reports, the boy represents "the whole history of the Highlander's life," where the unfortunate signs of "his superstition" are presented in dynamic counterpoint with the signs of his "visionariness" and "communion with the unworldliness of nature." William's retrospective response to the Gaelic boy is, one notes, highly reminiscent of a much-discussed episode of *The Prelude,* Book V where the Boy of Winander sings "mimic hootings to the silent owls" who answer, "responsive to his call." When the natural world no longer repeats his cry, "sometimes in that silence, while he hung/Listening, a gentle shock of mild surprise/Has carried far into his heart the voice/ Of mountain torrents."[18] Like the Gaelic boy above, then, and like the Gaelic singer in "The Solitary Reaper," the Boy of Winander provides yet another instance of moments in which a pre-linguistic cry or incomprehensible voice becomes a figure for the meaning beyond words, language, or any worldly form of articulation. As Mary Jacobus writes, the "mimic hootings" of the Boy of Winander fulfill William's claim to know "a language more profound than that of books" (128).[19] In Dorothy Wordsworth's case, however, it would appear that this Highland boy's "hooting" does not qualify as a sign of inexpressive sublimity. Thus even as she acknowledges William's interpretation of the scene and therefore seems to approve the spirit that William brings to poems such as "The Solitary Reaper" or to the Boy of Winander passage, Dorothy provides details that work against it. Although Dorothy states that the boy's appearance is "in the highest degree moving to the imagination," his voice strikes her as strangely inhuman: while the "cry" of the boy arrested them both and led to William's commentary on the "visionariness" of the scene, Dorothy represents this sound, somewhat unpoetically, as a "half-articulate Gaelic hooting." In contrast to the Boy of Winander, then, Dorothy's Gaelic boy does not hoot in sympathetic imitation of natural sounds. For her, this half-articulate hooting is in fact an expression of near-animality, and therefore closer to Yearsley's "vulgar dissonance" than it is to "the voice of mountain torrents."

What interferes with the aesthetic moment is Dorothy's view of Gaelic, which is tinged by an ambivalence that elsewhere erupts in contempt. This

perception of Gaelic was based upon, and in its own negative way acknowl-
edged, the social and historical conditions that led to a severe decline in liter-
acy rates throughout the Highlands. As an effect of what has been called
internal colonialism, the increasing anglicization of the Highlands reinforced
a situation in which the local economy became dependent upon the economic,
social, and legal institutions of the south while it also deprived native Gaelic
of any social or cultural prestige (Hechter). A literate Highland culture ceased
to exist as such, replaced by a world in which Gaelic came to represent to
outsiders a barbarous language of an uneducated, economically backward
people.[20] Although in 1766 the Scottish Society for Propagating Christian
Knowledge—one of the great institutional engines driving the Highlands to-
ward anglicization—again allowed Gaelic texts to be taught in Highland
schools, this was not done to promote Gaelic but to facilitate the spread of
English (Withers, 125–26). Indeed, the Highlands were increasingly identified
as a region of savage illiteracy. In contrast, the highest literacy rates among
the laboring poor were found in the Scottish Lowlands and northern England,
including the Lake District. In terms of educational provision and the preva-
lence of the reading habit, then, the English north and the Scottish Lowlands
"may have formed a zone distinct from both southern England and Highland
Scotland" (Houston 1985, 265).[21] Given this situation, upon leaving the Low-
lands—where, as we have observed, Dorothy found numerous signs of the
reading habit, and a cultural environment not unlike the one she knew from
Penrith and Grasmere—Dorothy entered another, and to her savage, world.

Throughout her Scottish tours, accordingly, Dorothy portrays the High-
lands as everything the Lowlands and northern England are not—primitive,
foreign, at times repelling—thereby reproducing the structures of internal co-
lonialism mentioned above. While these cultural differences sometimes be-
come the basis of an objectifying and essentializing picturesque, that aesthetic
is punctured and often shattered when, in her accounts, Highland speech
intrudes. Dorothy's *Tour* reports on young women "gabbling Erse" (*Journals,*
I:280); a group of boatmen who "shouted to each other in Erse—a savage
cry to our ears" (I:294); children "laughing, screaming, and chattering Erse"
(I:302); a woman "screaming in Erse, with the most horrible guinea-hen or
peacock voice I ever heard (I:317); a group of "stout" working men "who
could speak very little English, and stared at us with almost a savage look of
wonder" (I:340). Her reference to the boy's "half-articulate Gaelic hooting,"
within this context, implies yet another moment of Othering in which the
primitive native becomes a sign of excess, an inhuman beyond of culture that
culture is compelled either to reclaim or to disown. Dorothy's half-articulate
boy, that is, fits into the mingled "sky, water, and mountains" not as one
image among others, but as a savage Other whose alien tongue cannot be
absorbed into the aesthetic moment. From this perspective, Dorothy's turn to
William for an aestheticizing frame argues that, for her, the Gaelic boy's

inarticulation represents a form of impropriety that works against the constructive design of the aesthetic response.

At the same time, her highly refined aesthetic sensitivity leads her to portray in cultural and therefore more concrete terms not only her own class and regional prejudices but, as we shall see, the structures of inarticulation upon which William's apparently more generous figurations of the foreign rustic are based. This point can be demonstrated by looking, briefly, at a scene from Dorothy's *Journal of a Tour on the Continent* (1820) where, once again, the aesthetic is disrupted, but this time in more radical and apparently self-conscious ways. In the entry for August 10, Dorothy describes how she and her party follow a stream to "the gray torrent of the Lutschine" until they arrive at the basin of a cataract "where two women," Dorothy writes, "appeared before me singing a shrill and savage air": "their tones were startling, and in connection with their wild yet quiet figures strangely combined with the sounds of dashing water and the silent aspect of the huge crag that seemed to reach the sky!" (*Journals*, II:118). Like the image of the Gaelic boy, the figures of the two women combine with the sounds of a torrent and "the silent aspect" of surrounding eminences of rock to form what is for Dorothy an unforgettable scene. And just as the boy's Gaelic cries had disturbed the composition of the aesthetic moment, here the women's "shrill and savage air" combines *"strangely"* with the torrent and the sublimely silent crag.

The further significance of the passage emerges in a lengthy footnote she appends to it. The note includes a sonnet by her brother written in memory of the occasion, and an excerpt from Robert Southey's journal of 1817 describing a similar encounter at the falls. William's sonnet, in the version Dorothy quotes, represents the women's "notes shrill and wild" as being more supernaturally musical than the fabled songs of mermaids or witches. The poem ends by declaring that it is a shame that this compelling music should come from the lips of mendicant women. While their song seems to echo the enthralling power of the waterfall, their pitiable appearance does not:

> Tracks let me follow far from human kind
> Which these illusive greetings may not reach,
> Where only Nature tunes her voice to teach
> Careless pursuits and raptures unconfined.
> No Mermaid warbles (to allay the wind
> That drives some vessel tow'rd a dangerous beach)
> More thrilling melodies! no caverned Witch
> Chaunting a love-spell ever intertwined
> Notes shrill and wild with art more musical!
> Alas! that from the lips of abject Want
> And Idleness in tatters mendicant
> They should proceed—enjoyment to enthral
> And with regret and useless pity haunt
> This bold, this pure, this skyborn WATERFALL! (*Journals*, II:118)[22]

In his later commentary on the poem, William writes that "this wild and savage air" (an unacknowledged quotation from Dorothy's account) "seemed to belong in some way or other to the waterfall and reminded me of religious services chanted to streams and fountains in Pagan times" (*Poetical Works,* III:373–74). This commentary indicates the ways in which the poem occludes the social meaning of poverty so that William may follow the play of imaginings that the poor women's song elicits. The song, a reminder of the supernatural, pagan ritual, and oral culture, belongs with the waterfall; the women, who conflict with the scene by raising a "useless" feeling of "pity" for the idle poor, do not. The poem thereby shows how the speaker associates the song with Nature's voice. It is this imaginative distance from "human kind," William implies, that once again allows him to hear in this song, in spite of the barriers of language and social position that separate him from the singers, a significance that belongs to imagination alone.

The excerpt Dorothy includes from Southey's journal proceeds in much the same way as William's poem: "'While we were at the waterfall, some half-score peasants, chiefly women and girls, assembled just out of reach of the spray, and set up—surely the wildest chorus that ever was heard by human ears—a song, not of articulate sounds, but in which the voice was used as a mere instrument of music, more flexible than any which art could produce,— sweet, powerful, and thrilling beyond description'" (II: 118).[23] William's poem and Southey's prose account, in spite of their obvious differences, both assign these voices a musical power beyond that of ordinary human sound. William may assert that the women, tattered and idle mendicants, interfere with the value and interest of their own song, but he shares with Southey the urge to disembody their voices, and therefore to idealize, dehumanize, and supernaturalize their music in one gesture. Thus in Southey, the song becomes something beyond anything "heard by human ears"—a figure he repeats when he later uses the same journal as the basis for his own poetic appropriation of the wild singers in Canto III of his poem *A Tale of Paraguay* (1819). In that poem, the wild music reappears in the voice of an unself-consciously beautiful but also pointedly inarticulate expression of a natural poetess who sings in the midst of the South American wilds beside a lonely and sublime waterfall. This "songstress wild" is overheard "Rejoicing in her consciousness of power," as her "unexpressive lay," fashioned from "inarticulate and long-breathed sound," holds her listeners "spellbound" in "mute astonishment."[24]

Dorothy's note, in contrast, which claims that these two accounts are similar, includes an interesting disagreement with them both:

> *I* was close to the women when they began to sing, and hence, probably it was that I perceived nothing of *sweetness* in their tones. I cannot answer for the impression on the rest of the party except my brother, who being behind, heard the carol from a distance. . . . (II:118)

It is perhaps surprising to see this presumably self-effacing writer go out of

her way to object to poetic accounts of this much-written image of the Staub-
bach singers. (If you count Southey's *Paraguay* and William's later prose de-
scription of the scene, the Staubbach episode gives rise to five different
renderings.) Added to this is that Dorothy's apparent appeal to the empirical
is simply beside the point in regard to Southey's description, since his account
is based upon a separate event. What seems to be happening here, however, is
not simply a local contest over descriptive accuracy, but a far more important
struggle over how the women's inarticulation is to be valued. Dorothy's under-
linings reinforce this view. Her intervention is based not only on her proximity
to the scene—"*I* was close to the women when they began to sing"—but, more
importantly, on her ability to comment upon the negative aesthetic quality of
their speech: "I perceived nothing of *sweetness* in their tones." In remarking
upon the affective appeal of a particular enunciation, she is, of course, reas-
suring her cultural function, to preserve and extend the grounds of articulation
itself. Apparently, Dorothy is so completely assimilated to this function that
she does not have to take the poets to task for indulging in the "lofty regions
of the mind," or for allowing their poetic ambitions to divert them from their
duty. But in her appeal to the real—that is, to the social imaginary—and in
her otherwise inexplicable exposure of the poets' "mistakes," Dorothy implies
that William Wordsworth and Southey, rather than being too immersed in the
(merely) aesthetic, are failing to demonstrate aesthetic sensitivity enough. In
Dorothy's more socially grounded vision of inarticulation, "vulgar disso-
nance" cannot be redeemed as a figure of the listening poet's imaginative
access to the beyond of language.

Conclusions

In distinguishing between Dorothy's account of the Staubbach singers and
those of her male companions, we mean neither to suggest that Dorothy's is
a morally superior vision nor to deny its obvious political problems but merely
to identify a form of power that, as Nancy Armstrong puts it, "does not seem
to be power because it behaves in specifically female ways" (26). Indeed, our
argument as a whole has the effect of calling in question the still prevalent
notion that women were necessarily "silenced" by romantic aesthetic dis-
course. Thus throughout this essay, we have focused, first, upon the positive
efforts of two women from different social ranks to appropriate, subvert, and
otherwise negotiate the idioms of what we have been calling official literary
culture. Much like William Wordsworth, as we have seen, Dorothy Words-
worth and Ann Yearsley appropriated the peculiarly romantic trope of inar-
ticulation in their writings and, given their commitment to aesthetic discourse,
occasionally applied it to themselves. Among writers of the early romantic
period this trope is vastly overdetermined, we have insisted, precisely because
it stands on the (shifting) borders between literacy and literariness, and there-
fore of vulgar dissonance and cultured articulation. It is, in other words, not

only a descriptive but a value term, an exceptionally powerful variable that enables the sublime, marks the borders of proper speech, and helps to constitute prestigious literary production. In this view, the real grounds of articulation are not ontologically given in the essence of the (imaginary) linguistic community but are effects of the value systems which produce and reproduce a cultured disposition, where the forms of that acculturation are variously organized by middle-class men and women alike.

Within literary culture proper, however, it also is true that men had more power than women in formulating and monitoring the rules and strategies of the cultural wars that we now identify as romanticism as such. And because inarticulation was such an unstable and mobile term in those skirmishes, women who put this trope into discourse did so at considerable risk. The most famous example of this phenomenon is, of course, William Wordsworth's "Tintern Abbey," where Dorothy appears as a supplementary and therefore confirming repetition of William's own vision: "in thy voice I catch/ The language of my former heart, and read/My former pleasures in the shooting lights/Of thy wild eyes" (117–20). Dorothy's relatively complex aesthetic sensibility is here cast as a natural stage of human development that William has surpassed. In a more prosaic version of the same tendency, Thomas De Quincey describes Dorothy as a woman of profound feelings and perceptions that she could not articulate because she was too acutely aware of her station in life: "Her sensibility seemed constitutionally deep; and some subtle fire of impassioned intellect apparently burned within her, which, being alternately pushed forward into a conspicuous expression by the irrepressible instincts of her temperament, and then immediately checked, in obedience to the decorum of her sex and age . . . gave to her whole demeanour and to her conversation, an air of embarrassment and even self-conflict" (131). Even if this were an accurate description of Dorothy's condition, it is so clearly shaped by romantic figures that it is impossible not to assume that De Quincey, like William, is writing Dorothy into a myth that both he and Dorothy had inherited. "Even her very utterance and enunciation often, or rather generally," he continues, "suffered in point of clearness and steadiness, from the agitation of her excessive sensibility" (131). Strangers, he concludes, might think her to be plagued with an "infirmity of speech" (132). Thus despite her many volumes of letters and travel writing, Dorothy Wordsworth enters into the texts of publicly successful male writers as a woman who was thoroughly emblematic of an aesthetic response she does not herself voice.

One can see a similar mode of dispossession at work in Ann Yearsley's reputation. That many of Yearsley's moments of sublime inarticulation can support two apparently contradictory meanings marks them, we have argued, as the products of a particular and even fleeting moment in the history of literacy and literary culture, when the rhetoric of sublime silence was thought to indicate that which is beyond words. Yearsley seemed to take advantage of this situation to demonstrate the competencies that, according to any number

of cultural imperatives, she was not supposed to have had. Yet the same equivocation that enabled Yearsley's poetic distinction was easily collapsed back into the cultural logic of those reformers for whom, one recalls, literacy is concomitant with Anglican reform. A friend of More, for example, commenting upon Yearsley's "curious" descriptions of the "state of her own mind," writes: "The consciousness of extraordinary powers, unable to exert themselves (as she seems to conceive) from the insuperable barrier of ignorance, with which her mind is surrounded, and which it is perpetually struggling to surmount, is a new and very interesting representation.[25] This writer seems to suspect a gap between Yearsley's aesthetic performances and her almost obsessive claim that she is unable to perform at all. But his apparent suspicion is quickly explained away, as Yearsley's sublime inarticulation is cast into a myth of self-development, one quite different from her own. A similar kind of primal inarticulateness may be "observed in a child," he continues, "who has been conscious of more mind than might be expected from its years, and who seemed to feel that it was only withheld by the imbecility of its age from saying or doing something above the reach of a child's capacity" (Roberts, I:217). This remark, of course, is meant to be sympathetic, but it effectively and completely erases the complex social, cultural, aesthetic, and literary imperatives with which this particular poet was compelled to contend. Indeed, it mirrors the efforts of William Wordsworth to literalize and reify his sister's tropes of inarticulation, to represent them as a stage in a presumably universal condition, and to offer that scheme, in turn, as proof of his own distinction. In this sense, Yearsley's seemingly generous reader does more damage than the oft-cited ravings of the equally condescending More against her "ungrateful" charge. In naturalizing Yearsley's carefully crafted inarticulate sublime, More's correspondent effectively guarantees that Yearsley, however artful her poetic performances, could never achieve the kind of cultural capital that, apparently, she so desperately desired. Given this context, Yearsley's question—"why should I wish for words?"—is not only unanswerable but bitterly ironic.

If these two examples may be taken as representative of a gendered economy of prestige, the value of romantic women's writing is determined in advance, not by the words they use, but by the words they meet. It is subject to a kind of symbolic violence through which social and cultural differences are not mitigated, but (re)produced. Thus women writers may seem to occupy a similar position as Dorothy's Highlanders who, as we have seen, mark the necessary border of literary culture, the place at which the other's language must be domesticated, disowned, or *repossessed*. Felicia Hemans, for example, epitomizes her ambivalence about the literary marketplace when she comments that writing is defined by an impossible struggle with language: "do not words faint and fail?" she asks. In a massive displacement of—and highly conventionalized protest against—a cultural predicament, Hemans decides that the aspiring soul will find its voice only in heaven, where, "Powerless no

more," "Vainly it shall not strive ... on weak words to pour a stream of fire. ..."[26] Such ambivalences leave feminist critics of romantic writing in a somewhat precarious position. It is possible, of course, to revalue the usually didactic, devotional, or sentimental writing of many women writers of the period, to insist, with Hannah More, that they constitute a separate (and perhaps more socially valuable) realm of letters than that practiced by men. It is possible, alternatively, to refuse that imaginary community and to focus, instead, on how "woman" is a necessary figure of inarticulation in the (more legitimate) productions by William Wordsworth and his literary allies. Yet it is worth remembering that Ann Yearsley, Dorothy Wordsworth, and other late eighteenth-century women are neither Dorothy's Highlanders nor her singers at the Staubbach falls. Instead, their works are symptomatic of struggles within literary culture to police, protect, and promote the bounds of literariness itself. The specific social character of these struggles is often obscured, albeit in different ways, by contemporary neo-formalist and feminist analyses that reify the figure of inarticulation in attempts to identify, define, or revalue romantic writing. We hope to have suggested, alternatively, that to enter into debates about the moral or literary value of women's writing while using the sublime as a norm, even when that norm is challenged, could be simply to reproduce, yet again, the notion of an official literary language, and with it the ideological tensions that such an effort undoubtedly implies. As Bourdieu puts a similar idea, the struggles among writers—and critics, one assumes—over the protocols of literariness "contribute, through their very existence, to producing both the legitimate language, defined by its distance from the 'common language,' and belief in its legitimacy' (58). Given this, one wonders what would happen if we simply stopped playing the game of aesthetic mastery in relation to the sublime and focused, instead, on the social relations that the notions of mastery and competency both imply and help to reproduce.

NOTES

1. See Wordsworth, *George and Sarah Green—A Narrative* (1808). The *Narrative* indicates something of Dorothy's interest in literacy and popular education, and demonstrates the ways in which this interest intersects with the gendered ideology which states that it is the (educated) woman's duty to become a moral guardian of social stability by educating the poor. Not surprisingly, the *Narrative* also expresses many of Dorothy's misconceptions of the rural poor and popular literacy. To offer a suggestive example, while she is delighted that the Greens had encouraged the children "in the love of learning" (79), Dorothy inventories their various reading skills and decides that, as orphans to be put under the care of the more fortunate, they are now "likely to be better instructed in reading and writing" (87). It is as if being orphaned, and becoming servants or wards of the parish, suddenly gives these children an unexpected opportunity to be domesticated to the written word. Dorothy believes that the children

can now be *"instructed,"* not that they will be "instructed" *differently* than they would have been had their parents lived. On the relationship between woman's authority of the heart and her role in consolidating middle-class economic and cultural hegemony, see Armstrong. On the reading habits of the laboring classes, see Vincent 1989. On Wordsworth's *Narrative,* see Levin, 41–52; and Wolfson, 154–62.

2. Yearsley, "Brutus: A Fragment," in *The Rural Lyre:* ll. 291, 293, 295–96. The poem is an unfinished epic about an encounter between the Trojan Brutus and British "savages." It is also an obvious allegory of contemporary England and the civilizing influence the literate must exercise over the "savage" poor.

3. "To Mr. Raikes, on His Benevolent Scheme for Rescuing Poor Children from Vice and Misery, by Promoting Sunday Schools" (*Poems, on Several Occasions,* ll. 131–32, 130).

4. Our emphasis differs from that of critics who insist that when women writers recoil from the sublime, it is a *symptom* of their preoccupation with domesticity, community, the material, the near at hand, and the literal. These arguments reflect Carol Gilligan's continuing influence on romantic studies (see for example Homans, 40–67; and Alexander, 167–192). Anne K. Mellor makes a similar argument in *Romanticism and Gender:* women writers, she writes, contest "Burke's and Wordsworth's representations of the sublime as a moment of masculine empowerment over female nature" by "offering an alternative definition of the sublime as an experience that produces an intensified emotional and moral participation in a human community" (105). In contrast, our focus is not on romantic ontologies of nature, gender, and community but on the relationship among gender, class, and the cultural (re)production and circulation of literariness in texts by women, for whom the sublime is variously rendered and valued.

5. "Clifton Hill" (*Poems, On Several Occasions,* ll. 195–99).

6. For highly relevant discussion of the ideology of (imaginary) linguistic communities, see Pratt. Although space does not permit us to pursue the point, Pratt's observation that "modern linguistics of language, code, and competence posits a unified and homogeneous social world in which language exists as a shared patrimony—as a device, precisely, for imagining community" (50) can be applied to romantic efforts to assign to language the power to fashion a unified national, moral, and cultural community. Olivia Smith has begun such a study in *The Politics of Language,* without, however, addressing the kinds of theoretical questions raised by writers such as Pratt.

7. Since the late 1970s and early 1980s, historians have begun to define literacy as "a cultural form, a social product whose shape and influence depends upon prior political and ideological factors" (Street, 96). Street summarizes a series of developments which led historians to consider the social variables conditioning not only the acquisition of literacy but the cultural and political values with which it is associated. Of chief importance in the development of this "ideological model" of literacy is Graff (1979); see also Street, 95–125. Also of significance are Scribner and Cole, who argue that the cognitive effects usually attributed to literacy are more probably due to *schooling.* The field is a large and vexed one, but for a selected list of useful commentaries see Houston (1983), Graff (1987, 1988), and Stephens. In addition, for studies of literacy rates in the period we are covering, see Stone (1969) and Schofield (1968, 1973). Finally, for an examination of literacy rates and their relationship to educational provision in Bristol, Yearsley's (and More's) place of residence, see Campbell.

8. Thomas W. Laqueur observes that "For most people before the mid-nineteenth century, literacy was not the inevitable product of schooling; nor was non-literacy a necessary consequence of its absence" (1983, 45). Following Laqueur's insistence that scholars must be sensitive to the cultural codes and practices organizing the acquisition of literacy, we suggest that Yearsley's education and reading practices illustrate De

Certeau's observation that popular culture develops improvisational, largely tactical ways of gaining access to both the technologies and the artifacts of dominant culture (29–44, 165–76). For studies of working-class reading habits in this period, see Laqueur, "Cultural Origins," Vincent (1981, 1989), Stephens, and Reay. Finally, see Smith, who discusses the politics of literacy and the tactics of working-class self-education (156–59).

9. Sunday schools were by no means a unitary phenomenon with calculable ideological effects. For the argument that the Sunday school movement which took off in the 1780s was fueled in part by working-class involvement and demand, see Altick, 68, Laqueur ("Working Class Demand" and *Religion*), and—although he covers a somewhat later period—Hunter ("Setting Limits" and *Culture and Government*). On radical influence in the history of education, see Silver, 6–72. Alternatively, Johnson stresses the ways in which Sunday schools were morally regulative (48), while Sanderson stresses the relationship between Sunday schools and the formation of an industrialized workforce (9–23). For his part, E. P. Thompson remarks on the influence Sunday schools had upon radical political discourse and its "evocative language of the Old Testament" (50). On Sarah Trimmer and Anglican efforts to found an official school curriculum, see Goldstrom, 8–25. For useful summaries of the social, cultural, and political controversies surrounding the emergence of Sunday schools and popular literacy, see Katz, 383–90, and Kaestle.

10. The Sunday school movement is said to begin with a letter published by Robert Raikes in *The Gentleman's Magazine* 54 (1784). Interestingly, the first public notice of Yearsley's poetry also appeared in that journal in the same year (497). The correspondent makes a special effort to observe that "the language" of her poem on Sunday schools "estimated the high value of a human soul:—how much it merited such culture as might aid it to attain human happiness hereafter." Compare this to Raikes's statement that Sunday schools would inculcate "notices of duty, and practical habits of order and decorum, at an early stage" (412). Further analysis of the contexts of Yearsley's writing might proceed by examining the points of ideological contact and difference among Raikes's letter, Yearsley's poem dedicated to Raikes, and the anonymous letter on Yearsley's character that singles that poem out for praise.

11. From *Poems, On Several Occasions*.

12. Our reading of Yearsley's rhetoric of inarticulation is indebted to Landry's searching analysis of her poetry. For other valuable and sympathetic examinations of her work, see Klaus (1–21), Ferguson, Zionkowski, and Shiach (56–59). For the scholarly sources on Yearsley, including her conflict with More, see Tompkins, Ferguson, Waldron, and Landry.

13. "Remonstrance in the Platonic Shade, Flourishing on an Height" (*The Rural Lyre*, ll. 49–54).

14. *The Letters of William and Dorothy Wordsworth: The Early Years, 1787–1805*, 27, 30. Dorothy's interest in Sunday schools continued intermittently throughout her life. In 1811, for example, she gladly finds time to "encourage" local Sunday schools by lending her "occasional presence" in the classroom (*Letters of Dorothy and William Wordsworth: The Middle Years, Part I: 1806–1811*, 492 [cited hereafter in the text as *MY*, I]). To remark another, related illustration of her interest to educational schemes, in 1814 Dorothy remarks approvingly that Mary Hutchinson, the wife of Tom Hutchinson, is running a private school "on Dr. Bell's plan" (i.e., Dr. Andrew Bell, the educational reformer whose system also appealed to William Wordsworth). Significantly, Dorothy adds that Mary Hutchinson is "well fitted for the duty of instruction by Books, and all other cares belonging to children," thereby indicating the close ideological association between concepts of femininity, women's social function, and their duty to educate poor children (*Letters of Dorothy and William Wordsworth: The Middle Years, Part II: 1812–1820*, 162).

15. "Irregular Verses" ("The Collected Poems of Dorothy Wordsworth," ll. 60–69).

16. For Bourdieu, "intimidation" is a "symbolic violence which is not aware of what it is." Since it "can only be exerted on a person predisposed (in his habitus) to feel it," its cause lies not in an individual but "in the relation between the situation or the intimidating person (who may deny any intimidating intention) and the person intimidated, or rather, between the social conditions of production of each of them" (51). To analyze the "intimidation" of a particular female writer, from this perspective, is to replace considerations of personal psychology with those of social structure.

17. Levin observes that Wordsworth's writing is "frequently in line with the attitudes and diction of writers on the sublime and picturesque" (13). See also Nabholtz, and Woof (24–25). For a valuable critique of Bermingham, see Michasiw. Of special interest here are Michasiw's remarks on the deliberate artificiality of Gilpin's picturesque. Gilpin, Michasiw insists, consciously produced a set of arbitrary rules of aesthetic practice, rules which could be reproduced by any literate person (92). Michasiw does not, however, consider the possibility that "literate" and "literacy" are themselves ideologically overdetermined terms.

18. *The Prelude* (1805), V:398, 401, 406–409.

19. "The text" Dorothy attributes to William in this passage—"containing in itself," as she writes, "the whole history of the Highlander's life," including "his melancholy, his superstition" and "visionariness which results from a communion with the unwordliness of nature"—is more than an example of William's propensity for transforming solitary Highlanders into emblems of sublime ideality. It is also an example of his penchant for interpreting Highland life on the basis of prior reading, since this "text" is in fact an inter-text based upon a note to the fourth book of Ossian's *Temora*. Here Macpherson explains that local methods of cattle tending often forced Highlanders to sleep in the open "amidst the whistling of winds, and the roar of waterfalls. The gloominiess of the scenes around them was apt to beget that melancholy disposition of mind, which most readily receives impression of the extraordinary and supernatural kind" (quoted in Landon, 363). Many details of Macpherson's note are repeated in the "text" Dorothy records here, including the presence of cattle herders amid the "gloominess" of Highland nature, and the Highlander's predisposition to melancholy superstition, and a supernatural visionariness. As is well known, the "Solitary Reaper," another of William's idealized emblems of Highland melancholy, is based upon a prior text, namely, the passage of Thomas Wilkinson's *Tours to the British Mountains* (London, 1824), where he describes a solitary Highland reaper singing in Erse: "the sweetest human voice I ever heard: her strains were tenderly melancholy, and felt delicious, long after they were heard no more" (12). William of course knew Wilkinson and had read this text before writing the poem.

20. On schooling, literacy, and fate of Gaelic see Durkacz (1978, 1983), MacKinnon (127–29), Houston (1985), Stephens (555–57), and Withers (57–271).

21. See also Jones, who argues that in the later eighteenth century the largest numbers of book buyers among the Scottish laboring classes resided in the southwest and the Borders (35).

22. The revised poem "On Approaching the Staub-bach, Lauterbrunnen" was published in 1822. See *Poetical Works*, III:171.

23. The lines Dorothy quotes were published in 1819 in a note to *A Tale of Paraguay*, Canto III (Southey, *Poetical Works*, II:125). Southey's note includes the first (unpublished) version of William's sonnet in addition to William's brief prose description of the same event.

24. See *A Tale of Paraguay* (*Poetical Works*, VII: Canto III, stanzas 35–39).

25. Although her poetry was reviewed favorably (Tompkins, 89), writers far into the 1850s echo the view of her recorded here. Cottle remarks that had she been educated, "there is no limiting the distinction to which she might have attained" (I:70), while an anonymous reviewer writes in 1855 that her poetry presents the equally sublime and ridiculous spectacle of a "mind conscious of extraordinary powers vainly

struggling to surmount the barriers of ignorance" (*Chambers Journal* 24 [1855]: 302. This source has not been previously located; it is reprinted in the *Eclectic Magazine* 37 [1856]: 396). Southey suggests that she died "deranged" by this conflict (*Uneducated Poets,* 134). For similar estimates of Yearsley's poetry, see, for example, Tompkins (69), Curran (199), and Waldron (319).

26. Hemans, "A Thought of the Future," from *The Complete Works,* II: 296, 297.

WORKS CITED

Alexander, Meena. *Women in Romanticism.* Maryland: Barnes & Noble, 1989.

Altick, Richard D. *The English Common Reader.* Chicago: University of Chicago Press, 1957.

Anonymous. "Letter on the Character of Mrs. Yearsley." *Gentleman's Magazine* 54 (1784): 497.

Anonymous. "The Bristol Milkwoman." *Chambers Journal* 24 (1855): 300–303. Rpt. as "An Historical Milkwoman." *Eclectic Magazine* 37 (1856): 393–98.

Armstrong, Nancy. *Desire and Domestic Fiction: A Political History of the Novel.* New York: Oxford University Press, 1987.

Barrell, John. *English Literature in History, 1730–80: An Equal, Wide Survey.* New York: St. Martin's Press, 1983.

———. *The Idea of Landscape and the Sense of Place, 1730–1840.* New York: Cambridge University Press, 1972.

Bermingham, Ann. *Landscape and Ideology: The English Rustic Tradition, 1740–1860.* Berkeley: University of California Press, 1986.

Bourdieu, Pierre. *Language and Symbolic Power,* ed. John B. Thompson, trans. Gino Raymond and Matthew Adamson. Cambridge, MA: Harvard University Press, 1991.

Campbell, John. "Occupation and Literacy in Bristol and Gloucestershire, 1755–1870." In *Studies in the History of Literacy: England and North America,* ed. W. B. Stephens. Leeds: University of Leeds, 1983, 20–36.

Cole, Michael, and Sylvia Scribner. *The Psychology of Literacy.* Cambridge, MA: Harvard University Press, 1981.

Cottle, Joseph. *Early Recollections.* 2 vols. London, 1837.

Curran, Stuart. "Romantic Poetry: The I Altered." In *Romanticism and Feminism,* ed. Mellor, 185–207.

De Certeau, Michael. *The Practice of Everyday Life,* trans. Steven Rendall. Berkeley: University of California Press, 1984.

De Quincey, Thomas. *Recollections of the Lakes and the Lake Poets,* ed. David Wright. New York: Penguin, 1970.

Durkacz, Victor Edward. *The Decline of the Celtic Languages: A Study of Linguistic and Cultural Conflict in Scotland, Wales and Ireland from the Reformation to the Twentieth Century.* Edinburgh: John Donald Publishers, Ltd., 1983.

———. "The Source of the Language Problem in Scottish Education." *Scottish Historical Review* 57 (1978): 28–39.

Ferguson, Moira. "Resistance and Power in the Life and Writings of Ann Yearsley." *The Eighteenth Century* 27 (Fall 1986): 247–68.

Goldstrom, J. M. *The Social Content of Education, 1808–1870: A Study of the Working Class School Reader in England and Ireland.* Shannon, Ireland: Irish University Press, 1972.

Graff, Harvey J. "Whither the History of Literacy? The Future of the Past." *Communication* 11 (1988): 5–22.

———. "Reflections on the History of Literacy: Overview, Critique, and Proposals."

In *The Labyrinths of Literacy: Reflections on Literacy Past and Present.* New York: The Falmer Press, 1987, 15–43.

———. *The Literacy Myth: Literacy and Social Structure in the Nineteenth-Century City.* New York: Academic Press, 1979.

Hechter, Michael. *Internal Colonialism: The Celtic Fringe in British National Development, 1536–1966.* Berkeley: University of California Press, 1975.

Hemans, Felicia. *The Complete Works of Mrs. Hemans.* 2 vols. Philadelphia: Geo. S. Appleton, 1845.

Homans, Margaret. *Bearing the Word: Language and Female Experience in Nineteenth-Century Women's Writing.* Chicago: University of Chicago Press, 1986.

Houston, Robert Allan. *Scottish Literacy and the Scottish Identity: Literacy and Society in Scotland and Northern England 1600–1800.* New York: Cambridge University Press, 1985.

———. "Literacy and Society in the West, 1500–1850." *Social History* 8 (1983): 269–93.

Hunter, Ian. "Aesthetics and Cultural Studies." In *Cultural Studies,* ed. Lawrence Grossberg, Cary Nelson, and Paula Treichler. New York: Methuen, 1992, 347–67.

———. *Culture and Government: The Emergence of Literary Education.* New York: Macmillan, 1988.

———. "Setting Limits to Culture." *New Formations* 4 (1988): 103–23.

Jacobus, Mary. *Romanticism and Sexual Difference: Essays on The Prelude.* Oxford: Clarendon Press, 1989.

Johnson, Richard. "Notes on the Schooling of the English Working Class 1780–1850." In *Schooling and Capitalism: A Sociological Reader,* ed. Roger Dale, Geoff Esland, and Madeleine MacDonald. London: Routledge & Kegan Paul, 1976. 44–54.

Jones, R. E. "Book Owners in Eighteenth Century Scotland." *Local Population Studies* 23 (1979): 33–35.

Kaestle, Carl F. "Between the Scylla of Brutal Ignorance and the Charybdis of a Literary Education': Elite Attitudes toward Mass Schooling in Early Industrial England and America." In *Schooling and Society,* ed. Stone, 177–91.

Kant, Immanuel. *The Critique of Judgement,* trans. James Creed Meredith. Oxford: Clarendon Press, 1928.

Katz, Michael B. "The Origins of Public Education: A Reassessment." *History of Education Quarterly* 16 (1976): 381–407.

Klaus, H. Gustav. *The Literature of Labour: Two Hundred Years of Working-Class Writing.* New York: St. Martin's Press, 1985.

Landon, Carol. "Some Sidelights on *The Prelude.*" In *Bicentenary Wordsworth Studies,* ed. Jonathan Wordsworth and Beth Darlington. Ithaca: Cornell University Press, 1970, 359–76.

Landry, Donna. *The Muses of Resistance: Laboring-Class Women's Poetry in Britain, 1739–1796.* New York: Cambridge University Press, 1990.

Laqueur, Thomas W. "Toward a Cultural Ecology of Literacy in England, 1600–1850." In *Literacy in Historical Perspective,* ed. Daniel P. Resnick. Washington, D.C.: Library of Congress, 1983, 23–57.

———. "Working-Class Demand and the Growth of English Elementary Education, 1750–1850." In *Schooling and Society,* ed. Stone, 192–205.

———. "The Cultural Origins of Popular Literacy in England, 1500–1850." *Oxford Review of Education* 2 (1976): 255–75.

———. *Religion and Respectability, Sunday Schools and Working Class Culture, 1780–1850.* New Haven: Yale University Press, 1976.

Levin, Susan M. *Dorothy Wordsworth and Romanticism.* New Brunswick: Rutgers University Press, 1987.

Levine, David. "Education and Family Life in Early Industrial England." *Journal of Family History* 4 (1979): 368–80.

MacKinnon, Kenneth M. "Education and Social Control: The Case of Gaelic Scotland." *Scottish Educational Studies* 4 (1972): 125–37.

Mellor, Anne K. *Romanticism and Gender.* New York: Routledge, 1993.

———, ed. *Romanticism and Feminism.* Bloomington: Indiana University Press, 1988.

Michasiw, Kim Ian. "Nine Revisionist Theses on the Picturesque." *Representations* 38 (1992): 76–100.

More, Hannah. "Prefatory Letter to Mrs. Montagu." In Yearsley, *Poems on Several Occasions,* v–xvii.

———. *The Works of Hannah More.* 7 vols. New York: Harper & Brothers, 1836.

Nabholtz, John R. "Dorothy Wordsworth and the Picturesque." *Studies in Romanticism* 3 (1964): 118–28.

Pratt, Mary Louise. "Linguistic Utopias." In *The Linguistics of Writing: Arguments between Language and Literature,* ed. Nigel Fabb, Derek Attridge, Alan Durant, and Colin MacCabe. New York: Methuen, 1987, 48–66.

Raikes, Robert. "Letter on the Establishment of Sunday Schools." *Gentleman's Magazine* 54 (1784): 410–12.

Reay, Barry. "The Context and Meaning of Popular Literacy: Some Evidence from Nineteenth-Century Rural England." *Past and Present* 131 (1991): 89–129.

Roberts, William. *Memoirs of the Life and Correspondence of Mrs. Hannah More.* 2 vols. London, 1836.

Sanderson, Michael. *Education, Economic Change and Society in England.* London: Macmillan, 1983.

Schofield, R. S. "Dimensions of Illiteracy in England, 1750–1850." In *Literacy and Development in the West,* ed. Harvey J. Graff. New York: Cambridge University Press, 1982, 201–13. Also in *Explorations in Economic History* 10 (1973): 437-54.

———. "The Measurement of Literacy in Pre-Industrial England." In *Literacy in Traditional Societies,* ed. Jack Goody. New York: Cambridge University Press, 1968, 311–25.

Scribner, Sylvia, and Michael Cole. *The Psychology of Literacy.* Cambridge, MA: Harvard University Press, 1981.

Shiach, Morag. *Discourse on Popular Culture: Class Gender and History in Cultural Analysis, 1730 to the Present.* Stanford: Stanford University Press, 1989.

Silver, Harold. *English Education and the Radicals, 1780–1850.* Boston: Routledge & Kegan Paul, 1975.

Smith, Olivia. *The Politics of Language, 1791–1819.* Oxford: Clarendon Press, 1984.

Southey, Robert. *The Lives and Works of the Uneducated Poets,* ed. J. S. Childers. London: Humphrey Milford, 1925.

———. *The Poetical Works of Robert Southey.* 10 Volumes. Boston: Little, Brown & Co., 1844.

Stephens, W. B. "Literacy in England, Scotland, and Wales, 1500–1900." *History of Education Quarterly* 30 (1990): 545–71.

Stone, Lawrence. "Literacy and Education in England, 1640–1900." *Past and Present* 42 (1969): 69–139.

———, ed. *Schooling and Society: Studies in the History of Education.* Baltimore: Johns Hopkins University Press, 1976.

Street, Brian V. *Literacy in Theory and Practice.* New York: Cambridge University Press, 1984.

Thompson, E. P. *The Making of the English Working Class*. New York: Vintage, 1963.
Tompkins, J. M. S. "The Bristol Milkwoman." In *The Polite Marriage: Eighteenth-Century Essays*. New York: Cambridge University Press, 1938, 58–102.
Trimmer, Sarah. *Reflections upon the Education of Children in Charity Schools . . .* London, 1792.
———. *The Oeconomy of Charity*. London, 1787.
Vincent, David. *Literacy and Popular Culture England, 1750–1914*. New York: Cambridge University Press, 1989.
———. "The Decline of the Oral Tradition in Popular Culture." In *Popular Culture and Custom in Nineteenth-Century England*, ed. Robert D. Storch. New York: St. Martin's Press, 1982. 20–47.
———. *Bread, Knowledge, and Freedom: A Study of Nineteenth-Century Working Class Autobiography*. London: Europa Press, 1981.
Waldron, Mary. "Ann Yearsley and the Clifton Records." *The Age of Johnson: A Scholarly Annual* 3, ed. Paul J. Korshin. New York: AMS Press, 1990, 301–25.
Webb, Robert K. *The British Working Class Reader*. London: Unwin & Allen, 1955.
Weiskel, Thomas. *The Romantic Sublime: Studies in the Structure and Psychology of Transcendence*. Baltimore: Johns Hopkins University Press, 1976.
Williams, Raymond. *Marxism and Literature*. New York: Oxford University Press, 1977.
Withers, Charles W. J. *Gaelic Scotland: The Transformation of a Culture Region*. New York: Routledge, 1988.
Woof, Pamela. *Dorothy Wordsworth, Writer*. Grasmere: The Wordsworth Trust, 1988.
Wolfson, Susan. "Individual in Community: Dorothy Wordsworth in Conversation with William." In *Romanticism and Feminism*, ed. Mellor, 139–66.
Wordsworth, Dorothy. *Journals of Dorothy Wordsworth*. 2 vols., ed. Ernest de Sélincourt. London: MacMillan, 1952.
———. *George and Sarah Green—A Narrative*, ed. Ernest de Sélincourt. Oxford: Clarendon Press, 1936.
———. "The Collected Poems of Dorothy Wordsworth." Appended to Levin, *Dorothy Wordsworth and Romanticism*, 175–237.
Wordsworth, William. *Wordsworth's Guide to the Lakes*, ed. Ernest de Sélincourt. 1906. Rpt. New York: Oxford University Press, 1982.
———. *The Prelude, 1799, 1805, 1850*, ed. Jonathan Wordsworth, M. H. Abrams, and Stephen Gill. New York: Norton, 1979.
———. *The Poetical Works of William Wordsworth*. 5 vols. 1946. Rpt. Oxford: Clarendon Press, 1968.
Wordsworth, William, and Dorothy Wordsworth. *The Letters of William and Dorothy Wordsworth: The Early Years, 1787–1805*, ed. Ernest de Sélincourt. Rev. Chester L. Shaver. Oxford: Clarendon Press, 1967.
———. *Letters of Dorothy and William Wordsworth: The Middle Years, Part I: 1806–1811*, ed. Ernest de Sélincourt, revised Mary Moorman and Alan G. Hill. Oxford: Oxford University Press, 1970.
———. *Letters of Dorothy and William Wordsworth: The Middle Years, Part II: 1812–1820*, ed. Ernest de Sélincourt, revised Mary Moorman and Alan G. Hill. Oxford: Oxford University Press, 1970.
Yearsley, Ann. *Poems, On Several Occasions*. London, 1785.
———. *The Rural Lyre*. London, 1796.
Zionkowski, Linda. "Strategies of Containment: Stephen Duck, Ann Yearsley, and the Problem of Polite Culture." *Eighteenth-Century Life* 13 (1989): 91–108.

8

History, Imperialism, and the Aesthetics of the Beautiful

Hemans and the Post-Napoleonic Moment

NANORA SWEET

In describing the work of the poet, William Wordsworth used terms that would come to be especially compelling for the island empire that he eventually served as poet laureate: "The poet binds together by passion and knowledge the vast empire of human society as it is spread over the whole earth, and over all time."[1] Wordsworth's combination of sweep ("empire") and interiority ("passion and knowledge")—of imperial sublimity and a poet's local knowledge of valley and isle—has proved equally compelling for much criticism of romanticism since. The recent "criticism of consciousness" (I am thinking here especially of the work of Harold Bloom, Geoffrey Hartman, and Paul de Man) has retained both the sublime transcendence (however much a matter of negativity) and the patrimonial continuity (however convoluted by influence) that mark the Wordsworthian project.[2] Nonetheless, there were contemporary romantic projects that undermined the transcendence and disrupted the continuity of Wordsworthian romanticism; the work of the "later romantics," for instance, prefers the *international* to the insular, the *republican* to the imperial, and the *beautiful* to the sublime.

Current critical projects which concentrate on later romantic writers have in various ways contested Wordsworthian romanticism and begun to nudge romantic studies toward a version of literary history informed by the internationalist and anti-imperial poetics of the later romantics.[3] To the end of contesting the limits of romantic patrimony as well as of romantic insularity, I shall be examining here the poetics of their contemporary, Felicia Hemans (1793–1835). In the context of a romantic literary history marked, in the case

of Byron and Shelley, by critique and exile, Hemans represents a particularly challenging figure. Although she never left the British Isles, she is nonetheless displaced within them; an internal exile, she lived to see her internationalist critique of imperialism become rescheduled as nationalist Tory apologia.[4]

I

It was in particular the reactions of Byron to British policy in the years before and after Waterloo which set the terms for Hemans's work in the post-Napoleonic moment. In "The Curse of Minerva" (1812), for example, Byron denied that a militant Britain was necessarily morally superior to a militant France. After the Congress of Vienna, he and Shelley bitterly deplored England's collusion with the Holy Alliance and especially its collusion with a dynastic Hapsburg empire committed to enforcing Bourbon restoration and to suppressing republican revolt across Europe. Byron's critique of foreign policy was given further bite by his pointed advice to England to "look at home," "till it becomes ascertained that England has acquired something more than a permanent army and a suspended Habeas Corpus."[5]

In an era of sedition laws and "suspended Habeas Corpus," the political commentary of alienated writers was defensively couched in irony and conveyed through allusion. Byron's, and indeed Shelley's, evocations of classical and Italianate literature and culture, for instance, may be read as encoding their recognition of Greece and Italy as sites of imperial struggle between Austria, Britain, Turkey, and Russia.[6] For these two writers the particular legacy of the Greek and Italian city states is above all a *republicanism* that is superior to the unreformed constitution of the island empire; as a result, their references to Mediterranean culture generally serve to adumbrate republican values. When, in *Childe Harold's Pilgrimage* II, Byron publicly lambastes Lord Elgin for removing the Parthenon friezes to Britain, he is covertly deploying the incident to comment upon the struggle between the values of an imperialist Britain and those of the classical city state of Athens; as the privately printed "The Curse of Minerva" makes even clearer, Lord Elgin's misdeed is just the occasion for a much broader condemnation of Britain's wartime conduct. Here, Byron rails against Britain's conduct both abroad and at home, arguing specifically that, when it betrays allies and abuses its own people, Britain betrays its own (supposedly classical) heritage.

Byron's contemporary, Felicia Hemans, also debates Britain's role abroad and at home. More than Byron, more even than Shelley, Hemans works to direct British consciousness away from imperial modes and insular destinies toward a model of history that defeats the imperial project. Although, like Byron, she couches her political commentary in classical and Italianate terms, she adopts in particular a Mediterranean aesthetics of the beautiful whose instability and productivity work against the sublimity of monument and empire, whether these are associated with Paris, Rome, Athens, or London.

This aesthetics of history and its application within the contemporary moment was developed by Hemans in an energetic dialogue with her fellow poets.

To claim that Hemans actively participated in the contentious international-ist discourse of her times may come as a surprise, for the prevailing view of her in the twentieth century has been of an effusive lyricist writing in sorrowful seclusion.[7] However, a brief account of Hemans's life and work will suggest that even while writing in near-retirement in Wales, Liverpool, and Dublin, Hemans could and did marshal the resources for a politically attuned and internationalist poetic project.[8]

Felicia Dorothea Browne was born in 1793 to a mother who claimed to be of Italian and German ancestry and a merchant father who for a time was the "imperial and Tuscan consul" in Liverpool. Her father's business failing, the family relocated in north Wales—her father emigrated to Canada soon after. Except during her first year of marriage (1812), Hemans lived until she was thirty-four in her mother's book-filled home. From that setting, her three brothers were steered toward diplomatic and colonial careers; she and her sister Harriet were expected to write, compose, and publish. In her youth, Hemans learned Italian, French, Spanish, and Portuguese, to which as an adult she added Latin and German, eventually publishing poetry translated from all six languages.[9]

From the beginning of her writing career, Hemans showed herself an ener-getic commentator on the international scene. In one of her three juvenile volumes, *England and Spain* (1812), she portrays the glories and the geopoli-tics of the Peninsular War.[10] In 1816 her first mature work, *The Restoration of the Works of Art to Italy,* appeared, a response to the sculptor Canova's recovery of some part of the artwork that Napoleon had taken from Italy to the Louvre. During the five years after Waterloo, Hemans wrote further odes and "triumphs" in a similar occasional vein. So enthusiastically were these political poems received, especially by the Tory press, that Stuart Curran has recently suggested that it might be appropriate to view Hemans as a Regency laureate *manqué.*[11]

In the age of Southey, a laureate, whether official or unofficial, may seem alto-gether very similar to an apologist. For Hemans and her contemporaries Shelley and Germaine de Staël, however, the laureate tradition included the often cultur-ally critical work of Sappho, Pindar, Horace, Petrarch, Camoens, and Lope de Vega: Hemans's *Translations from Camoens, and Other Poets* (1818) and her later "Translations from Horace" demonstrate the active interest she took in these figures and in the tradition of the ode more generally. Not one of monologic apology, this is a tradition of address to victors and rulers that makes a duality of tone its speciality; for Hemans, this double-voiced laureate tradition offered critical resources to a woman poet who found herself both placed and displaced, both enclosed in the culture and disenfranchised by it.[12]

If Hemans produced a flow of laureate-like poetry in the post-Napoleonic moment, she also, and more critically, addressed the dispositions of empire

and studied the means of resistance to it. From 1819 to 1823 she published in narrative and drama a body of work keyed to a new moment in history—the republican revolts in Greece and elsewhere of 1820 to 1821. With 1823 came new projects—ballad and song cycles in a variety of politically charged settings (such as "Greek Songs" [1823]). Numerous miscellaneous lyrics began appearing from her pen, published most often in *Blackwood's Edinburgh Magazine* and, increasingly, in *The New Monthly Magazine* and verse annuals. In this work she assessed the adequacy of republican forms as well as imperial ones in terms of their handling of women's interests, depicting Britain's empire less as glorious military expansion than as a dispersion of exiles into a new world with its abundance of watery graves.[13]

Hemans's critique of empire and parallel espousal of Continental cosmopolitanism is underpinned by one early nineteenth-century Continental project in particular, the disseminative, recreative work of Germaine de Staël's circle at Coppet. Most important for the early Hemans were de Staël's novel *Corinne* (1807) and critical work *De l'Allemagne* (1813), books that reread—from a woman's point of view—Italian and German culture as part of a North-South dialectics.[14] In particular, *Corinne* offered a model of the woman laureate in de Staël's heroine, crowned at Rome's Capitol in the tradition of Petrarch. This woman laureate came to represent a powerfully enabling figure, not only for Hemans (who wrote of Corinne, "C'est moi"—Chorley I:304) but for Margaret Fuller, Lady Sydney Morgan, Elizabeth Barrett Browning, and other nineteenth-century woman writers.

Like Hemans, Corinne combines in her heterodox identity (English and Italian, by birth and by domicile) powerful Britain and defenseless Italy; her odes, like Pindar's, are accordingly double-voiced—glory and defeat are inextricably involved. In the novel as a whole, a debate unfolds between the "romantic" and the "classical," the term *romantic* meaning northern, English, austere, monumental, imperial, and masculine, the term *classical* meaning southern, Italian, refulgent, fragmented, post-imperial, and feminine. The novel's lovers Oswald and Corinne dramatize this dialectic: the Englishman Oswald is austere and heroic, yet debilitated by his father's disapproval and, once seduced by Corinne, forever in her control; Corinne, on the other hand, is demonstrative and magnetic, but the England that cannot accommodate her ambitions and abilities has exiled her, and for the love of an Englishman she will lose salon, career, and life—although not before she suborns Oswald's wife and daughter.

In her dramatization of a struggle between a heroic but vulnerable sublimity and a vulnerable but powerful beauty, de Staël reopened the eighteenth-century debate between the sublime and the beautiful. Whereas Edmund Burke in his *Enquiry into the Origins of Our Ideas of the Sublime and Beautiful* (1757) had favored a masculine, powerful sublimity over an enfeebled, feminine beautiful, de Staël newly located a destabilizing and critical power in the beautiful. Although other European intellectuals (including, of course, Kant)

had shown renewed interest in this aesthetic debate, it was de Staël who privileged the feminine beautiful as an instrument of a woman's aesthetics; and while others among Hemans's British contemporaries reworked the inter-actions of beauty and sublimity (Byron in Cantos 3 and 4 of *Childe Harold's Pilgrimage,* Shelley in his "Hymn to Intellectual Beauty" and "Mont Blanc," Keats in his poems and letters),[15] it was Hemans who, more than any of her contemporaries, followed up de Staël's lead, committing herself to the beauti-ful as an aesthetics of real historical force.

As the argument developed by de Staël and Hemans runs, the experience of woman in history is one of displacement into marriage or exile outside it. Hemans's work is full of instances of women for whom marriage at best is removal into an uncertain sanctuary and at worst is exposure to rapine: "The Bride of the Greek Isle" (1828), "The Wife of Asdrubal" (1819), and "The Widow of Crescentius" (1819). Corinne's repeated exiles and her loss of ca-reer, on the other hand, show the instability that awaits a woman who refuses marriage. At the level of nation this logic of feminization within history also operates: experience of exile and even rapine mark postimperial Italy as well, which has become in consequence a conquered, fragmented, feminized land. If Italy's crumbling ruins and lush vegetation signal its feminine character, more insidiously they signal its power to feminize, to seduce sublimity and monumentality to its historical end as Corinne included Oswald in hers. In *Corinne*—and in Hemans's poetry—feminization is the condition to which we all come, male and female, conqueror and conquered.

In the writings of de Staël and Hemans the beautiful as an aesthetics of history is figured as the flower, the fragmented artwork, and the processional. Since Sappho, the broken or crushed flower has been associated with the feminine,[16] conjuring up more generally the floral and its ambience, its hues and scents and the breezes of the Mediterranean South. Characterized by a shifting spectrum of "hues" and by a cycle of growth, destruction, and resur-gence, a floral aesthetic suggests not only fragility but also a productivity and recurrence available in history and for consciousness. Another key emblem is the fragmented, plundered artwork which transfuses this consciousness of history from the Mediterranean to France and Britain. Yet other emblems include Corinne's participation in and love of civic and religious processional. Processionals enact a continuity of evanescence itself; and Hemans consis-tently embraces the processional as an emblem of temporality. Its sign is the varicolored banner, its literary form the ode-like "triumph" poem. If the target of de Staël's cultural criticism as embodied in these pervasive images was Napoleon's empire, the object of Hemans's would be the attempt by the Holy Alliance and Britain to restore dynasty and consolidate international influence.

II

In the years after Waterloo, *restoration* came to be a term of ambiguous meaning. Imagined as referring to the "Restoration" of the powers of the

Bourbon monarchy extending across France, Spain, and southern Italy, it was clearly a reactionary term; imagined as the restoration of classical culture, however, it could have either reactionary or liberal resonance—on the one hand, Papal archaeological recovery was called "Restoration," but on the other, the "restoration" of classical culture in Italy and Greece signified, for Byron at least, a liberal, republican revolution that he would fund with his goods and ultimately with his life.[17]

Hemans herself radically questioned *all* "restorations" of monumental classical culture, whether Papal or Byronic, imperial or republican, by adopting a Staëlien view of history. Her goal was not the restoration of sublime monumentality but the recuperation of the productivity of the beautiful. In her *Restoration of the Works of Art to Italy* (1816) and *Modern Greece* (1817), Hemans argues for an alternative understanding of history as fragmentation, evanescence, and feminization. (*Restoration* was read and enjoyed by Byron, who wrote John Murray that it was "a good poem—very," apparently failing to sense its demurral from his views.[18] Hemans's poem exerted enough pressure upon Byron's poetic practice to appear generously adapted in the Italian canto of *Childe Harold* begun in the spring of 1817.) In her first "triumph" poem, the 500-line *The Restoration of the Works of Art to Italy,* Hemans portrays the return of classical artifacts carried off by Napoleon.[19] The poem thus declares as its subject the restoration of classical culture—but in the equivocating tradition of the ode, it both celebrates and questions this restoration. Echoing and revising "The Curse of Minerva" in numerous ways (as in its opening panoramas and personification of Florence as the "Athens of Italy"), *Restoration* establishes Hemans's gendered aesthetics of history: there, Italian history is read as feminization and even rapine; Britain's war dead in Italy are treated non-monumentally; classical artwork and culture are permanently destabilized; and a consciousness of history flows from the breakage of this art and the energy associated with its removal.

The epigraph and headnote to *Restoration* establish the gendered terms of this history. Hemans's epigraph quotes (in Italian) the first five lines of a sonnet by the seventeenth-century Italian patriot-poet, Vincenzo da Filicaja. (Byron will use a redaction of the Filicaja sonnet in *Childe Harold* IV: 42–43.) Hemans's translation of this sonnet appears in her collection, published in 1818, where the lines read:

> Italia! thou, by lavish Nature graced
> With ill-starred beauty, which to thee hath been
> A fatal dowry, whose effects are traced
> In the deep sorrows graven on thy mien;
> Oh! that more strength, or fewer charms were thine.[20]

In Hemans's *Restoration,* the "charms" of Italy are the now-plundered works of art; they are what renders her liable, like women, to exchange and sexual aggression. The poem's headnote from John Chetwode Eustace's *A Classical*

Tour through Italy (1802) further accentuates the quasi-sexual violence entailed in Napoleon's removals, claiming as it does that Napoleon's greed surpassed "the rapacity of the Goths and Vandals." In the poem that follows, Italy becomes a "fallen" and "lost, lovely realm" (12–13); as a fallen woman, Italy can never be restored to her original value and so the possibility of "restoration" is undermined before the poem is fairly under way. Nor are the British champions of beautiful Italy, for their part, granted any enduring monuments in this land of "myrtle vale," "laurel grove," and "proud wreck of vanished power" (10–24). No "urn" will mark their gallant deeds, "no sculptured trophy rise" (62, 68). "A prouder sepulchre" must satisfy, "—the field ye won!": "well may flowers suffice those graves to crown" (64, 67). Not stone, but "every breeze" will bear "some name to glory dear" (74). History is registered, not on stone monuments, but in a transient show of flowers and on an evanescent breeze. The war dead remain unrestored to their native land.

Although in the main business of the poem the trophies of Italian art are returned to Florence, Venice, and Rome, they cannot be *restored:* as plunder now, they will never be restabilized. They are instead suspended, according to Hemans, in a feminine "veil of radiance" suffused with the beauty and deceptiveness that are associated with the feminine: "Those precious trophies o'er thy realms . . . throw"

> A veil of radiance, hiding half thy woe,
> And bid the stranger for a while forget
> How deep thy fall, and deem thee glorious yet. (89–92)

This equivocal veil "half" hides Italy's irretrievable (because sexual) fall. Next, Hemans extends this "fall" to the classical world as a whole, to the privileged locus, that is, of Western history.

Italy's artwork, after all, was itself plundered long ago from elsewhere in the Mediterranean world. The famous horses of St. Mark's, the poem points out, were booty "from Byzantium's lost domain." Images of mobility in themselves, they have been "from clime to clime by conquest borne,/ Each fleeting triumph destined to adorn" (259–67). From the mobility of these trophies, the poem teases out a sense of history as record of the mutability of empire:

> How many a state, whose pillar'd strength sublime,
> Defied the storms of war, the waves of time,
> Towering o'er earth majestic and alone,
> Fortress of power—has flourish'd and is gone! (255–58)

Imperial history (that "pillar'd strength sublime") is actually subject to continual evanescence, and the migratory artwork is the sign of that discontinuity, a prize that is the knowledge of its prizing. Turning from Venice to Rome,

Hemans points out that, after all, classical Rome itself had originally imported *its* famous statuary from Greece.

With its varied freight of celebration and valediction, praise and dismissal, Hemans's equivocal poem comes itself to function as the deceptive veil of feminization; in the process, a new and energetic consciousness accumulates. The trophies' "veil of radiance," the vibrant horses of St. Mark's, the art of Rome—these have a role in historical consciousness beyond that of any particular "state" of "pillar'd strength sublime." As imperial plunder, they encode the passing of an Athens "who never shall return!" (386–88). As ruined beauty, they associate a knowledge of history with the feminine. As fragments rather than intact monuments, from their fractured surfaces they pour forth "beauty" or "radiance" as though from the facets of "matchless gems" (150–52, 156, 369–70). This "beauty"—or knowledge of history—not only casts doubt on imperial ventures and confirms the moderns' feminization in history but, above all, offers the possibility of a newly productive consciousness.

Restoration closes, as will *Modern Greece*, with a carefully worked processional in which artifactual history is parlayed into temporality, a process which reworks dissolution into new consciousness. The poem itself closes in praise of the "pictured glories" of Raphael's art; but, undercutting this gesture, Hemans's last textual note evokes a specific painting, Raphael's famously never-finished *Transfiguration*, and contextualizes it within historical process—specifically, within a funeral procession: "it was carried before his body to the grave" (467, 504, 516; 108n.6). Here the hues of the beautiful lead the way across the threshold of death, their incompletion, motion, and multiplicity leading not to "restoration" but, in Raphael's term, to "transfiguration."

Modern Greece, a poem of over 1,000 lines and forty-four footnotes, brought Hemans into confrontation with Byron over the question of the government's purchase of the Elgin marbles (a question which came before Parliament in 1816—several of Hemans's notes cite from the Parliamentary hearings): this poem Byron did *not* like (*BLJ*, V:262).[21] We should not be surprised, given the tenor of her work in *Restoration*, that Hemans would find the marbles' displacement to England both inevitable and somehow desirable. Before declaring this position, she takes her poem on a leisurely progress through a "modern Greece," arguing the case that Greece's history (like Italy's) is best figured in a beauty floral and feminine—what survives "empires" is "verdure and flowers" (27, 76). Hemans reserves her most subversive aesthetic commentary for Sparta and Athens, the best-known sites of ancient Greek culture. Sparta's ruins she describes as "very inconsiderable," in her text and notes smothering these remains in flora: "fruitful groves," olive branches, myrtle, roses, rose-laurels, lilies, tuberoses, hyacinths, and "narcissus orientalis" (stanzas 58–59; 170nn. 24, 26). Here Hemans is at her most dismissive: "Oh! thus it is with man—a tree, a flower,/ While nations perish, still renews its race" (63). Once in Athens, Hemans prepares to show her hand

on the Elgin marbles by establishing two powerful arguments. The first again refuses Byron's ideal of classical restoration: the "Athens" of classical Greece, Hemans argues, simply no longer exists, living only in "Fancy's vivid hues," or at most in the "tints" of pencil drawings such as those attempted by Elgin's preservationist predecessors (71). The best analogue to Byron's treasured Athens, Hemans proposes subversively, is the "fata Morgana," a many-hued, many-colonnaded optical illusion that appears intermittently off the coast of Sicily (73, 171n.33). Further, the current conquerors of Athens are immune to the effects of the ancient city's remaining "traces" of glory (82, 86), so "who may grieve," the poem asks, that Athens's relics have been rescued from such "rude insensate conquerors" and "borne to other lands" (88)?

Hemans's second argument is to do with the knowledge of history that plunder brings to today's empires. Simply put, it is Britain who now needs the transfusion of beauty and truth offered by these relics. As in *Restoration*, this "blooming" of truth is the result of fragmentation; and tropes of the floral and of the fragmented interact in this passage:

> As vital fragrance breathes from every part
> Of the crush'd myrtle, or the bruisèd rose,
> E'en thus the essential energy of art
> There in each wreck imperishably glows! (91)

The truth that the marbles will transfuse into British consciousness is that of history's breakage, or, simply, of history. Notoriously resistant to its own feminization, Britain has heretofore, according to Hemans, maintained a climate of "cold neglect" toward the arts. The Elgin marbles might instead "call ... to life" the "rich blooms" of some British "Genius" (100–101). Allowed to move across national borders, art permits the "bright flame" of knowledge to pass from a Florentine to a "British Angelo" (99).

As a sign of this fleeting but recurrent knowledge, Hemans again closes her triumph poem with a processional. She recalls that the "marbles" themselves form a processional:

> Mark—on the storied frieze the graceful train,
> The holy festival's triumphal throng,
> In fair procession, to Minerva's fane. (92)

Tinting the friezes, Hemans gives this procession "every shade of bright existence." The multicolored and transitory art of processional in which the marbles are now suspended resembles the "veil of radiance" in which the Italian "trophies" float. Indeed, "Minerva's veil" had been the banner of an ancient processional to and from the Parthenon. This veil or awning is now "rent"; but Hemans supplies a note describing an ancient "Panatheniac" processional in which the awning "embroidered with various colors" is carried about the

Acropolis and then returned and reconsecrated. This many-colored, fragile, and feminine "veil" might better represent the aesthetic that Greece bequeaths, Hemans suggests, than might an attempted restoration of stone.

III

In subsequent poems, Hemans argues further that feminization of national consciousness can produce both the nurturing national identity and the sustaining domestic institutions that monumentality fails to provide. In her royal odes of 1817 and 1820, Hemans probes the decay of Britain's monarchy for these new, more nourishing resources to regenerate the nation. In her two odes on deaths in the royal family and in several occasional poems on national issues, Hemans puts her aesthetic of feminization to work on domestic institutions. Her "Stanzas on the Death of Princess Charlotte" (1817) opens with a festival-funeral trope refashioned from Horace's *carpe diem* motif, juxtaposing a celebration of Britain's victory over Napoleon with an elegy for the disruption of British dynasty represented by the princess's death in childbed. In this poem and in the later *Stanzas to the Memory of the Late King* (1820), Hemans also unsettles her account of the postwar celebrations of Britain's international might with an evocation of the madness and death of the king; while "sceptered chieftains throng'd with palms to hail/ The crowning isle," and "Within thy palaces the lords of earth/ Met to rejoice" (73–76), this king is an exile at home.

In these poems Hemans persistently depicts George III as a feminized ruler who nurtures his people from his own decay.[22] The feminization of this king, the refiguration of the British oak as breast-feeding mother, signals a new and nourishing historical consciousness. A "shattered tree" or "blasted oak," he offers "Fresh nurture from [his] deep decay" to the "tendrils of our love" (21–30). In this baroque image of maternity, Hemans revises the *caritas Romana* of *Childe Harold* IV:148–51: there a young woman feeds her aged, imprisoned father from the "vein" of her "unmantled neck." The king's rich "stream of thought, though broken" is Hemans's fullest example yet of the productivity of her aesthetics: "The mind hath sense of its own,/ To people boundless worlds, in its most wandering hours."

As Hemans concludes her *Stanzas to the Memory of the Late King,* she wonders whether in death the king's eye ("one glance of tenderness") might be turned at last to earth (163). The answer: "Away, presumptuous thought!" (170). However, the reversal of vision proposed here will in fact take place in *Dartmoor* (1821), a double reversal that will permit a richly feminized consciousness to accumulate and become the site of new domestic institutions. In *Dartmoor* (1821), Hemans alternates history's bloodletting with its productivity, thickening her historical consciousness into the site for new institutions—ones safely beyond the imperial cycle of rise and fall. In this poem, historical depth and geopolitical breadth will undergird a vision of domestic

reform, in this instance a vision of the reconstruction of a French prisoner-of-war camp as a school for the "children of convicts" (176n.7).[23] *Dartmoor* frames this subject—set by the Royal Society of Literature for a prize of fifty guineas, a prize which Hemans actually won—by registering the death of Napoleon, opposing the Promethean politics of Byron and Shelley, and responding, however covertly, to the massacre at Peterloo.

The poem begins by reminding Britons that, while "empires tottered, and the earth was rent," their island has seemed immune from history, from "the spoiler" and the "stain of carnage" (3, 7, 10). But deep inside Britain at "Wild Dartmoor," "Hath Desolation reared herself a throne" (5, 17). Asking "Who shall unfold thine annals?" the poem clearly casts Hemans as the bard who will expose this discontinuity at the heart of Britain—a *desolation* in the sense of emptiness—that will be filled with a rich consciousness of the poem's own fashioning—a *desolation* in the sense of grief. In keeping with this version of desolation, the poem identifies the "cairns of yore, all rudely piled" (51–52) as Dartmoor's "memorials" (51–52). These almost unnoticed monuments are "chronicles of death," not this time evidences of invasion or conquest, but of civil, or domestic, force (63, 73–85). Yonder "altar of unsculptured stone . . ." "propped [Stonehenge-like] on its granite pillars" was, the poem speculates, the site of Druid sacrifice (87–89, 103).[24] Here a sublime "savage grandeur" sought to appease "the war-gods of the North" (103–106). Human sacrifice, like the crushing of the flower and the plunder of Greek art, is a vascular accident of history: the question is whether these accidents can be recuperated. As Hemans develops the scene in some detail, it appears that the victim's blood ebbs into the soil and the transfusion of knowledge fails:

> With faint and fainter moan
> Bound on the shrine of sacrifice he lay,
> Till, drop by drop, life's current ebbed away;
> Till rock and turf grew deeply, darkly red. (114–17)

The transfusion of knowledge available in previous poems from the carnage of art and consciousness here seems to fail, and the discontinuity of history initially suggested by Dartmoor seems confirmed. However, Hemans then turns to an implicit comparison between that ancient rite and the recent war abroad, which, like the Druidic sacrifice of Dartmoor, "drank/ The life blood of her heroes" (133–34). Is history continuous after all, merely displaced overseas? Once again the sign of this history is not sublime monumentality but the floral beauty of victimage, "the wild flowers . . . in luxuriant beauty, o'er their grave" (135–36). In this displacement are the sources of a reversal that will harness Hemans's aesthetic of history to the tasks of social change.

Ironically, while British soldiers die abroad, their foreign enemies live—imprisoned in Britain on Dartmoor. In the poem, the victimizing, feminizing

displacements of history are refracted back and forth between England and the Continent in a reversal or mirroring that allows historical consciousness to accrue. Thanks as well to the dynamics added by the whirligig of Napoleon's ambition (139–42), *Dartmoor* achieves the reversal that failed in the ode on the king. While British soldiers abroad bleed, the French imprisoned in England dream of their home (138, 143–69) or grow inflamed with fiery thoughts, or laugh in "strange and savage mirth." The shift at Dartmoor is from physical bleeding to the letting of a painful subjectivity into barren space. The building of consciousness continues: "deeper thoughts" of "guilt" and "Remorse" (171–76). Mute when "Havoc's train/ Crushed the red vintage of devoted Spain" (185–86), this deeper consciousness is now "gathering silent strength" (191), forming the private matter of "death-bed" scenes—perhaps even, the poem speculates, of the last "dark" moments of Napoleon, who died in May 1821 (223–28).

If earlier the poem confronted an apparent historical discontinuity with the real continuity of victimage, now, given the new energy of consciousness at Dartmoor, the poem dares to imagine that the chain of victimage might be broken. The "magic breath" of spring might beautify "bleak mountains," but more productive is the feminine figuration of "Peace" produced over Dartmoor (235ff.). Under "*Her* influence" Dartmoor is recuperated for domestic purposes, turned from a P.O.W. camp into a school to save the children of domestic "convicts" from the "captive's chain" (237–39). In essence, the remorseful consciousness of foreign captives has facilitated a disruption of social disadvantage at home. As evidence, the widow, always a sign of dispossession in Hemans, regains a home for her children; and the effect of this historical reversal glides on unchecked "from clime to clime" (245). The "hues" of childhood bloom uncrushed, fulfilling the biblical promise of "incense" or "perfume" that is not literal "sacrifice" (298–99).

Such, argues Hemans, must be the tenor of victory over the "crowned emperor" Napoleon who "trampled" the "world" (301, 311–18): not Byronic Titan-worship (319–24), but the nobler "strains" sponsored by biblical culture and the "beams of hope" from the stars who alone survive as witnesses of the Druids (335); not restoration of empire but the projection of a "temple in the silent waste" (344). Hemans hopes by a combination of discontinuity and displacement, by reversing contemporary understandings of the relations between geography, gender, and politics, to project new domestic institutions. She wishes not to deny history but to use a knowledge of it, a knowledge that she sees as gendered. For Hemans, history in an imperial era is best seen, not as stasis, monument, or monolith, but as displacement and dispersal—even discontinuity. The aesthetic that best figures such a history is one of evanescence, of fragility and fragmentation but also, and crucially, of a fluidity that is not, after all, discontinuous. Restoration is not possible, but, given the productive capacities of this aesthetic, recuperation is. Like women displaced from their childhood homes and then confined in marriage, soldiers learn of

history from a feminine position and, in their newly productive consciousness, participate in history's reconstruction.

In its idiosyncratic treatment of history, geography, gender, and politics, *Dartmoor* develops these possibilities as fully as any poem by Hemans. The fifty-guinea prize she received for it suggests the real but circumscribed value attached to this woman's attempt to play laureate to Britain's post-Napoleonic settlements. Hemans was welcomed by the Tory press as an ally against the dissident Whigs, but she was not heard as a powerfully monitory voice speaking to Tory governance as well.[25] Only in de Staël's novelistic "Italy," after all, could a woman be poet laureate. In the end, Hemans's work itself survived dispersed into lyrics that could be consumed (and they were, eagerly) for their plangent affect rather than read for their political analysis. It would seem that, like the artwork that can never truly be returned to Italy, the fate of her work serves instead to mark the traces of nineteenth-century imperialistic history. History changing as it does, however, it might be that in our own internationalist moment, we can again read Hemans's text simply because it does travel "from clime to clime," bringing its consciousness of exile into the heart of a (British or American) island empire.

NOTES

1. *The Prose Works of William Wordsworth*, ed. W. J. B. Owen and Jane Worthington Smyser, 3 vols. (Oxford: Clarendon, 1974), 141. This passage occurs in Wordsworth's preface to *Lyrical Ballads* as revised in 1802 or later.

2. See *Romanticism and Consciousness: Essays in Criticism*, ed. Harold Bloom (New York: Norton, 1970). For a recent discussion of this group's work as "genetic criticism," see Jonathan Arac, *Critical Genealogies: Historical Situations for Postmodern Literary Studies* (New York: Columbia UP, 1987), 11–56.

3. There are more important studies in this area than can be enumerated; exemplary texts are Jerome J. McGann, *The Romantic Ideology: A Critical Investigation* (Chicago: U of Chicago P, 1983); Marjorie Levinson, *Keats' Life of Allegory* (Oxford: Blackwell, 1988); and Marlon B. Ross, *The Contours of Masculine Desire: Romanticism and the Rise of Women's Poetry* (New York: Oxford, 1989).

4. It is both difficult and exciting to consider the term *nationalism* in the moment when it is emerging as a concept. Generally, I substitute for it in describing British and Mediterranean nationalism, respectively, the terms "island empire" and "postimperial" or "republican." For a provocative study of the emergence of nationalism in this moment, see Marlon B. Ross, "Romancing the Nation-State: The Poetics of Romantic Nationalism," *Macropolitics of Nineteenth-Century Literature: Nationalism, Exoticism, Imperialism*, ed. Jonathan Arac and Harriet Ritvo (Philadelphia: U of Pennsylvania P, 1991), 56–85.

5. The edition of Byron used here is *The Complete Poetical Works*, ed. Jerome J. McGann, 6 vols. (New York: Oxford UP, 1980–). This passage is from Byron's letter to Hobhouse, introductory to *Childe Harold's Pilgrimage* 4, volume II, 124.

6. For a fuller portrait of the Shelley circle and its poetics of the classical and Orientalist "South," see Marilyn Butler, *Romantics, Rebels, and Reactionaries: English*

Literature and Its Background, 1760–1830 (Oxford: Oxford UP, 1981), 112–37 (especially 124).

7. Such a portrait of Hemans is given in William Rossetti's "Prefatory Notice" in the oft-reprinted *The Poetical Works of Mrs. Felicia Hemans* (London: Moxon, 1873), 11–24.

8. Nineteenth-century memoirs of Hemans include Henry F. Chorley, *Memorials of Mrs. Hemans*, 2 vols. (London: Saunders and Otley, 1836); and Harriet Hughes [Hemans's sister], "Memoir of Mrs. Hemans," *The Work of Felicia Hemans*, vol. 1 (Edinburgh: Blackwood, 1839); and Rose Lawrence, "Recollections of Mrs. Hemans," *The Last Autumn in a Favorite Residence* (Liverpool and London: n.p., 1836), 231–419. For a useful introduction to Hemans, see the brief book by Peter W. Trinder, *Mrs Hemans* ([Cardiff?]: U of Wales P, 1984). For a recent study of Hemans as a woman writer in conjunction with others, see Norma Clarke, *Ambitious Heights: Writing, Friendship, Love—The Jewsbury Sisters, Felicia Hemans, and Jane Carlyle* (London: Routledge, 1990). For studies of Hemans's critics, her work, and her circle, see Marlon Ross, *Contours*, 232–316.

9. To this day, more studies of Hemans's poetry have been published on the Continent than in England or the United States. Continental studies include these three dissertations: Walther Ledderbogen, *Felicia Dorothea Hemans' Lyrik: Eine Stilkritik*, Christian-Albrechts-U Kiel (Heidelberg: Winters, 1913); Edwin Werner, *Die Verstechnik der Felicia Hemans*, U K.B. Freidrich-Alexanders-U (Erlangen: Junge & Sohn, 1913); Edith Dúmeril, *Une femme poète au déclin du romantism anglais: Felicia Hemans*, U Toulouse (Paris: Didier, 1929).

10. Felicia Dorothea Browne, *England and Spain* (London: Cadell & Davies, 1808). The best bibliography of Hemans to date is by Nicholas Jones in *British Romantic Poets, 1789–1832, Dictionary of Literary Biography*, 2nd ser. (Detroit: Bruccoli, 1990), 96.130–31.

11. Stuart Curran, "Hemans as Regency Poet," Special Session on Felicia Hemans, MLA Convention, San Francisco, December 30, 1991. According to Curran, Hemans was more attuned to the British temper than were officially nominated male laureates like Walter Scott and Robert Southey.

12. For her, de Staël, and Shelley, Sappho's odes and Petrarch's laureate poetry of love contribute to the cultural enfranchisement of women. Percy Shelley, "A Defence of Poetry," *Shelley's Prose, or the Trumpet of a Prophecy*, ed. David Lee Clark (Albuquerque: U of New Mexico P, 1954), 295.

13. Tricia Lootens has written a richly various paper on the Victorian Hemans, debating among other things whether the dispersal of graves in Hemans's work reinforces or subverts empire: Tricia Lootens, "Hemans and Home: Romanticism, Victorianism, and the Domestication of National Identity," Special Session on Felicia Hemans, MLA Convention, San Francisco, December 30, 1991. Important poems in this connection are "England's Dead" (1823) and the less trenchant but better-known "The Graves of a Household" (1828).

14. After 1823, Hemans's attention was additionally absorbed by the lyrics of Herder, Körner, Tieck, Schiller, and Goethe, to the extent that she boldly attempted to conquer Wordsworth's prejudice against Goethe on her visit to Rydal Mount in 1830—a graphic example of her pressure on the limits of a Wordsworthian romanticism (Chorley II:145–46). This incident suggests that Hemans's career was culturally, as well as politically, altogether more tendentious than we might expect of a poet still regarded as a Victorian parlor commodity or, at most, an apologist for the Regency. For a recreation of Hemans's place in the Victorian parlor, see Amy Cruse, *The Victorians and their Books* (London: Allen & Unwin, 1935), 18, 178, 222, 225–26, 229; for a view of Hemans as a patriotic poet now "as far outmoded as daguerreotypes,"

see Clifford Box and Meum Stewart, *The Distaff Muse: An Anthology of Poetry Written by Women* (London: Hollis & Carter, 1949), 59–61: this view is still current among many.

15. One thinks particularly of Keats's comment on "the poetical character" and "the Beautiful" versus "the Wordsworthian or egotistical sublime" in the October 1818 letter to Woodhouse: *The Poetical Works and Other Writings of John Keats*, ed. H. Buxton Forman (New York: Phaeton, 1970), VII:129–31.

16. Germaine de Staël, *Corinne or Italy*, trans. Avriel H. Goldberger (New Brunswick, NJ: Rutgers UP, 1987), 195. The crushed flower of *Corinne* alludes to the crushed hyacinth of Sappho. See Mary Barnard, trans., *Sappho: A New Translation* (Berkeley: U of California P, 1958), n. 34.

17. On Papal archaeology, see Carolyn Springer, *The Marble Wilderness: Ruins and Representations in Italian Romanticism, 1775–1815* (Cambridge: Cambridge UP, 1987), 74–75.

18. *Byron's Letters and Journals*, ed. Leslie A. Marchand, 12 vols. (London: Murray, 1973–82), V:108; subsequently, *BLJ*.

19. The text used here for Hemans's poems is *The Poetical Works of Mrs Felicia Hemans* (Oxford: Oxford UP, 1914).

20. *The Poetical Works of Mrs Felicia Hemans* (Philadelphia: Grigg and Elliott, 1835), 257. This edition, which unlike the Oxford includes Hemans's footnotes, appeared throughout the mid-nineteenth century in Philadelphia.

21. For this reason or some other, Hemans published *Modern Greece* anonymously.

22. Hemans's poem on Princess Charlotte (dated November 23, 1817) appeared in *Blackwood's Edinburgh Magazine* (April 1818); her ode on the death of King George was published in book form by Murray in 1820.

23. *Dartmoor* first appeared in an 1821 book published by the Royal Society.

24. In its use of Druidic imagery, *Dartmoor* offers parallels with Wordsworth's Salisbury Plain poem of the 1790s (not published until 1842).

25. The best example of early Tory reception of Hemans is John Taylor Coleridge, "Rev. of *The Restoration. . .*," *Quarterly Review* 24 (October 1821): 130–39.

9

Trans-figuring Byronic Identity

NICOLA J. WATSON

> Not quite adultery, but adulteration.
> —Byron, *Don Juan*[1]

In the face of dominant romantic myths of literary production which assume the priority and autonomy of the individual imagination, it has only very recently become possible to think of a romantic poetic identity as a produced representation, and so to ask to what extent the romantic poet's claim "to generate and govern his authorship, his own name and fame," in Sonia Hofkosh's words, is at once instigated and invalidated by others' readings and re-representations.[2] In what follows, I shall be expanding upon recent work on this construction of romantic authorship, in particular that of Hofkosh, by speculating upon the possibility of reading Byron's personae—both "private" and "literary"—as produced in part through a series of negotiations with an established genre, that of sentimental fiction.[3] I want to suggest in particular the ways in which Byron's deformations of that genre defensively structured his relations with the feminine and, by extension, the literary marketplace, while also aggressively constructing a Byronic identity which carried a radical political charge.

By reading the composite "text" produced by Byron and Lady Caroline Lamb between 1812 and 1824—which includes letters, Lamb's notorious roman à clef *Glenarvon* (1816) whose eponymous seducer-villain writes love letters transcribed from Byron's own, and Byron's *Don Juan* (1818–1824)—I shall therefore be tracing the convoluted circuits of genetic mutation by which Byron's sometime mistress sought to write him first into the sentimental epistolary novel of passion associated with French revolutionary ideology and then into its compromising mirror-image, the reactionary anti-jacobin novel,

Illustrations of Harriette Wilsons Memoirs.____ Page 161.

Let our Religion alone,
till you can furnish us with a
more perfect Creed; till then, neither
you nor Voltaire will ever enlighten
the World by laughing at it

The Glenarvon Ghost at the Masquerade.

Pub.d by S.W.Fores Aug.28.
1825 Piccadilly

BRITISH 13 MUSEUM

and by which Byron in defensive retaliation attempted to relocate the Byronic as radically and antisentimentally inauthentic in order to escape these successive appropriations. This correspondence, quasi- and more properly literary, depended crucially upon the structure of feeling epitomized by the sentimental letter; I shall be tracing its appearances throughout this "correspondence" in order to show how that which has been all too frequently suppressed within accounts of romanticism, or at best imagined only as hovering at its limits—the novelistic, the woman writer, and the literary marketplace, all metonymically linked in the Regency cultural imagination[4]—in practice exerted formative pressure upon the production of the romantic which for contemporaries was paradigmatically embodied by Byron.[5]

One of the side effects of this exercise will be, I hope, to demonstrate the desirability of situating the kinds of selfhood and self-representation that have been considered quintessentially "romantic" within a historical territory crisscrossed and fissured according to competing logics of gender and genre, rather than viewing them purely as triumphs of originary and aestheticizing self-fashioning. Furthermore, by concluding with a reading of the noted courtesan Harriette Wilson's exposé of the genres of Byronic identity purveyed in her best-selling and scandalous *Memoirs of Herself and Others* (1825), I hope also to indicate one way in which it might be possible to rethink the terrains of romanticism in such a way as to accommodate and to articulate within a common syntax both "romantic" and "nonromantic" identities, seeing them as engaged with common cultural and political anxieties, and thereby recognizing both continuities and mutual determinations.[6] A certain urgency might well inform this project, given the peculiar situation of feminism in relation to the mainstream of romantic studies: by occupying any one of the array of critical positions currently available to them—typically analogous to those occupied by Dorothy Wordsworth, Mary Wollstonecraft, Ann Yearsley, and Mary Shelley in relation to the romantic canon—contemporary feminist critics all too frequently find themselves, like their avatars, professionally positioned at the limits of romanticism proper.[7]

From the Sentimental to the Simulated

The affair between Lady Caroline Lamb and Lord Byron lasted, in a local sense, for about three months. They first met in early 1812, and the wildly flagrant *liaison* which ensued incorporated all the appropriate and inappropriate manuevers: indiscreet visits by Lamb, cross-dressed as a page boy, to Byron's apartments; threatened elopement; passionate and consciously sentimental letters; gifts of and requests for jewelery, pubic hair, etc., etc. The aftermath of the affair was considerably longer and even more socially outrageous, culminating in a theatrical suicide attempt by Lamb at a major ball, which led directly to her exile from London society and the Lamb family's

first attempt to produce a separation from her husband, Sir William Lamb, on the grounds of insanity.

Despite its status as a historically verifiable, authentic correspondence, the exchange between the two throughout displays all the generic features of the sentimental/epistolary novel of passion then associated primarily with Rousseau's *Julie: ou La Nouvelle Héloïse,* Goethe's *The Sorrows of Young Werther,* and latterly with the output of Germaine de Staël, a form which was, through these associations, popularly connected with radical politics; by the early nineteenth century, moreover, the sentimental letter was regularly and specifically imagined as an agent of revolution because it characteristically detoured patrilineal authority at both the local and national level.[8]

Nor did this generic logic escape either Byron or Lamb. On her part, for instance, Lamb seems at one point to have fashioned their adulterous correspondence into some sort of epistolary novel which, from her description "— 250 letters from a young Venetian nobleman—addrest to a very absurd English Lady—"[9] sounds as though it would have borne a remarkable similarity in point of subject matter to de Staël's best-seller *Corinne* (1807). Byron himself, during the prolonged aftermath of the affair, explicitly read Lamb as casting their affair within an extravagantly sentimental plot and discourse, identifying her letters as belonging to the genre of de Staël's *Delphine* and the "German"[10] sentimental novel; and, as his remarks to his confidante Lady Melbourne (Lamb's mother-in-law) on September 13, 1812, suggest, he was to some large extent complicit in the production of this discourse:

> In the mean time I must and do write the greatest absurdities to keep C[aroline] "gay" & the more so because ye. last epistle informed me that "8 guineas a mail and a packet *could* soon bring her to London" a threat which immediately called forth a letter worthy of the Grand Cyrus or the Duke of York, or any other hero of Madame Scudery or Mrs. Clarke. (*BLJ,* II:194).

If this correspondence was, therefore, essentially sentimental, Byron here can be shown already engaged in a programmatic deformation of that genre. On the one hand, the logic of the sentimental is already crucially damaged by Byron's triangulation of his correspondence with Lamb by the inclusion of Lady Melbourne; more tellingly, Byron's allusions rewrite the sentimental in terms of Regency politics, conflating the hitherto revolutionary sentimental letter with compromised Tory politics, and reserving the Lovelacean stance of literary pastiche to his own broadly Whig position: the fantastic fustiness of "French romance" (an object of satire at least since Charlotte Lennox's *The Female Quixote* [1752]) is collapsed into the sordid politico-sentimental scandal of the sale of army commissions by the Duke of York's mistress, Mrs. Clarke, on the proceeds of which she was enabled to maintain her establishment—a scandal that involved the extensive publication of their correspondence and that severely damaged the credibility of the Tory party.

This induced slippage of the politics of sentimental genre is homologous with another pervasive feature of the Lamb-Byron correspondence, a conspicuous deformation of the constitutive premise of the sentimental letter—its organic relation to the body of the writer—via the mechanisms of forgery.[11] Supposedly functioning as an unironized substitute for the sincere body of the writer, the forged sentimental letter renders absolutely undecidable the relation between originating body and signature, breaking thereby what Jacques Derrida has called the "law of genre."[12]

This destabilization of genre becomes visible during the prolonged and acrimonious sequel to the Lamb-Byron affair in a combat of mutual forgery of both sentimental discourse and the authorial body for which it stands. One of Lamb's earliest escapades involved her expert fake of a letter from Byron, supposedly to herself, in order to purloin his favorite portrait of himself—the so-called Newstead miniature—from John Murray, his publisher.[13] In producing this simulation of Byron, Lamb effectively masqueraded as him in order to obtain a simulacrum of him. Although it appears that Lamb in the event did not make use of this letter but simply stole the picture from Murray's empty rooms (*BLJ*, II:11n.), Byron himself presumed that the forgery had been good enough, both of his handwriting ("the hand she imitates to perfection") and of his signature, to induce Murray to give up the miniature.[14]

Lamb's deformation of the principles of the sentimental by adopting the very strategy of pastiche that Byron had apparently made use of in concocting his own letters to her seems to have threatened Byron's notions of his own authorial identity.[15] Although a writer who took conspicuous delight in his own performative mobility, it seems that Byron nevertheless grounded his identity in an essentially sentimental model—a model provided by the sincere relation between text and body as mediated by "handwriting." The importation of *"errata"* which disfigure the authentic Byron text seems to have haunted Byron's imagination: he later remarked to Henry Fox that Lamb "has the power of imitating [my] hand to an alarming perfection and still possesses many of [my] letters which she may alter very easily."[16] Worse, as he remarked anxiously, "now what is to prevent her from the same imitation for any less worthy purpose she may choose to adopt? . . . For aught I know she may have forged *50* such to *herself*—& I do not feel very much refreshed by the supposition" (*BLJ*, III:14). Indeed, so threatening are these "Carolinish" errata (which figured in a notable incident later when she even quoted his seal against him, strategically misquoting his family motto "Crede Byron" on her livery buttons as "*Ne* 'Crede Byron'" [*BLJ*, III:9]) that Byron wrote in March 1813 (at the height of the furor over Lamb's appropriation of the miniature) that he was thankful that at least he could get away without having seen Lamb at all—"no bad thing for the original whatever may become of the copy" (*BLJ*, II:26). But if Byron registered Lamb's textual impersonations as a threat to his authentic authorial identity, he also recognized the ways in which his adoption of an essentially sentimental identity laid him open to

another generic confusion, this time of gender: elsewhere he acknowledges the extraordinarily upsetting gender-inversion to which Caroline's burglary has subjected him by describing the theft as a rape upon himself, a parodic abduction of (Miss Harriet?) Byron in the best traditions of the sentimental novel. Writing again to Lady Melbourne, he requests her to "recover my *effigy* if you can—it is very unfair after the restoration of her own—to be *ravished* in this way" (*BLJ*, III:12).

Responding to this act of forgery on Lamb's part, Byron reclaimed his copyright by mimicking Lamb's logic precisely, exacting revenge by imitation. Especially anxious to retrieve his likeness from his *quondam* mistress, because it had been requested most particularly by his new mistress, Lady Oxford, Byron eventually offered Lamb a copy of the miniature (*BLJ*, III:11), and also acceded to Lamb's crucially sentimental request for a lock of Byron's hair—apparently offering her an authentic and original part of the physical head in exchange for a mere representation of it. In early April 1813, Byron accordingly sent Lamb, along with a copy of the miniature, a lock of "double" hair which, though it resembled his own, was in fact that of Lady Oxford (*BLJ*, III:36, 40). Once again co-opting the Lovelacean position, Byron, under his own seal and signature, sent in effect a clipping of Lady Oxford cross-dressed as "Byron," sent, in fact, what was indeed a simulacrum; moreover, he once again triangulated the correspondence by incorporating a foreign body. In so dissimulating himself within the structures of a sentimental exchange, he both withheld his own sentimental identity and ironized the status of the sentimental letter as a metonym for the sentimental body.

Replication in the Literary Marketplace

This seesaw pattern of appropriation and reappropriation of the sentimental and its simulations is repeated and expanded on a strictly literary and public level in the competition between Lamb and Byron to reproduce his figure, carried out in Lamb's novel *Glenarvon* and Byron's answering strategies in *Don Juan*.[17] In publishing *Glenarvon*, Lamb effectively pilfered Byron's authority to fashion his own self-image, offering in its protagonist Lord Glenarvon a representation of the "Byronic" hero which, as I shall be showing below at more length, successfully remolded readers' conceptions of Byron himself (as Sonia Hofkosh has remarked, "*Glenarvon* shows that the author's private life and work are always another's imaginative property").[18] This theft is at once expressly registered in the reproduction and recirculation of Byron's gifts and especially his letters—Lamb supplying *Glenarvon* with certain passages from Byron's letters to her—and dependent for confirmation on this reproduction and recirculation.[19] This act of citation precisely repeats that of an earlier letter from Byron; according to Lamb, her practice of quoting a letter from Byron in another context seems both to have been precipitated by and designed to repeat that letter's original frame of production—Byron's "subscrip-

tion" beneath another's "seal" and "frank": "There was a coronet on the seal. The initials under the coronet were Lady Oxford's. It was that cruel letter I have published in *Glenarvon.* . . ."[20]

This citation of Byron-as-Lovelace not only reproduces him under the "seal" of Caroline Lamb but also allows Lamb to position the figure of Byron within a genre that was specifically critical of the sentimental plot and its revolutionary tendencies:[21] the reactionary (or "anti-jacobin") polemical novel produced in post-French Revolutionary Britain. Accordingly, Lamb reproduces Byron, figured at the heart of the text in the compromised genre of the duplicitous (because both replicated and insincere) sentimental letter, as the glamorous but reprehensible Lord Glenarvon, who unites the ambiguously revolutionary gothic figure of the monk[22] with that of a more politically explicit villain—the stereotypical philosophic freethinker who seduces on revolutionary principles.[23] Glenarvon is first encountered under the alias "Viviani," disguised at a masked ball as an Italian monk, in allusion to the real-life masquerade adopted by Byron at the most brilliant masquerade of the London season of 1814 (which itself alluded on the one hand to a whole series of Mephistophelean monks in gothic fiction from Lewis's Ambrosio onward, and on the other to Byron's own youthful propensities for dressing up as a friar, hiding in coffins, quaffing blood from a specially mounted skull, and supposedly leading orgies at the family home, Newstead Abbey). In Lord Glenarvon's subsequent appearances *in propria persona,* however, Lamb unmasks the monk to reveal a standard "jacobinical" villain, represented both as the leader of the 1798 Irish rebellion and as a seasoned libertine who seduces the married Calantha, a stand-in for Caroline Lamb herself.[24] Lamb ultimately provides a *grande débâcle* in which Glenarvon is driven to suicide and thence snatched to hell by a ghostly Black Friar—a fate not insignificantly reminiscent of that of another of Glenarvon's avatars, Don Giovanni. In so delineating Byron for a readership more than prepared to credit this highly colored and politically charged version, Lamb had not so much stolen the miniature as simply produced her own portrait. Byron implicitly conceded this in his sarcasm on the novel that "Elle aurait étè plus resemblante si j'avais voulu donner plus de séances."[25]

Voluminous and vitriolic as Byron's letters are on this subject, his best-known comment upon the whole Lamb imbroglio may be found in Canto II of *Don Juan,* where it appears in the context of a meditation upon the effects on women of frustrated libido: "Some play the devil, and then write a novel."[26] The carelessness of this throwaway line (belied by its privileged position as the stanza's punch-rhyme) obscures the ways in which *Don Juan* is pervasively engaged with *Glenarvon*—determined to reappropriate in particular the figures of the sentimental letter and of the monk, and with them the political significations of Byron's own public identity. *Don Juan* accordingly describes a formally anti-jacobinical trajectory from the burlesqued sentimental to the travestied gothic, in the process systematically dismantling both

versions of revolutionary genre by deploying in amplified form the strategies evident in the Lamb/Byron correspondence. Just as in his dealings with Lamb Byron worked his way through available conventions of authentic feeling with increasing levels of duplicity, so in *Don Juan* even the most apparently stable textual figures—epistolary heroines, sentimental letters, avenging ghosts—are destabilized by their serial mutation through incompatible genres. Quotation out of context and under another "seal" of the sentimental letter modulates into cannibalism; forgery expands into cross-dressing. The result is a funda- mental undoing of exhausted radical genres, not in order to institute a more conservative genre, but rather to institute a potently radical heterogeneity of genre; at the same time, in so undoing the sentimental, Byron produces for himself an authorial and political identity so inauthentic as to be apparently immune to appropriation.

Like *Glenarvon, Don Juan* takes its departure from a sentimental letter; and initially, like Lamb, Byron frames the sentimental letter within a thoroughly conservative generic framework. Don Juan's initial escapade, recounted in Cantos I and II (composed in 1818), is based upon the conventional sentimen- tal plot, specifically upon the novel that was held to distill it in a peculiarly revolutionary and deleterious form, Rousseau's *Julie; ou la Nouvelle Héloïse*, which retails a story of seduction and near-adultery centering on the quintes- sential sentimental heroine Julie (with whom Lamb's Calantha is also identi- fied). In a thoroughly conventional fashion Byron translates St. Preux into the standard (albeit burlesqued) jacobinical villain, Don Juan, and had indeed planned from the first to consign him in the traditional (and in contemporary terms anti-jacobinical) manner, sanctioned by contemporary pantomime and by Da Ponte, to "The very place where wicked people go" (I:207). Moreover, according to the "Memoranda" on the Murray manuscript of the last canto of the poem as it stands, "The D[eath] of J[uan]" was to be specifically associ- ated with "The Shade of the/Friar"—Juan would thus have precisely repeated the awful fate of Glenarvon. Indeed, Byron at one stage explicitly politicized Juan's prospective fate by proposing that his hero should end his days during the Terror at the hands of the French revolutionaries (again, a stroke of poetic justice suffered by a number of anti-jacobin villains, notably Isaac D'Israeli's Vaurien [1797]) courtesy of Madame La Guillotine (which ending Byron, of course, never executed).[27]

In Byron's Hispanic variant of the story of seduction and adultery, Donna Julia, the heroine of Juan's first adventure is "married, charming, chaste, and twenty-three" (I:59), married in fact to a much older man, in parallel to Rous- seau's Julie after her marriage to her father's choice, Wolmar. Julia's struggles with her growing passion for Juan, despite her attempts to relegate it to a purely platonic feeling, end at last in adultery (the consummation that Rousseau nar- rowly evaded), in pregnancy, and at length in discovery, Juan's disgrace and ex- ile, and Julia's banishment to a convent, from which she writes the letter which remains one of the most frequently excerpted passages of the poem.[28] Unlike

Julie's letters to her lover St. Preux, however, which represent in themselves a successful transgression against paternal authority, the sentimental letter written by this latest Eloisa[29] from the convent is notably powerless, largely because it appears so intransigently self-reflexive, so narcissistically caught up in its own generic laws. The sardonic detail of the stanza immediately following the close of Julia's letter shows the epistolary heroine to be engaged, not in entirely spontaneous sentimental effusion,[30] but in the crafting of a conventional discourse of self-fetishization:

> This note was written upon gilt-edged paper
> With a neat crow-quill, rather hard but new.
> Her small white hand could hardly reach the taper,
> But trembled as magnetic needles do,
> And yet she did not let one tear escape her.
> The seal a sunflower; *Elle vous suit partout,*
> The motto cut upon a white cornelian;
> The wax was superfine, its hue vermilion. (I:198)

The material and the calculated intrude to ironize the letter's emotional power. Byron's remark that *Don Juan* was not liked by women because "the wish of all women [is] to exalt the *sentiment* of the passions—& to keep up the illusion which is their empire.—Now D. J. strips off this illusion—& laughs at that & most other things.—I never knew a woman who did not protect *Rousseau*" is especially relevant here, for it suggests that Byron viewed *Don Juan* as the antithesis of Rousseauistic sentimentalism.[31]

The invalidating discrepancy inserted between the content and the materiality of this letter is expanded still more insistently by its subsequent misfortunes, which decisively evacuate any remaining force from the sentimental genre which it signifies. The two ensuing "rereadings" of the letter (what Percy Shelley called percipiently its appropriation)[32] subject it, as a conventional substitute for the sentimental feminine body, to the violent demands of an emphatically antisentimental and masculine body: Juan's first rereading on board ship is interrupted by seasickness, and the second "rereading," in the lifeboat where Juan finds himself after the ensuing shipwreck, also eventually induces vomiting, the final outcome of his starving fellow-survivors' decision to adopt the desperate measure of drawing lots to decide "who should die to be his fellow's food" (II:73):

> At length the lots were torn up and prepared,
> But of materials that much shock the Muse.
> Having no paper, for the want of better,
> They took by force from Juan Julia's letter. (II:74)

The dismemberment of the sentimental letter (and, by metonymic inference, of Julia's body), followed by its promiscuous dissemination, results here in

the dismemberment, dissemination, and consumption of Juan's surrogate father, his Rousseauistic tutor, Pedrillo: the consequences of this recycling first of revolutionary sentiment and then of revolutionary philosophy are, just as always in the anti-jacobin novel, madness, blasphemy, despair, and death—with, in this instance, the familiar trope of ideological poisoning rendered grotesquely literal.

Although this sequence would appear to ironize, violate, and ultimately suppress altogether the power of the sentimental letter, in ways very similar to those strategies employed by Lamb in *Glenarvon,* Byron does not choose (unlike his more conventionally anti-jacobin friend, the author R. C. Dallas)[33] to reestablish paternal authority; the voiding of the sentimental letter, after all, actually leads to the eating of the man who stands (however problematically) in the place of Juan's father. In fact throughout the poem, so far from being interested in reestablishing paternal authority, Byron takes pains to render that authority problematic, if not phantasmagoric. At the end of *Don Juan* as it stands, in Canto XVI, he summons the ambiguous ghost of the Black Friar, a phantasm which, related to a whole series of other dubiously legitimate paternal figures, finally breaks both the law of genre (affiliated, according to Derrida, with patrilineal law) and that which Derrida argues is intimately associated with it, the law of gender or of sexual difference.[34] Like the earlier letter, this ghost features as a revenant extravagantly demystified on its second appearance; indeed, as I shall show, this pastiche paternal proves to be radically heterogeneric, in fact, to be hauntingly inhabited by a final, still more debased incarnation of the sentimental letter.

Fetching up at Lord and Lady Amundeville's house party, held at a venue at once gothic and autobiographical (the house looks altogether very like Newstead Abbey), Juan (who increasingly seems to solicit identification in these cantos with some version of the young Byron) encounters what appears to be the resident ghost, the Black Friar. In addition to functioning as a citation or repetition of the friar who drags Lord Glenarvon off to Hell, this figure also inescapably encodes that of "Viviani" or Lord Glenarvon himself. Its problematically double nature—as at once a conservative representative of paternal and divine law and a figure for revolutionary transgression—calls up in Byron's text, on its first appearance, a constellation of other literary allusions and generic signals, all of them associated with peculiarly compromised or detoured paternal interdictions.[35] Most importantly, this supposed "supernatural agent" claims a genealogy from old Hamlet, announced as it is by what Juan thinks might be "a mouse,/Whose little nibbling rustle will embarrass/Most people as it plays along the arras" (XVI:20–21). This rodent behind the arras, however, turns out to be neither Claudius nor Polonius but the figure of a perhaps equally compromised ghostly father, who by rights should be calling for the revenge that both old Hamlet and his analogue the Commendatore (released according to the traditional account from the precincts of a monastery) conventionally exact.

The dubious political genre of this "Father"—avenging old Hamlet? burlesque Viviani? silenced Commendatore?—is amplified by Juan's choice of reading matter to exorcise it: retiring to bed after its first manifestation, he calms his mind by reading a political pamphlet which attacks the king, a commercial advertisement for "Patent Blacking" (suggesting the superficiality and marketability of the friar's sableness), and a paragraph about Horne Tooke, which raises the question of the Treason Trials simultaneously with the problem of the apparition's grammatical, etymological, and epistemological status (XVI:26–27). This undecidability is tellingly underscored by a trope of generic fluidity that, appearing along with the ghost, invokes switching-mechanisms of transfiguration and substitution: paper money. Juan is described as having given no credit to the rumor of a ghost, having dismissed it as "Coined from surviving Superstition's mint,/Which passes ghosts in currency like gold,/But rarely seen, like gold compared with paper" (XVI:22);[36] the suggestion is that the ghost, like paper money, may or may not be underwritten by sufficient authority, whether of the father or of the state (a suggestion, incidentally, given a political savor by the fact that in the 1790s France went off the gold standard while Britain remained on it). The destabilization of paternal authority evident in this episode is amplified in the episode of the country girl, another "double figure," pregnant outside wedlock, who, on the day following the ghost's first appearance, is brought up before Lord Henry Amundeville in his capacity of J. P. "To name a thing in nomenclature rather/Perplexing for most virgins—a child's father" (XVI:67). The perplexing absence of the name of the father throughout this section of the poem, a narrative ellipsis for which the law demands remedy, and its connection with the lapses of illicit female sexuality, is reiterated more signally in the episode of the Black Friar's second appearance.

On its second portentous appearance, appropriately enough as from Dante's Hell (XVI:116), and equally appropriately, given the parallel to *Hamlet,* in Juan's bedroom, the ghost finds Juan "completely *sans culotte*" (XVI:111), in burlesque keeping with Byron's projected catastrophe. However, Juan's pursuit ends in a transformation scene from "stony death" to living flesh:

> Back fell the sable frock and dreary cowl,
> And they revealed—alas! that e'er they should!
> In full, voluptuous, but *not o'er*grown bulk,
> The phantom of her frolic Grace—Fitz-Fulke! (XVI:123)

Old Hamlet's "gracious figure" metamorphoses into "her gracious, graceful, graceless Grace"—an altogether accessible and thoroughly adulterous Gertrude. If in the case of the Lamb correspondence adultery bred generic adulteration, here generic/genderic adulteration actually allows for and sanctions adultery.

The Duchess of Fitz-Fulke is effectively the last appearance of the sentimental letter, however travestied, in the poem as we have it; she here bears more than a passing resemblance to another woman in an incongruous habit, functioning, as W. Paul Elledge points out, as "a ghostly iteration of a habited Julia deceitfully writing from another monastic house."[37] Fitz-Fulke further combines in a debased register a number of revolutionary/sentimental features: she is in the habit of conducting adulterous flirtations that turn young men into suicidal Werthers (XIV:64); her name indicates that, like so many jacobinical villains, she is not only Irish but from an illegitimate branch of the family; and she refigures Glenarvon's female counterpart, the cross-dressing Irish revolutionary Elinor, herself a figure (albeit a more Amazonian one than the victimized Calantha) for Caroline Lamb. This radically heterogeneous version of the sentimental letter precludes the plot's anticipated conservative ending except at the level of a consciously sordid pun—in that the reader is permitted to infer that this ghostly cross-dresser successfully seduces Juan, it might, for instance, be possible to say that Juan is, if not literally then metaphorically, "snatched" to "Hell" in the embraces of the fair Fitz-Fulke.

At stake in this installation of a scandalous heterogeneity in the place of the paternal, in this apparent replacement of the properly anti-jacobin with the actually adulterous, seems to be the legitimacy of fathers; combined with the narrative's definite preference for their absence (coded through a sardonic reading of *Hamlet,* a text, as Gary Taylor has argued, vivified from the 1790s onward by anxieties over the status of the monarchy),[38] this translates into a definite distaste for the general process of Restoration that governed Europe in the post-Napoleonic era.[39] In other words, the sentimental letter is here being newly rescripted as radical in Regency terms. Perhaps as crucially, however, what is also at issue is Byron's own authority over his poetic persona. The debased sentimental heroine is throughout closely identified with Byron's own writerly identity, however extravagantly Juan-ish: Julia uses his own "seal" ("Elle vous suit partout")[40]; furthermore, resurfacing as the disguised Fitz-Fulke, the sentimental heroine is translated into his own masquerade likeness as Black Friar, only to be revealed as an even more thoroughly promiscuous woman. I would suggest that this episode, far from staging, as Susan Wolfson has contended, "female appropriation of male property,"[41] represents instead a simultaneous appropriation and adulteration of Lamb's compromised sentimental position; authorizing his poetic identity as profoundly antisentimental, Byron serializes himself as fundamentally duplicitous, dissimulative, and deferred.

The net result was and is that Byronic identity is in its quintessence a simulacrum, a form of paper money, always a "double figure." For Byron, this radical inauthenticity, which would seem to guarantee his inimitability, may well have allowed a withholding of authentic identity; for his readers, however, and especially his women readers, it allowed for a full-scale appropriation of Byronic identity under the sign of masquerade. It seems inevitable

that Lamb should have made her final riposte to *Don Juan* not on paper but in person when, in 1820, producing herself as a "hermaphroditical rhyme"[42] compounded of Byronic libertine and sentimental heroine, she appeared at a masquerade, complete with entourage of vengeful devils, "dissimulating" Don Juan, a.k.a. Lord Byron—"playing the devil" himself. As I shall show by a concluding glance at the *Memoirs* of the celebrated demi-mondaine Harriette Wilson—specifically their narrative of a meeting with Byron during another such masquerade—the evasive disavowal of self-authenticity by which Byron strives to withhold himself from public circulation eventually allows for the very commodification that he seems to have been so very anxious to avoid.

From Simulation to Simulacra: Poetic Identity and Pastiche[43]

The appropriability of Byronic poetic identity for exchange within the social and literary marketplace is nowhere more clearly manifested than in Wilson's account of her meeting with the poet at the most brilliant masquerade of the 1814 London season, an account which suggestively conflates all the generic negotiations I have been detailing into one multiply compromised example of what Wilson terms "masquerade-attitude for effect."

> At last I found myself in the still quiet room I have before described. It was entirely deserted, save by one solitary individual. He was habited in a dark brown flowing robe, which was confined round the waist by a leathern belt, and fell in ample folds to the ground. . . . He was unmasked, and his bright penetrating eyes seemed earnestly fixed, I could not discover on what. "Surely he sees beyond this gay scene into some other world, which is hidden from the rest of mankind," thought I, being impressed, for the first time in my life, with an idea that I was in the presence of a supernatural being. . . . "I will speak to him. . . ."
> "I entreat you to gratify my curiosity. Who and what are you, who appear to me a being too bright and too severe to dwell among us?"

After some initial reluctance the stranger enters into conversation with Harriette, and her account of it continues as follows:

> "This," said I, pressing the arm that I had taken, "this seems, I am sorry to say, to be mere flesh and blood. I had fancied—"
> "What?"
> "Why," continued I, half ashamed of myself, "upon my word and honour, I do confess I thought you something supernatural!"[44]

Apparently prefiguring Juan's encounter with the shade of the Black Friar, the conversation which ensues is, aptly enough, largely devoted to the question of the authenticity of the sentimental letters inset within *Glenarvon*. As the interview turns to consider love, Harriette declares that she could never love the (rather piqued) Byron, in part, she says, because "such contempt as you

have lavished on poor Lady Caroline Lamb would kill me," a remark that gives rise to the following exchange:

> "I would never put myself in the power of a man who could speak thus of any lady whom he had once professed to love."
> "How do you know I ever did?"
> "Those letters, in her Ladyship's novel, *Glenarvon,* are much in your own style, and rather better than she could write. Have you any objection to tell me candidly whether they are really your originals?"
> "Yes! they are. But what of that? Is it not absurd to suppose that a woman, who was not quite a fool, could believe such ridiculous, heartless nonsense? Would not you have laughed at such poetical stuff?"
> "Certainly. Those letters would have done more to convince me of your perfect indifference, than even your silence and neglect. Nobody ever did or can impose upon me by a heartless love-letter. *Quand le coeur parle, adieu l'esprit.* It is, in fact, almost impossible, to compose anything which has a resemblance to strong feeling, when one is addressing a person towards whom our heart is cold."[45]

Byron's reappropriation of the "originals," his confirmation that he indeed wrote what Wilson regards as the novel's most impressive passages, is immediately followed by a disavowal of their authenticity—they are, he insists, and she agrees, manifestly sentimental forgeries, pastiches from which all real feeling—all that is authenticated by the body—has not just been evacuated, but from which it was always withheld in the first place. Byron, in this rendition, effectively has it both ways; he repossesses the letters that Lamb had so outrageously purloined *and* insists that they were, however "original," nonetheless fakes—that even if they were sent, they were never meant. Rewriting the substance of the letter in this manner, he not only repossesses the copyright on those letters but also witholds himself as original, that is to say, as sentimental, romantic poet from the processes of reproduction within the literary, social, and amatory marketplaces; the real Byron, he claims, is not available.[46]

The attitude thus adopted by Byron at this masquerade is eerily reiterated by a subsequent, and still more characteristically Byronic, performance, recalled in his "Detached Thoughts," a journal kept from October 15 through May 18, 1822 (the period during which he refrained from working on *Don Juan* at Teresa Guiccioli's request):

> In the Pantomime of 1815–6—there was a Representation of the Masquerade of 1814—given by "us Youth" of Watier's Club to Wellington & Co.—Douglas Kinnaird—& one or two others with myself—put on Masques—and went *on* the Stage. . . . Douglas danced among the figuranti too—& they were puzzled to find out who we were. . . . It was odd enough that D. K. & I should have been both at the *real* Masquerade—& afterwards in the Mimic one of the same. . . .[47]

Byron's covert reappropriation of the public representation of himself—exceeding the mimetic conventions of the theatrical performance by inhabiting

a mimic figure of a masquerading self—is indeed "odd enough"; by taking part as the most famous literary lion of the season in a show entitled "Harlequin and Fancy; or, the Poet's Last Shilling" he would seem to attempt to re-embody the sign of his own lucrative position in the marketplace, but so covertly as to withhold the actual Byron nonetheless. This episode reveals the Byronic persona to be inimitable not simply because never self-identical but because even its self-identity masquerades under the sign of flaunted slippage.

There is, however, a final twist to Wilson's report of her glamorous encounter with Byron, elegantly illustrated by an opportunistic print entitled "The Glenarvon Ghost at the Masquerade," a twist that demonstrates that the Byronic may nonetheless be available to others precisely because it is "a masquerade-attitude for effect." It is by no means certain that Wilson ever actually conversed with Byron in the flesh (although she certainly corresponded with him both before and after this date), and the remarks attributed to her in this caricature are actually drawn from a letter included in the *Memoirs* apropos of *Don Juan* which Wilson claims to have written to Byron some time later.[48] Moreover, if Leslie Marchand's identification of the date of this masquerade as 1814 is correct, Wilson and Byron could not possibly have discussed *Glenarvon,* which was not published until some two years later. Wilson's account, which this picture illustrates, is in fact, with all its lively and engaging circumstantial detail, effectively itself merely a profitable replication in another register of the serialized Byronic identities produced by Lamb's *Glenarvon* and *Don Juan*. The Byron here apparently unmasked as "flesh and blood" is actually a recycled version of Lamb's *Glenarvon*, Byron's Juan, and, most appropriately, the disguised Fitz-Fulke. This replication is both registered and redoubled by the glamorous ghostliness of the apparition, an appropriate trope for a figure who is indeed, via the mechanisms of textual replication, only some very minimal part flesh and blood.

Byron's self-defensive maneuvers are thus both ratified and undercut in this instance by their context: the "Byron" who asserts his inviolable copyright has already been profitably rewritten by Harriette Wilson, who not only casts herself as an intrepid questioning Juan (doubling Lamb's occupation of this position) but animates the textual shade of the Black Friar in much the same way as does that extraordinarily compromised sentimental heroine, the Duchess of Fitz-Fulke. Wilson thus denies Byron a monopoly on his unsalability and turns a pretty penny on the transaction in the process.

Postscript

One reason why the narrative I have outlined strikes me as so suggestive is perhaps because it so vividly annotates the situation of the contemporary feminist critic working at the edges of romantic studies. These women's multiple impersonations of the Byronic raise a number of timely questions for the feminist reader: they put into question, for instance, whether it is possible for

an "outsider" to do more than repeat the available dominant poetics of identity—whether to add oneself in as a woman critic is inevitably to lock oneself into a dubious mimicry. On the other hand, they might suggest, alternatively, that masquerade could usefully destabilize myths of romantic (masculine) poetic identity.[49] Whether their antipaternal practice of pastiche and parodic repetition is eventually domesticated or effectively disruptive,[50] Caroline Lamb and Harriette Wilson do offer us two alternative critical positions vis-à-vis the romantic, both of them aggressively appropriative. By imagining a spectrum running from a sentimental identity premised upon the body through to a promiscuous pastiche of that identity, we might read Caroline Lamb's critical position as tending toward a quintessentially "sentimental" feminist criticism, one which tries to make a Byronic textuality accountable to the female body. Harriette Wilson, by contrast, takes up a frankly disreputable critical position that, Byronically promiscuous, pastiches the sentimental claims of the body, superseding it in favor of salable simulacra. Should we be prepared to take Wilson seriously, her strategy here of self-empowerment through out-Byroning Byron would suggest the possibility of jettisoning a "sentimental" feminist identity (and Lamb's fate, half-unhinged and virtually incarcerated by her husband, hardly recommends it!) in favor of an unscrupulously decadent and profitable process of retail. One might choose, in fact, Wilson's deconstructive "adulteration" of the romantic persona over Lamb's adulterous impersonation of the romantic author as a model for future feminist critique within the field.

NOTES

1. All references to *Don Juan* are from Jerome J. McGann, ed., *Lord Byron: The Complete Poetical Works* (Oxford: Clarendon Press, 1986).

2. Sonia Hofkosh, "The Writer's Ravishment: Women and the Romantic Author—The Example of Byron," in Anne Mellor, ed., *Romanticism and Feminism* (Bloomington: Indiana University Press, 1988), 94.

3. Some work has been done on the political valences of genre in romantic autobiographical poetry, notably by Alan Liu. I here expand upon Alan Liu's insight that "genre is . . . a proper logic in which to think about literature and history . . . [for it] tells the story of a poet's relation to history." Alan Liu, *Wordsworth: The Sense of History* (Stanford: Stanford University Press, 1989), 49.

4. See Nicola J. Watson, "Conceiving the Canon: The Novel and the Reviews, 1765–1825," in *Readers, Writers and Reviewers: The Rise of Review Criticism in the Eighteenth Century*, ed. James Basker (Carbondale: Southern Illinois University Press, forthcoming).

5. In so doing, I shall at once be expanding upon recent feminist speculation that the poetic authority claimed by "romantic" poets, depends upon the simultaneous suppression and appropriation of the feminine, and linking these manuevers with the ways that the exigencies of the marketplace fret romantic texts. As will become clear, I am generally indebted to Sonia Hofkosh's ground-breaking essay on Byron's anxieties about effeminization as a poet in the literary marketplace, cited above. I am also, inevitably, indebted in a general way to Marlon B. Ross's essay in the same volume,

"Troping Masculine Power in the Crisis of Poetic Identity," 26–51 and to recent work on romanticism and economic tropes of poetic identity, in particular Kurt Heinzelman's essay, "Byron's Poetry of Politics: The Economic Basis of the 'Poetical Character,'" *Texas Studies in Literature and Language* 23 (Fall 1981): 361–87.

6. In so doing, I find myself on the one hand expanding on Stuart Curran's insistence that, contrary to "a myth of a radical generic breakdown in European Romanticism," romanticism is intimately structured by generic conceptions, and on the other, implicitly critiquing his decision to confine himself to the "major" romantic poets and to canonical poetic genres. *Poetic Form and British Romanticism* (New York: Oxford, 1986), 5. Similarly I find myself in sympathy with Marlon Ross's interest in "establishing some critical and historical continuity between contemporaneous romantic and nonromantic writers," a project which entails, as he says, placing romanticism within history. *The Contours of Masculine Desire: Romanticism and the Rise of Women's Poetry* (New York and Oxford: Oxford University Press, 1989), 5.

7. A sweeping generalization admittedly, and subject to the citation of any number of exceptions. Nonetheless, the anthology edited by Anne Mellor, *Romanticism and Feminism*, particularly although not exclusively the last section "The Women Respond," would seem to bear me out.

8. On the politics of the epistolary novel in this period, see Nicola J. Watson, *Revolution and the Form of the Novel, 1790–1825: Intercepted Letters, Interrupted Seductions* (Oxford: Clarendon Press, 1994); on reworkings of those politics by Burke, Byron, and others, see Nicola J. Watson, "Novel Eloisas: Revolutionary and Counter-Revolutionary Narratives in Helen Maria Williams, Wordsworth and Byron," *The Wordsworth Circle* 23 (1992): 18–23.

9. Murray MSS; cited Leslie Marchand, *Byron: A Biography* (2 vols.; New York: Alfred A. Knopf, 1957), 616.

10. See Byron's letter to Lady Melbourne, November 10, 1812: "[Caroline's] letter to Ly. O[xford] was a long *German* tirade . . ." (*Byron's Letters and Journals*, ed. Leslie A. Marchand (12 vols.; London: J. Murray, 1973–), II:244 (*BLJ* hereafter).

11. It has, of course, become a commonplace of post-structuralist criticism of epistolary fiction to point out that the relation between the letter and the body is never in practice organic, and that the fascination of the epistolary inheres precisely in the discrepancy between its claims to record the body and the threat of the slippage between text and body. See, among other studies, Terry Eagleton, *The Rape of Clarissa* (1982), and Terry Castle, *Clarissa's Ciphers* (1984). Nonetheless, I wish here to take the claims of the sentimental seriously, however fragile they turn out to be.

12. Jacques Derrida, 'La Loi du Genre/The Law of Genre,' *Glyph* 7 (1980): 221. By extension, as a juxtaposition of the remarks of Susan Stewart with the work of Jacques Derrida might suggest, forgery, by producing a masquerade of authority, not only betrays its ambition of superseding the law of the father, but actually denies it, in the act damaging not only the "law of genre" but also the "law of gender." See Susan Stewart, *Crimes of Writing: Problems in the Containment of Representation* (New York and Oxford: Oxford University Press, 1991), 146. Such a transgression, according to Mary Jacobus's elaboration of Derrida's thesis, is implicitly a politically radical manuever in its breaking of patrilineal lines of descent, for "recognizability and an unbroken line of descent are the final criteria" for generic identification. Mary Jacobus, *Romanticism, Writing, and Sexual Difference: Essays on* The Prelude (Oxford: Clarendon Press, 1989), 188, 202.

13. For another reading of this episode and other related incidents, also concerned with the ways in which Lamb's forgeries of and masquerades as Byron contested his understanding of his own authority, see James Soderholm, "Lady Caroline Lamb: Byron's Miniature Writ Large," *Keats-Shelley Journal* 40 (1991): 24–46. Soderholm's

reading depends upon a Girardian construction of fanship, through which lens Lamb is seen as attempting to make herself into Byron by strategies of self-glamorization which he in turn comes to imitate and appropriate. As will be clear from what follows, I wish to open up this transaction which Soderholm reads as essentially private and idiosyncratic to questions of marketplace, genre, gender, and finally, of critical position-ing—in short to read these negotiations as culturally determined rather than deter-mined by strictly interpersonal negotiations.

14. On January 8, 1813, he wrote to Murray that "You have been imposed upon by a letter forged in my name to obtain the picture left in your possession. . . . [I]f you have the letter *retain* it. . . . You will also be more cautious in the future & not allow anything of mine to pass from your hand without my *seal* as well as signature" (*BLJ* III:11).

15. On this mirroring by Lamb, see Soderholm, "Byron's Miniature."

16. *His Very Self and Voice: Collected Conversations of Lord Byron,* ed. Ernest J. Lovell (New York: MacMillan, 1954), 353.

17. For another attempt to consider these two texts together, in particular to see them as rival versions of the Don Juan myth, see Peter W. Graham, "A Don, Two Lords, and a Lady," *Don Juan and Regency England* (Charlottesville: University Press of Virginia, 1990), 89–124.

18. Hofkosh, 105.

19. For the letters in question see *BLJ*, II:242. In recirculating the figure of Byron and his letters, Lamb was simply replicating a practice of extraction, quotation, and recirculation that both she and Byron had indulged almost from the earliest days of the affair, as evidenced, for instance, by Byron's letter to Lady Melbourne of September 18, 1812: "I am not sorry that C[aroline] sends you extracts from my epistles, I deserve it for the passage I shewed once to you, but remember that was in the *outset*. . . . Moreover recollect what absurdities a man must write to his Idol, & that 'garbled extracts' prove nothing without the context." (*BLJ*, II:200–201) The readings and rereadings that this correspondence underwent—what Byron dubbed extra '*winding*[s]' to our *Labyrinth*' (*BLJ*, II:203)—are therefore merely redoubled. The generic appropri-ateness of Lamb's action, however extreme, seems to be underscored by the curious fact that Byron seems to have anticipated this recirculation of his letters as early as September 1812, when he wrote that "I am certain that I tremble for the trunkfuls of my contradictions, since like a Minister or a woman she may one day exhibit them in some magazine or some quartos of villainous memoirs written in her 7000th love fit" (*BLJ*, II:200–201); by December, during the complicated negotiations over the return of gifts and letters, he was writing "She will not deliver up my letters—very well—I *will* deliver up hers nevertheless—& mine she may make the most of, they are very like the Duke of York's & the Editor of any magazine will treat with her for them on moderate terms. . . . I leave the story entirely to her own telling." (*BLJ*, II:255–56)

20. Lady Sydney Morgan, *Memoirs* (2 vols.; London: W. H. Allen, 1863), II:201.

21. This she carefully signals in her preface to the second edition of *Glenarvon,* insisting that the novel was designed to inculcate an impeccably conservative moral—"to enforce the danger of too entire liberty either of conduct, or of opinion; and to show that no endowments, no advantages, can insure happiness and security upon earth, unless we adhere to the forms as well as to the principles of religion and moral-ity." [Lady Caroline Lamb], *Glenarvon* (2nd ed., 2 vols.; Philadelphia, 1816), I:vi. The preface to the second edition of *Glenarvon* was necessitated, in fact, by outraged response to the excesses of the novel; as self-exculpation it is to some extent suspect. Nonetheless, however entangled the novel is between its incompatible impulses on the one hand to ratify or be seduced by the glamour of revolutionary passion and on the other hand simultaneously to condemn it as socially transgressive, the plot-line is

recognizably "anti-jacobin" despite the disruptive energies that constantly overflow. For a view of this novel as in the end a "novel of passion" (which would rank it as ambiguously revolutionary in its sympathies), see Gary Kelly, *English Fiction of the Romantic Period 1789–1830* (London and New York: Longman, 1989), 185–87. See also Mrs. Elizabeth Thomas's indignantly and more unambiguously anti-jacobin re-writing of *Glenarvon, Purity of Heart; or, The Ancient Costume, A Tale . . . Addressed to the Author of Glenarvon* (London, 1816), designed to correct "its horrible tendency, its dangerous and perverting sophistry; its abominable indecency and profaneness" (vi). Thomas conflates Lamb's real-life escapades with those of her characters Calantha and Elinor to contrast the excesses of Lady Calantha Limb's passion for the Byronic poet De Lyra with the virtuous restraint of Camilla besieged by the glamorous addresses of the Byronic Lord Ellesmere.

22. For a discussion of the ambiguously revolutionary politics of the gothic, in particular of *The Monk,* see Ronald Paulson, *Representations of Revolution (1789–1820)* (New Haven and London: Yale University Press, 1983), 219–25.

23. For another attempt to consider the political valences of *Glenarvon* see Malcolm Kelsall, "The Byronic Hero and Revolution in Ireland: The Politics of *Glenarvon,*" in Edwin A. Stürzl and James Hogg, eds., *Byron: Poetry and Politics* (Salzburg, Austria: Institüt für Anglistik und Amerikanistik, Universität Salzburg, 1981), 137–51. Kelsall argues that Lamb's novel "reveals the inherent contradictions of the Whig ideology in which she was reared and the utility of the Byronic myth in providing a scapegoat for the failure of her society to find a solution to the Irish problem" (138). Kelsall, while registering the presence of revolution and revolutionary philosophy in the text, fails to recognize the genres upon which it draws.

24. Compare such luminaries as the energetic Marauder of Charles Lucas's *The Infernal Quixote* (1798), who includes in his catalog of resourceful villainies (all attributed to his loose principles, revolutionary leanings, and philosophical scepticism) a series of heartless amatory and political seductions; having seduced Emily Vasaley with the help of the rubric from Wollstonecraft's *A Vindication of the Rights of Woman,* he abandons her to try his luck with her younger sister Fanny. Leaving a trail of murders, he then plots the Irish Rebellion of 1798, supports Catholic Emancipation, and eventually, kidnapping Fanny, offers her the alternatives of marriage or rape. She is rescued in the nick of time by the Christian hero, Wilson; Marauder throws himself over a precipice to escape. His philosopher-tutor has already come to a bad end, executed for treason, and his philosophical friend dies in the remorseful agonies of the atheist, just in case any reader should still be in any doubt as to the novel's moral. *Glenarvon* is structured as just such another antirevolutionary polemic, its protagonist Lord Glenarvon being presented as one of Marauder's most infernally faithful disciples, and the scene, as in much of *The Infernal Quixote,* set for the most part in Ireland (where Lamb had been sent to cool off in September 1812) in 1798, in the time of the French-backed Irish Rebellion, which was considered both analogous to the French Revolution and a consequence of the spread of French revolutionary principles.

25. Mabell, Countess of Airlie, *In Whig Society, 1775–1818* (New York and London: Hodder and Stoughton, 1921), 185.

26. All references to *Don Juan* are from *Lord Byron: The Complete Poetical Works,* ed. Jerome J. McGann (6 vols.; Oxford: Clarendon Press, 1986), V.

27. "I meant to . . . make him finish as *Anarcharsis Cloots* [Prussian aristocrat imprisoned in the Terror under Robespierre and executed March 1794] in the French Revolution," *BLJ,* VIII:78 (February 16, 1821). See also *Medwin's Conversations of Lord Byron,* ed. Ernest J. Lovell Jr. (Princeton: Princeton University Press, 1966), 165. For a discussion of the historical frames of *Don Juan,* see Jerome McGann, *The Beauty*

of Inflections: Literary Investigations in Historical Method and Theory (Oxford: Clarendon Press, 1985), 264ff.

28. Byron in fact goes so far as slyly to underline Julia's near relationship to her French sister:

> And if in the mean time her husband died . . .
> Never could she survive that common loss;
> But just suppose that moment should betide,
> I only say suppose it—*inter nos*—
> (This should be *entre nous,* for Julia thought
> In French, but then the rhyme would go for nought.) (I:84)

For a reading of Cantos I and II that similarly connects the figure of Donna Julia with Rousseau's Julie see Lawrence Lipking, *Abandoned Women and Poetic Tradition* (Chicago: University of Chicago Press, 1988), 32–56. Lipking also connects Julia with de Staël (36–37). Lipking's reading registers the aggression encoded within this episode toward the figure of the abandoned woman as primarily autobiographical; as will become clear in what follows, while I do connect the autobiographical with the poem, I am not interested in positing a strictly causal relationship, preferring instead to present the generic homologies between Byron's negotiations with Lamb and his negotiations with Rousseau as crucially informed by a politics of genre that has implications at both the level of poetic practice and authorial identity.

29. The relationship, mediated through Pope, was noted by one contemporary review, which considered Julia's letter to be "equal, in its way, to the celebrated epistle of Eloisa." Quoted in Bernard Blackstone, *Byron: A Survey* (London: Longman, 1975), 299.

30. As Julia Epstein has observed, "the 'true art of letter-writing' in the eighteenth century . . . relied upon the letter's concealing its nature as a *written* artifact." Julia L. Epstein, "Fanny Burney's Epistolary Voices," *The Eighteenth Century* 27 (1986): 162–79: 177. For a reading of this episode which is similarly engaged with material contingency of the letter (although it accounts for this guilty fragility in rather different ways), see Jerome Christensen, *Lord Byron's Strength; Romantic Writing and Commercial Society* (Baltimore and London: The Johns Hopkins University Press, 1993), 234–57. Regrettably, Christensen's reading of *Don Juan* came out after this essay was already in press.

31. To John Murray, July 6, 1821, *BLJ*, VIII:148.

32. Letter to Byron, May 26, 1820. *Letters of Percy Bysshe Shelley*, ed. Frederick L. Jones (2 vols., Oxford: Clarendon Press, 1964), II:198.

33. See R. C. Dallas, *Percival; or, Nature Vindicated* (London, 1801).

34. For a similar interest in figures of paternal authority in this section of *Don Juan,* see Christensen, *Lord Byron's Strength,* 328–30, 335–38, 340–42.

35. According to the ballad that the Lady Adeline Amundeville composes and performs, the monk haunts the family of the Amundevilles, particularly at moments when patrilineal succession is at issue: "By the marriage-bed of their lords, 'tis said/He flits on the bridal eve;/And 'tis held as faith, to their bed of Death/He comes—but not to grieve./When an heir is born, he's heard to mourn. . ." (XVI:3–4).

36. See Andrea Henderson's essay in this volume for a provocative reading of exchange-value against gothic characterization. The appearance of paper money at the precise moment of the appearance of the ghost jibes very suggestively with her thesis; I would amplify it to remark that, given that Byronic identity is compromisingly bound up with this figure (see argument below), it might suggest that Byronic identity was at the further end of the spectrum of romantic identity in much the same way as gothic identity is for Henderson, and that this may well account for the persistent unease in

romantic studies, premised as they are upon the very different productions of Words-worthian identity, around the "subject" of Byron.

37. W. Paul Elledge, "Immaterialistic Matters: Byron, Bogles and Bluebloods," *Papers on Language and Literature* 25 (1989): 279.

38. Gary Taylor, *Reinventing Shakespeare: A Cultural History* (New York: Weidenfeld and Nicholson, 1989), 102ff.

39. For a reading which notes that Hamlet consistently appears in the work of Coleridge, Byron, and Shelley as the figure of the impotent intellectual as opposed to the man of action, Napoleon himself, who is figured by contrast most frequently as the regicide usurper, Macbeth, see Malcolm Kelsall, "Hamlet, Byron, and an 'Age of Despair,'" *Beyond the Suburbs of the Mind: Exploring English Romanticism,* ed. Michael Gassenmeier (Essen: Blaue Eule, 1987), 40–54.

40. Lipking, 44.

41. Susan J. Wolfson, "'Their She Condition': Cross-Dressing and the Politics of Gender in *Don Juan,*" *ELH* 54 (1987): 609.

42. I take the phrase from Lamb's other feat of Byronic literary imposture in the summer of 1819 when she published "A New Canto." This more than competent pastiche was designed to supplement the two already published Cantos of *Don Juan* (see Peter W. Graham for a reading of this piece), a supplementation perhaps analogous to an earlier attempt to persuade Murray to interleave a new edition of *Childe Harold* with her own drawings (Byron to Lady Melbourne, February 7, 1813, *BLJ,* III:17). In this canto Lamb/Byron characterizes his/her style as at once revolutionary and "hermaphroditical."

43. I intend here that the term "simulation" should evoke Jean Baudrillard's use of the term in his *Simulations* trans. Paul Foss, Paul Petton, and Philip Beitchman (1981; New York: Semiotexte, 1983).

44. Harriette Wilson, *Memoirs of Herself and Others* (1825) with a preface by James Laver (New York: Minton, Balch and Company, 1929), 588–93.

45. Wilson, 588–93.

46. In this context, one might recall the 1960s rock groupie who made a career of sleeping with all the most famous rock stars, dismissing them all after the event with the disappointed comment that "It was all right, but it wasn't Mick Jagger." On finally adding the self-consciously Byronic Jagger to her collection, she remarked, "It was all right, but it wasn't *Mick Jagger.*" The deferred identity of the romantic poet is thus unmasked as the original for the phantasmagoric identity of the modern star.

47. *The Works of Lord Byron: Letters and Journals,* ed. Rowland E. Prothero (London, 1901), IX:36–37.

48. Wilson, *Memoirs,* 613. See Leslie Marchand's remark that "It is more likely . . . that she only *saw* him on that occasion," for she wrote to him after he had gone to Italy: ". . . we never shall meet, and never *have* met. . . ." Cited from "George Paston" and Peter Quennell, "To *Lord Byron* . . . ," 157; see Leslie Marchand, *Byron: A Biography,* 460ff., for this remark and also for a discussion of their correspondence. Some of Byron's later letters to Wilson and her supposed replies are quoted in Wilson's *Memoirs,* 611–15, along with the following *affidavit* for their authenticity:

> Lord Byron wrote me many letters at different times; but I have lost or mislaid them all, except those which I have herein given, and can show to anyone who may be pleased to question their being really originals. (615)

49. That Byron has come to occupy a newly central position in romantic studies among materialist critics (a position crucially sponsored by the work of Jerome McGann) is in part a result of, to borrow Jerome Christensen's phrase, his "symbolic mobility," a mobility of identity that effectively challenges a romanticism stabilized

around the Wordsworthian model of poetic identity. Jerome Christensen, "Theorizing Byron's Practice: The Performance of Lordship and the Poet's Career," *Studies in Romanticism* 27 (Winter 1988): 477–78.

50. Cf. Judith Butler's remarks apropos of pastiche and "parodic repetitions" that some "become domesticated and recirculated as instruments of cultural hegemony" while others are "effectively disruptive, truly troubling." *Gender Trouble* (London: Routledge, 1990), 139.

10

Butchering James Hogg

Romantic Identity in the Magazine Market

MARK L. SCHOENFIELD

[Hogg:] Were you the author of the article al-
luded to in my paper which places you at the
head and me at the tail . . . of all the poets
in Britain?
[Scott:] What right had you sir to suppose
that I was the author of it?
[Hogg:] Nay what right had *you* to suppose
that you were the author of it? The truth is
that when I wrote the remarks I neither knew
nor cared who was the author of the article [I]
alluded to. . . . But if the feather suits your cap
you are perfectly welcome to it.
[Scott:] Very well Hogg, that is spoken like a
man and like yourself. I am satisfied.

Referring to at least three articles and invoking a body of British literature
self-consciously bounded by Scottish talent, this exchange between James
Hogg and Walter Scott, recorded in Hogg's *Familiar Anecdotes* (103), displays
the entanglement of identity and authorship in periodical publication during
the romantic period. Hogg's witticism—"what right had *you* to suppose that
you were the author of it?"—acknowledges that authorship arises not merely
by the writing of a work but by its deployment, circulation, reviews, and
allusions. To speak "like a man and like [him]self," and to have Scott say so,
achieves a triumph of self-identity for Hogg. The incident ends with Scott

declaring, with a touch of his native legalese, that he is "satisfied"; Scott's authorization affirms Hogg's identity by guaranteeing consistency of style both in the particular (Hogg) and in a class (man). Hogg replays this exchange in various guises throughout the *Anecdotes:* a misidentification creates a confusion, Hogg asserts himself, and Scott adjudicates. The repetition of this scene underscores Hogg's anxiety about, and rhetorical manipulation of, his identity within a profession for which he played both ventriloquist and dummy and in which his very name was asset and liability as reviewers butchered him with porcine puns.

In contrast to the contemporaries who have emerged as the dominant romantic voices, Hogg acknowledged the self as a function of professional contingencies and accidents. William Wordsworth portrays his career in the unifying architectural metaphor of a gothic church, with his unpublished autobiographical poem as the ante-chapel,[1] and Byron interweaves his poetry with the stabilizing (if fragile) sovereignty of his lordship through complex networks of autobiographical reference.[2] Both of these models propose a coherent inner self, or at least a self accountable for its own instabilities, and obscure the point that this self is a mediated public figuration. James Hogg's career, however, repeatedly emphasizes this figuration, even as he resists it. In each edition of his *Memoir,* Hogg listed and numbered his publications. Reviewers, however, routinely suspected the attributions, suppressions, and uniqueness of this *curriculum vitae;*[3] in subsequent editions of the autobiography Hogg would then present evidence for the accuracy of his list. This textual flux suggests that the inward motion of romantic writers to establish an identity is accompanied by an outward, often concealed, passive, or defensive engagement with critics who had the institutional power to define literary identities.

In this essay, I continue the critical tradition of using James Hogg for my own ends, this time to focus on how his identity is constituted through a knot of textual interrelations. I neither cut nor untangle this Gordian knot, but tease out threads to argue the general proposition that the boundaries producing the notion of identity that Wordsworth and Byron exploited are not personal but institutional and always entail social agendas. The texts I will excerpt come from Hogg's *curriculum vitae* and from its primary review board, *Blackwood's Magazine.* Hogg published his *Memoirs of the Author's Life* in 1806 and 1821; in the intervening years, he had established his credentials in both poetry and prose and had published a journal, *The Spy* (1810–1811), as well as the pseudonymous *Poetic Mirror* (1816). In 1817, he wrote the *Chaldee Manuscript,* which, published anonymously, established the reputation of *Blackwood's Magazine.* Starting in 1819, John Wilson and John Lockhart, editors at *Blackwood's,* developed fictitious dialogues and adventures in which "Hogg" figured; these articles were the prototype for the regular feature of *Noctes Ambrosianae,* a series of dialogues in which "Hogg" appears, that ran from 1822 to 1835, the year of Hogg's death.[4] In response to Hogg's 1821 *Memoir, Blackwood's* published a devastating review (as well

as a disclaimer and rebuttal). In subsequent years, Hogg covertly replied to that review with the publication of a short letter, "A Scot's Mummy," and, more substantially, with the anonymous *Private Memoirs and Confessions of a Justified Sinner* (1824). These efforts were followed by a reissue of the *Memoirs* in 1832, and the *Anecdotes of Sir Walter Scott* in 1834. The publication of the *Confessions* especially generated reviews by several other magazines which referred, in turn, to *Blackwood's*. In this swirl of intertextuality, subjectivity is not only mirrored by its forms of representation but constituted by them.

To Market, to Market

Two boundaries delineate the self for the late eighteenth century. The divide between the body and the external world limits the self in the present; and the distinction between memory and imagination separates the past from phantasms of uncertainty and madness. Yet, as David Hume argued, these distinctions are conventional and tentative. Samuel Johnson declared Berkelean idealism—which he thought threatened the boundary of self—refuted when he kicked a stone on his way out of church (Boswell, 333); in Boswell's *Life of Johnson,* however, the incident exists only as a sequence of Humean perceptions more illustrative of Boswell's "Johnson"'s personality than any epistemological proposition.[5] The narration (or invention) of the event enmeshes Johnson and his anti-philosopher's stone in a dilemma of textual identity: how can (re)iterations of the incident—through editions, readings, paraphrases, and plagiarisms—maintain a self; and yet, without such reproductions which serve as cultural memory, in what sense does the incident exist? Although this question of dependency echoes the critique of writing by Plato's Socrates in *Phaedrus* and anticipates the hijinks of selfhood in Fowles's *The Magus* and other post-Freudian works, in the romantic period the problem derived a specific shape from a burgeoning periodical industry. Journalists and journals seized upon the possibilities implicit within an epistemological crisis which revealed a "self" created within a matrix of consumption and production.[6]

For many romantic writers, identity became vexed upon entering (or imagining entering) the literary marketplace, at the moment of glimpsing a literary double. "Who am I," the questioning might run, "once a publisher, a journal, a series of reviews incorporate my labor? At what risk am I from the mediating persons and institutions? Does a double confirm the self, deny it, supplant it?" As early as 1794, when he considered producing a periodical, Wordsworth voiced contempt for magazines which echoed one another in a swirl of institutional solipsism.[7] Wordsworth strategically integrated that contempt into a poetics which, in the *Prelude,* must transcend those "master pamphlets" organizing the ideology of the French Revolution debate. By contrast, in letters to potential publishers, Thomas De Quincey vows to convert his life experience

into capital through the medium of print. His *Confessions of an English Opium-Eater* weaves this transformation as De Quincey seizes the advantage of what Coleridge warns against, turning oneself into *"merely* a man of letters" (*Biographia* I:229).[8]

Kenneth Simpson has suggested that eighteenth-century Scottish writers were "particularly prone to adapt personae and project self-images," a tendency which "may well reflect a crisis of Scottish identity in the century after the Union" (*Protean Scot,* ix). A refiguration of that crisis emerged in the early nineteenth century as Edinburgh attempted to establish itself as a center of British, and European, culture and trade. Journals like *Blackwood's Magazine* and the *Edinburgh Review* presented themselves as distinctly Scottish, but expanded the Scottish empiricist tradition—spearheaded in the previous century by David Hume, Thomas Reid, and Adam Smith—into a general theory of British nationalism.[9] These tensions animate the representation of identity in periodicals; their pitfalls and possibilities shape the career of James Hogg and his best-known work, *Confessions of a Justified Sinner.*

In his 1821 autobiography *Memoirs of the Author's Life,* Hogg describes coming under the influence of the publisher James Robertson. Daily, they "drank whiskey and ate rolls with a number of printers, [so that] I was at times so dizzy, I could scarcely walk; and the worst thing of all was, I felt that I was beginning to relish it. . . . [I]nstead of pushing myself forward, as I wished, I was going straight to the devil" (20). Hogg saves himself by changing publishers, and deploys Robertson's name in his 1824 novel, *Private Memoirs and Confessions of a Justified Sinner,* when the "Justified Sinner" is reborn "Robert's son" through a series of linguistic transformations.[10]

First, the Editor describes Old Wringhim's nights with Rabina, Young Wringhim's mother, as a series of theological debates, laced with sexual innuendo:

> [I]t was their custom, on each visit, to sit up a night in the same apartment, for the sake of sweet spiritual converse; but that time, in the course of the night, they differed so materially on a small point . . . that the minister, in the heat of his zeal, sprung from his seat, paced the floor, and maintained his point with such ardor, that Martha [the maid in the other room] was alarmed. . . . (42)

The pun on "converse," at once a symmetrical exchange of words and an asymmetrical transfer of semen, establishes a flux, continual throughout the novel, between the production of words and the procreation of mirroring, second selves. Yet identity, within patriarchy, is given not by bodily conception or birth but by the acquisition of a name. Old Wringhim "baptize[s] him by the name Robert Wringhim,—that being the noted divine's own name" (43). The phrase following the dash adds no new information but emphasizes the production of young Wringhim's linguistic continuity.

Struggling to establish his independence, Young Wringhim derides his

mother's feeble theological understanding (and, therefore, unknowingly que-ries the "converse" of his own conception). Old Barnet, who overhears Young Wringhim's diatribe, worries that the lad will "turn out to be a conceited gowk":

> "No," said my pastor, and father, (as I shall henceforth denominate him,) "No, Barnet, he *is* a wonderful boy; and no marvel, for I have prayed for these talents to be bestowed on him from his infancy; and do you think that Heaven would refuse a prayer so disinterested?" (111)

The son denominates—names—the father and becomes himself ("a wonderful boy"), and his father's double, in the gesture. Old Wringhim's "prayers" are the linguistic equivalent of genetic determinism, empowered by the empiricist guarantor of objectivity, disinterest. Finally, like Hogg, the adult Wringhim arrives in Edinburgh to discover himself in the power of a publisher: Gil-Martin. As the novel develops, both Old Wringhim and Gil-Martin in effect publish Young Wringhim, by circulating his name and his likeness respectively. In the gap between these two stories, Hogg's escaping Robertson and Wringhim succumbing to Old Wringhim and then Gil-Martin, we glimpse the conflict of identity that inheres in the hierarchical structure of the publishing industry. Robert Wringhim's name points not only to illegitimacy within the novel (he is, after all, a bastard) but also to the problem of legible identity within Hogg's career. Hogg's novel figures this problem as a negotiation be-tween an editor (who mirrors not only Wringhim but his denominated father and "printer's devil," Gil-Martin) and a self whose existence is implicated in works extending beyond the novel itself.

The *Confessions* was published anonymously, and in the coda the "Editor" explains how he came upon the manuscript that comprises the second part of the novel. Quoting the "Scots Mummy" letter, planted in *Blackwood's Maga-zine* the year before the novel's publication, he says that the manuscript "bears the stamp of authenticity in every line; yet, so often had I been hoaxed by the ingenious fancies displayed in that Magazine, that when this relation met my eye, I did not believe it" (234). This comment about the magazine, whose treatment of *Confessions* would most influence its reception, prepares to nul-lify a bad review. As Redekop points out, "Hogg has his editor interpolate this 'authentic' [and authenticating] letter at the end of the novel and embark on a search for [the mummy's] grave, taking the August issue of *Blackwood's* with him as a treasure hunter might take a map" ("Beyond Closure," 160). In this extratextual encounter, a reader is invited to position the novel within the wider framework of material print production.

Hogg dissolves the margins of his fiction by marshaling procedures usually *about* a novel, including its typesetting, advertisement, and review, as part *of* the novel. For example, the Editor had wished to title the volume "Confessions of a Self-Justified Sinner," but was prevented by his book-seller. Slipping the

bounds of the novel, Longman's advertising list nevertheless offers the editor's title: *Self*-Justified Sinner. That document, like *Blackwood's Magazine,* becomes part of the fiction within the novel, despite being actually outside it. This strategy, literally a disappearing/reappearing "self," raises doubts not only about Hogg's fictional editor but about the editorial role within publishing. The construction of a literary self was a corporate effort, even if, as Hogg often recognized, the corporation was an unholy alliance of writer(s), publishers, reviewers—anonymous, named, pseudonymous, and mistakenly or purposefully misidentified or unmasked in other publications. And, of course, only some readers would be in on the games.

Less an irony than a testament to the power of literary institutions to stereotype its professional servants, Hogg remains in the public eye the bumpkin Ettrick shepherd of *Noctes Ambrosianae,* the product of a collaborative dialogue masterminded by John Wilson for *Blackwood's Magazine.* Reviewing *Confessions of a Justified Sinner,* Hunt's *Examiner* refers tactically to *Noctes:*

> We gather from [Hogg], that every man is the child of his own creation, and may do or say what he pleases. If he can say as much of himself, well; but let him first pause and consider whether he has not more than once favoured himself with an unintended head-ach after spending the previous evening with Christopher North and Co.? (483)

The pseudonymous Q challenges Hogg's self-reliance by employing *Noctes* as a historical representation with a physical trace—a hangover from alcohol or, perhaps, verbal abuse. He asks Hogg to contemplate his own existence, and body, through Christopher North's incorporation ("and Co."). Q has constructed an analogy in which John Wilson (a.k.a. Christopher North) stands in the same relation to Hogg as Gil-Martin (who, like Wilson, is pseudonymous) does to Robert Wringhim. Wringhim, having fallen under Gil-Martin's control, is given to fits of amnesia during which he may or may not have committed various crimes and indiscretions. Hogg, similarly, could open *Blackwood's Magazine* to learn he had spent an evening drinking immoderately and bragging about his poetic abilities in a self-defeating doggerel. Q's observation is not original but a belated entry into an array of documents in which Hogg's identity is contested.

Hogg (dis)appears most famously as the caricatured "Ettrick Shepherd" in *Noctes Ambrosianae.* He could not refute the characterization without playing into it, nor could he ignore it. He sometimes dressed the shepherd's role, sometimes denounced it. He could also impersonate an editor; in the "Advertisement" to *The Poetic Mirror,* a collection of poems from "the principal living Bards of Britain," Hogg announces that "after many delays and disappointments, he is at last enabled to give this volume to the public" (145). His authors had not sent their promised contributions, and his editorial solution was, simply, to write them himself. These parodies, including self-parodies,

take advantage of the complexity of "self"-representation. In Hogg's aggres-sive response to his situation (which in turn partly validated Wilson's charac-terization), he exerts a limited agency within an institution, publishing, that seeks to be determinant but requires the fiction of the transcendent author.

In search of this fleeting authority, Hogg published his autobiographical *Memoirs of an Author's Life* four times, in conjunction with other literary ventures. Hogg intended these accretive versions to assist his claim to be the heir of Robert Burns in Scottish letters by exploiting his position outside the Edinburgh cartel of professional writers. *Blackwood's Magazine* replied to the 1821 *Memoirs* with a "Familiar Epistle," a vitriolic attack couched in satire. Penned by Wilson, it asserted the primacy of Edinburgh's cultural posi-tion against an egotistical intruder. Hogg did not react directly to the "Old Friend's" review—he understood the rhetoric of satire too well for that. In the *Confessions of a Justified Sinner,* however, he responds to certain specific moments in the letter and, in doing so, enforces the correspondence between the procedures of the "Editor" in the novel, modeled on Wilson, and the "Old Friend," the pseudonym under which Wilson wrote the "Familiar Epistle."

Speculating in Hogg Futures

In the August 1821 issue of *Blackwood's Magazine,* the second edition of Hogg's autobiography, *Memoirs of the Author's Life,* was scrutinized by Wil-son in the guise of a correspondent ("an Old Friend with a New Face") writing a "Familiar Epistle" to Christopher North, Wilson's usual pseudonym. Wilson conceals his own solipsism (as correspondent and recipient, author and editor, writer and reader) while exploiting Hogg's identity through plays on his name:

> I take the liberty of sending back Hogg, which has disgusted me more severely than anything I have attempted to swallow since Macvey's Bacon.

Overdone by references to "pickled pork," "roast pig," "boar," and so on, the puns position Hogg as consumable, uncouth, and, I suppose, unkosher. Besides objecting to Hogg's egotism, the Old Friend will not tolerate the proliferation of lives Hogg achieves through his writing:

> Besides, how many lives of himself does the swine-herd intend to put forth? I have a sort of life of the man, written by himself about twenty years ago. There are a good many lives of him in the Scots Magazine—a considerable number even in your own work, my good sir—the Clydesdale Miscellany was a perfect stye with him—his grunt is in Waugh—he has a bristle in Baldwin. . . . This self-exposure is not altogether decent; and if neither Captain Brown nor Mr. Jeffrey will interfere, why I will—so please print this letter. (43)

The transformation from "shepherd" to "swine-herd" attacks the self-author-ship of Hogg tending Hoggs. The dissemination of lives, then, becomes a

disintegration (butchering) of self, as body parts haphazardly disperse across periodicals dependant upon regularity of circulation. Although many of Hogg's "self-exposure[s]" are not by Hogg, the menace of indecency and contamination validates the reference to Francis Jeffrey, editor of the *Edinburgh Review* and future Sessions Court Judge. Jeffrey's anonymous work did not obscure his presence but broadened it both across contributors (who complained of work edited beyond recognition) and across other journals that adopted the *Edinburgh*'s standards of professionalism. The seeming erasure of identity by transforming it into an objective voice secures editorial power. The "Old Friend's" regulatory image has been prepared by the militaristic language of his wager to

> undertake, in six weeks, to produce six as good poets as he [Hogg] is, from each county in Scotland. . . . I engage to draw them up two deep. . . . Lieutenant Juillinan shall be at their head—Mr. ———— shall officiate as chaplain—and ———— if he pleases, shall be trumpeter.

The sequence from "Lieutenant Juillinan" to "————" dissolves the authors into editorial anonymity. The phrase "if he pleases" suggests a subjective perspective, but one belied by the (non)denominating "————"; "————" cannot know if he pleases, since he cannot know he is being addressed. Although the "Old Friend's" boast begins by projecting the fantasy of poets running wild through Scotland, they can please, in both senses, only within the ranks of editorial authorization.

As neither judicial Jeffrey nor Brown, captain of the Edinburgh police, take up their duty, the Old Friend will. His own presence ("please print this letter") relies on the policing function to expose, and decompose, the breeding Hoggs. A public letter by Brown defending his management of the Edinburgh police, and a subsequent vindication by *Blackwood's*, had recently answered accusations by the *Caledonian Mercury*, so the reference to Brown both suggests the criminality of Hogg's activity and highlights the press's function of regulating policy by manipulating public opinion. Preserving his own masks, the Old Friend exposes Hogg's—and creates a few new ones to expose. He maintains that Hogg takes credit for the notorious murder of Begbie, an act equated, in daring and elegance, to writing the Chaldee Manuscript. Despite Wilson's insinuation that Hogg wrongly claims authorship, Hogg's surviving holograph demonstrates his composition, aided afterward, as he observes, by "a good deal of deevilry" by Wilson and company (*Memoirs*, 43).

The Old Friend typically addresses North in an argumentative mode: "Come now, Christopher, and be honest with me. Do you believe that there is a man living who can repeat a single line of Hogg's?" (44). This particular jibe is, I think, a joke since Wilson could easily repeat, and invent, Hogg's poetry. After the Old Friend's letter, a note initialed "C. N." (for Christopher North) justifies the publication of the letter since it will "tickl[e] the public

sympathy . . . and put a few cool hundreds in [Hogg's] pocket" (52). Besides, he adds, "as [Hogg's] autobiography sufficiently proves, his fame can be in no hands more friendly than his own." Whether Wilson formed an attitude toward Hogg's *Memoirs* outside his various personae is hard to know, because, finally, the journalistic function of *Blackwood's,* like the *Edinburgh,* was not to produce individual opinions but to establish the range of opinions that constituted public aesthetic (or political) thought. In the "Familiar Epistle," the Old Friend marks one margin, and Christopher North marks the other.

Wilson's hidden division of self reinforces a unified editorial consciousness differentiated from Hogg's wildly proliferating lives, which Wilson links to sexual promiscuity and textual deviance. The Old Friend's letter precedes a long excerpt from *Memoirs* detailing Hogg's effort to publish *The Spy* with these remarks:

> The author makes love like a drunken servant, who has been turned out of place for taking indecent liberties in the kitchen with the cook-wench. The Edinburgh young ladies did not relish this kind of thing,—it was thought coarse even by the Blue Stockings of the Old Town, after warm whiskey toddy and oysters; so the Spy was executed, the dead body given up to his friends—where buried, remains a secret until this day.[11]

The model for this execution is Swift's literary assassination of the almanac-making Partridge (the bird as appropriately hunted as the swine slaughtered), and the Old Friend plays on the absurdity of someone as gross as Hogg acting the spy. Conflating work and human being, the Old Friend suggests that the always recognizable Hogg makes an equally unsuitable spy and editor.

Through both the Blue Stockings and Hogg, the Old Friend connects identity to the refinement (through eating) and sublimation of desires, and such sublimation then becomes the operative characteristic of Wringhim's misogyny and Gil-Martin's projection of violence and rape onto Wringhim. While maintaining his innocence based on "the purity of nature and frame to which I was born and consecrated" (177), Wringhim acknowledges:

> Here I must confess, that, highly as I disapproved of the love of women, and all intimacies and connections with the sex, I felt a sort of indefinite pleasure, an ungracious delight in having a beautiful woman solely at my disposal. (181)

The horror of this observation increases when the implicit pun on "disposal" becomes evident and Wringhim disposes of (murders) the woman. Where the Old Friend has argued that sexual impropriety results from Hogg's assertions of self, Hogg connects sexual violence to the denial of desire in the form of institutional fanaticism, both religious and editorial.

The Old Friend disputes the continuity between Addison's *Spectator* and

The Spy. The character of the Spectator is chameleon, capable (like the successful journal itself) of infinite circulation:

> I have been taken for a Merchant upon the *Exchange* for above these ten Years, and sometimes pass for a *Jew* in the Assembly of Stock-Jobbers at Jonathan's. (*Spectator 1*, 142)

Hogg, in the unsuccessful *Spy*, constantly points to the impediments to such circulation in contemporary Edinburgh. In "A Dialogue in the Reading Room" (December 29, 1810), someone is mistaken for "the Spy on account of his lean, starved appearance, while the true author turns his small legs and meagre hands to one side that the truth may not be discovered" (Hughes, 49). As Hughes and others have pointed out, Hogg was well built, and is here playing on a convention. But the Old Friend targets his attention on the physical body, precisely what Addison made invisible, by describing Hogg's visits to "bookseller's shops":

> What would he himself have thought, if a surly brown bear, or a huge baboon, had burst open his door when he was at breakfast, and helped himself to a chair and a mouthful of parritch? (45)

The vulgarity of his ingestion anticipates the quality of his (literary) output. By contrast, according to the Old Friend, Byron wrote the two good poems in the *Poetic Mirror* (parodies of Wordsworth) "with an immense stack of bread and butter before him, and a basin of weak tea" (49).[12] To struggle over authorial identity meant contesting the body as a site of production. Only when dead, consigned to an unmarked grave, does the Spy achieve the paradoxical anonymity of editorial power.[13]

Hogg takes his revenge in the *Confessions*. David Groves points out that

> "Nearly everything about . . . [the *Confessions'*] editor, his arrogance, his modern upper-class Toryism, his friendship with other *Blackwood's* writers like Lockhart, and his university background, indicates that he is based on the real-life John Wilson, although in a few other respects he is a more generalized portrait of a successful man-of-letters." (*James Hogg*, 114)

I would add that Wilson's identity is that of the generalizing man of letters, whose type is Addison's chameleon Spectator, and whose anti-type is Hogg's Spy. Christensen has shown in David Hume a generalizing impulse that fed on other identities in its self-figuring (*Practicing Enlightenment*, chapter 4). Wilson adopted this role as Christopher North and converted it into the Chair of Moral Philosophy that Hume had unsuccessfully sought. In Hogg's fiction, the Editor's situating of "traditionary facts," re(as)sembling Wilson's editorial

tyranny, contains the Burnsian (Hoggish?) voice of traditional farmhand within the Humean frame of Historian. The change from Longman's advertisement announcing "Historical Facts" to the title page's more modest "Traditionary Facts" indicates the slippage.

Hogg, in his *Memoirs*, argues that his late literacy allowed him to develop a personal integrity prior to his literary self. A friend "often remonstrated with me, in vain, on the necessity of a revisal of my pieces; but in spite of him, I held fast my integrity." Revision, internalized editing, threatens integrity. The Old Friend responds vigorously, focusing on Hogg's physical production of literature:

> He could not write, he says, till he was upwards of twenty years of age. This I deny. He cannot write now. I engage to teach any forthcoming ploughman to write better in three weeks. Let Hogg publish a fac-simile of his hand-writing, and the world will be thunderstruck at the utter helplessness of his hand. (44)

The attack on Hogg's irregular handwriting foreshadows the extended pun in the *Confessions* on "justification," as the epitome of both textual and spiritual regularity. Further, the choice of a "ploughman" as a pupil recalls Robert Burns, and so the phrase "write better" combines mechanical and imaginative skills.

But Hogg pushes the Old Friend's joke further in his novel, having his Editor produce a manuscript page in Wringhim's hand. The use of the facsimile, an effort for unmediated proof, satirizes the inherently mediating position of the editor as a consumer of truth.[14] As the handwritten page turns into facsimile, it loses its status as handwriting and becomes another form of justifying print, another mechanical reproduction. Blanchard, Wringhim's first murder victim, warns him, "There is no error into which a man can fall, which he may not press [pun intended] Scripture into his service as proof [pun still intended] of the probity of." The message for Wilson and his readers is that the mechanics of justification delude, precisely because of their pseudo-objectivity. Because identity always refers beyond the self toward that to which the self is identical, any representation of self can be only a facsimile, a similarity masquerading as a fact.

To write a memoir is to edit a life, and if Wringhim's life is preordained, then such editing is liable to the curse that ends his manuscript: "cursed be he who trieth to alter or amend." Hogg, in contrast, acknowledges omissions in his own *Memoirs,* and refers to a larger, obscure master-text (the existence of which remains conjectural):

> In this short Memoir, which is composed of extracts from a larger detail, I have confined myself to such anecdotes only as relate to my progress as a writer. (51)

He reserves himself, as individual and text, but this is also a rhetorical strategy

to suggest that a reserved self *exists* apart from its published manifestations—a claim targeted by the Old Friend. Wringhim, by contrast, intends to present the entire story; omissions cease to exist. Wringhim is advised to keep the actual type "close," a word that coordinates the secretive production of the text with the condensing procedures that result in Wringhim's repeated amnesia; in his next encounter with Gil-Martin, the latter says, "I am wedded to you so *closely,* that I feel as if I were the same person" (220). The correspondence of the contents and the form of production highlight the transforming character of print.

The use of justified print implies a teleological perspective that novelists evade with various ploys; the found diary, private letters, and the hiatus in a mutilated journal all allow the introduction of an editorial figure who offers the transformation of handwritten forms into print as a transparent procedure that preserves their unjustified (subjective) character and deflects the teleology onto the editor. He grasps the public meaning of what was intended only privately. The private character of the manuscript, then, becomes evidence of truth as an admission against interest. Hogg's presentation of the typesetting, however, constructs both justified print and unjustified handwriting as tentative positions. Wringhim errs in trusting his own editing and typesetting, and the linguistic puns that pervade the descriptions of his crimes emphasize the mistake as symptomatic of a particular perspective.

Wringhim does not begin his memoirs until after he has learned to set type, and the confession begins:

> My life has been a life of trouble and turmoil; of change and vicissitude; of anger and exultation; of sorrow and of vengeance. My sorrows have all been for a slighted gospel, and my vengeance has been wreaked on its adversaries. (109)

The implied perspective is that of completion, of a life summed up, as certain as the Gospel to which it is dedicated. The balanced construction of the sentences work an illusion of completeness, and the final contraries of the first sentence become the reconciled antitheses of the second. This is a life, the rhetorical structure tells us, whose meaning may be read.

The confession within the novel is typeset almost to completion. Under the sign of justified print, Wringhim "will let the wicked of this world know what I have done in the faith of the promises, and the justifcation by grace, that they may read and tremble" (109). The reader does not interpret but merely recognizes his own fallenness in contrast to Wringhim. Yet near the end, Hogg creates an intermediate stage of text, handwritten but part of the typeset work, that indicates a change in Wringhim's program:

> I must furnish my Christian readers with a key to the process, management, and winding up of the whole matter; which I propose, by the assistance of God, to limit to a very few pages. (215)

"Winding up" puns inadvertently (from Wringhim's perspective) on the winding sheet in which Wringhim is buried and the winding, circular chase described by the "driver" in Hogg's "Scot's Mummy" letter. The pun undermines the hope of making the matter whole by resolving the doubles and divisions within the convention of a printed conclusion. In the process of composing, Wringhim has transformed his audience; moreover, the shift from "the wicked" (109) to "my Christian readers" reconceptualizes Wringhim's own role as narrating subject of an autobiography. In the paragraph following this shift, set off by an italicized date, he writes: "My hopes and prospects are a wreck." This collapse begins the "handwritten" section. The play on "prospects" remind us that, so far, Wringhim has pointed his confessions toward a specific conclusion—one they will never reach. Now each day's entry only guesses at the continuation. September 7, 1712, finds Wringhim handing over to the reader the task of judgment: "And to what I am now reduced, let the reflecting reader judge" (229). A final curse ends Wringhim's tale:

> now my fate is inevitable.—*Amen, for ever!* I will now seal up my little book, and conceal it; and cursed be he who trieth to alter or amend! (230)

The insistence on completion exposes an anxiety about teleological possibilities having escaped Wringhim. To unseal (and to unconceal) by publication is an alteration that questions the inevitability of Wringhim's suicide, since fate depends on the certainty of text.[15] The reader and the mediating Editor discover that no text is transparent, nor any interpreter a free agent. Wringhim's insistence on a justified identity, like the Editor's guise of objectivity, fails to notice institutional constraints such as those Hogg faced. The reflective reader, like Wringhim and the Editor (who offers himself as surrogate reader), gazes into a maze of refracting texts, in which the "stamp of authenticity" is only a facsimile.

The novel, however, does not mark a final retort to periodical machination, but only part of a sequence that Hogg struggled to control. He had hoped to have his *Confessions* reviewed in *Blackwood's,* but failed; the journal teased both author and readers with references to the novel and hints of a review. A few brief anecdotes, which will wind up the matter, suggest that Hogg's identity continued to be reconstructed at the margins of his novel. For instance, *The British Critic* reviewed *Confessions:*

> Write what he will, there is a diseased and itching peculiarity of style, . . . which, under every disguise, is always sure to betray Mr. Hogg. (July 1824)

Hogg's publication appeared near the end of June, and it is unlikely that the reviewer would have obtained such an early copy other than from Longman's. Thus, he deduces the author via style, because he knows the author. Such

fraud is the wit of the critical trade.[16] Like the reviewer's own work, prose style should not betray particularity. In this regard, the anonymity of the Waverley novels pointed to their value, though that value depended upon the suspicion of Scott's authorship (in which Hogg asserts a "fixed belief" until "Johnny Ballantyne had fairly sworn me out" of it). By contrast, *Blackwood's Magazine* blasts Hogg's anonymity for the *Confessions* in the June 1824 *Noctes Ambrosianae* and reenforces the unmasking when the Ettrick Shepherd offers a subsequent denial. The play between the anonymous and the named as a struggle for self-authorship charts a more general tension between the journals of judgment and the authors of identity who came before their bar. A second anecdote concerns the last version of *Confessions* published in Hogg's lifetime. Among the significant changes are the elimination of "Hogg"'s appearance at the end and the signature of "JH" as the editor. The retitled *Private Memoirs and Confessions of a Fanatic* (1837) traps Hogg in the snare he set for Wilson. Doubt as to the edition's authorization reiterates the confusions of identity and style that the novel opens.

George Saintsbury, a Victorian canon-builder, expatiates on *Confessions of a Justified Sinner:*

> [That novel is] one of the most remarkable stories of its kind ever written—a story which . . . is not only extraordinarily good of itself, but insists peremptorily that the reader shall wonder how the devil it got where it is. (*English Literature,* 43–44)

The joke of "devil," though feeble, rhetorically aids the shift from the novel's problematizing its own authorship (the Editor exclaims, at the end of Wringhim's tale, "What can this work be? . . . I cannot tell") to questioning Hogg's actual authorship. The novel is, Saintsbury maintains, so much better than anything else Hogg wrote that someone must have ghostwritten at least portions of it (Saintsbury suggests John Lockhart). Saintsbury's *ad hominem* attack depends upon the *Blackwood's* construction of the "Ettrick Shepherd" to which Lockhart substantially contributed. Since, however, that persona was the implied author for the reading public, at least after reviews unmasked Hogg's anonymity, Saintsbury is, in a sense, right: James Hogg may have written the novel, but the identity of its author(s) is a complicated question of editorial interaction. For Hogg, then, the literary marketplace was not a site for the romantic expression of identity but rather the place of contention in which the self was revealed as a social construction, a mediation between personal agency and institutional power. Last, a twentieth-century critic offers Wringhim's fictional facsimile as a sample of James Hogg's holograph—a mastery of confused identities, or, if you will, pickled Hogg.

NOTES

1. In 1805, Wordsworth recognized his autobiographical project as "a thing unprecedented in Literary history that a man should talk so much about himself," and he announced that he would never publish the poem during his life. Wordsworth translated this reluctance to publish into a professional asset by asserting, in the 1814 preface to *The Excursion,* that the "preparatory poem" *(The Prelude)* was the antechapel of *The Recluse,* which was itself the "body of the gothic church." His lesser pieces constituted the "little cells, oratories, and sepulchral recesses" that will make Wordsworth's career whole. Strategically withholding a crucial document (but allowing hints of it to circulate in the works of Coleridge and De Quincey), Wordsworth projects the possibility of a unified identity of both poetry and poet; in doing so, he typifies Marlon Ross's generalized description of romantic poetic activity:

> Convinced that within the individual an autonomous and forceful agent makes creation possible, they [romantic poets] struggle to control that agent and manipulate its energy; they struggle for self-possession—a state in which the individual has mastered his genealogy, his internal contradictions, his doubts about his power of mastery and the world that seems to obstruct its sway. ("Troping Masculine Power," 26)

2. "The Byronic text heroically pretends to resist the massive encoding of culture while providing an ensemble of identificatory procedures and inducements that 'solve' the incompatibility between general law and individual application by mystifying it. . . . Critical employment of Byron's biography has consistently recapitulated this mystification: the poems are imagined as an elaborate code which, by way of a handily metaphoric secret, can be brought into some determinate relation with a singular circumstance of Byron's life" (Jerome Christensen, "Theorizing Byron's Practice: The Performance of Lordship and the Poet's Career," 482–83).

3. "The Hunting of Badlewe is reprinted in Dramatic Tales,—therefore strike off one volume for that. The Pilgrims of the Sun, Mador of the Moor, may sleep in one bed very easily, and the Sacred Melodies and the Border Garland may be thrown into them. This most fortunately cuts off three volumes" (Wilson, "Familiar Epistle," 31).

4. Several of the earlier articles, including the *Chaldee Manuscript* and "Christopher in the Tent" (which uses "Tickler—Hogg—Odoherty" intermittently as a running head) appear in the collected *Noctes Ambrosianae* (1855).

5. Charles Rzepka points out that by kicking the stone in Boswell's presence, "Johnson is playing himself; he is becoming what Boswell expects him to be" (*Self as Mind,* 1). In his introductory chapter, Rzepka delineates the problem of skepticism about the self in the romantic period as a post-Johnsonian phenomenon. See also Cafarelli, *Prose in the Age of Poets: Romanticism and the Biographical Narrative from Johnson to De Quincey.*

6. Karl Polanyi's *The Great Transformation* and Michel Foucault's *The Order of Things* provide the broad conceptual base for this claim. Polanyi demonstrates the transformation of labor into a commodity produced for sale within the enforced wage-market of *laissez-faire* economics (139). Foucault recognizes at this same moment a corollary development in the intellectual perceptual frame of what he calls the "new empiricities," scientific discourses which produce labor as "an irreducible unit of measurement" (223) and allow *"general grammar* to be *logic"* (296). Both theorists, interestingly, look to Scottish Enlightenment figures for verification.

7. "All the periodical miscellanies that I am acquainted with, except one or two of the reviews, appear to be written to maintain the existence of prejudice and to disseminate error" (Wordsworth, *Letters,* 119).

8. Jerome Christensen argues that in the *Biographia* this phrase is "taken literally and feared" ("Mind at Ocean," 156).

9. See Robertson (200–28) for the role Hume played in beginning this transformation, and Harvie (118–35) for a more general consideration. Harvie notes that Francis Jeffrey "headed the movement for political assimilation" (121).

10. His surname Wringhim (more punned against than punning) plays on the sense of "wring" as a wine-press, a common figure for a printing press. That Hogg himself was a Robert's son adds an additional layer of nominal play; for Robert Hogg's contribution to Hogg's writings, see Petrie's "Odd Characters: Traditional Informants in James Hogg's Family."

11. The reference to the Blue Stockings silently paraphrases Hogg's assessment: "The literary ladies, in particular, agreed, in full divan, that I would never write a sentence which deserved to be read" (20). For *Blackwood's* readers, who would encounter this sentence in the midst of a several-hundred-word excerpt, the Old Friend puts a lascivious spin on "in full divan."

12. The Old Friend, again linking text and body, reading and sexual desiring, continues the joke: "Does Hogg believe, that if he were to walk down the Rialto, that the Venetian ladies would mistake him for his lordship?" (49).

13. Hogg does not take this attack lying down. The spy's burial is undone in the final section of *Confessions* when the Editor discovers the grave and body of the suicide in a parodic replication of what "Hogg" has already accomplished. The Editor reprints so much of the "Scot's Mummy" letter that the omission of the final paragraph is striking. While suggesting the appropriateness of a single fate for Christopher North and the Scot's Mummy, the deleted passage also recalls the Old Friend's treatment of the Spy:

> ...I am sure you will confess that a very valuable receipt may be drawn from it for the preservation of dead bodies. If you should think of trying the experiment on yourself, you have nothing more to do than hang yourself in a hay rope . . . you shall set up your head at the last day as fresh as a moor-cock. ("Scot's Mummy," 190)

Hogg's language of objectivity—"receipt," "experiment," "venture to predict"—mimics an editorial tone, revealing its ambition not to arise and crow at judgment day but to maintain an ambiguous identity—the sexual ambivalence of a moor cock. By omitting this paragraph, the Editor hides the anxieties about editorial identity and mortality that Wringhim's story has activated.

14. Hogg had already observed of booksellers in *The Spy* that "there is a numerous race of beings in this world who feed themselves upon the brains of their own species" ("The Spy's Account of Himself," September 1, 1810, 4).

15. Hogg emphasizes the ironic teleological significance of the suicide by retitling the 1828 edition *The Suicide's Grave.*

16. Hunt's *Examiner,* August 1824, attributes the "very singular production" to the Ettrick Shepherd:

> . . . its principal defect is, that with much elaboration in the assumption of disguise, no one can be deceived for a moment. In other respects, the strong hand of Mr. Hogg is often recognizable. (482)

WORKS CITED

Addison, Joseph, and Richard Steele. *Selected Essays from "The Tatler," "The Specta-tor," and "The Guardian".* 1709–1714. Ed. D. McDonald. New York: Bobbs-Merrill Co., Inc., 1973.

Anonymous. "Art. V. *The Private Memoirs . . .*" *British Critic* N.S. 24 (July 1824).

Boswell, James. *Life of Johnson.* 1791. Ed. R. W. Chapman. New York: Oxford UP, 1980.

Cafarelli, Annette Wheeler. *Prose in the Age of Poets: Romanticism and Biographical Narrative from Johnson to De Quincey.* Philadelphia: U of Pennsylvania P, 1990.

Christensen, Jerome. "Theorizing Byron's Practice: The Performance of Lordship and the Poet's Career." *Studies in Romanticism* 27 (Winter 1988): 477–90.

––––––. *Practicing Enlightenment: Hume and the Formation of a Literary Career.* Madison: U of Wisconsin P, 1987.

––––––. "The Mind at Ocean: The Impropriety of Coleridge's Literary Life." *Romanti-cism and Language.* Ed. Arden Reed. Ithaca: Cornell UP, 1984, 144–67.

Coleridge, Samuel Taylor. *Biographia Literaria, or Biographical Sketches of My Liter-ary Life and Opinions.* 1817. Ed. J. Engell & W. J. Bate. Princeton: Princeton UP, 1971.

Foucault, Michel. *The Order of Things: An Archaeology of the Human Sciences.* Trans. of *Les Mots et les choses.* 1966. New York: Vintage Books, 1973.

Groves, David. *James Hogg: The Growth of a Writer.* Edinburgh: Scottish Academic Press, 1988.

Harvie, Christopher. *Scotland and Nationalism: Scottish Society and Politics, 1707–1977.* London: George Allen & Unwin, 1977.

Hogg, James. *Memoir of the Author's Life* (1st ed. 1806, 2nd ed. 1821, 3rd ed. 1832) and *Familiar Anecdotes of Sir Walter Scott* (1834). Ed. Douglas Mack. Edin-burgh: Scottish Academic Press Ltd., 1972.

––––––. "A Scot's Mummy." *Blackwood's Magazine* 12 (August 1823): 188–92.

––––––. *The Private Memoirs and Confessions of a Justified Sinner* (1824). Ed. John Wain. London: Penguin, 1983.

––––––. *Poetic Mirror* (1816). In *The Works of The Ettrick Shepherd: Poems and Ballads.* Vol II. Edinburgh, 1865; rpt. New York: AMS Press, 1973.

––––––. *The Spy: A Periodical Paper, of Literary Amusement and Instruction.* Edin-burgh: Robertson, 1810, and Aikman, 1810–1811.

Hughes, Gillian. "*The Spy* and Literary Edinburgh." *Scottish Literary Journal* 10 (1983): 42–53.

Petrie, Elaine. "Odd Characters: Traditional Informants in James Hogg's Family." *Studies in Hogg and His World* 1 (1990): 136–52.

Polanyi, Karl. *The Great Transformation: The Political and Economic Origins of Our Time.* 1944. New York: Beacon Press, 1957.

Q. "Literary Notices." Ed. (and possible author) Henry Leigh Hunt(?). *The Examiner* (August 1824): 482–83.

Redekop, Magdalene. "Beyond Closure: Buried Alive with Hogg's *Justified Sinner.*" *ELH* 52 (1985): 159–84.

Robertson, John. *The Scottish Enlightenment and the Militia Issue.* Edinburgh: John Donald Pub., Ltd., 1985.

Ross, Marlon. "Troping Masculine Power in the Crisis of Poetic Identity." In *Romanti-cism and Feminism,* ed. Anne Mellor. Bloomington: Indiana UP, 1988, 26–51.

224 MARK L. SCHOENFIELD

Rzepka, Charles. *The Self as Mind: Vision and Identity in Wordsworth, Coleridge, and Keats*. Cambridge, MA: Harvard UP, 1986.

Saintsbury, George. "Hogg" (1889). Rpt. in *Essays in English Literature: 1780–1860*. London: Rivington, Percival & Co., 1896, 33–66.

Simpson, Kenneth. *The Protean Scot: The Crisis of Identity in Eighteenth-Century Scottish Literature*. Aberdeen: Aberdeen UP, 1988.

[Wilson, John]. "Familiar Epistles: Letter I. On Hogg's *Memoirs*." *Blackwood's Magazine* 10 (August 1821): 42–52.

Wordsworth, Dorothy, and William Wordsworth. *The Letters of William and Dorothy Wordsworth*. Vol 1, 2nd ed. Ed. E. de Selincourt et al., 6 vols. Oxford: Clarendon Press, 1967–1978.

Wordsworth, William. *The Excursion*. 1815. Vol. 5. In *The Poetical Works of William Wordsworth*, ed. E. De. Selincourt and H. Darbishire. 5 vols. London: Oxford UP, 1940–1949.

11

"An Embarrassing Subject"

Use Value and Exchange Value in Early Gothic Characterization

ANDREA HENDERSON

As Jean Hall points out, criticism has long argued that for Byron and his contemporaries "personal identity results from the turn toward innerness, the creation of an interior poetic world that builds the core of selfhood. In this view personality becomes an affair of depth, not surface; of integrity, not display" (135). This spatial model, with its emphasis on depths and interiors, while not peculiar to romanticism, is an important part of its rich legacy. The romantic self was "identified as the power, not the object, of perception";[1] it was a self defined as mind. Those romantic poets and texts that focus most closely on deep inner selves have traditionally been the most canonical, with Wordsworth and *The Prelude* serving as touchstones for romanticism as a whole. Trained by romanticism itself to associate such depth with integrity, we cannot help but find gothic effects in general and the gothic novel in particular unsatisfying in fundamental ways; gothic display and superficiality have long appeared as incoherence and sensationalism according to a paradigm that privileges depths. It is, however, no accident of history that even post-structuralist challenges to centered notions of "the subject" have not fully suppressed our tendency to conceive of the subject in spatial terms with priority granted to the interior. That this model of identity dominates the canonical writings of the late eighteenth and early nineteenth centuries—as well as our own assumptions about personality and the role of literature—can be related to economic and social pressures that continue to be influential and that govern our responses to the period and its products.

In this essay I argue that the growth of the perceived division between a "true" inner self and a superficial social self is intimately related to economic

developments; as Lukács notes, it is not without reason that during the age of romantic bourgeois revolutions "the hiatus between appearance and essence (which in Kant coincides with that between necessity and freedom) is not bridged. . . . Even worse than that: the duality is introduced into the subject. Even the subject is split into phenomenon and noumenon . . ." (124). It is my contention that at the moment the traditional genealogy-based model of identity was called into question by the ideals of the French Revolution and the realities of capitalist and industrial development, a market-based model of identity that had long been emerging rapidly gained prestige. This model situates identity along a continuum that includes, on the one hand, an "essential" and private identity that is, paradoxically, developed through labor, and, on the other, a social identity that is relationally determined and associated with consumption. Canonical romantic interiority focuses on that first pole: it presents a subject that simultaneously appears to have an intrinsic and relatively stable character and to be the product of its own labor. The early gothic novel, however, tends to focus on the opposite pole, making character a matter of surface, display, and "consumption" by others. The gothic novel associates this relational character both with traditional signs of identity and the vagaries of exchange value, focusing on the danger the old *and* the new systems of identification represented for an increasingly capitalist society. This representation of identity accounts for many of the gothic novel's peculiar thematic and formal features as well as its lower canonical status and association with the feminine. We will see that much of the mystery and violence of the gothic, and much of its distastefulness for us, arises from its vision of a world of what could be called "commodities among themselves" (Irigaray, chapter 9). After using eighteenth-century moral theory and the sentimental novel to provide a groundwork for understanding the prevalent models of identity in the period, I will describe the way the gothic novel carries certain trends to their logical—and ghastly—conclusions.

I

As early as the seventeenth century, one finds evidence of tension between two modes of personal valuation—one based on social rank and blood lines, reflecting an older and more static order, and the other based on individual merit and associated with capitalist-class imperatives and the growing strength of the market economy. Jean-Christophe Agnew traces this tension in *Worlds Apart* and argues that the expansion of the marketplace during the seventeenth century, both extensively and intensively, caused fundamental changes in the perception of human value and identity. Agnew convincingly shows that developments such as "the maneuvers of class and faction in the wake of the Revolution settlement, . . . the new relation of the state to speculative capital, and . . . the emergence of a distinctly urban, consumer culture . . . encouraged some thinkers, at least, to reconsider the notion—first broached by Hobbes—

of a commodity self: a mercurial exchange value or 'bubble' floating on the tides of what attention others were disposed to invest" (13). I would argue that the continuing extension of market relations, the rapid early development of industrialization, the weakening of larger patriarchal family ties, and the attack on aristocratic privilege precipitated another major shift in the conception of identity in the late eighteenth century.

One must of course be careful in associating these broad social and economic changes with the interests and doings of any single class, as William Reddy demonstrates, and in the past fifteen years historians have refined the category of the "middle class" into ever more specific and numerous subgroups (Reddy, 6). Nevertheless, it is undeniable that British elites were learning "between about 1780 and 1820, to invest money in a thoroughly capitalist manner: 'capitalist' in the strict sense of seeking to maximize return through the transformation of production methods" (12). And while "manufacturing and landowning classes were not so distinct as was once supposed" (10), it is clear that the new capitalist class that could be said to draw its members from both needed, in order to establish its hegemony, to develop its own methods for characterizing and evaluating persons. J. G. A. Pocock argues that "the century that followed the Financial Revolution witnessed the rise in Western thought . . . of an ideology and a perception of history which depicted political society and social personality as founded upon commerce: upon the exchange of forms of mobile property and upon modes of consciousness suited to a world of moving objects" (108–109). I will show, moreover, that people increasingly did more than present themselves as "marketable" objects and anticipate commercial deceit in others; as the traditional system of identification and valuation of individuals lost its prestige, people came to understand personal identity, in its public and its private aspects, in terms of the dominant evaluative scheme of the growing capitalist and credit economy, a scheme based on market forces. As we will see, this model for classification was characterized by an internal division between use value and market or speculative value.

A book like Hume's 1752 *Inquiry Concerning the Principles of Morals* provides a useful starting point for the exploration of changing terms of identity in the eighteenth century, analyzing as it does the processes according to which not only moral value but also social identity and status are conferred on individuals. Hume's catalog of behaviors describes the personal characteristics that define both a public and a private identity at the same time that it evaluates those characteristics. This text nicely illustrates the result of the growing sense that personal identity should be based on merit rather than blood lines: identity came to be constructed in terms of an aggregate of characteristics, each of which was understood in commodity terms. Fittingly enough then, the identity described by that aggregate was also understood in those terms.

Hume's principal argument is that moral worth and personal identity are

determined on the basis of characteristics whose value resides ultimately in their utility. It comes as no great surprise that the first traits mentioned in the section "Of Qualities Useful to Ourselves" are good mercantile traits: "*discretion,* by which we carry on a safe intercourse with others . . . [and] weigh each circumstance of the business which we undertake" (61); "what need is there to display the praises of *industry* and to extol its advantages, in the acquisition of power and riches, or in raising what we call a *fortune* in the world?" (62); "all prospect of success in life, or even of tolerable subsistence, must fail where a reasonable *frugality* is wanting" (62). But the *Inquiry's* mercantile perspective becomes even more apparent on those occasions when the fundamental role of utility, Hume's primary concern, is challenged:

> can it possibly be doubted that this talent itself of poets to move the passions, this *pathetic* and *sublime* of sentiment is a very considerable merit, and, being enhanced by its extreme rarity, may exalt the person possessed of it above every character of the age in which he lives? . . . No views of utility . . . enter into this sentiment of approbation, yet it is of a kind similar to that other sentiment which arises from views of a public or private utility. The same social sympathy . . . gives rise to both. . . . (82–83)

Hume somewhat awkwardly tries to account for the value of poetic sensibility, suggesting that although it does not originate in considerations of utility, it nevertheless does appear to have a social character and so to arise according to a process that is at least analogous to the one he has focused on. But the hint that rarity is at the root of this value suggests that the mercantile quality of Hume's system of valuation runs even deeper than may at first appear. Hume's naturalizing account of value—his contention that it arises from some combination of rational consideration of utility and basic human sociability— is exposed as an idealization of commercial valuation whenever the issue of traditionally aristocratic abilities or characteristics arises. At times it becomes quite obvious that market value and not just an abstract notion of utility structures this system, as when he notes that "eloquence, genius of all kinds . . . have a merit distinct from their usefulness. Rarity, likewise, which so much enhances the price of everything, must set an additional value on these noble talents of the human mind" (85). This book, this analysis of "that complication of mental qualities which form what, in common life, we call 'personal merit'" (7), does not merely favor mercantile virtues but uses a market scheme for the determination of human value. Men, like commodities, are valued not just for their usefulness but also for qualities whose value is largely conditional and extrinsic:

> If refined sense and exalted sense be not so *useful* as common sense, their rarity, their novelty, and the nobleness of their objects make some compensation and render them the admiration of mankind, as gold, though less serviceable than iron, acquires from its scarcity a value which is much superior. (65)

The impulse to describe the ostensibly natural and rational character of status determination under capitalism gives way here to a need to account for the lingering importance of the traditional marks of nobility (such as refined sensibility and good taste)—signs of status that the monied class has chosen to claim for itself. The significance of these noble characteristics, since it cannot be accounted for in terms of utility, is imported into Hume's evaluative system under the banner of exchange value rather than use value—but with the result that the ideal of utility is undermined. As we saw above, for instance, common sense, although more useful than refined sense, is actually less valuable, and that this can be true gives the lie to the argument for the foundational role of utility that Hume has so patiently constructed.

Taking the assumptions of his "ingenious and agreeable" (179) fellow philosopher one step further, Adam Smith aptly demonstrates in his *Theory of Moral Sentiments* of 1759 the power of that quintessential sign of exchange value: money. Even in the realm of personal evaluation relative value finally triumphs over the ideal of intrinsic value grounded in utility:

> We are no more concerned for the destruction or loss of a single man, because this man is a member or part of society, and because we should be concerned for the destruction of society, than we are concerned for the loss of a single guinea, because this guinea is a part of a thousand guineas, and because we should be concerned for the loss of the whole sum. (89)

The loss of a man, like the loss of a guinea, is no great threat to the health of a society concerned primarily with amassing large sums and where men, like coins, possess a limited and relative value. Smith's analogy exposes the impulse behind and the implications of Hume's scheme.

In spite of its focus on utility, then, Hume's *Inquiry* describes personal identities in commodity terms, as determined on the basis of an exchange value that often diverges from use value. Ironically enough, it is the moments when the *traditional* signs of nobility become an issue that exchange value explicitly enters the scene and threatens the ideal of a personal identity grounded in considerations of private and social utility. It is not insignificant that, in the chapter "Political Society," this threat prompts a series of reflections on what could be called gothic horrors: infidelity, incest, secrecy, spying, immoral gallantry, and murder.

II

The sentimental novel of the latter part of the century registers considerable anxiety over the problem of personal value and identity—an anxiety that is expressed and managed through a distanced and often comic treatment of the issue. A case in point, Henry Mackenzie's *The Man of Feeling*, takes the associations we saw in Hume a pessimistic step further. Mackenzie includes

both exchange value and traditional signs of nobility in the category of empty forms and opposes them to true content, which, by implication, amounts to real virtue and intrinsic value:

> Honour and Politeness! this is the *coin* of the world, and passes current with the fools of it. You have substituted the *shadow* Honour, instead of the substance Virtue; and have banished the reality of friendship for the fictitious semblance which you have termed Politeness: politeness, which consists in a certain ceremonious jargon, more ridiculous to the ear of reason than the voice of a *puppet*. You have invented sounds, which you worship, though they tyrannize over your peace; and are surrounded with *empty forms. . . .*" (26; my emphasis)[2]

Honor and money and even certain words are all associated with empty form in this critique of the world the capitalist class has created. Signs of upper-class status have been imported into the marketplace and have acquired, like money, what Lukács would argue is the typical quality of objects and ideas under capitalism: sheer formality (see Lukács, 83–222). It is interesting to recall in this context that in that more playful and more famous sentimental novel, *A Sentimental Journey,* Yorick describes Englishmen as coins who, by virtue of their limited circulation, at least retain a legible superscription, unlike their politely smooth French brothers.[3] (It is perfectly fitting that in 1770 a novel should be written in which the protagonist is literally a circulating bank-note: Thomas Bridges's *Adventures of a Bank-Note.*) In *The Man of Feeling,* deceptive surfaces are a constant theme and are linked to the money form; as Harley is reminded, "all's not gold that glisters" (30). Dress, even when appropriate to its wearer, can be misleading, as when Harley mistakes a re-cruiting officer for a neighbor's servant because of his hat (77). The misan-thropist, whose complaint is quoted above, recognizes that these forms have been worshiped, fetishized, in spite of the fact that they tyrannize over their own producers. His reference to a puppet hints that people themselves have become empty, hollow forms, expressions of a power not their own. As the narrator says himself later in the book: "we take our ideas from sounds which folly has invented; Fashion, Bon ton . . . are the names of certain idols, to which we sacrifice the genuine pleasures of the soul: in this world of sem-blance, we are contented with personating happiness; to feel it is an art beyond us" (70). This complaint is, of course, a humanist one that is itself thoroughly "bourgeois," a reminder of the ideals the capitalist class used to strengthen its own position: utility, authenticity, the natural. All of these were ideals that Hume was, for the most part, able to consider as being at the center of social life.[4] But the world of the man of feeling of the 1770s is a world of "shadowy" forms emptied of content; of hollow, powerless people who have, in essence, sacrificed their souls; a world of coins—the prototype of the gothic world.

III

By the end of the eighteenth century, anxieties concerning the deepening division between use value and exchange value, and the problems that division produced in the realm of personal identification and evaluation, had become even more acute. Speculative capital especially, with its extreme immateriality, foregrounded the distinction between tangible and intangible values. Since, as Pocock argues, "property was acknowledged as the social basis of personality, the emergence of classes whose property consisted not of land or goods or even bullion, but of paper promises to repay in an undefined future, was seen as entailing the emergence of new types of personality, unprecedentedly dangerous and unstable" (235). But the rift between forms of value was in itself to create problems in the determination of identity. At the end of the century, moreover, the French Revolution challenged the naturalness of the genealogical system of distinctions while simultaneously foregrounding the contingency of commodity and monetary value. Burke, in his *Reflections,* shows that he was fully aware of the disruption this represented: "Are all orders, ranks, and distinctions to be confounded, that out of universal anarchy, joined to national bankruptcy, three or four thousand democracies should . . . be organized into one?" (67). The problem is not, of course, that France is actually devoid of wealth, but that it has established a paper currency without a solid and consistent backing. The difference the French Revolutionary *assignats* introduced between real and apparent value is, to Burke's eyes, the forerunner to bankruptcy. And it is not by chance that he associates the breakdown of hereditary and other distinctions with this toying with value, for he recognizes that the "alchemistical legislators" of France "reduce men to loose counters merely for the sake of simple telling, and not to figures whose power is to arise from their place in the table" (201). If people are treated like money-style ciphers in a society where money itself has a highly variable value, then there is no hope for social stability: "Who would insure a tender and delicate sense of honour to beat almost with the first pulses of the heart, when no man could know what would be the test of honour in a nation, continually varying the standard of its coin?" (109). The standards of honor and morality that Hume and Smith worked so hard to root in utility are here quite frankly exposed in their connection with exchange; even personal value becomes contingent when the coin standard fluctuates.

In 1790, when *Reflections* first appeared, these issues were very much on the minds of the British but had no immediate analogue on the British economic scene. The shortage of silver coin had been a constant cause of complaint throughout the eighteenth century (Fetter, 2), and, indeed, in the latter half of the century there was considerable discussion of the role of banks and the use of paper credit. Hume remarked that the investigation of the relation

of prices to exporting "had made me entertain a doubt concerning the benefit of *banks* and *paper-credit,* which are so generally esteemed advantageous to every nation . . ." ("Of Money," 35). Smith, too, showed some reservations regarding paper money: "The commerce and industry of the country, . . . though they may be somewhat augmented, cannot be altogether so secure, when they are thus, as it were, suspended upon the Daedalian wings of paper money, as when they travel about on the solid ground of gold and silver" (*Wealth,* 305). The outbreak of war with France in 1793, however, was followed within a month by what Frank Fetter calls "one of the worst financial and commercial crises that England had experienced up to that time" (12). In 1796 in Ireland and in 1797 in England fears of an invasion drove people in town and country to demand specie (gold or silver) for their notes: "following a rumor of invasion farmers brought their livestock and produce into town and on receiving payment went to the banks and converted their notes into specie" (21). The result was the Restriction, the suspension of specie payments. Given Burke's fears, it is ironic that England's own specie standard was challenged not only by costs arising from the war with France but also as a result of the collapse of the *assignats* beginning in 1795. This collapse "led to an increase in the use of a metallic currency in France, and substantial amounts of gold and silver probably found their way from the vaults of the Bank [of England] into the monetary system of England's enemy" (Fetter, 19).

The problem of stable value, as reflected both in commodity prices and the monetary system itself, was acutely felt in the period of the burgeoning of the gothic novel. The division between intrinsic and socially determined value that was already a problem for Hume, Smith, and Mackenzie makes itself even more powerfully felt in the early gothic novel. The reader of early gothic fiction—those novels by Walpole, Lewis, and Radcliffe written before the turn of the century[5]—notices first of all that gothic characterization is strongly bifurcated. On the one hand, the characters are offered to the reader as entirely coherent and distinct personalities and we are asked to value and respond to them according to these personalities. These personalities, moreover, appear to be exact expressions of, and are fundamentally tied to, their private and intrinsic merit. On the other hand, the novel represents them as mysterious in relation to one another and presents them in a series of shifting interrelations.

There can be no doubt, for instance, that Ellena Rosalba is supposed to represent for us a "good" young woman: virtuous, chaste, sincere. As readers we feel fairly assured that Ellena's personality will undergo no abrupt changes, and, in fact, one of the complaints traditionally leveled against the gothic novel is that characters like Ellena not only do not change abruptly but do not change at all.[6] One of the reasons gothic characterization fails to produce a "depth-effect" is that it suggests so few contradictions or complications at the level of personality or private character—the level at which canonical romanticism offers such fruitful contradictions and dialectical energies.

At the same time, however, *The Italian* keeps us constantly wondering about

Ellena's identity vis-à-vis other characters: is Schedoni really her father? does she merit Vivaldi's hand in marriage? who is her mother and what is she like?[7] While limiting our knowledge of practical and familial relations between characters, the novel hints at relational identity through a tissue of parallels and repetitions—a network so complicated and various that it could hardly be considered directly informative. To offer just one example, Ellena's first sight of Olivia parallels Vivaldi's first sight of Ellena. Both spectators are fascinated by the modesty, grace, and piety of a veiled woman attending a service:

> It was in the church of San Lorenzo at Naples, in the year 1758, that Vincentio di Vivaldi first saw Ellena Rosalba. The sweetness and fine expression of her voice attracted his attention to her figure, which had a distinguished air of delicacy and grace; but her face was concealed in her veil. (5)

> Among the voices of the choir, was one whose expression immediately fixed her attention; it seemed to speak a loftier sentiment of devotion than the others, and to be modulated by the melancholy of an heart, that had long since taken leave of this world. . . . Her face was concealed by a black veil. (86)[8]

Gothic repetitions stage compulsive rehearsals of sameness and difference as if the obvious personalities of these characters were not truly sufficient to the construction of identity. In fact, the novel produces identities through two separate processes: the display of personal qualities and merits through speech or action and the relational display of character that we see, for instance, in the structural paralleling of two characters—with the emphasis on the latter. For the modern reader of these texts, such parallels tend either to go unnoticed or simply to irritate. Expecting a certain kind of character development, that is, with high romantic expectations, we notice only that the intrinsic character presented in these novels tends to be static and dull, and that it does not correspond to the fluid relational character that sets the plot in motion.

This bifurcation of character harks back to Hume and Mackenzie and signals a division analogous to that between utility and market value; characters have both an undeniable and reasonably stable identity to which their fellows and the reader should, according to the ethics of the novel, respond, and a strictly relational identity that is frighteningly fluid and a source of fascination for the characters and the novel's readers. Of course, the market quality of this relational identity is most explicit in scenes like that in *The Mysteries of Udolpho* when Morano tells Emily that Montoni tried to sell her to him (262), or that in *The Castle of Otranto* when Matilda complains to Bianca that she should not "make a property of" Theodore (41). Again and again, a character's "real" value stands opposed to his or her social value: when Valancourt tells Emily he is ruined financially, she determines that she must not involve herself with him, and yet "she was compelled to admire his sincerity" (*Udolpho,* 515), and finds it difficult to give up loving him. Similarly, Ellena Rosalba,

in *The Italian,* helps to support herself and her aunt by embroidering silks, and we are told that this industry "did honour to her character" (9). Ellena keeps her vocation a secret, however, since public knowledge of it would actually decrease her social status. The issue of Ellena's status represents the typical driving tension of the Racliffean novel: in spite of her obvious personal merits, does Ellena really deserve to fetch such a high price on the marriage market? As a general rule, neither we nor those in the novel have doubts about a character's "personality"—the problem is not, for example, that Vivaldi mistakes Schedoni for a good guy—the confusion and the threat reside in relational identity: what does it say about Ellena if Schedoni is her father?

Altogether then, gothic characterization suggests a model of identity that is strikingly similar to those we saw implied in the work of Hume and Mackenzie. The old genealogical model of personal identification and evaluation has by now lost a considerable amount of prestige and is increasingly being replaced by the model used to classify commodities. This model's two privileged categories, utility and exchangeability, and their tendency to become mutually exclusive (recall Hume), are thus imported into the realm of personal evaluation. On the one hand we have identity as it "should" be: a matter of personality and intrinsic individual virtue. On the other hand we have a relational, changeable identity associated simultaneously with the outmoded criterion of birth *and* the superficiality, contingency, and indeterminacy of market value. Indeterminacy of identity, then, is associated both with the old, genealogy-based notion of identity and with new, increasingly fluid market relations. What ostensibly matters most is personality—that aspect of identity associated with use value (an apparently "real," materially grounded value, but one that is, as Baudrillard demonstrates, itself an ideal). But what is far more interesting is relational identity—"exchange-value" identity—because in social life that is what is really at stake. Early gothic characterization derives its energy from the mystery and conflict inherent in the weakening status of the old system of personal valuation and the growing power of a system based on competitive market exchange.

Relational identity, the simultaneously forward- and backward-looking side of gothic characterization, focuses the anxieties that generate the gothic genre and lend it some of its best-known features. As in Hume and Mackenzie, *traditional* class indices such as dress and name signal a value extrinsic to an idealized system of value based on the useful and natural and so seem like empty (although still powerful) forms. Clothes often function as disguises, and while in the sentimental novel such disguise generally takes the form of mimicking the garb of a higher class, in the gothic it tends not only to serve ambition but also to mask individual peculiarities of all kinds—the evil man dressed as a monk among many monks being one of the most common and sinister of such images. This difference reflects a subtle difference in the two genres: in the world of the sentimental novel, it is the fault of the man who does not dress his part that clothes do not work as signs of status, whereas

the gothic finds coded dressing threatening in itself, blaming, as it were, the clothes and not just the man. Dress seems by its very nature to flatten out rather than clarify the differences between persons; in *The Italian,* for instance, Schedoni and Bianchi do not realize that they are living in the same town because "her veil, and the monk's cowl, might easily have concealed them from each other if they had met" (382–83). Even when the manipulation of costume is done by or for a protagonist, we almost wish the opportunity for it were not there; Ellena dressed as a nun makes readers nervous, and their fears are realized when her habit is used as a pretense for taking Vivaldi to the Inquisition. Characters whose only interest is in matters of form and appearance are immediately suspicious: in *The Romance of the Forest,* the first sign that the Lady Abbess is not to be trusted is that she is "exact in the observance of every detail of form" (36). Traditional signs of one's role and rank are automatically suspect.

More importantly, the relational identities constituted by signs such as dress and manners, signs that are already metaphoric ghosts in Mackenzie ("you have substituted the shadow Honour instead of the substance Virtue"),[9] become literally ghostly in the gothic. To give just a few examples of this spectralization from *The Italian:* "she seemed like a spectre newly risen from the grave, rather than a living being" (67); "he resembled a spectre rather than a human being" (110); "shadowy countenances and uncertain forms seemed to flit through the dusk" (311). Terry Castle has brilliantly argued that "the other" is spectralized in *The Mysteries of Udolpho* and that the underside of romantic individualism—the growing palpability of subjective reality—is the increasing sense that others are merely specters, phantasms of the observer's mind.[10] Castle offers three sets of evidence for such a reading of the novel: cases of the appearance of someone after thinking of him; a sense that the other is always present, especially when absent; and finally, as Castle puts it, the fact that "every other looks like every other other" (238). In this final category she includes those uncanny repetitions I have already mentioned. But the deindividuation Castle describes is not always or even usually presented in the novel as a subjective effect, and her constant reference to an "other" does not quite make sense in the absence of a governing subject-position. Although Castle's overall argument is convincing, I would argue that the dreamlike effects she describes in her third category reflect not just a subjective spectralization of others but a general confusion (from any perspective) regarding relational identity. The condemnation of external signs of status and the fear that real virtues have been replaced by ghostly forms is vividly and literally rehearsed here; people themselves have taken on an indeterminate, spectral quality.

Since relational identity is associated not just with traditional status markers but also with market value and speculation, it is not surprising that in their relations to one another characters have the qualities of commodities as they were soon to be described by Marx: they are immaterial, fetishized, transpar-

ent, metaphysical, and they only acquire value in relation to others.[11] The analogy Irigaray draws between the role of the commodity as defined by Marx and "the status of women in so-called patriarchal societies" (172) suggests a second analogy between commodities/women and characters in gothic novels. One could substitute "gothic characters" for "women" in the following quotation: *"women are thus two things at once: utilitarian objects and bearers of value"* (175). Those processes by which relational character is determined result in a "spectralization of the other" because they are not grounded in intrinsic value: "in order to have a *relative value,* a commodity has to be confronted with another commodity that serves as its equivalent. Its value is never found to lie within itself. And the fact that it is worth more or less is not its own doing but comes from that to which it may be equivalent. Its value is *transcendent* to itself, *super-natural, ek-static"* (176). This supernatural and relational aspect of identity is, indeed, not a character's own doing. The exchange-value side of character lends itself to a metaphoric description powerfully reminiscent of that used in Mackenzie's account of social life; these are people of shadows and forms who tend to "bubble" each other (an eighteenth-century metaphor for deception) and whose very voices—traditional signs of self-presence—are nothing more than puppet-voices, signs of hollowness. The association of the marketplace, theatricality, and shadows is nicely encapsulated in the fair scene in *The Italian:*

> They . . . passed . . . into a market place . . . on one spot . . . the *improvisatore,* by the pathos of his story, and the persuasive sensibility of his strains, was holding the attention of his auditors, as in the bands of magic. Farther on was a stage raised for a display of fireworks, and near this a theatre, where a mimic opera, the "shadow of a shade," was exhibiting, whence the roar of laughter . . . mingled with the heterogeneous voices of the venders. . . . (273)

The ultimate sign of the importation of marketplace evaluation into the realm of personal identification is the focus on surfaces to the point that characters resemble the reified form of the exchange value of the commodity: money. Extreme flatness of character, images of identically dressed groups of people, and the sense of identity as mere sign all suggest this. As William Patrick Day notes, "in *Otranto,* Theodore, the nominal hero, proves an ineffective cipher" (45)—a fate common to early gothic heroes and heroines.[12] In their social relations people tend to become as interchangeable as coins, usually with unpleasant consequences. In *The Italian,* the association of people and coins is humorously made palpable through a pun on Vivaldi's servant's name:

> "Paulo made him merry perhaps?" asked Vivaldi.
> "But the coaxing ways you talked of," repeated Vivaldi, "what were they?—a ducat, or so?"
> "A ducat!" exclaimed the man, "no! not a *paolo!"*

"Are you *sure* of that?" cried Vivaldi, shrewdly.

"Aye, sure enough, Signor. This fellow is not worth a ducat in the world!"

"But his master is, friend," observed Vivaldi, in a very low voice, while he put some money into his hand. (366–67)

Paulo may not be worth a ducat, but he may after all be worth a *paolo*, especially in relation to his master. Traditional master-servant roles and the modern emphasis on money intersect in a scene of indeterminate relational identity.

Problems in the determination of value, with people as with market goods, are related to a problem in the determination of origin: "*In order to become equivalent, a commodity changes bodies. A super-natural, metaphysical origin is substituted for its material origin. Thus its body becomes a transparent body, pure phenomenality of value*" (Irigaray, 179). In the world of the gothic, where people's material origins (their parents, and especially their mothers) are so often unknown, not only their origin but their very existence takes on a supernatural quality. The mysterious Schedoni is quite typical—"an Italian, as his name imported, but whose family was unknown"—and only differs from the good characters of *The Italian* in that "he *wished* to throw an impenetrable veil over his origin" (34; my emphasis). Not surprisingly, the novel's final resolution of the gap between relational and intrinsic identity involves a revelation of material origins: who was born to whom and where. Such revelations serve to reconnect persons with the site of their original "production," and this is as close as the gothic novel comes to focusing on production rather than social consumption, given that, unlike the *bildungsroman* and romantic poetry, it does not show individuals producing or determining themselves.

At the same time that it is driven by the mystery and fascination of a world where people tend toward sheer transcendental form, the gothic constantly strives (or threatens) to reground its characters in the natural, an impulse that often takes the form of reintroducing the body, and usually a body subjected to violence. Elaine Scarry argues that the image of opened or dead bodies often serves to ground a belief system that has been challenged: "the sheer material factualness of the human body will be borrowed to lend that cultural construct the aura of 'realness' and 'certainty'" (14); the logic of this tactic would, of course, be particularly compelling in a context where the hegemonic class understands the body as the site of sincerity and the natural.[13] The binary oppositions that Irigaray outlines speak powerfully to the issue of the status of the body in gothic characterization: "that economy subjects women [gothic characters] to a schism that is necessary to symbolic operations: red blood/semblance; body/value-invested envelope; matter/medium of exchange; (re)-productive nature/fabricated femininity" (188). The gothic novel constantly threatens us with images of the first set of terms: red blood, body, matter, reproductive nature. The suggestion of corporeality frequently appears at the

moments of greatest semantic indeterminacy: beside books "written in un-
known characters" lie instruments of torture (*Italian,* 102). Often, however,
especially in Radcliffe's novels, the effort to turn the narrative to something
palpable fails or is simply cut short—the rape of the heroine never actually
occurs, the corpse turns out to be a wax effigy. Rather than find the body she
expects, Ellena at one point "discovered what *seemed* a dreadful *hieroglyphic,*
a mattrass of straw, in which she *thought* she beheld the death-bed of the
miserable recluse; nay more, that the impression it still retained, was that
which her *form* had left there" (*Italian,* 140; my emphasis)—just another
elusive sign, a form from which the body has been evacuated. Neither person-
alities nor bodies, neither the useful nor the natural, can stabilize the gothic
world of relations gone wild.[14]

IV

Of course, my gesture toward Irigaray foregrounds the question of the relation
of women to the gothic mode of characterization. It is clear first of all that
the association of women and the gothic is an overdetermined one, and one
that reflects more than the simple fact that many women wrote and read
gothic novels. The gothic is, truly, the world of "commodities among them-
selves," differing from Irigaray's vision in that *all* people represent such com-
modities, and this association of character with commodity generates a
parallel association with the feminine.[15] It is perfectly fitting that these texts
often focus on women, and especially young, unmarried ones: "*The virginal
woman . . . is pure exchange value.* She is nothing but the possibility, the
place, the sign of relations among men. In and of herself, she does not exist:
she is a simple envelope veiling what is really at stake in social exchange"
(Irigaray, 186).

In the gothic, of course, veiling appears literally and frequently and is often
a sign for the traffic in women; Ellena, for instance, must choose in *The Italian*
between taking the veil (becoming a nun) and wearing the marriage veil. That
it so happens that Ellena is forced to make this choice to satisfy a mother
superior and her lover's mother shows, however, that in the gothic it is not
really the "phallic function" that women serve to support and veil. No charac-
ter, male or female, effectively directs the action in the gothic.[16] It is significant
that, as Sedgwick notes, in the gothic novel "always for women, and very
often for men, life begins with a blank. The mother, if known, has disappeared
temporarily, and an aunt may substitute. The women's names suggest the
blank, the white, the innocent, and the pristine: Blanche (who lives in Cha-
teau-le-Blanc), Virginia, Agnes, Ellena Ros*alba,* Emily St. *Aube*rt, even Signora
Bianchi" (261). Although female characters in the gothic may constitute a
blank page, the male characters are in no position to use them as the site of
symbolic or practical operations that would construct themselves as deeply
meaningful subjects.[17] If the practical sign of the effective use of women for

the support of the social and symbolic order is the successful exchange of women,[18] it comes as little surprise that the threat of incest should be such a popular gothic theme.

Gothic characters are linked with the feminine not just in their association with the commodity but also in their superficiality and "theatricality." Naomi Schor has shown that the "normative aesthetics of neo-classicism" linked the feminine and the superficial, an association supported in part by the assumption that women have a special interest in personal ornamentation and display—an interest, that is, in their consumption by others (19–20). This association is predicated, Schor suggests, on the argument that women have to compensate for an essential lack and a lack of essence.[19] For Radcliffe calculated self-representation is indeed preeminently the virgin's task: Ellena "was . . . embarrassed to observe, in the manners of young people residing in a convent, an absence of that decorum, which includes beneath its modest shade every grace that ought to adorn the female character, like the veil which gives dignity to their air and softness to their features" (*Italian,* 94). But in the gothic all characterization takes on the qualities of a mere show, from the wild gesticulations of the characters in *The Castle of Otranto* to the pretense of religiosity that makes the goal throughout *The Italian* the unmasking of father Schedoni (103).

The long-standing critical dismissal of the gothic, then, arose not simply because it is inherently inartistic *or* because it was often written and read by women. The peculiar "femininity" of the gothic arises in part as the result of the intersection of gender and economic paradigms; the gothic expresses a concern with relations, extrinsic signs, and indeterminate value—qualities associated with the feminine but also associated with an aspect of market relations (exchange value unconnected to utility) that the capitalist class has continually to repress.[20] Traditional complaints about the gothic, although usually presented as strictly aesthetic complaints, often reflect impatience with its emphasis on relational value and betray an unconscious recognition of its palpably "bourgeois" character. We fear that the book is as superficial as its characters appear to be, and suspect that a put-on, a show, is being foisted not just on the characters but also on us. The gothic emphasis on form makes the novel itself appear to represent nothing more than an arbitrary and hollow exchange value, and older criticism of the gothic constantly reiterates the disjunction between its considerable commercial success (high exchange value) and its "real" worth (low use value). The gothic, it is said, offers us only "trappings," "décor," "stage-sets," and "machinery."[21] These terms bring to mind associations that threaten the self-conception of the capitalist class and they imply some recognition on the critic's part that the gothic lays out the maneuvers and characteristics of that class a bit too clearly. Trappings and décor remind us of the association of both women and the upwardly mobile with ornamentation in excess. Stage-sets bring to mind the pervasive sense of the theatricality of social relations that Agnew argues is characteristic of life

in a capitalist economy. This theatricality is elevated to a structural feature, a quality of the setting, in the gothic. And machinery suggests the "problem" of industrialization, of apparently dehumanized and inorganic modes of production that create breaches that literature since romanticism has been expected to heal. The gothic novel's formal features display too openly the way the capitalist class as a whole is in many respects an upstart class whose hegemony is not, in fact, grounded in utility, sincerity, and nature.

Although Radcliffe's novels, for instance, are resolved through the discovery of a correspondence between relational and intrinsic value—not only is Ellena virtuous but so were her parents, and they were of a reasonably high class as well—such discovery generally tends to be "mechanically" tossed in and anticlimactic. One thinks here of Lukács's analysis of the tendency of bourgeois thought toward an empty formalism (208); in such a system, it is the task of art to restore a sense of wholeness and depth (137), but the early gothic novel simply disturbs us with its hollow forms. Canonical romanticism responded to the bifurcation of identity by largely dismissing relational identity and forging images of depth, images that are figures for intrinsic identity. Romantic inwardness thus represents a literally more profound resistance to commodification. But for that very reason, the gothic lends itself to a more thorough analysis of certain social pressures than the lyric poetry that dominates our sense of the literary period—a poetry that, for all its concern with social problems and reform, often obscures the issue of relational power with its emphasis on personality. Even the "trappings" of the gothic can be put to rhetorical and analytical use, particularly in discussions relating to the period, from Norbert Elias's description of late eighteenth-century courtly manners as a "ghostly perpetuum mobile" (86) to Marx's description of the enchanted world in which "Monsieur Le Capital and Madame La Terre do their ghostwalking as social characters and at the same time as mere things" (384–85). Romanticism's answer to capitalism is largely our answer, and this gives rise to our blindness to the special insights of the gothic. The early gothic novel is not a *bildungsroman* gone awry; it traces problems in the perception or "consumption" of other people rather than the work involved in personal growth.

Kiely's comment on the novels of the romantic period—"they are not all bad; indeed, some are very good. But in nearly every case one has a sense of unresolved struggle, of intelligence and energy at odds" (1)—is on the mark in more ways than he probably intended. Kiely opens his study of the gothic novel by noting that "the English [gothic] novel is, in some ways, an embarrassing subject."[22] But if the gothic novel is an embarrassing subject, it is so at least in part because it presents an embarrassing "subject"—a subject who is little more than a "mercurial exchange value or 'bubble,'"[23] a hollow puppet, a woman, a commodity, a coin.

NOTES

1. Rzepka, 11. It is worth noting that for Rzepka "Romantic visionary solipsism" tended to produce, as its repressed double, a sense of the insubstantiality of selves that has a distinctly gothic flavor: "as Gray and Hume show, the more we search for the self within, the more it shrinks to a ghost haunting the fringes of experience" (16).

2. These are the words of a "misanthropist," but even Harley recognizes the truth in them.

3. "The English, like antient medals, kept more apart, and passing but few peoples hands, preserve the first sharpnesses which the fine hand of nature has given them—they are not so pleasant to feel—but in return, the legend is so visible, that at the first look you see whose image and superscription they bear" (Sterne, 90).

4. As Barbara Herrnstein Smith points out, the "central axiological move of Hume's argument" is "to ground the standard of taste in (naturally, one might say) nature: specifically, the presumed psychophysiological nature of all human beings" (59).

5. Later gothic novels such as *Frankenstein* and *Melmoth the Wanderer* tend to fuse early gothic and romantic trends in the handling of character.

6. As Robert Kiely says of *Udolpho's* Emily St. Aubert, "Mrs. Radcliffe leaves her heroine to the devices of her own mind which, admittedly, turns out to be a fairly dark and empty place, save for the presence of a few lascivious-looking but impotent spectres. There is nothing salutary, creative, or formative about Emily's interior experience" (78). Given the longtime critical tendency to argue for the psychological depth of gothic characters, it may be useful to note here that I would argue (as will become clear in my discussion of the bifurcation of gothic character) that gothic characters are remarkable for their *lack* of depth. In 1972 Kiely wrote that for Lewis "the proper metaphor for personality was not . . . one of depth, but of surfaces" (107), and that "in the context of Freudian psychology, this sounds naive and superficial." Nevertheless, Kiely argues, "too many modern critics have tried to rescue [*The Monk*] from the rubbish heap by claiming profundity for it" (107). Most commentators on the gothic have indeed set out to discover depth not only in its texture but also in its characters, assuming from the outset that identity must be generated from within. Even a recent commentator like Patrick Day, who says that he intends to look only at the text itself, since "the surface of the Gothic fantasy is its substance," and who argues that the gothic is the *forerunner* of Freudian psychoanalysis and not simply its ideal testing ground, treats the problem of identity from the inside out, offering a psychological reason for the fragmentation of identity: the fusion of fear and desire within an originally whole individual causes self-division (14). I would argue that it is the powerful emotional charge of the issues the gothic treats—family relations, death, sex—more than its characterization per se that has made it so available to psychologizing criticism. In the gothic itself, when the mind is defined as deep it is described as capable of being filled primarily by conventions and from without; St. Aubert teaches Emily that "the vacant mind" should be "store[d] . . . with ideas" (Radcliffe, *Udolpho*, 6), especially those of the best poets. Roughly ten years after Kiely, Eve Sedgwick directed our attention back to surfaces; the features of gothic personality may make "gothic characters seem devitalized or two-dimensional" (256), but we do not do justice to the gothic by simply ignoring these features and drawing out the similarities between gothicism and romanticism. In my discussion of the gothic I follow Sedgwick's lead in focusing

unabashedly on that superficiality that seems finally to define the form and make its assimilation to canonical romanticism impossible.

7. Social character generally is oddly ungraspable: "where any human contact requiring time, intensity, and reciprocity is called for, whether it be violent or loving, one of the two characters involved is almost certain to evaporate or become someone else. One of the most overused and therefore amusing stock devices in the novel is mistaken identity" (Kiely, 39).

8. David Morris offers a catalog of examples of repetitions and parallels of this type in *The Castle of Otranto,* arguing that they "call into question received ideas of character and of social relations" and that this repetition "proves basic to gothic terror" (304). Morris relates such repetitions to Freud's notion of the uncanny, which he presents as the key to understanding gothic effects. But gothic characters are not "eerily drained of content" (311) simply for the purpose of reminding us of death, as Morris argues, but are associated with death as a result of our assumptions about the nature of character. As Eve Sedgwick notes, "in the Gothic view . . . individual identity, including sexual identity, is social and relational rather than original or private; it is established only ex post facto, by recognition" (256).

9. It is not insignificant that similar terms are used in the context of the American money debates of the late nineteenth century; as David Wells argued, paper could no more be money than "a shadow could be the substance" (quoted and discussed in Michaels, 146).

10. Terry Castle, "Spectralization," 231–53. See also Castle's further work on the topic, where she examines the popularity of the "magic lantern," analyzes the terms used to understand "spectral technology," and argues that "if ghosts were thoughts, then thoughts themselves took on—at least notionally—the haunting reality of ghosts" ("Phantasmagoria," 52).

11. See Marx, vol. 1, chapter 1, section 1; and Irigaray, chapter 9.

12. Eve Sedgwick describes "two kinds of marking—the marking of flesh and the marking with blood of veils and other surfaces—as referential: both kinds, that is, have important though incomplete similarities to written language, and the use of the term 'character,' like the gothic conception of human character itself, is anchored in this image of the contagious, quasi-linguistic inscription of surfaces" (256). As with monetary inscriptions, these "inscriptions," while direct and honest in their way, still manage to be referentially insufficient, contingent in their meaning: "while the 'identity' a pendant represents is only the character's social identity, that turns out to be an intimate and inclusive category: one's true name, one's closest ties, and one's radical erotic choices," but "when there is no other way to establish identity, this method is slippery itself—most often sideways within a generation, between siblings" (262).

13. Comparison of the status of the body in the texts of Hume and Smith with the medieval conception of the body as little more than the site of sin and temptation highlights the more positive role of the sensible body in the eighteenth century.

14. Just as the gothic presents a world where too much has been commodified, it presents one that has, in a sense, been overcivilized. Scarry's claim that civilization deprives the external world of the privilege of being inanimate (285) is borne out in the extreme by the gothic, where objects not only have the power to recall an absent person, as Castle notes, but where they sometimes seem almost to come alive themselves. The gothic accomplishes that reversal Marx so much lamented, whereby people take on the qualities of mere things and mere things seem to come alive with a power of their own. This confusion of agency and perspective is made literal in the gothic, whose salient feature is, according to David Punter, an obsession with the mysterious that is a response to the apparently mysterious workings of a capitalist economy—an economy that seems to govern people rather than being governed by them (see chapter

1). In a world where people have themselves taken on the qualities of commodities, imagine what perversities might occur:

> Man endows the commodities he produces with a narcissism that blurs the seriousness of utility, of use. Desire, as soon as there is exchange, "perverts" need. But that perversion will be attributed to commodities and to their alleged relations. Whereas they can have no relationships except from the perspective of speculating third parties. (Irigaray, 177)

Unfortunately for characters in the gothic world, while the third thing that serves to direct the relations between commodities does exist, even if not recognized as such (human agents), the third thing that would direct the relations of people-as-commodities does not exist, at least not within the world of the novel. There, there is no privileged "speculating third party"; the common impulse to voyeurism and the fascination with spectacle and speculation within the novel generally only lead to a dangerous enthrallment, as Day points out (24). Readers of the novel, on the other hand, are granted a special pleasure: they are presented with mysterious relations about which they can make certain judgments because they know that the mystery will be resolved along conventional lines.

15. In fact, one could argue that it is not only the association with the passive commodity that "feminizes" gothic characters; as Pocock points out, while the capitalist of the nineteenth century was imagined as a masculine conquering hero, "his eighteenth-century predecessor was seen as on the whole a feminised, even an effeminate being, still wrestling with his own passions and hysterias" (114).

16. As Day notes, "male heroes in the Gothic fantasy take on feminine qualities of passivity and endurance, rather than the conventional hero's capacity for action" (16).

17. This is, of course, considered by many feminist theorists to be the quintessential masculine activity; as Judith Butler puts it: "reason and mind are associated with masculinity and agency, while the body and nature are considered to be the mute facticity of the feminine, awaiting signification from an opposing masculine subject" (37).

18. See Rubin, and Irigaray, *This Sex*, chapters 8 and 9.

19. On the problem of woman's "lack of essence" (and the strategic usefulness of Irigaray's "essentialism") see Fuss, 72.

20. As Herrnstein Smith remarks, the discourses of humanistic studies continue to be characterized by a "dualistic structure," a structure that "recurs in the familiar distinctions drawn between lower and higher—or, alternately, 'superficial' and more 'profound'—types of value or modes of valuing" (126).

21. In spite of the growth of critical interest in the gothic, there can be no doubt that it is still considered, at best, a second-rate genre. One need only note the continuing efforts of critics to dissociate the romantic poets from gothicism, even when they are quite clearly working in a gothic mode. (To give just one example, in an issue of *Studies in Romanticism* devoted to the topic of Wordsworth's early [and gothic-influenced] play *The Borderers,* Thomas Whitaker recommends we look "beneath" the "trappings of the Jacobean and the Gothic" to see that the play anticipates Pinter [360], while William Jewett, when discussing "Mortimer's line about the spectral appearance of some being," is quick to point out that this "madness has little to do with Gothic hallucinations" [408].)

22. Kiely, 1. I have substituted "gothic" for Kiely's "romantic" since, throughout this essay, I use "romantic" to mean "canonical romantic" or "related to romantic poetry."

23. Agnew, 13.

WORKS CITED

Agnew, Jean-Christophe. *Worlds Apart: The Market and the Theatre in Anglo-American Thought, 1550–1750.* Cambridge: Cambridge University Press, 1986.

Baudrillard, Jean. "For a Critique of the Political Economy of the Sign." *Selected Writings,* ed. Mark Poster. Stanford: Stanford University Press, 1988, 57–97.

Burke, Edmund. *Reflections on the Revolution in France.* New York: Anchor Books, 1973.

Butler, Judith. *Gender Trouble: Feminism and the Subversion of Identity.* New York: Routledge, 1990.

Castle, Terry. "Phantasmagoria: Spectral Technology and the Metaphorics of Modern Reverie." *Critical Inquiry* 15 (1988): 26–61.

———. "The Spectralization of the Other in *The Mysteries of Udolpho.*" *The New Eighteenth Century,* ed. Felicity Nussbaum and Laura Brown. New York: Methuen, 1987, 231–53.

Cooke, Michael, and Alan Bewell, eds. *The Borderers: A Forum.* Special issue of *Studies in Romanticism* 27, no. 3 (1988).

Day, William Patrick. *In the Circles of Fear and Desire: A Study of Gothic Fantasy.* Chicago: University of Chicago Press, 1985.

Elias, Norbert. *The Court Society,* trans. Edmund Jephcott. Oxford: Basil Blackwell, 1969.

Fetter, Frank. *Development of British Monetary Orthodoxy.* Cambridge, MA: Harvard University Press, 1965.

Fuss, Diana. *Essentially Speaking.* New York: Routledge, 1989.

Hall, Jean. "The Evolution of the Surface Self: Byron's Poetic Career." *Keats-Shelley Journal* 30 (1987): 134–57.

Herrnstein Smith, Barbara. *Contingencies of Value.* Cambridge, MA: Harvard University Press, 1988.

Hume, David. *An Inquiry Concerning the Principles of Morals.* New York: Macmillan, 1957.

———. "Of Money." *David Hume: Writings on Economics,* ed. Eugene Rotwein. Madison: University of Wisconsin Press, 1970.

Irigaray, Luce. *This Sex Which Is Not One,* trans. Catherine Porter. Ithaca: Cornell University Press, 1985.

Kiely, Robert. *The Romantic Novel in England.* Cambridge, MA: Harvard University Press, 1972.

Lewis, Matthew. *The Monk,* ed. Howard Anderson. Oxford: Oxford University Press, 1973.

Lukács, Georg. *History and Class Consciousness,* trans. Rodney Livingstone. Berlin: The Merlin Press, 1971.

Mackenzie, Henry. *The Man of Feeling.* New York: W. W. Norton, 1958.

Marx, Karl. *Capital.* 3 vols. Moscow: Foreign Language Publishing House, 1961. Vol. 3.

Michaels, Walter Benn. *The Gold Standard and the Logic of Naturalism.* Berkeley: University of California Press, 1987.

Morris, David. "Gothic Sublimity." *New Literary History* 16, no. 2 (1985): 299–319.

Pocock, J. G. A. *Virtue, Commerce, and History.* Cambridge: Cambridge University Press, 1985.

Punter, David. *The Literature of Terror: A History of Gothic Fictions from 1765 to the Present Day.* New York: Longman, 1980.

Radcliffe, Ann. *The Italian,* ed. Frederick Garber. Oxford: Oxford University Press, 1968.

———. *The Mysteries of Udolpho,* ed. Bonamy Dobrée. Oxford: Oxford University Press, 1966.

———. *The Romance of the Forest,* ed. Chloe Chard. Oxford: Oxford University Press, 1986.

Reddy, William. *Money and Liberty in Modern Europe.* Cambridge: Cambridge University Press, 1987.

Rzepka, Charles. *The Self as Mind: Vision and Identity in Wordsworth, Coleridge, and Keats.* Cambridge, MA: Harvard University Press, 1986.

Rubin, Gayle. "The Traffic in Women: Notes on the 'Political Economy' of Sex." *Toward an Anthropology of Women,* ed. Rayna Reiter. New York: Monthly Review Press, 1975.

Scarry, Elaine. *The Body in Pain.* Oxford: Oxford University Press, 1985.

Schor, Naomi. *Reading in Detail: Aesthetics and the Feminine.* New York: Methuen, 1987.

Sedgwick, Eve. "The Character in the Veil: Imagery of the Surface in the Gothic Novel." *PMLA* 96, no. 2 (1981): 255–68.

Smith, Adam. *An Inquiry into the Nature and Causes of the Wealth of Nations,* ed. Edwin Cannan. New York: The Modern Library, 1937.

———. *The Theory of Moral Sentiments.* Oxford: Oxford University Press, 1976.

Sterne, Laurence. *A Sentimental Journey,* ed. Ian Jack. Oxford: Oxford University Press, 1984.

Walpole, Horace. *The Castle of Otranto,* ed. W. S. Lewis. Oxford: Oxford University Press, 1964.

12

"Liquidating the Sublime"

Gossip in Scott's Novels

JAN B. GORDON

> Each printer in those days, as I have already
> informed you, had his device, his impresa, as I
> may call it, in the same manner as the doughty
> chivalry of the age, who frequented tilt and
> tournament.
>
> —*The Antiquary*

I

If *Waverley* (1814) is taken as a model Scott narrative, then the "myth of the Highlands" would appear to offer one of the only possibilities for escape from the imprisoning potential of family history, figured as the family library, for the future heir of a noble estate. The noble elite into which Scott's assorted representatives of privilege are born is structured by a highly codified set of discursive practices (which resemble nothing so much as those of medieval chivalry). Both "fields" of inscription share a version of history metaphorically conceived of as a direct, lineal descent from some incessantly re-petitioned sacred origin, the founding moment of an inscripted order. As with the so-called order of literary kinds in the eighteenth century, status within the feudal hierarchy is dependent upon a tradition of written en*title*ment. So many of the scions and displaced wards in Scott are early on apprenticed to the library and to antiquarianism: the antique tomes within a paneled library both maintain the family (as a continuous register) and are maintained by it as an economic asset, in a symbiotic reciprocity.

Crucial to any system of patronage—social or literary—is what we might

call the metaphysics of *dedication*. As a noble text or noble family enters social consumption, it must re-petition the occasion of chronological or inspirational instantiation. Hence, among so many of Scott's bibliophiles and pedantic tutors, the form of the dedicatory preface or announcement is of paramount importance, establishing a continuity of sorts

> to ancient histories, or in the little work compiled by Julius Obsequens and inscribed by the learned Scheffer, the editor, to his patron, Benedictine Shytte, Baron of Dudershoff.[1]

The dedication is an acknowledgment of dependency, but expressed as a form of inspirational *credit*. Creating a figurative family of authority where in fact it might not exist literally, the dedication is the repayment of a debt which, outside the "meaning" of the text, adds no economic or thematic value. The dedication is characteristic of an intransitive economic grammar: it represents one more attempt to re-petition an origin by bringing it to "book."

But, functionally, it would be no different from the mutual dedication in which Edward Waverley's uncle, the Baron of Bradwardine, and his neighbors engage in their strange roundtable. Celebrations there are complete with oaths of allegiance, drunken bouts and boasts, martial challenges and debates over the origin of the phoneme "Brad" in the family name, debates resolved by recourse to the seventeenth-century compendium of animal family names, the *Hieroglyphia Animalium*. What is remarkable about this education is the way in which it invariably privileges a mnemonic notion of *recovery*. Early rote exercises are deployed for Edward Waverley to assist in the development of a specific kind of historical recall: events which shaped the family at whose head he will stand. In fact, Scott's use of the *Bradwardine* branch of the family may have a delightful historical resonance, for the baron's namesake was none other than the fourteenth-century scholastic who articulated a bizarre scheme of memory reenforcement, in opposition to the classical "architectural mnemonic." In contradistinction to visualizing memory as a *memoria loci* on the order of Dame Frances Yates's "memory theatre," Bradwardine insisted that the object of memory must be seen as a page in a book. The recall of one "cell" within a system of cells arranged on rectangular "grids," phonetically "keyed," would enable a page of memory to be retrieved.[2] In more than one sense, then, Edward Waverley's family memory is a "lost" text, the search for which is intellectually confining.

But this early education, with its homage to the "jargon of heraldry, its griffins, its moldwarts, its wyverns, and its dragons,"[3] is part of a cultural "set" of values of which Edward becomes aware. In opposition to the exclusionary family library with its inscripted and encrypted, historically authentic truths is an alternative, orally based culture south of the Tweed, imagined as a corrupting, superstitious deviation,

more befitting canters, gaberlunzies, and suchlike mendicants whose gibberish is formed by playing upon the word than the noble, honorable, and useful science of heraldry which assigns armorial bearing in the award of noble and generous actions.[4]

The operative distinction here is between a *science* of some authentic historical tradition and a *play* of language which belongs to an environment of mendicant (and therefore landless) reality whose subaltern practitioners are potentially subversive. Implicit is a familiar ideology: any "union" of a historically antecedent, inscripted genealogical order (which pretends to a neutrality because it is in effect a science) with a *poetic,* fanciful predisposition to superstition must be resisted as subversive to—and the very word speaks to inscription—"as-signed" bearing. Presumably, a political United Kingdom would represent the dilution of an inscripted family science by an orally based, fanciful "canter."

And yet, in almost every instance, Scott's future heirs harbor such "fancy," even as they outwardly collude with tutors' requests to master Latin declinations and the intricacies of Renaissance cursive styles or Newton's laws. The study of "minute narratives of family history" leaves little time for lyrical flights, and yet many of them—Edward Waverley, Lovel *(The Antiquary),* and Harry Bertram *(Guy Mannering)*—in their youth show not only a sympathy for the village mendicants but also a predilection for art which is excluded from the classical canon: love letters, French novels, the songs of gypsies. Hence the combination of restlessness and indifference which they exhibit in the classical study or library suggests at least an awareness of what is repressed. What is propelling each of them toward sublime heights and flights is but the outward manifestation of a private and intellectually persecuted taste. In Scott, the hero *manqué* has *always already* made a space—a resistance dedicated to the oral rather than the written—wherein the sublime, given the opportunity, might be nurtured.

And, at first glance, Edward's unexpected excursion into the Highlands would seem to be that opportunity. A matriarchal culture dominated by the mixture of civilized and spontaneous accomplishments of Flora Mac-Ivor, Glennaquoich seems radically antithetical to the values of Waverley-Honour and Tully-Veolan. In contrast to the debauched entertainments below the clouds chez Bradwardine, the Highlands is the scene of a living reality. Each elder of the clan supplements a continuous "founding" epic by free recitatives, added each evening incrementally from a pool of deeds and verses collectively shared. In contrast to the hours spent in studying grammar at his previous abodes, Gaelic is for Edward Waverley a highly "liquid" language that resists his efforts at precisely transcribed recovery. In parallel, lands are not enclosed nor is domestic space curtained in contrast to the heavy panels and bindings which partition social privilege at Tully-Veolan and Waverley-Honour. In place of the emphases upon establishing a "proper" genealogical descent and its

meticulous recapitulation of ancestry which occupies idle hours with the Baron of Bradwardine, Edward Waverley is readily adopted as Flora Mac-Ivor's "second brother" by his host clan, even though there is no blood-tie; the Highland "family" is as extended as the lowland nobility had been exclusionary.

Perhaps the Highlands is fertile ground for the cultivation of the sublime imagination because it symbolizes a resistance to canonization in "antique researches" that is invariably the domain (in some double sense?) of a scholar of "a very ancient family, and somewhat embarrassed fortune; a scholar according to the scholarship of Scotsmen."[5] Such is the resistance to historical closure so characteristic of oral cultures, a reminder that there is always an alternative history. In fact, the heights literally echo with a variety of sounds, endemic to what Edward Waverley insists is an "uncommonly vocalic"[6] culture: the haunting love lays of Flora; the cries of hunting parties imitating animals; the healing invocations which accompany the embrocations of medicine men.

The critical "master narrative" of Scott's narrative structure is predictable enough. In keeping with its status as a conventional *Bildungsroman,* the protagonist, having survived his Highland "fling" with its exposure to oral legend and tribal violence, descends from the sublime to inherit the ancestral property whose lethargic dependency he infuses with a new spirit of economic independence. Marriage to the forlorn Rose Bradwardine, the last of a lost lineage which had systematically excluded the female branch, grants both Tully-Veolan and Waverley-Honour new "honor," including the possibility of genealogical succession, so antithetical to practices of historical recuperation. Taking advantage of a new cross-border commerce established by his adventures, the experience of the Highlands is in every sense necessary, if not enabling, of Edward Waverley's future.

Nonetheless, *Waverley* could also be read as a sophisticated critique of the benevolence of the sublime. On its own terms, the Highland culture is as doomed to decadence as the noble library. In fact, Flora Mac-Ivor will end her days in precisely such a library, as the resident of a Continental convent. The clans' vaunted devotion to the uninscribed includes a political alliance with a remotely descendant, but totally alien, Chevalier with little popular support, whose political future is as compromised by shifts in the political winds as is Waverley-Honour itself. Despite their aggressiveness, the Highlanders are locally confined; they are militarily mismatched as soon as the theater of war shifts from mountain passes and trails. And finally, the assorted tartan are increasingly dependent upon lowland provisions, indicated by frequent and daring raids upon domestic cattle, the landed nobility with its spare *caves,* and empty larders. Entailed property shares with the nomadic tribes a waning self-sufficiency.

To be sure, the Highland sublime, with its majestic natural prospects and continuous oral epics, does exhibit an "on and on," that limit to visual and

inscripted vistas, that the late Thomas Weiskel saw as crucial to the sublime paradigm.[7] Moreover, the sublime in *Waverley* is complicated in the love/hate dialectic with an antecedent which Neil Hertz sees as crucial to the figuration of the Oedipal within the sublime.[8] Yet the longer the Scott hero dwells in the Highlands, the more he becomes aware that this particular version of the sublime is itself a limit. Neither the sublime "interruption" nor the illusion of a scientifically valid aristocratic continuity can establish a political "state." The sublime here would bear a certain resemblance to the *aporia* of contemporary reader-response criticism: based upon an *ad hoc* subjective experience of a private relationship, it can never ground *community*. And yet, the sublime clearly *echoes* some need of a subject for relief from dreary texts by a therapeutic, spontaneous reality, which Edward describes in metaphors of "liquidity."[9]

What we are addressing is nothing less than a certain ambivalence toward the sublime in Scott's novels. On the one hand, the oral culture of Glennaquoich is foundational—the anthropological patriarchy of the Scottish noble patriarchy, and thereby deserving of veneration. For in truth, the "political family" of Scotland is the result of an unusual historical accommodation; we tend to forget that the feudal ruling class, initially brought in from Norman England by the first Celtic kings to bolster a precarious political and military hold, in effect grafted a feudal society upon a tribal culture. As heads of clans as well as lords of the realm, the dominant landowning class had a patriarchal status which caused the peasant to think of himself as being bound by duty of submission, and yet pride himself on being distantly related to his lord (an essentially repressive relationship). (This is socially evident, to name just one example, in the ease with which the Laird of Dumbiedikes enters the tiny habitation of David Deans at Saint Leonard Crags in *The Heart of Midlothian* and takes a more than familial interest in Jeanie Deans.) Because of this unusual political "accommodation" between the historically antecedent Highland clans and their noble, landed masters, and because of the potential military threat posed by the former, reality could be simultaneously regarded as some metaphysical *grounding* of the nobility with its privileging of inscription and as a potentially disruptive, even superstitious, *supplement*. The clans' alliance with an abdicated king, again depending upon perspective, could be imagined as the maintenance of a legitimate lineage, but also as a subversive, even treasonous, discontinuity. In other words, the anthropological *status* of the clans (and, derivatively, of the sublime in which they dwell) blurs the distinction between metaphysical origin and discontinuity. Hence, within Scott's work, the limited prospects for the reproduction of a certain kind of "voice" which can be collectively shared within the politics of Scott's novels may well be related to the strategies by which a "politics of reality" is formally represented *within* the written text. How would an orality which appears to exist in two radically oppositional registers, politically, come to have a place in the seams of Scott's written texts, "squeezed," as in fact the Highland

clans were geographically, by a lettered lineage which must imagine reality as subversive of a proper (in the sense of self-same) aristocracy?

The problematic in Scott's world is that of making an oral culture relevant to Scotland's future rather than some tribal past. This project is made even more difficult since the orality in his work, when we do encounter it, tends to be bound to ideologies which embrace some semi-republicanism and are therefore dismissed, as in fact the geographic heights and desert wastes of the sublime often were, as either emotional stimulation for the young (like Edward Waverley) or, alternatively, as terror in disguise. The Covenanters, whose inevitable decline and martyrdom is charted in Old Mortality, would be a case in point. The religious movement, founded by a group of radical adherents to the "National Covenant" signed in 1638 as a pledge to protect Kirk and creed against the (state) interference of Charles I, was one more example of theology becoming, in V. G. Kiernan's words, the "chrysalis of nationalism."[10] But it was a theology which, like the culture of the Highland clans, took to the hills, in this case the remote open-air "field preaching" of the southwest. Combined with a boycott of attendance at churches occupied by conforming or "indulgent" members of the clergy, the Covenanters attracted those resistant to the government's attempt to create a religious umbrella under which all Christians might take civilized shelter. As portrayed by Scott in Old Mortality, the Covenanters' faith was largely oral; the appropriately named minister, Kettledrummle, preaches a ranting sermon which occupies over two hours, characterized by all the highs and lows of the vocal register, but totally resistant to inscription by strangers: "some parts of his discourse might be called sublime and others sunk below the burlesque."[11]

What a decadent feudal-based nobility and the doomed Covenanters share is in fact the idea of a social *covenant:* the Hebraic concept of a people chosen by history for an appointed, redemptive task. A nobility which defines itself by an inscribed "succession" and a faith defined by "canting" both remain isolated as historical curiosities, because under both schemes, membership is afforded only to a privileged few who must share all of the "line" or none of it. An orality regarded as in some sense divinely inspired is no different from an inscripted nobility, since both depend upon the constant intransitive clarification and re-petition of an originary moment or occasion when the permanent syntagmatic order of descent—be it the laying on of hands, texts, swords, or patrimony—was instantiated. And yet, this putative authenticity is often nothing more than an arbitrary privilege to which is added the category of *scarcity.* The threat of imminent extinction or martyrdom faced by landed nobility, Highland chieftain, and Covenanter is, then, implicit in the social value of these enclaves, how they mean. The analogy with inscription is nowhere made more explicit than in *The Antiquary,* when after viewing the well named Oldbuck's venerable collection of manuscripts, Lovel, whose taste, like that of Edward Waverley, runs to light extemporaneous poetry, observes:

Here were editions esteemed as being the first, and there stood those scarcely less
regarded as being the last and best; here was a book valued because it had the
author's final improvements, and there was another (which strange to tell!) was
in request because it had them not. One was precious because it was a folio,
another because it was a duodecimo; some because they were tall, some because
they were short; the merit of this lay in the title-page, of that in the arrangement
of the letters of the word Finis. There was, it seemed, no peculiar distinction,
however trifling or minute, which might not give value to a volume, providing
the indispensible quality of scarcity, or rare occurrence, was attached to it.[12]

In words which could have been written by Walter Benjamin, the value of a
text (and by implication, textually informed families which also bear titles) is
seen not as something foundational or intrinsic but rather as a supplementary
quality which *attaches* itself when either families or texts enter circulation.
Value is *added* as an economic function.

Unfortunately, the Scottish nobility and the various sublime "interruptions"
which offer alternative models of transcendence—the Highland clans and the
Covenanters to name the two deployed by Scott—can never be open to any
system of public consumption (through which an exogamous notion of value
might be added) because circulation can only be imagined as a corruption of
some antecedent purity which enables transcendence to limit access. In Scott's
fiction, the process by which pure families, texts, and religious ideas enter
public consumption is "backsliding," a wonderful metaphor suggesting the
descent from the mountains of sublime transcendence and hence a contaminat-
ing reversal of the process of endless re-petitioning of an antecedent moment.
Arminianism, Erastianism, popery, superstition, or a totally exogamous sexual
alliance would all qualify as stains to be eradicated. Yet, Scott's plots all
emphasize the doomed status of these three exclusive groups by exposing the
limits to their potential for either maintenance or continuity. The malingering
male heir indifferent to the life of libraries and stuffy tutors who devotes
himself to "subversive" skills (like poetry) or, alternatively, a family with
no male heir at all and unsatisfactory marital prospects for females (Rose
Bradwardine, Flora Mac-Ivor, Jeanie and Effie Deans, Ellen Douglas) repre-
sents resistance to the transmission of values. The political irony should not
be lost on us: the phylogenetic "family arrangement" between an alien feudal
nobility and a historically antecedent tribal ethos which constitutes Scotland
has produced ontogenetic families with no long-term biological or economic
prospects.

Despite any suspense it offers, the romantic sublime in neither of its anti-
thetical interventions offers the possibility of improving the present or future
of those who share in it. Its confining grammar leaves the protagonist, the last
"hope" of the family, defenseless. The flight of Edward Waverley to
Glennaquoich *(Waverley);* the disappearance of the heir of Ellangowan by a
fall from a precipice and a protective kidnapping *(Guy Mannering);* the sur-
vival of a misnamed Lovel through an underground maze *(The Antiquary);*

the forced removal of Henry Morton from landed conformity to bleak hilltop conventicles by marauding Covenanters *(Old Mortality)*; and even the seduction of Effie Deans at a remote wilderness promontory by the ventriloquist George Robertson née Staunton *(The Heart of Midlothian)* are among the forms which the sublime interruption assumes in Scott's plots. Existing in two registers simultaneously, the sublime offers the appeal of transcendence, as it openly proposes expansive vistas, a nonhierarchical society or experience, freedom from an overdetermined inscripted order, and the spontaneity of nature. But, at the same time, this sublime is immanent insofar as the separation from familial ideological interests may not be a real separation or discontinuity, but a repetition. For in every instance the victims of the experience have displayed a secret sympathy with the lyric or oral life—even the Effie Deans who attends dances as relief from her father's parsing of a text, a practice which differs little from that forced upon Edward Waverley or Harry Bertram by tutors. Either way, as an escape into otherness or as an echo of internalized antisocial sentiment, the sublime can have only the status of a costly diversion.

<center>II</center>

What exists as either a terrorizing transcendent sublime or an idle and doubly self-indulgent pursuit will, in Scott's hands, become part of an economy which will infuse new blood and new money into Scotland. He achieves this, initially, by a subtle "re-inscription" of the sublime, analogous to that worked by Kant upon Edmund Burke's model. In contradistinction to Burke's emphasis upon an empirical imbalance during which a perceptual relationship with nature becomes indeterminate either through sensory insufficiency or, alternatively, some syntagmatic excess in the natural object, the sublime with Kant becomes part of a complex symbolization. "In feel[ing] itself *set in motion* in the representation of the sublime,"[13] reason compensates by filling in the gaps—linking the signifiers into a continuous chain in such a way as to create a continuity to what had previously appeared as the sublime interruption in the form of romantic abyss, expanse, or peak:

> We can describe the sublime in this manner: it is an object (of nature) the representation of which determines the mind to think of the unattainability of nature as the presentation of [reason's] ideas.[14]

With this deft stroke, the sublime enters an economy of gain and loss, wherein something is purchased (transcendence) at the price of something else (the uninterrupted experience of natural objects in socially confirmable representations). Only within such a scheme of compensation can what had previously been terrifying be perceived as habitual or normative—what reason must live with as part of itself. One could easily make the case that in fact Kant's

intriguing analysis of the sublime is the first of a succession of radical attempts
to make the resistance to (or the limits of) representation *mean*—a succession
which will reach its apotheosis in Freud, who deploys a similar notion of
compensation. With Kant, the sublime comes to describe the process of subli-
mation—literally, the "putting under" of what had previously been a limit.
The sublime would be indistinguishable from a "counter-sublime," becoming
part of the mechanism of its rationalization, as the mind abhors the vacuum
(the sublime absence) it perceives.

This sublime evacuation in Scott's text is filled by an economically func-
tional reality produced by a series of subalterns. Representing an alternative
narrative devoted to adding value rather than the fruitless recuperation of a
historically *prop*er name (in the sense of self-same) or theological word, these
gossips committed to a *supplementing* model of reality inhabit neither sterile
library nor sublime heights and wastes, but rather (at least initially) the cave
or tunnel, the liberatory *opening* in Scott's family text. Although limitations
of space do not permit an extended analysis of each gossip-figure, Meg Merril-
ies of *Guy Mannering,* Elspeth Mucklebackit and Edie Ochiltree of *The Anti-
quary,* Madge Wildfire of *The Heart of Midlothian,* and, most professionally
perhaps, Dame Ursula Suddlechop of *The Fortunes of Nigel* all circulate his-
tory as a rival narrative which adds value *to* rather than restoring the loss *of*
a putative mythical past.

One of the most remarkable features of Scott's fictional universe is the
relative insulation of political and social groups from each other. Fortified
estates and Highland enclaves can be penetrated only by the martial skills of
professionals or letters of introduction from distant relatives, ecclesiastics, or
those with *entrée* at court or hearth. Whereas the plot of a Dickens novel is
often structured by hidden historical or family secrets, connecting classes or
activities which would normally be incommensurable and tending to support
a model of society as a network of hidden relationships, Scott's society is
rather built of a series of (increasingly less) self-sufficient enclaves which have
little commerce with their neighbors. Hence, even as a precondition, there is
almost a desperate need for information; this need increases proportionately
as the old loyalties, so crucial to economical maintenance, diminish. This
informational vacuum may well account for the ease with which Scott's gossip-
ing mendicants associate with brigands, free-booters, smugglers, and
poachers—those who work at eluding the fiscal and political impediments to
the free flow of goods and services.

The subaltern hence tends to occupy some "border" region, a political gray
zone, where neither primitive *voice* nor civilized *law* holds permanent sway.
Often the domain of the gossip-figure is a zone born of the breakdown of some
usually unwritten agreement or settlement between members of the Scottish
"family." In *Waverley,* Evan Dhu Maccombich descends from the heights to
arrange for the return of cattle poached from the patriarchal estate (Tully-
Veolan) in violation of a permanent settlement designed to prevent such raids,

protection money. The bilingual Highland *negociant* knows precisely where to locate the missing animals and to arrange for their speedy return in favor of advanced warning of impending government military sweeps of the Highlands. He enables an exchange to occur by blurring the qualities endemic to two oppositional political realms. As money is a *transparency* in Marx's *Grundrisse* insofar as it enables dissimilar objects to be exchanged by a "neutral" general equivalent, so the gossip-figure in Scott makes communicative exchange independent of producers in the same gesture that makes the producers dependent upon exchange. When "tribute" and dedication are in decline, each realm needs information about the other from a relatively mobile "carrier." (These carriers, to be sure, invite comparison to E. J. Hobsbawm's *banditti* in the purposeful self-effacement of their structural "share.")[15]

Similarly, when we encounter the subaltern in *Guy Mannering,* she dwells in the corporeal corollary to the geographic border, that is, in androgyny. As an embodiment of sublime "heights," with a voice like that of the Cumaean Sybil, Meg Merrilies

> was full six feet high, wore a man's great-coat over the rest of her dress, had in her hand a goodly soe-thern cudgel, and in all points of equipment, except her petticoats, seemed rather masculine than feminine. Her dark elf-locks shot out like the snakes of the gorgon, between an old-fashioned bonnet called a bongrace ... while her eyes had a wild roll that indicated something like real or affected insanity.[16]

Although her tribe of itinerant gypsies of Derncleugh had historically "been such long occupants [of the glen adjacent] that they were considered in some degree proprietors,"[17] the Laird of Ellangowan, in the interests of law and order attendant upon his new position as justice of the peace, had begun to enforce new statutes of enclosure by limiting access of those without title to his land. One consequence was the predictable collapse of an arrangement by means of which itinerants had aided in the estate's defense in return for the right to farm its margins—the "gap" in Scott's text.

In the politically *de facto* domestication of the sublime,

> latterly, their services were of a more pacific nature. The women spun mittens for the lady, and knitted boot-hose for the laird, which were annually presented at Christmas with great form. The aged Sybil blessed the bridal bed of the laird when he married and the cradle of the heir when born.[18]

As a substitute parent, Meg Merrilies assumes the traditional role of the "*sibling of God,*" called to bear witness in the event of the genealogical father's absence (or its metaphoric inversion, his presence as an absentee landlord) or the early death of the mother—in this case, coincidental. Most of Scott's gossips are weavers—producers of *text*-iles, including both garments and rhyming

incantations, which, from one perspective, might mark the displacement of the Sybils' role in military protection:

> Saint Bride and her brat,
> Saint Cole and his cat,
> Saint Michael and his spear,
> Keep the house frae neif and wear.[19]

Swaddling children at birth and cleansing the body at death, Meg Merrilies exhibits a chronological, as well as political, sexual, and geographic resistance to closure in a novel where the nobility is newly committed to enforcing legal and genetic limits: "she appeared rather to glide than to walk."[20] Here, sublime is "full presence," but potentially containable by one or another family, in an approved syntagmatic lineality.

The assorted gypsies, witches, and dispossessed types with whom Meg shares caves, vaults, and other "mouths" in the novel comprise one alternate family. As the mother of twelve sons and daughters, Meg is the priestess of both her own biological "lost tribe," as well as that of her gypsy companions, and, as it turns out, Harry Bertram, the future heir of Ellangowan. Lacking any fixed abode, her mobility provides the "cover" which enables her both to join and secede from families, even noble ones, at will. Yet, that very mobility leads to charges of "idleness" by those aristocrats who epitomize leisure, like the baronet, Sir Robert Hazlewood, who deflects even the possibility of an extant heir to Ellangowan by discounting it as information "whispered about among tinkers, gypsies, and other idle persons."[21] The association of the oral register with idleness and inauthenticity is not philosophically *necessary,* and yet it reveals the extent to which Ellangowan and its claimants are governed by inscripted ideas of precedence, like those implicitly addressed by the family barrister, Pleydell:

> in civilized society, law is the chimney through which all that smoke discharges itself that used to circulate through the whole house and put everyone's eyes out—[22]

Law and the family lawyer attempt to use an inscripted "practice" to circulate what is resistant to it; yet law can never rebuild a decadent social order once it has been interrupted. The books which occupy the shelves of a family library—be it at Ellangowan or Woodbourne—can only function defensively, as with Julia Mannering's father's efforts to transform the instruments of cultural hegemony into one last defensive partition:

> He has had a hard task replacing the folios which were used in the barricade, smoothing out the creases and dog-ears, and repairing the other disasters they have sustained during their service in the fortification. He brought us some pieces

of lead and bullets which these ponderous tomes had intercepted during the action. . . .[23]

In contrast to the role of books which defend but never advance noble interests, Meg Merrilies's characteristic syntax, in which conjunctions, ellipses, and exclamations link discontinuous clauses, betrays an attempt at discursive reconstruction. This is to suggest that her contribution is part of the gossip's traditional attempt to de-privilege grammatical law as well as the letter of the (father's) law. Lacking both the dedication and the periodicity which punctuate inscription, she rather

> spoke to herself in broken expressions as these: "It is to rebuild the auld house— it is to lay the cornerstone—and did I not warn him?—I tell'd him I was born to do it, if my father's head had been the stepping stone. . . ."[24]

Mixing soliloquy and dialogue, prophecy and memory, in a verbal recipe as exempt from discursive convention as her culinary cauldron is exempt from the restrictions of game laws, Meg Merrilies speaks in a broken syntagmatic lineality whose antecedent, her father, is metaphorically at risk. This is, verbally, the discontinuous realm of the romantic sublime, reflected in nature as well as in the fragmented "lines" of gothic ruins. Illiterate, Meg appropriately refers to her oral speculations as "mystic epistles,"[25] for they have the power to resist being waylaid, a fate common to traditional epistles and written "orders" in *Guy Mannering*.

Scott initially "liquidates" the potentially terrorizing aspects of Meg's sublime intervention by allowing it to become *de-nominated* in some double sense. For she becomes "an uncommon kind of creditor"[26] to Harry Bertram's plotted future by evolving from a mere surrogate protectress (whom he will come to address as "mother") to a financial investor who creates new value. Just as her mouth mingles various dialects and grammatical forms in a manner common to those uninhibited by national loyalties, so her purse is similarly internationalized, insofar as "it contained, besides a considerable quantity of gold pieces, of different Coinage and various countries . . . valuable rings and ornament,"[27] which collectively becomes the downpayment on the financial repatriation of Ellangowan, now laid siege to not by armies but rather by hostile creditors. In enabling "Brown" to reenter social circulation as Bertram, she fulfills one role of the counter-sublime: the return of a repressed narrative. The gossip-figure releases heirs, information, and money for public consumption, all of which become interchangeable "currencies." Her oral contribution to his inherited (and hence inscripted) share is that which she has negotiated as taxes from smugglers. From this vantage, the counter-sublime constitutes an alternative, *ad hoc* nation (with powers to redistribute income) which allows the previous notion of a "state" as a mere collection of "estates" to become part of a new political as well as economic order.

This tendency of the subaltern to convert previously hoarded value into money so as to create a negotiable "currency" which allows an exiled individual to share in a productive process is best illustrated with the figure of Isaac of York in *Ivanhoe* (1820). Excluded both from the archaic culture of the Anglo-Saxon dependent upon hoarded animals and women as wealth and from the invading Normans with their commitment to pillage and plunder, the Jew—dark, homeless, persecuted, the possessor of secret information by virtue of his occupation as a usurer—uses two neutral mediums of exchange, the Venetian zecchin and bills of credit, into which a variety of other values can be translated. Only in this way can wealth (and the information for which it is a synecdoche) cross social and geographical boundaries so as to produce an exchange economy, the new consumer culture with a recognizable division of labor created by Wilfrid of Ivanhoe at the novel's end. Once credit and investment mediate between defense and rapine, power can be redistributed within the culture and cross-culturally by a leader who speaks Norman, Saracen, Spanish, and, apparently, Latin as well. Isaac's economic utility guarantees his survival along with new professionals—chefs, tailor, jewelers—and, as it turns out, the daughter who just missed an extraordinary assimilation within Scott's inscripted plot.

Hence, there are economic pressures toward acceptance of the subaltern's "share" in Scott's work. To be sure, Meg Merrilies dies (as do most of Scott's oral-economic mediators), in the same emotional border region in which she has lived: between "the shriek of pain and the sound of laughter, when at its highest and most suffocating height."[28] But, as we shall see, she dies *into text*. Although her final "deposition," which combines financial and discursive "wills," remains oral, and hence not institutionally or legally admissible, her oral recitative proves a reliable currency guaranteed by the existence of Mannering's amulet. Meg's plight is simultaneously typical of the gossip, the counter-sublime, and the subaltern: namely, how and under what circumstances is its contribution to be received or acknowledged by civilization's or the nation's (or God's) texts? Given that it adds value to enclosure, how precisely is the oral share to be formally narrated in the written text (a problem no less Scott's than that of the culture which privileges the letter of the law). The minister who attends Meg's last rites almost succeeds in the effort to cover over her oral intrusion in the text, by incorporating her resistance into its inscripted representations of civilization:

> In some degree she might be considered as an uninstructed heathen, even in the bosom of a Christian country; and let us remember, that the errors and vices of an ignorant life were balanced by instances of disinterested attachment, amounting almost to heroism.[29]

A previously subversive romantic sublime is transformed into a "disinterested attachment," a wonderful euphemism both for gossip and the enfolding of

the counter-sublime into an unacceptable form. Meg comes to participate in an *ad hoc* narrative union which may in fact reproduce another United Kingdom. By the novel's end, her hallucinatory speech, whose difference had earlier required translation in a footnote by Scott's imaginary narrator in order to share in the authority of the written word, no longer requires editorial intercession, and is in fact indistinguishable from the collective rhetoric of all the other voices in *Guy Mannering.* Similarly, the strong anticlericalism, typical of Scott's gossip-figures, has been absorbed: the voice of one referred to as "Beelzebub's postmistress," by novel's end is audible to all with properly attuned ears as a "message from Heaven."[30]

Invariably in Scott's hands, at the same time that the privilege of the letter is established in determining social status, this authority is being subtly questioned by another presence. In *The Antiquary,* the appropriately named bibliophile, Jonathan Oldbuck of Monkbarns, has established a metaphoric kinship to rival that of the impoverished Sir Arthur Wardour, by proclaiming a "typographical" lineage:

> I conceive that my descent from that painful and industrious typographer, Wolf-brand Oldenbuck . . . is more creditable to me as a man of letters, than if I had numbered in my genealogy all the brawling, bullet-headed, iron-fisted, old Gothic barons since the days of Crentheminachryme. . . .[31]

Yet his interest in old editions is challenged by a familiar community presence, that of Edie Ochiltree, who, in the blue gown of the licensed mendicant, combines the roles of entertainer, oral historian, and local herbalist, but is in reality "by *profession* [italics added] gossip-general of the whole neighborhood."[32] Like most gossips, he is simultaneously welcomed for the information he supplies to a closed community and vulnerable to suspicion because of anticlerical sentiments he shares with Meg Merrilies and Madge Wildfire of *The Heart of Midlothian.* As an intelligence system, this oral counter-sublime exists as an alternative yet competitive narrative which lies in close proximity, at times even an adjunct, to that which would suppress it. This spatial symbiosis is often expressed as an "underground," the knowledge of a local channel, such as the vault of the Presbyter beneath the Kirk to which Meg Merrilies holds the key, or Edie Ochiltree's detailed knowledge of the labyrinthian catacombs beneath an ancient monastery which will assist the mysterious Lovel to escape the hegemony of the inscripted letter. In this instance, that *letter* would include the legal authorities in pursuit of Lovel as well as Oldbuck's publication schemes for his poetry.

Such a site would suggest that the counter-sublime exists as a recursive narrative, contained by or lying beneath or inside another into which it intrudes, deflecting claims of authenticity by miming or parodying a master narrative which it subverts by re-citing/re-siting. One example might be the post office at Fairport, the destination for so many of Oldbuck's old books,

sent by mail from dealers in exclusive volumes. Each day, all mail, including books, is subject to a de-privatization of the letter by postal clerks:

> the gossips, like the sybils after consulting their leaves, arranged and combined the information of the evening, which flew the next morning through a hundred channels, and in a hundred varieties through the world of Fairport.[33]

Hence there is a provisional aspect to all narratives, including those of noble families which presume to a historical indelibility.

Elspeth Mucklebackit of *The Antiquary* does not, like Meg Merrilies, take possession of the stray child, but she does possess the *narrative* of a child's absence. An attendant God-sib years earlier at the birth of an unwanted child from an "unauthorized" marriage within a wealthy family, she has repressed (for payment in gold) the authentic narrative in order to instantiate a false story of extreme continuity—incest—the curse of which introduces a discontinuity into future prospects of the lineage. A once noble estate is reduced to the broken, sublime ruin of the haunted Gothic house. As one will often lies behind another in Dickens, so a repressed oral narrative—represented here as the knowledge of a stranger's origin—is contained *within* another, so as to suggest that every account is *always already* mediated. If one narrative can enter exchange only in terms of another, then they may be said to share an economy, verified by the denomination of the suppressed narrative in terms of gold. The plot of *The Antiquary* is resolved when Edie Ochiltree circulates the purchased narrative of a missing heir which Elspeth Mucklebackit, his female counterpart, sings as a folk ballad. Orality requires more than one mouth to see the light of day, hence its resistance to easy privatization. As a fisherman's wife whose morning *cree* is memorable in the novel, Elspeth's dying cry, albeit contained within an archaic Scottish art form, nonetheless adds new value to a decayed Glenallan-house by its effective renomination of Lovel, first as Neville, then as Lord Geraldin.

At the novel's end, there is, as customary in Scott, an attempt to control this reality by bringing its spokesmen, the poet Lovel and the gossip Ochiltree, into some reestablished patriarchal "line." Both men have shown a resistance to privileged forms of inscription: Lovel by escaping invitations to entomb his lyrics in Oldbuck's *The Antiquarian Register,* and Ochiltree by refusing to provide a written deposition, even under threat of incarceration. But, by novel's end, like Lovel,

> Old Edie . . . has given some symptoms of becoming stationary, being frequently found in the corner of a snug cottage between Monkbairns and Knockwinnock to which Caxton retreated upon his daughter's marriage.[34]

The gossip in Scott is typically absorbed in one of two ways: a strategic self-effacement or an appropriation within a textual lineage where it settles down,

removed from an itinerant existence to the historically resonant retreat of a "Caxton." A potentially politically destabilizing orality is to be quietly "administered" by the state which has been subsidizing the blue-gowned mendicant: the counter-sublime as state monopoly.

An unsuccessful or aborted assimilation of the sublime interruption would mean that an oral "seam" would continue to exist within society's (or Scott's) texts, with the familiar terrorizing consequences that the Highland sublime holds for the inhabitants of Tully-Veolan in *Waverley.* Madge Wildfire in *The Heart of Midlothian,* to be sure, represents an unsuccessful version of Meg Merrilies, to whose demeanor and role she bears a superficial resemblance. Of abnormal strength and height, and, like Meg, sufficiently androgynous to be mistaken for a man, Madge has an intimate knowledge of local geography, sufficient to act as a guide to the lawless and dispossessed, in the course of which expedition she crosses frontiers of knowledge and space easily. She is possessed ("alienated" is the word Scott uses, a euphemism for madness) of a haunting voice, and her songs, embedded within the novel's long, dreary stretches of legal and religious disputation, combine local history, old wives' tales, and political prophecy in a "clamorous loquacity"[35] which releases the secrets of all classes in "the confidential tone of a gossip giving the history of her next-door neighbor."[36] As with most gossips, her memory is highly selective. She has instant recall of political events, but often forgets her own name. She is endowed with the typical transparency of the counter-sublime in Scott, particularly when we first encounter "her" as the "empty" clothing worn by an ex-lover, George Robertson, in a pose like that of some imaginary "Hysteria Leading the People."

Like Meg Merrilies, she also takes possession of the inherited child born to Effie Deans in apparent secrecy. Scott uses as his trope for her role the Scottish statute governing infanticide in the eighteenth century: the mother of a newborn infant gone missing is *prima facie* guilty of murder if she has not informed someone of the pregnancy or sought assistance at the child's birth. Hence, Madge Wildfire as the attending God-sib takes possession of both the illegitimate child and the missing narrative of its birth, leaving Effie Deans vulnerable to an inscripted, legal indictment.[37] A recurrent theme in *The Heart of Midlothian* is the relative limits of the law in the achievement of justice or in the restoration of order. Landed families appear increasingly under siege by mob subversion, which necessitates ever more circuitous detours to avoid. In the wake of the Porteous Riots, the written injunctions of a court administered by an alien crown are routinely ignored or destroyed. Solicitors, like those in the first chapter impeded by a coach mishap or, alternatively, the amateur Saddletree, fond of splitting legal hairs, are inefficacious. For inscripted statute, like the landed nobility, must appeal to the sacred nature of *precedence,* which presumes the possibility of a narrative restoration. Gossip would be the rhetorical form which speaks to the endless *différance* of such recovery.

The oral counter-sublime takes possession of sublime discontinuity by "passing it on" in two ways. First, Madge, a traditional God-sib by vocation, "passes on" the illegitimate child left in her hands, first to her mother, then to a Highland chieftain, and, finally, for resale in the slave trade. In other words, Madge Wildfire does for the child precisely what she does with old Scottish ballads in *The Heart of Midlothian:* she circulates that which resists inscription within an approved *canon.* But, in addition, she is a "second Mother"—to which the French for "gossip," *commère,* pays homage—in a symbolical reproduction. Madge Wildfire has borne an illegitimate child to the same George Robertson who is Effie Deans's seducer. Hence she re-cites/re-sites Effie's "transgression" as part of history: the victimization to which a marginal reality is traditionally subjected at the hands of a largely male, highly literate, nobility. What had appeared as moral lapse, a discontinuity, is in fact a repetition, to which the figural representative of a differential repetition, the gossip, doubly testifies.

It must not be forgotten that Madge Wildfire, whose oral "line" spreads in a manner befitting her surname, straddles a thematic "gap" between two impossible political extremes. On the one hand, like Meg Merrilies, she must resist the colonialism of a seductive, decadent nobility which, even in "folk" disguise, would "domesticate" and then abandon her. But her violent death, a feature of the plot of *The Heart of Midlothian,* results in a kind of abundant recompense, a parricide which would destroy all antecedents. Mediating between an overdetermined patriarchy and its violent elimination, neither of which adds economic value, the subaltern's orality, the gossip's share as it were, must ally itself (from a distance) with a patriarchy which privileges inscription, in order for *writing* to enter circulation. The demonic counter-sublime must become a transparent catalyst which enables social and economic reproduction to occur in tandem through some "collective" form.

III

A note added by Scott early in *Guy Mannering* might provide a clue as to precisely how a displaced narrative (or child, whose story is "held" by others) acquires supplementary value that is in fact economic:

> The father of Economical Philosophy was, when a child, actually carried off by gypsies and remained some hours in their possessions.[38]

Sir Walter Scott's "lost" children, then, are figuratively speaking following in Adam Smith's footprints. Is it possible that whatever these orphans acquire during their sojourn with the subaltern *is* economic in some crucial sense? If so, then the role of a folk orality in lives earmarked for patronage must be crucial to this determination of value. Walter Scott had attended the classes held by Dugald Stewart, professor of moral philosophy and Adam Smith's

chief popularizer, at the University of Edinburgh in 1789–1790, and his general adherence to the teachings of the Scottish "moral philosophers" has been recognized.[39] But, in the "Epistle" to *The Fortunes of Nigel*, the "Author" justifies his "share" in a productive economy, as one type of added value:

> If a new commodity, having an actual intrinsic and commercial value, be the result of the operation, why are the author's bales of books to be esteemed a less profitable part of the public stock than the goods of any other manufacturer? I speak with reference to the *diffusion* [italics mine] of wealth arising to the public, and the degree of Industry which even such a trifling work as the present must stimulate and reward, before the volumes leave the publisher's shop. Without me, it could not exist and to this extent I am a benefactor of the country.[40]

In other words, the successful author is inserted into a production process in two unique ways: as a workman whose creative efforts initiates manufacture and, more generally, as a manufacturer who places a specific capital sum into circulation, diffusing wealth by endowing it with velocity.

Wealth is obtained, then, by making of authorship a necessarily *collective* activity in which a number of unique tasks are combined, with value added at each supplementary phase. In order to acquire exchange value, any heretofore privatized, noble author(ity) must be circulated by mechanical means, a prospect in fact broached as early as *The Antiquary*, where Oldbuck, in order to deflect Lovel's anxieties about financial disaster should his light lyrics find no buyers, proposes a manufacturing scheme which will divide labor, risk, and responsibility between an author and one who, like Oldbuck, intends to "package" the product with introductions, editorial apparatus, and index. All writing needs a productive midwife in the same way that Scott's would-be heirs need the gossip as a counter-sublime who would make any discontinuity economically and, ultimately, historically continuous.

Such is precisely the technique adopted by Sir Walter Scott himself, who often "frames" his interior "written" narratives with a gossipy, oral storyteller, compiler, or redactor charged with bringing a text or manuscript hidden in some architectural recess to the light of commercial day. In the introductory "Epistle" to *The Fortunes of Nigel*, Scott's presentational mask is one Captain Clutterbuck who enters Archibald Constable's publishing house in search of the putative author whom he finds, as with most writers and fathers in Scott, at the center of a maze of "secrecy and silence." In the four series of *Tales of My Landlord*, a pseudonymous Peter Pattieson assembles the narrative from scattered oral accounts and legendary records. Jedediah Cleishbotham is the equally gossipy literary executor who, posthumously, rearranges a discontinuous narrative with no other purpose than his own economic self-improvement. In the introduction to *The Betrothed*, the "Author of *Waverley*" proposes a joint-stock company for the production-line manufacture of fiction in much the same way that Dousterswivel, the fraudulent necromancer of *The Antiquary*, having succeeded in inventing a steam-powered machine which trans-

forms raw linen into finished shirts, wonders aloud if the same mechanically reproductive process could be applied to the love speeches of a hero so as to produce more efficiently Gothic narrative. To be sure, Dousterswivel, like so many of Scott's subaltern, harlequin gossips, is a quasi-magician who promises to turn heated air into gold in *The Antiquary,* but he is surely no less adept than the Sir Walter Scott who, first as co-partner (with James Ballantyne) and then as sole proprietor of a publishing house, profited simultaneously by authorship, again at the phase of material production, and finally, during the regular reproduction of what was planned to be a cheap format—all assisted by the radical deployment of rotary steam-powered presses, not generally adopted by the publishing industry until the mid-1840s. Hence, in both the narrative structure of his novels and at the level of their reproduction as a cultural commodity, Scott adds value by bringing to the plot someone—usually imagined as an attendant orality—who seems superficially at least to be economically external to it. The *commère's* share would thereby become crucial to a transactional notion of value—*commerce.* History acquires meaning only in *circulation.*[41]

Such would surely represent one solution to the problem raised by what Susan Stewart has described as the advent of the "distressed genre."[42] For the chronological border (late eighteenth and early nineteenth centuries) and the geographical border in which Scott rose to prominence was also the setting for literary scandals involving the authenticity of a "re-covered," abandoned orality: those of Percy, Chatterton, and Lady Warlaw's "Hardyknute." Scott, remarkably enough, saw through these forgeries while at the same time understanding the role of a counterfeit orality in a literary economy. Writing or orality only become cultural *specie* through the supplement:

> the art used to disguise and misspell the words only overdid what was intended and afforded some evidence that the poems published as antiques had been, in fact, tampered with by a modern artist, as the newly forged medals of modern days stand convicted of imposture from the very touches of the file by which there is an attempt to imitate the cracks and fissures produced by the hammer upon the original.[43]

Rather than an existence behind writing (as in Percy's "restorations" of orality) or *above* it (as in Edward Waverley's flirtation with the Highland site of another attempted Restoration), Scott as his career develops *integrates* orality as an inseparable part of the reproduction of inscription. All reproduction involves a *dis-simulation* which corrupts at the same time that it puts a historically abandoned discourse into "play." Hence, the presence of the subaltern gossip, embodying the counter-sublime, both contains and maintains a potentially orphaned narrative. One consequence is the transformation of all narrative—written as well as oral—into a provisionality which is dependent upon social reproduction for whatever value it will have. Scott's text invariably

calls attention to itself as a diluted artifact as a consequence of elaborate prefatory and supplementary apparatuses which may or may not be faithful to an originary or transcendental value or investment. The gossip-figure *in* the text does the same for history: appearing initially as an obstructing discontinuity, only retrospectively is she seen to add value to a lost hero's continuity.

But these assorted reproductive hands—of either the gossip in the text or some loquacious redactor at its margins—must remain, to borrow from Adam Smith, in some sense "invisible." In order to avoid producing the threatening discontinuities typical of the romantic sublime, they must be absorbed, becoming virtually invisible within the syntagmatic order of writing: as an accepted member of a noble family; within the safe blessings of a more tolerant clergy; by a language assimilated into the folds of the text with no need of translation; or by representing terror as historically recurrent. This belated assimilation of the subaltern is as crucial to a discursive transparency as are the masks donned by Scott's assorted narrative re-tailer, for both share in the invisible reproduction of symbolic or literal, historically "sacred" narratives.

The fear that a title disseminated by the gossip-effect could spread like "Wildfire," threatening not only the patriarchy of a single author but of authority itself, was not lost on Thomas Carlyle, no stranger to pseudonymous "editors," in a review of Scott. The economic "denomination" of the hero is a threat to inscripted authenticity:

> If once Printing have grown to be Talk, then DEMOCRACY (if we look at the root of things) is not a bugbear and probability, but a certainty, and event as good as come.[44]

Once freed from the confinement of a patriarchal genealogy (or written genre) into a new economic order, then writing mimes the "on and on" of the oral. The serialized, self-supplementing novel in Scott's hands—writing resistant to the traditional forms of closure—is like money insofar as demand creates the potential for a gossip-like dissimulation—the counterfeit.[45]

In Scott's narrative economy, a subaltern (or its formal corollary, a textually marginal reality) adds *credibility* to a politically abandoned patriarchy whose *credit* has been foreclosed. A twentieth-century disciple, whose South shared with Scotland the misery of a hill folk conquered by those who spoke the same language, and who bestowed the name "Quentin" on a deranged gossip, William Faulkner understood the double liquidation worked by a recursive reality upon an incestuous model of history. For only in the gossip's mouth does an authorized history become inseparable from its social consumption. It comes to have a wider social meaning, as the "money-words" of a collective, never-ending saga which can no longer be hoarded in familial enclaves. Gossip creates value by giving the library a currency:

> The Southerner had very little of his money to devote to the buying of books. . . . And so every southern household when they bought books they bought Scott.

That was because you got more words for your money, maybe, could have had something to do with it.[46]

NOTES

1. Walter Scott, *Waverley*, ed. Andrew Hook (Harmondsworth: Penguin, 1972), 113–44.
2. For a discussion of the historical tradition in which "Bradwardine" has a dual resonance, see Mary Carruthers, "Thomas Bradwardine and the Calculus of Memory," *Mentalities/mentalités* 7 (1992): 39–51.
3. *Waverley*, 51.
4. Ibid., 117.
5. Ibid., 66.
6. Ibid., 173.
7. Thomas Weiskel, *The Romantic Sublime* (Baltimore: Johns Hopkins University Press, 1986), especially 38–46. In my analysis, Scott must make the challenge of reality economically viable rather than merely psychologically acceptable; otherwise, voice, like writing, dies out, or, alternatively, we are left with attraction/repulsion as a response, but no opportunity for added value.
8. Neil Hertz, "Lecture de Longin," *Poetique: revue de théorie et d'analyse litteraires* 15 (1973): 303.
9. *Waverley*, 377.
10. See the remarkable essay by V. G. Kiernan, "The Covenanters: A Problem of Creed and Class," in *Poets, Politics, and the People,* edited and introduced by Harvey J. Kaye (London and New York: Verso, 1989), 40–64.
11. Walter Scott, *Old Mortality,* ed. Angus Calder (Harmondsworth: Penguin, 1985), 238.
12. Walter Scott, *The Antiquary* (Household Edition), 24 vols. (Philadelphia: Porter and Oates), III, 1:32.
13. Immanuel Kant, "Analytic of the Sublime," in *Kant's Critique of Aesthetic Judgment,* trans. J. C. Meredith (Oxford, 1911), 47–48.
14. Immanuel Kant, *Gesammelte Schriften* (Prussian Academy Edition), 22 vols. (Berlin 1900–1942) V:268; my translation. In Kant's definition, a representation *(Vorstellung)* is converted to a presentation *(Darstellung),* a sleight of hand which might *presuppose* some syntagmatic lineality in the normative pattern by which reason appropriates natural objects. If so, then the more intensive the mechanical "processing," the greater the chances of a relatively minor "discontinuity" being "presented" as a sublime "unattainability."
15. E. J. Hobsbawm, *Bandits* (London: Weidenfeld and Nicolson, 1969), especially 17–40. In Hobsbawm's analysis, because the gossip-figure derives his or her existence from an independence of "informational management," it invariably appears as representative of some decentralization. In the political history of South and Southeast Asia—and particularly during the 1965 coup in Sukarno's Indonesia—the village story-tellers-cum-medicine men (known in *Bahasa* as "bomoh"), to which Madge Wildfire and Meg Merrilies might be compared, were subject to harsh governmental repression under emergency measures to bring all forms of communication under official government control.
16. Walter Scott, *Guy Mannering, or the Astrologer* (London and Toronto: J. M. Dent, 1933), 31–32.
17. Ibid., 58.

18. Ibid., 58.

19. Ibid., 32.

20. Ibid., 384.

21. Ibid., 379.

22. Ibid., 273.

23. Ibid., 205.

24. Ibid., 387.

25. Ibid., 212. There would seem to be some subtle critique of epistolarity (and perhaps of the epistolary novel) in both *Guy Mannering* and *The Fortunes of Nigel*, with their "privileged" petitions, remarkably like that worked by Jane Austen in *Emma*.

26. Ibid., 190.

27. Ibid., 191.

28. Ibid., 394.

29. Ibid., 402.

30. Ibid., 334.

31. *The Antiquary*, I:66.

32. Ibid., I:126.

33. Ibid., I:154.

34. Ibid., II:241–42.

35. Walter Scott, *The Heart of Midlothian*, ed. Claire Lamont (Oxford: Oxford University Press, 1982), 172.

36. Ibid., 173.

37. When the harsh provisions of the Scottish Statute Book (1680) Sec. XXI were abolished in 1803, banishment was often substituted for the death sentence. This change might suggest some intriguing relationship between infanticide (as a form of contraception) and the abolition of public penance by the Kirk. The "privatization" of penance created a demand for some intermediate role, between the mother and an obtrusive state which is assumed by the god-sib/mid-wife: someone who regulates the (female) body's secrets so as to remove them from the control of both grace (state or church) and disgrace (the unwed mother and her family). The gossip would have carved out a pro-life position.

38. *Guy Mannering, or the Astrologer*, 62.

39. See Kathryn Sutherland, "Fictional Economies: Adam Smith, Walter Scott, and the Nineteenth Century Novel," *ELH* 54 (1989): 97–128.

40. Walter Scott, *The Fortunes of Nigel* (Household Edition), 24 vols. (Philadelphia: Porter & Oates) XIV, 2: 152.

41. In fact, Abbotsford combined in its household "furnishings" both the "collection" (Scott's artifacts from the Highlands) and "circulation." Gas heating in many rooms, one of the earliest functioning water closets, and call chimes activated by compressed air coming into contact with mallets were among the technical applications of the circulation of energy. See A. N. Wilson, *The Laird of Abbotsford* (Oxford: Oxford University Press, 1989), 50–53.

42. Susan Stewart, *Crimes of Writing: Problems in the Containment of Representation* (Oxford and New York: Oxford University Press, 1991), 66–101. For a compatible reading of Scott as an author who "clears" a late eighteenth-century fictional "field" for the eventual domination of the "male historical epic," see Ina Ferris, *The Achievement of Literary Authority: Gender, History, and the Waverley Novels* (Ithaca, NY: Cornell University Press, 1991).

43. Walter Scott, "Essay on Imitations of the Ancient Ballads," in *Minstrelsy of the Scottish Border*, rev. and ed. T. F. Henderson (Edinburgh: Oliver and Boyd, 1932), IV:10–11.

44. Thomas Carlyle, *Critical and Miscellaneous Essays,* 5 vols. (London, 1899) IV:82.

45. Scott's popularity was such that, more than any other nineteenth-century British novelist, he was often victimized by remarkable counterfeit "Scott novels," often published clandestinely in Prussia, and occasionally reviewed as Scott's own work. For an account of Scott's difficulties in writing "legitimate endings" to his own novels, see Francis R. Hart, "Scott's Endings: The Fictions of Authority," *NCF* 33 (1978): 48–68.

46. *Faulkner at the University,* ed. F. L. Gwynn and Joseph Blotner (New York: Alfred Knopf, 1959), 135.

13

Romantic Criticism

The State of the Art

MARJORIE LEVINSON

I would like to apologize at the outset for the pretentiousness of my title. All I want from that phrase, "state of the art," is the double reference to technologies of reading and to textuality. The idea is to signal my interest in agency, an interest I pursue first in a theoretical fashion, and second in the context of a romantic text, Wordsworth's "Old Man Travelling." You will see that the first movement frames its questions at a level of abstraction that I justify up and down the scale. I believe my arguments, but am still confused that my own critical practice (insofar as it is ever "one's own") should have brought me to so strange a place. I would call it uncanny if that were not so glib.

Alongside my lofty argument runs an institutional brief: the wish to distinguish, even now, a Marxist materialism from the cultural studies that appear to have absorbed and surpassed it. I will be drawing on the work of Althusser and Adorno, writers who struggle with the productivism and valve-emphasis of the classic Marxist account, and also on Spinoza, invoked to suggest what a non-dialectical but also non-mechanistic materialism might look like: a postmodern materialism. What seems crucial in the distinction between the two materialisms, cultural and Marxist, is not the matter of struggle as the plot line of history, but rather the peculiar dialectics of that struggle. The question I cannot answer in this brief essay, however, is the status of dialectics—*any* sort of dialectics—today, now that the mythic differences between East and West have warped or torqued or just flattened out, as the events of the past few years have made so dramatic. This situation, a legitimation crisis for even the most academic of Marxist devotions, informs the moves and tone of this paper in a way that I did not see until it was done.

Critique of Materialism

To review the familiar: dialectics models identity as the product of contradiction, a function of the objective embeddedness of any first term in its concrete determinations. These predicates, by their determinacy and their difference from the subject term, both check the unboundedness of that subject term and mediate its full presence. By this double process of negation and diremption, they *actualize* the identity of the subject term. By the same token, however, they lock into this identity a tension or asymmetry that commits it to innumerable return engagements.

Now consider a criticism undertaking the historical *re*constitution of such vexed identities (I will call them "works"). Such a criticism will, in its first or antithetical stage, negate the various closures that suppress the work's struggle with the internalized cultural immediacies of its origin. This struggle is what brought the work into being as a particular work, a work of art, and an artwork "of that kind." By this view, the changing identity of artworks over time, and thus the need for qualitatively different critical practices, follows from changes in the work's delimiting negation. This latter will reflect the different pressures of the different formations from which the artwork, if it survives, keeps on emerging. On that score, it should be noted that because criticism, or what is positioned as the discourse of knowledge, is also, ideally, engaged in a dialectical dance with *its* moment, only those works of the past that can assist that discourse's own struggle for definition will materialize for it as objects of interest. As reality changes, altering the modes of reflection and thus resistance, so does the work that is made by opposing that reality. What I want to stress is the *double opposition* carried out by the work: negation at the point of reception (which will include certain readings from the past) no less than at the point of origin.

Here is a summary of the process. Let us say that we intervene within some artwork from the past by dissolving its ideological shell, showing how it legitimates forms of domination prevalent in its society.[1] You can see that the critical action repeats with a difference—more precisely, from a distance— the constitutive violence visited upon that work by its own cultural moment. Insofar as the work disrupted the heteronomies of its founding (and perhaps subsequent) moments, we would anticipate its return upon our own ideas and methods, which have become, through our interventions, immanent to the work, part of its identity structure. This return upon the illusions, the coerciveness, the heteronomy of the present, will be *related* to—not identical with— the work's earlier acts of resistance.

In other words, the dialecticity we restore to the work through our criticism—its agency in the past—is also its agency in the present. This explains why those who pursue a materialist inquiry must factor their own situation into the process and must do so at the level of form, that of the work and

that of the critique. This necessity has nothing to do with either political correctness or an ethic of self-consciousness; it is an objective requirement of the inquiry itself or of the method which grounds it. The poem we read is not only its original negation of that first Nature that took dominion everywhere; nor is it just its own course of resistance to the many Natures in whose aspects history occupies the poem through time. The poem also negates, in turn, the mediations performed upon it (and entertained *within* it) by people like us, professional readers who are also, as they write, vectors of the present. These initially realizing actions become, in time, both the work's own nature—its practico inert, to use an old phrase—and our idea of it. Rather than remaining negations of "what hurts," to use Fredric Jameson's synonym for history, these critical interventions become affirmations of what Coleridge called the "it is," the false immediacies that comprise ideology.

An older dialectics would relish this assimilative moment and call it sublation. One could also, however, in the style of Adorno and, more recently, Slavoj Žižek, emphasize the contingency that is the by-product of each regrettably assimilative or syncretic moment. One could conceive this residue—in Žižek's words, this "kernel resisting symbolic integration-dissolution"—as a reprise of the romantic critique of Enlightenment. Romanticism was, after all, the first critique *of* critique as a practice implicated in the political economy it attacked: the first discourse to try to step outside its own shadow, all the while protesting through its textuality the hopelessness of the endeavor. Readers who are alive to the strategies of domination that descend through all the legacies of Enlightenment, including our more advanced scholarly practices, might find romanticism's return upon the negations of the last decade a thing worth studying.

The negations to which I refer are part of the general, recent rethinking of social and aesthetic production in terms of large-scale processes working through and upon human and linguistic sites, regarded as epiphenomenal subjects of those workings. This critical action did for a time reorganize the poetry, for reasons that had to do both with the poetry itself—its founding conditions—and with the institutional history of that poetry. The simple coupling of "literary" with "production," before the late seventies a contradiction in terms, set up a difference *from* the romantic (still, at that time, an autotelic model) by reviving a working difference within it: its negation of particular modes and relations of production emergent in the early nineteenth century.

Since then, in the discourse of romanticism, production has lost its outside, as the near-disappearance of the term and the ubiquity of its more inclusive and affirmative substitute, "practice," might suggest. Ironically—or rather, dialectically—this is what the first phase of our materialism has yielded. At this stage we allow no materials that are not traces of former or competing practices, no alienation that is not rich in countercultural opportunities, no ends that are not "for" someone or some group (however dispersed, unselfconscious, and undesigning), and thus prolifically "against" another such

group, and no determining orders or even conditions that are not also and *essentially* anthologies of human interest stories. Even the bodies are scripts, purged of the dogmatism of the physical.[2]

Kant's world-making subjects have in effect taken up residence in our criticism's subject-making worlds. The infinitely recuperative productivity of the romantic—its model of self-enriching alienation, enterprising offshoot of Kant's intuition-concept partnership—has assimilated the scandal of a determining, internal otherness that is called history, politics, or other people rather than, as in the old days, temporality, nature, or the many. This reversal is more than unfortunate. Given that production *outside* the academy has lost its negative differential, its scholarly reinscription under the sign of cultural practice smacks of denial. Then again, the aestheticism of the picture betrays the truth of our postindustrial order of things (or of the conviction that such is our moment).

Romantic Indifference

The salient change in the body of romantic poetry right now crystallizes around a set of effects that resist our codes not through denial, displacement, or repression—the conditions for the old hermeneutics of suspicion—but through something like indifference. This is my name for the fact that many of the works and effects we had so profitably elucidated, as recently as the eighties, no longer abide our questions. Inquiry into their production and reception histories yields facts, of course, as does the reconstruction of cultural discourses informing the work and period. But because these facts do not engage the poetry's own interests, which appear to have moved or mutated, so radically that they do not even look like interests anymore, these inquiries remain decorative.

A new kind of negativity becomes available. To call it indifference is to coordinate it with the disinterest that romanticism, in its high argument, promoted as its chief selling point. It is also, however, a way of measuring the distance between two romanticisms, a function of the poetry's present failure not just to make good its losses but to *produce* them, in the present, *as* losses, that is, in the form of consumable, reproducible, and prolific value. If indifference means no interest and instrumentality, it also means no overcoming or repudiation of them. It involves a setting aside of purpose; it also holds off that formal purposiveness without which the setting aside cannot materialize as a negation, the sort that cannot help but affirm. And while indifference fails to project a subject or consciousness form that could translate into a model of social action, it also withholds a figure of meaningful nonintervention.

This new rhetoric of romanticism suggests a withdrawal from the scene of interpretation. The poems evince what Deleuze has described as a "becoming minor"—or, echoing Louis Renza, a short-circuiting of the *Voluptas* of literary

production.[3] What to make of a diminished thing? This question, one that concerns agency, identity, and production, is the question the poetry now puts, and it does it, like Dora or Bartleby, by just saying no. Rather than defend itself through a deeper or more devious repression, the poetry suffers our impositions, but without making an agony, a passion, of them. If anything, the poetry grows transparent to our gaze. Passive-aggressive is too dynamic a label for these poems which cannot be said either to succeed or to fail, lacking, as they do, both a formal and a deforming intention, as well as a reflexive or ironic dimension capable of converting those lacks into the stuff of self-consciousness. Because of this negativity, a function of their double relation to a particular point of origin and reception, these poems—the *same old poems*—will not cooperate with our enlightening agendas. This means that they may, for a minute, thwart the critical self-making, part of the commodification of consciousness, that follows from these programs.

I must stress that this change is not to be read as the release of a possibility there from the start, "there" in those myriad-minded works that anticipate every critical future. The change I describe occurs in the present as the effect of an origin that is thereby changed. For the *first* time, the objective core of romanticism's subjective themes emerges: its attachment to nature over mind, suffering over doing, unreadability over generation, Vorstellung over Darstellung, Spinoza over Kant. For the first time there is a nonironic sense to Blake's proverb, "he who has suffered you to impose on him knows you," and in that reading lives a critique of the muscular dialectics that had incapacitated Blake's writing, or its liberationist themes, for students of the 1980s. The poetry is suddenly larger, more interesting, less Enlightened than the stories we tell about it. It is as if we are encountering the inaugurative cut of romantic poetry, and once again what is distinctive about this moment is its metaphysical aspect.

I refer to the fact that romanticism's counter-epistemology, its rejection of the formalism of the Enlightenment economies of knowledge, rested on two metaphysical postulates—nature and mind—and their punctual immanence as irreducible, unitary otherness in the phenomenon of the sublime. Against the commercial and scientific tendencies of Enlightenment, all entailed by the principle of equivalence, the concept—an unintuitable and therefore incommensurable form—operated a critique that was strongly objectivist. The sublime *was* a trope for material too conflictual, the conflicts too determining, for cognition. But the trope was also real, also an action in the world. I recall this fact so as to emphasize that when we *dissolve* the metaphysical into its concrete determinations, when we *equate* it with such local habitations and names as Napoleon, sociality, sexuality, and so on, we expunge a working distinction of the day. Any rationality not grounded in an unsurpassable otherness, however tenuously or tortuously, would have been, in effect, instrumental. And any negation that simply abolishes its object acts out an idealist scenario, not a materialist process.

These ratios crystallize now, as they did not as little as five years ago, for two reasons. First, there is the success of that antithetical project which, in recovering the belonging-together-in-opposition of romanticism and Enlightenment, also pressed out the deterritorialized, time-lagged, or in some way contingent relation of the two paradigms. Second is the fact of our own political context, where freethinking is again disabled from within by jargons of authenticity and repressive desublimation, unsuspecting allies of the coercive repressions that are so much scarier. Once again, the arts take flight in a strange, flat, disengaged negativity, a postmodern effect that has some of the same fascination for us that Wordsworth's stripped-down, nonpropositional naturalism had for Arnold. In other words, the new nonidentity in romantic poetry is also the old one, mediated by the specific differences of the present. It is, to give an example, Wordsworth's idiot boy mediated by Chauncy Gardener, hero of the movie *Being There*. The immediacy, self-identity, and repetition that characterize the organic (or romantic organicism) translate, in Gardener, into idiocy, impotence, and mimicry. Caught up in a contingency machine, however (they call him Chance)—not, as in the old days, cycles of necessity—organicism emerges as the new man of the Reagan era. Here is the dog biting its own tail: the head, early nineteenth-century agricultural capitalism and its back-to-nature ideology; the tail, late capitalism with its collapse of the difference between nature and culture, its simulation economy. A dream come true.

In this context, Wordsworth's lunatic fringe figures a *critique* of the noble savage—that coupling of instinctuality with knowledge and power—and not, as was long the case, imitation in a minor (British and understated) key. The wisdom embodied by, among many others, Wordsworth's leech-gatherer, his discharged soldier, and Margaret of the Ruined Cottage, really *is* their passiveness, a nonstrategic indifference to knowing or doing, to language as meaning or experience, to self-reproduction, in short, to value. That there is nothing noble about this backwardness, and often something grotesque, is proof of the second-order critique waged by these figures, actualized in the present. They go at Rousseau this time, not, as five years ago, at Adam Smith.

One way to read these images is as fantasies of consciousness or personhood or simply individuated being, that neither makes nor is made by its world, neither does it reciprocally implicate those moments by first throwing them into contradiction, in the manner of affirmative dialectics. Humberto Maturana and Francisco Varela, theoretical biologists, have coined a word "autopoiesis," the definition of which comes closer than anything I have read (except Spinoza's theory of "conatus") to capturing this fantasy of quiet being for science. Autopoiesis locates the identity of living systems—that which *makes* them living systems—in their survival: not the survival of the system's parts or properties or static relations, but of those properties that organize it as a system whose purpose is nothing but the continsued function of that organization, however re-embodied. The model entails cognition without objectifi-

cation, expression without the positivity of a generative source, change without either loss or gain, and difference without distinction.[4]

"Animal Tranquillity and Decay, A Sketch"

As an instance of what an autopoietic discourse might look like, I will talk about one of Wordsworth's lyrical ballads, a poem called "Old Man Travelling," subtitled "Animal Tranquillity and Decay, A Sketch" until 1800, when the first part of that phrase was set as the title. In the earliest versions, the narrator closes his portrait of human existence at its most minimal, ecologically its least intrusive, by engaging its subject in dialogue. He asks the old man where he is going and learns that he travels to Falmouth where his son, injured in a sea fight, is dying "in an hospital." After 1805, Wordsworth deletes this material, depriving the old man of both a voice and an objective, depriving the narration of an embodied and interested subjectivity and the poem of a mimetic dimension. The man is thus defined as one whose very being is traveling, or process detached from origins and ends. And of course, the poem undergoes a parallel elevation: it too evinces motion without movement, meaning without reference, purposiveness without purpose. Both the poem and the protagonist are living critiques of the getting and spending society. Circulating right along with the values they reject, however, their negativity accrues value too. Wordsworth would have thought this is a good thing.

That is the poem's self-understanding. The opening materialist move is to relate Wordsworth's portrait of abjection to the social, political, and military histories encoded in the poem: narratives of the Revolution and French wars, and their home-front sequelae: the actual ones, as in displaced persons and changes in vagrancy, trespass, and welfare laws; and the ideological, as in new forms of humanitarianism and surveillance. Then, too, one would want to invoke Enlightenment anthropology as the poem's master-code, and work that discourse into the sociopolitical fabric through a "missing link" thematics, remembering the title phrase, "Animal Tranquillity and Decay," and even taking the inquiry up through Marx's distinction between human goal-setting action and animal behavior.

Because we know how to do this and roughly what such an inquiry yields, I recommend studying a line that remains puzzling even when the determining contexts are all sketched in. The old man is characterized as one "who does not move with pain, but moves/ With thought." Here is the entire poem, in its last version:

> The little hedgerow birds,
> That peck along the road, regard him not.
> He travels on, and in his face, his step,
> His gait, is one expression: every limb,

His look and bending figure, all bespeak
A man who does not move with pain, but moves
With thought.—He is insensibly subdued
To settled quiet: he is one by whom
All effort seems forgotten; one to whom
Long patience hath such mild composure given,
That patience now doth seem a thing of which
He hath no need. He is by nature led
To peace so perfect that the young behold
With envy, what the Old Man hardly feels. (*Poems,* I:242)

We are not told, exactly, that the man moves *in* thought, *from* thought, or thoughtfully. In conjunction with the title, the line I have isolated questions some standard connections between thought, negation, production, and self-preservation, and the relation of all four—roughly, the components of subjectivity, according to both reflection theory and philosophy of praxis—to "the human." The special business of the quoted line is to put thought in the place of pain, which is cast, circularly, not as the even minutely delayed *effect* of movement but as the movement *itself,* in its interior, invisible, or brain-state manifestation. I do not say "subjective" here, because the syntax dissolves the power-ratio supporting that term. If we perform the substitution cued by the grammar, we are led to imagine thought not as the product or consequence of action, not as action's origin, essence, or cause; neither is thought the reflection to action's datum, the truth to its beauty, nor the whole to its part.

What *is* a thinking that neither makes nor is made by action, forms no picture, conceives no end, premises nothing, intends nothing, reflects nothing, negates nothing? One thing is certain: all those rejected descriptions predicate something transformative—a third structure, place, or moment—acting to mediate inward and outward domains (here "mediate" is used in its classic sense, meaning to separate as well as connect). This mediating but also supervisory function is what we recognize from romantic poetry as the imageless deep truth of our being, an infinitely elusive subject-making mechanism—along the lines of categories, laws of association, drives, defenses, ministries of Fear and Beauty, and so forth. All those secular theogonies. In Wordsworth's "Old Cumberland Beggar," the extended study that came of this little sketch, the traveler is pointedly deprived of both the retinal reviewing apparatus and the equal, wide survey historically linked to productive and negotiable consciousness—that is, *self*-consciousness: "on the ground/ His eyes are turned, and as he moves along,/ *They* move along the ground; and evermore,/ Instead of common and habitual sight. . . . One little span of earth/ Is all his prospect." "Thus . . . his eyes forever on the ground,/He plies his journey; seeing still,/ And seldom knowing that he sees" (*Poems,* I:264). Here we are asked to imagine genuine seeing—not just scanning—in the absence of the barest sensation of seeing; or, without benefit of Kant's transcendental unity of apperception (or Descartes's cogito). At the end of the poem, the narrator blesses the

man with the hope that he will have around him, "whether heard or not, the pleasant melody of woodland birds." "Few are his pleasures," the narrator adds, by way of accenting this one. We might well ask, as Hazlitt did, what *is* this pleasure that does not depend on *hearing* the pleasing melody? The old answer—a technical and also aporetic one—would have been an *innocent* pleasure, and the poem would have been read as a sentimental picture of naive and, as it were, pre-romantic consciousness. Today's answer is to reframe the question as "*whose* pleasure is it?" To do that, however, spinning out the usual tale of high-cultural opportunism, means short-circuiting the long histories in which the poem enfolds us. Could we, for instance, abandon the distinction between what is given on the surface of the body and what is made in the mental workshop? Does the poem dream of a sensuousness transparent to itself and impervious to the mill that would grind it down to make the building blocks of negotiable (because fissured) identity? Does it conjure that "body ego" Freud mysteriously posits "in the beginning"? One thing is certain: Wordsworth is not after the sensuous-spiritual dialectic Keats explores in his odes, for if "spirit" means the doubled consciousness that turns silence into ditties of no tone, Wordsworth's travelers haven't got it. They are, we are told, "insensibly subdued/ To settled quiet." From the compound redundancies of this phrase, we understand that the insensibility goes all the way down.

In both poems, Wordsworth describes a vision innocent of both action and its product, the mental image. Seeing (like hearing and thinking) appears to be nothing but a modification of the body under the sign of, or within the system called, "mind." What is missing from this fantasy is any sort of agency to divide, organize, or mobilize mind-body relations. Moreover, without an internal "third," yielding up subjectivity from the inside, the implicitly three-part structure of *social* subjectivity comes unglued. This happens because the fiction of an independent perspective, constituting the individual-group, singular-plural dyad by its gaze, owes its persuasiveness to its mirroring of the specular self-consciousness rejected in this poem. Wordsworth's marked syntactic efforts to keep his gaze both diffuse and inert, and his decision to drop the poem's closing dialogue between the old man and the narrator, indicate his refusal to play the part of the maker, not just the maker of artifacts but also of values, even of experience. Wordsworth will not stand in for the old man's self-consciousness. We know how much he likes that move and how good he is at it, facts that underscore the suggestiveness of this deeply pathetic but also anti- or an-aesthetic poem.

It is, perhaps, in this context of a new aesthetic, that one could set the slight ambiguity of the verb in "a man who does not move with pain, but moves/ With thought." "Moves" *could* be an elliptically transitive verb, as in "he moves someone else (reader, spectator) with thought rather than pain." "Thought" and "pain," both, by convention, the most inward, ultimately ineffable and subject-defining events, are cast as undecidably shared between impulses from within and without. The grammar establishes the physical

movement of the old man—technically, the poetic object—as at once causing and being the same as the reader's state of being moved: causing and being *our* subjectivity. Just as the old man seems somehow generated by the field to which he belongs, as the part in which the effectivity of the whole resides, or as a kind of probability effect rather than a distinct entity, so we wonder if the poem as object, and ourselves as subjects, are somehow *not,* for a change, mutually defined by our differences from each other. If the old man's passage through a textual landscape just *is* or exactly parallels the mental movement of the narrator and reader, then the reverse is true too: *we* are that matter in motion, or ours is an agency unavailable to any reflective and reproductive purposes. This possibility may locate the peculiar hedonism intimated in the poem: the outline of an inclusive but not assimilative autonomy where distinction does not trigger a survivalist response: eat or be eaten, symbolize or suffer, "humanize" or die. By calling this phenomenon "thought," the poem guesses at a form of cognition that is not an operation on an object outside but rather an expression of processes internal to an entity larger than "the self" but not founded on a collectivity of either interest or exploitation, masters or slaves.

To say that is to appreciate the critical challenge set by the poem's representational nonviolence. What grammar could bind a mental to a material fact when mind and matter are conceived as simultaneous and coterminous but distinct dimensions? "And in his face, his step, / His gait, is one expression." The clumsy copula and the aimless indexing that precedes it establish a seamlessness that unsettles the distinction between action and motion. Not only does nothing arise in this poem to capture and capitalize on that indeterminacy, but the only figured perspective given, "the young behold with envy what the old man hardly feels," is there to point the error, not just of an appropriative, symbolic regard, but of any semiotic praxis, any driving of a wedge between physical and mentalist phenomena. The opening line of the poem prepares us for this indifference, more scandalous in the field of writing than character. "The little hedgerow birds / That peck along the road, regard him not." Even the Christological move (i.e., martyrdom) that is shadowed here—value through willed repetition of the negative—is refused. It is hard to conceive of a representation more critical of critical thought in the Enlightenment mode and of romantic thought in its major mode. I cast the difficulty under the rubric of "incommensurability."

I take this term from Spinoza's way of presenting thought and extension, roughly mind and matter, wherein each gives an exhaustive and accurate description of the single reality in which they both participate as identities. No possible relation can exist between these two systems, least of all causality, since they are one truth (as Spinoza says, one Substance). Neither, however, can propositions from one set be plugged into the other. They are both independent and infinite attributes, *expressions* of substance. When Spinoza describes an idea, for example, as a modification of the body under the sign of

the mind, he does so without at the same time reducing the intellectual to the physical. And, while affirming the possibility of more and less adequate ideas, he outlines a model of representation as distinction without difference, subsequence, or repression: without supplements and their logic of displacement. Unlike the difference and distance ideas that underwrite today's criticism, Spinoza's incommensurable systems close off the standard modes of logical relation and therefore foreclose on interest: say, the interest arising from the translation of a perceptual into a conceptual fact. They do so not through transcendence but, to the contrary, perfect immanence.

I am reminded of Gilbert Ryle's now classic example of analytic philosophy's answer to dualism: his postulate of Oxford, the university, and Oxford the collection of buildings, grounds, and persons one would see on a tour of the university. The two Oxfords are identical but noninterchangeable entities. One is visible, the other is not, but neither one explains, engenders, or encompasses the other although they reflect different kinds and levels of the real, a category which includes our understanding of it. Between the two obtains something like Althusser's structural causality, the effectivity of the whole in the part, when the part does not express the whole as in synecdoche, incarnate the whole as in symbol, indexically substitute for the whole as in allegory, nor does it recapitulate the whole, as in homology. It just *is* the whole, working within a different plan. Of the philosophers bearing on the romantic period, only Spinoza frames this conundrum, one that may remind those in the know of some aspects of quantum theory: such as its view of entities as artifacts or effects of fields which have no existence outside those effects. The sheer intellectual difficulty of Spinoza's materialism and the technical problems it sets for any kind of practical criticism produce it as a sort of infinity form without content: a utopia in the manner of Ernst Bloch. Perhaps this helps explain Spinoza's marginality within romantic studies old and new, as well as the passionate interest in Spinoza shown by such diverse thinkers as Hegel, Deleuze, Althusser, Einstein, and Arne Naess of the deep ecology movement.

None of these, however, develops what could be an available model for criticism. Only Adorno, who does not, as far as I know, comment on Spinoza, shares the values and resistances I have been exploring. His negative dialectics is the only critical form that has proved indigestible to the culture industry; the only one that does not "hail" its readers without at the same time reneging on rationality. A practice inspired by that model might be able to preserve the negativity of the work it reads, the effect known as internal distantiation, without either closing off its own inner distances or redeeming them. Arnold's "culture," embodiment of his edict against the representation of suffering unrelieved by action, is what happens to a criticism that tries to purge art of its guilt and sorrow, and to rob thought of its negativity.

One emphasis worth adding to Adorno is the delay separating the *elements*—not the moments—of the classical dialectical formation, preventing them from bonding into a contradiction. This is to construe the "negative"

in dialectics not by reference to space, a matter of insides and outsides, but as a time-function. This in turn means conceiving of critical agency in terms of discontinuous generations, broken lines, and not collectivities bound by interests, however diverse. Instead of the two-way street, Benjamin's model for dialectical reciprocity, we would have a multistage sequence, representing the action of the critic in the work, and then, at some foreseeable later moment or stage, the work in the critic—another or other critics—a plural and ongoing process. As a result of these lags, those virtues made available by the dialectic are never there for its agents and thus never there for the purposes of self-consciousness and self-making. Because the identities it reconstitutes take shape in the past or the future, criticism is always at a loss, like all nonprofit organizations. Moreover, it is driven by this fact always to try catching up with its effects. It has no choice but to throw itself into history, not by agonized confessions of its own locatedness but by its embrace of "the changing materialist content [and, adding to Raymond Williams's phrase, the changing *form*] of materialism."

Adorno saw the trouble facing dialectics in an age when "the difference between ideology and reality"—irony's medium—"has disappeared." In a situation where ideology duplicates or simulates rather than inverts the real, and where production turns around and mirrors ideology, critical negation must change. Adorno thought to outmaneuver the dominative discourses by a "changed philosophy, the substance of which would lie in the diversity of objects that impinge upon it." The configurational method of his writings shows the changed form. As for the content of the changed philosophy, for romantic studies that will involve a return to those tired old themes of our period: nature, weakness, passiveness, pleasure, disinterest, escape. The idea is not to trade one intransigence gone in the teeth for another that may now, again, bite back. We do not want to set nature and mind, object and subject, sparring again. Rather, we recall that history moves by its bad side. Having found out the barbarism in those high-romantic texts, we must submit to their civilizing hints or else worsen our own barbarism.

Returning to that paradoxical commitment to immanence and negativity, which I explored at the outset, I will close by quoting two old observations. Both speak to the reactionary trends moving today inside and outside the academy. Here first, is Hegel: "Genuine refutation must penetrate the power of the opponent and meet him on the ground of his strength; the case is not won by attacking him somewhere else and defeating him where he is not." And here is Marcuse, announcing in 1960 that he had written *Reason and Revolution* in 1941 to help preserve "a mental faculty in danger of being obliterated: the power of negative thinking." The update goes as follows: "as the power of the given facts tends to become totalitarian, to absorb all opposition and to define the entire universe of discourse, the effort to speak the language of contradiction appears increasingly irrational, obscure, and artifi-

cial." Spinoza, the incommensurable, indifference: these topics can find no better justification.

NOTES

1. John Brenkman, *Culture and Domination* (Ithaca: Cornell UP, 1987).

2. Only Althusser, I should note, of the theorists who shaped our practice, tried to separate determination from production without at the same time abstracting it from the structures and workings of culture and also without giving to consumption the agency taken from production. And, while distinguishing effects from substantial causes, Althusser did not, like Foucault, then metaleptically endow those effects with the systematicity and closure stolen from those old, first causes; nor did he eliminate the notion of the Real and its material contingencies. Maybe this—this vigilant anti-subjectivism—helps explain Althusser's fall from grace in the '80s.

3. Louis Renza, *"A White Heron" and the Question of Minor Literature* (Madison: University of Wisconsin Press, 1984), 38.

4. In an essay introductory to Maturana and Varela's work, Sir Stafford Beer characterizes the importance of this discovery in terms of a "'purposelessness' that makes good sense to a human being—just because he is allowed to keep his identity, which alone *is* his purpose." Preface to Humberto Maturana and Francisco Varela, *Autopoiesis and Cognition: The Realization of the Living* (Dordrecht, Holland; Boston: D. Reidel Publishing Co., 1980), 67.

NOTES ON CONTRIBUTORS

LUCINDA COLE is Assistant Professor of English literature at the University of Southern Maine. Her articles on eighteenth-century literature, feminism, and cultural theory have appeared in such journals as *ELH* and *The Eighteenth Century: Theory and Interpretation*. She is now working on a book-length study, *The Virtuoso Science*, which examines Shaftesbury's aesthetics and the construction of masculinity.

MARY A. FAVRET teaches English and Women's Studies at Indiana University in Bloomington. She is author of *Romantic Correspondence: Women, Politics, and the Fiction of Letters* (Cambridge University Press, 1993) and has published a number of articles on gender, genre, and romanticism.

JAN B. GORDON is Professor of English literature at Tokyo University. He has published on the romantic and nineteenth-century novel in journals such as *Genre, ELH, Ariel,* and *Nineteenth-Century Prose,* and his work has been widely anthologized. His book, *Echoes' Economics: Gossip and Subversion in Nineteenth-Century British Fiction,* is forthcoming from Macmillan.

KURT HEINZELMAN is author of *The Economics of the Imagination* and editor of *Romans and Romantics,* a special issue of *Texas Studies in Literature and Language.* He has published articles in *English Literary History, Studies in Romanticism, Stanford French Review, The Wordsworth Circle,* and the *Massachusetts Review.* His two current book projects are entitled *The Georgic Defense: History, Romanticism and Genre* and *The Cultural Contexts of Romanticism.*

ANDREA HENDERSON is Assistant Professor at the University of Michigan, where she currently holds a joint appointment with the English Department and the Michigan Society of Fellows. Her articles have appeared in *Studies in Romanticism, Genders, ELH,* and *Theater Journal.* She has recently completed a book entitled *Romantic Identities: Models of Subjectivity in Romantic-Era Writing.*

SONIA HOFKOSH is Assistant Professor of English at Tufts University. She has published on Byron and on Mary Shelley and is completing a manuscript on *The Culture of Romantic Authorship.*

ANNE JANOWITZ is Associate Professor of English at Rutgers University. She is author of *England's Ruins: Poetic Purpose and the National Landscape* and is currently working on a new project, funded by an NEH fellowship, entitled *The Tradition of Our Hope: Romantic Communitarianism in Nineteenth Century British Poetry.*

MARJORIE LEVINSON is Professor of English at the University of Pennsylvania. She is author of several books on romanticism, including *Wordsworth's Great Period Poems* and *Keats' Life of Allegory,* and is editor of *Rethinking Historicism: Critical Readings in Romantic History.* She is currently working on problems in the theory and practice of critique and on the relation between romantic and postmodern reinventions of nature.

PETER T. MURPHY teaches English at Williams College. He has received fellowships from the Mellon Foundation and from the NEH and has published essays on eighteenth- and nineteenth-century British culture and on critical theory. He recently completed a book on literary ambition entitled *Crossing the Border.*

JOHN RIEDER is Associate Professor and Director of Graduate Studies at the University of Hawaii at Manoa. His articles on Wordsworth, Percy Bysshe Shelley, Michel Foucault, and science fiction have appeared in *Studies in Romanticism, ELH, SEL, Boundary 2, Science-Fiction Studies,* and other journals. He is currently working on a book entitled *Wordsworth's Counter-Revolutionary Turn.*

MARK L. SCHOENFIELD teaches Romantic Literature at Vanderbilt University and has published essays in *Studies in Romanticism, Nineteenth-Century Studies,* and other journals. His current book-length project, *The Poet of Property: Law, Labor, and the Professional Wordsworth* brings together his work on interdisciplinarity, professionalism, and the literary marketplace in the early nineteenth century.

RICHARD G. SWARTZ is Assistant Professor of English literature at the University of Southern Maine. His articles on William Wordsworth, romantic aesthetics, and the debate over literary property have been published in *Works and Days, Nineteenth Century Contexts,* and *Modern Philology.* He is currently completing *Wordsworth's Ambition,* a study of the poet in relation to the politics of literary commodification.

NANORA SWEET has just completed *Mediterranean Poetics: Felicia Hemans and Later Romanticism,* her dissertation at the University of Michigan. She has presented on this topic at regional and national Modern Language Association conferences and as part of a University of Wisconsin conference on *1492.* Her poetry and reviews have appeared in the *Minnesota Review, River Styx, Ascent,* and elsewhere. Currently she teaches at the University of Missouri-St. Louis.

NICOLA J. WATSON is Assistant Professor of English at Northwestern University. She has published on fiction in the romantic period, Wordsworth, and Byron (most recently in *The Wordsworth Circle* and the *European Romantic Review*) and is author of *Revolution and the Form of the Novel 1790–1825: Intercepted Letters, Interrupted Seductions* (Oxford University Press, 1994).

INDEX

Abbotsford 61, 79 n., 267 n.
Abrams, Meyer H. 4, 5, 6
Addison, Joseph: *The Spectator* 215–16
Adorno, Theodor 269, 271, 279, 280
Agnew, Jean-Christophe 239–40; *Worlds Apart* 226–27
Akenside, Mark 42
Alexander, Meena: *Women in Romanticism* 95
Althusser, Louis 9, 24, 83, 84, 94, 269, 279, 281 n.
Anti-Jacobin, The 36
Anti-jacobin novel 8, 185; and Byron 191–96; and Lamb 191
Arac, Jonathan 2, 5, 17 n., 139 n.; *Critical Genealogies* 34–35
Armstrong, Nancy 8; *Desire and Domestic Fiction* 144, 159
Arnold, Matthew 28, 40, 78 n., 274, 279
Auden, Wystan Hugh 88
Austen, Jane 35, 267 n.
Authorial identity 128, 185–206, 207–24
Aveling, Edward 91

Baker, Carlos 85
Baker, Herschel 134, 137, 138
Barbauld, Anna 146
Barker, Francis 8, 11
Barker, John R. 137, 138
Barrell, John 6, 8, 9, 10; *Poetry, Language and Politics* 19 n.; *Political Theory of Painting* 65, 79 n.
Barthes, Roland 26; "Death of the Author" 21
Bate, Jonathan 19 n.
Baudrillard, Jean 205, 234
Beaumont, Sir George 115
Beckford, William 79 n.
Beer, Stafford 281 n.
Beers, Henry: *History of English Romanticism* 37 n.
Bell, Adam 138, 139
Bell, Dr. Andrew 164 n.
Belsey, Catherine 18 n.
Bender, John 8
Benjamin, Walter 252, 280
Benstock, Shari 136
Berger, John: "Nature of Mass Demonstrations" 96
Bethune, George 55 n.

Bialostosky, Don: *Wordsworth, Dialogics and the Practice of Criticism* 1–2
Birrell, Augustine 138, 140 n.
Blackwood's Magazine 76, 126–27, 210; in Hogg's *Confessions* 211–12; fictionalizes Hogg 208–209, 212–16, 220; publishes Hemans 173, 184 n.; publishes Hogg 211; reviews Hogg 208–209, 222 n.
Blake, William 9, 10, 42, 55 n., 84, 92, 93
Bloch, Ernst 279
Bloom, Harold 6, 126, 170
Bloomfield, Robert 118
Bonaparte, Napoleon 79 n., 172–81 *passim*
Boswell, James 209
Bourdieu, Pierre 145, 153; *Distinctions* 78 n.; *Language and Symbolic Power* 144, 162, 165 n.
Brenkman, John 270
Bridges, Thomas 230
British Critic, The 219
Bromwich, David 127, 134
Brooks, Cleanth 57 n.; *Well-Wrought Urn* 52
Brougham, Henry, Lord 124 n., 140 n.
Brown, Captain 213, 214
Browning, Elizabeth Barrett 173
Bryant, John Frederick 115–17
Bunyan, John 108, 109, 116, 123 n.
Burke, Edmund 10, 91, 163 n., 253; aesthetics 173; *Reflections* 231
Burney, Frances 10
Burns, Robert 40, 213, 216
Butler, Judith: *Gender Trouble* 206 n., 243 n.
Butler, Marilyn 2, 8, 9, 10, 37, 86, 99 n., 124 n., 134
Byron, George Gordon, Lord 9, 14, 40, 42, 44, 51, 93, 171, 180; aesthetics 174; and Lamb 187–90; and Hemans 175, 177; and Hogg 216, 222 n.; authorial identity 185–200, 208, 216, 225; critiques British policies 171; on Rogers 41, 43; on Southey 41, 102; ranks contemporary poets 41
—*Works: Childe Harold's Pilgrimage* 171; "Curse of Minerva" 171; *Don Juan* 185, 190, 191–97, 199

Caledonian Mercury 214
Calvert, Raisley 115
Camoens, Luis de 172

Campbell, Thomas 40, 41, 42, 43, 54, 55 n., 56 n.
Cannon, George 90
Canova, Antonio 172
Carlyle, Thomas: *Critical and Miscellaneous Essays* 265
Carnall, Geoffrey: *Southey and His Age* 122 n.
Castle, Terry 8, 34; "Phantasmagoria" 61, 242 n.; "Spectralization" 235
Chandler, James 9, 140 n.
Charlotte, Princess 179
Chartism 90
Chase, Malcolm: "'The People's Farm'" 90
Chatterton, Thomas 264
Chaucer, Geoffrey 154
Christensen, Jerome 18 n., 216; "From Rhetoric to Corporate Populism" 6–7, 17 n., 81 n.; "Mind at Ocean" 222 n.; "Theorizing Byron's Practice" 205 n., 221 n.
Clare, John 116, 118, 124 n.
Clark, Anna 140 n.
Clarke, Mary 188
Cobbett, William 108, 118
Cohen, Ralph 17 n.
Coleridge, Samuel Taylor 2, 9, 13, 14, 28, 35, 41, 65, 71, 88, 93, 95, 101, 103, 271; and Hazlitt 126, 127; and Wordsworth 52, 221 n.; critical reputation 37 n., 55 n.; on culture 112–15
—*Works: Biographia Literaria* 112–15; "Fears in Solitude" 60–61
Collins, William 42, 43, 49
Cottle, Joseph 165 n.
Courthope, William 28, 29
Crabbe, George 40, 101, 102
Cruikshank, Isaac 92
Cultural materialism 1, 3, 8–11; and Marxism 269–72; alternative critical models 279–81
Cunningham, Alan 109
Curran, Stuart 10, 172, 183 n.; *Poetic Form* 201 n.

da Filicaja, Vincenzo 175
Dallas, Robert Charles 194
Dante 114, 195
Da Ponte, Lorenzo 192
Darwin, Erasmus 10
Davidoff, Lenore 8
Day, William Patrick 243 n.; *Circles of Fear and Desire* 236, 241 n.
Debord, Guy 77
de Certeau, Michel 163–64 n.
Deconstruction 1, 3, 5–8
Deleuze, Jacques 272, 279
de Man, Paul 5, 17 n., 18 n., 170
De Quincey, Thomas 160, 209–10, 221 n.
Derrida, Jacques 52, 189, 194
de Staël, Germaine 28, 172, 182, 183 n., 188;

aesthetics 173–74; *Corinne* 173–74; *De l'Allemagne* 173
de Vega, Lope 172
D'Israeli, Isaac 192
Docherty, Thomas 18 n.
Dollimore, Jonathan 11
Dove Cottage 125, 129
Dowden, Edward 28
Drummond 154
Dryden, John: translates Virgil 106, 107, 108, 109, 116
Dyce, Alexander 55 n.

Eagleton, Terry 9
Edgeworth, Maria 10
Edinburgh Review 210, 215
Egremont, George Wyndham, Lord 62, 71, 79 n., 81 n.
Einstein, Albert 279
Elgin, Thomas Bruce, Lord 171, 178
Elgin marbles 171, 177–78
Elias, Norbert: *Court Society* 240
Eliot, George 123 n.
Elledge, W. Paul 196
Ellison, Julie 10
Emerson, Ralph Waldo 55 n.
English Institute 4
Epstein, Julia: "Fanny Burney's Epistolary Voices" 204 n.
Eustace, John Chetwode 175–76
Evans, Thomas 91
Examiner, The 126, 212

Faulkner, William 265–66
Fawcett, Joseph 36
Feminism, and romantic studies 7, 83
Fenwick, Isabel 109
Fetter, Frank: *Development of British Monetary Orthodoxy* 232
Foot, Michael 127
Foot, Paul 91
Foucault, Michel 8, 9, 19 n., 26, 34, 83, 93, 139 n., 281 n.; *Order of Things* 221 n.; "What Is an Author?" 21
Fowles, John 209
Fox, Henry 189
France, war with 232. *See also* French Revolution
French Revolution 4, 8, 10, 12, 26, 28, 80 n., 226, 231
Freud, Sigmund 242 n., 254, 277
Frye, Northrop 6, 59
Fuller, Margaret 173
Furet, François 8

Gage, John 80–81 n.; *J. M. W. Turner* 65, 79 n.
Gallagher, Catherine 6, 8
Gaskins, Avery 57 n.

Gentleman's Magazine, The 164 n.
George III (of England) 179
Gilbert, Sandra 7
Gill, Stephen 122 n.
Gilligan, Carol 163 n.
Gilpin, William 165 n.
Glenarvon Ghost at the Masquerade, The 186, 199
Glorious Revolution (1688) 226
Godwin, William 89, 92
Goethe, Johann Wolfgang von 183 n., 188
Goldsmith, Oliver 42, 43, 44, 46
Gothic effects 225, 229
Gothic novel 8, 15, 78, 225–26, 232–40; and Byron 191–97, 199; canonical status 226, 239; characterization 232–40; femininized 226, 239; and models of identity 225–40
Gowing, Lawrence 80 n.
Graff, Gerald 30; *Origins of Literary Studies* 31; *Professing Literature* 30
Grant, Douglas 129, 130
Gray, Thomas 42, 43, 46, 49
Greenblatt, Stephen 139 n.
Grosvenor House 79 n.
Groves, Davis: *James Hogg* 216
Gubar, Susan 7

Hall, Catherine 8
Hall, Jean: "Evolution of the Surface Self" 225
Hamilton, Paul 18 n.
Hancock, Albert: *French Revolution and the English Poets* 29
Hartman, Geoffrey 6, 47, 48, 50, 56 n., 57 n., 139 n., 170
Harvie, Christopher: *Scotland and Nationalism* 222 n.
Haydon, R. B.: on Hazlitt 126, 127, 129, 130
Hazlitt, Sarah: *Journal of My Trip to Scotland* 132–39
Hazlitt, William 13, 14, 28; and Sarah Hazlitt 132–39; and Sarah Walker 131–32; and Turner 71, 77; as romantic writer 125–39 *passim*; on art 62–64, 66–68, 75, 79 n., 80 n., 102; on Crabbe 122 n.; on Rogers 56 n.; on Wordsworth 126, 127, 277; visits Keswick 125–31
—*Works: An Essay on the Principle of Human Action* 125; *Liber Amoris* 131–32, 134–35; "On Consistency of Opinion" 125
Heffernan, James 78 n., 80 n.
Hegel, G. W. F. 279, 280
Heinzelman, Kurt 10, 201 n.
Hemans, Felicia 14, 40; biography 172, 173, 183 n., 184 n.; contestatory aesthetics 170–82; critiques British policy 171–82; position as woman writer 161–62, 184 n.
—*Works:* "The Bride of the Greek Isle" 174; *Dartmoor* 179–82; *England and Spain* 172;

"England's Dead" 183 n.; "Graves of a Household" 183 n.; *Modern Greece* 175, 177–79, 184 n.; *Restoration of the Works of Art to Italy, The* 172, 174–77; "Stanzas on the Death of Princess Charlotte" 179, 184 n.; *Stanzas to the Memory of the Late King* 179, 184 n.; "A Thought of the Future" 161–62; "Translations from Horace" 172; "The Widow of Crescentius" 174; "The Wife of Asdrubal" 174
Hendrix, Robert: "Necessity of Response" 86–87
Herder, Johann Gottfried 183 n.
Herford, C. H.: *Age of Wordsworth* 28–29
Herrnstein Smith, Barbara: *Contingencies of Value* 241 n., 243 n.
Hertz, Neil 250
Hesiod 106
Historicism 1, 3, 8–11
Hobbes, Thomas 226
Hobsbawm, E. J. 102, 255, 266 n.
Hofkosh, Sonia 11, 13, 185, 190, 200 n.
Hogg, James 15; authorial identities 207–20; authorship questioned 216, 220, 222 n.; reviewed 208–209, 213–16, 219–20
—*Works: Anecdotes of Sir Walter Scott* 209; *Chaldee Manuscript* 208, 214, 221 n.; "Christopher in the Tent" 221 n.; *Familiar Anecdotes* 207–208; *Memoirs of an Author's Life* (1806, 1821, 1832) 208, 209, 210, 213; *Noctes Ambrosianae* 208, 212, 221 n.; *Poetic Mirror* 208, 216, 212–13; *Private Memoirs and Confessions of a Justified Sinner* 209–13 *passim*, 215–20 *passim*, 222 n.; "A Scot's Mummy" 209, 211, 219, 222 n.; *The Spy* 208, 215, 216, 222 n.
Hogg, Robert 222 n.
Holy Alliance 171, 174
Homans, Margaret 7, 10, 93, 100 n.; *Women Poets and Poetic Identity* 95, 97
Homer 116
Honour, Hugh 69
Horace 172, 179
Hume, David 209, 210, 216, 217, 230, 231, 233, 234, 241 n., 242 n.; *Inquiry Concerning . . . Morals* 227–29; "Of Money" 232
Hunt, Leigh 40, 87, 93; reviews Hogg 212, 222 n.
Hunt, Lynn 8
Hunter, Ian: "Aesthetics and Cultural Studies" 154

Identity, models of 225–40
Inarticulacy, trope of: and deconstruction 162; and feminist criticism 162; as gendered aesthetic 143–62; and women 160
Intellectual labor 25, 102–103

Irigaray, Luce: *This Sex Which Is Not One* 226, 236, 237, 238, 243 n.
Irish rebellion (1798) 191, 203 n.

Jacobin novel 8
Jacobus, Mary 7, 10, 155, 201 n.
Jameson, Fredric, 271; "Postmodernism" 70, 77–78, 81 n.
Jeffrey, Francis 42; on contemporary poets 40–41; as editor of *Edinburgh* 213–14
Jewett, William 243 n.
Johnson, Claudia 8
Johnson, Samuel 111, 209
Johnston, Kenneth 128
Jones, Ernest 88
Jones, John 101, 115, 119
Jones, R. E. 165 n.
Jones, Stanley 129, 130, 131, 134, 137, 138
Jonson, Benjamin 154

Kant, Immanuel 147, 173, 226, 253–54, 266 n., 272, 276; *Analytic of the Sublime* 253
Keats, John 4, 9, 40, 42, 55 n., 88, 93, 174, 184 n., 277
Kelly, Gary 8; *English Fiction of the Romantic Period* 135
Kelsall, Malcolm: "The Byronic Hero" 203 n.; "Hamlet, Byron, and an 'Age of Despair'" 205 n.
Kiely, Robert: *Romantic Novel in England* 240, 241 n., 242 n., 243 n.
Kiernan, V. G.: "The Covenanters" 251
Kingsley, Charles 88
Kinnaird, Douglas 134, 198
Klancher, Jon 10, 98; "English Romanticism and Cultural Production" 3–4, 17–18 n.; *Making of English Reading Audiences* 33–34
Knight, Richard Payne 10
Körner, Karl Theodor 183 n.
Kowaleski-Wallace, Beth 10

Lacan, Jacques 94
Laclau, Ernesto: *Hegemony and Socialist Strategy* 19 n.
Lahey, Gerald 135
Lamb, Charles 130
Lamb, Lady Caroline 14; and Byron 187–90, 197; and feminist criticism 200; *Glenarvon* 185, 190–92, 194, 196, 197–98, 199, 202–203 n.; *A New Canto* 205 n.
Lamb, Sir William 188
Landry, Donna 164 n.
Landseer, Charles 76
Laqueur, Thomas 8; "Towards a Cultural Ecology of Literacy" 163 n.
Leavis, F. R. 85
Lennox, Charlotte 188
Leslie, C. R. 81 n.

Levin, Susan M. 165 n.
Levinson, Marjorie 9, 11, 19 n., 30, 129, 139 n., 140 n.
Lewis, Matthew 191, 232, 241 n.
Lindenberger, Herbert 19 n.; *History of Literature* 59–60, 61, 78 n., 139 n.
Lindsay, Jack: *J. M. W. Turner* 75
Lipking, Lawrence 204 n.
Literacy 156; and romantic trope of inarticulation 159–60
Literary-critical labor, nature of 41–55
Liu, Alan 2, 3, 9, 30, 35, 47, 56 n., 57 n., 78 n., 139 n.; "The Power of Formalism" 4, 17 n., 71, 79 n.; *Wordsworth: The Sense of History* 47–48, 50, 200 n.
Lockhart, John Gibson 128, 208, 220
Longmans 212, 217, 219
Lootens, Tricia 183 n.
Louvre, The 79 n.
Lovejoy, Arthur 84, 87
Lucas, Charles 203 n.
Lukács, Georg 226, 230, 240

McCalman, Iain 90
McFarland, Thomas 6, 126
McGann, Jerome 2, 3, 8–9, 30, 36, 78 n., 205 n.; *Romantic Ideology* 27; "Tennyson and the Histories of Criticism" 57 n.
Macherey, Pierre 9
MacIntyre, Alasdair: *After Virtue* 85
Mackenzie, Henry 232, 233, 234, 236, 241 n.; *The Man of Feeling* 229–30, 235
Mackintosh, Sir James 43, 44
Maclean, Catherine 127
Malthus, Thomas 105
Marchand, Leslie 199
Marcuse, Herbert 280–81
Marx, Eleanor 91
Marx, Karl 24, 26, 91, 103–104, 105, 235, 236, 242 n., 255, 275; *Capital* 240
Maturana, Humberto 274
Maturin, Charles 241 n.
Melbourne, Charlotte Lady 188, 201 n., 202 n.
Mellor, Anne 10, 95, 163 n.
Michasiw, Kim Ian: "Nine Revisionist Theses on the Picturesque" 165 n.
Miller, Nancy 140 n.
Milton, John 154; *Paradise Lost* 108
Mitchell, W. J. T.: "Metamorphoses of the Vortex" 75
Montagu, Elizabeth 152
Monthly Review 56 n.
Moore, Jane 10
Moore, Thomas 40, 41, 42, 54, 55 n.
More, Hannah 14, 36, 144, 148, 161, 162, 164 n.; and Yearsley 149–50, 151, 152, 164 n.; on women 145, 152–54 *passim*; on the sublime 145–46, 152

Morgan, Lady Sydney 10, 173
Morris, David: "Gothic Sublimity" 242 n.
Mouffe, Chantal: *Hegemony and Socialist Strategy* 19 n.
Murray, John 128; and Byron 175, 189, 202 n.; and Hemans 184 n.
Myers, Mitzi 10

Naess, Arne 279
Napoleon. *See* Bonaparte, Napoleon
New Criticism 3–4, 18 n.
New Historicism 18 n., 19 n.
New Monthly Magazine 173
Newstead Abbey 191, 194
Nietzsche, Friedrich 33
Nixon, Richard 5
North American Society for the Study of Romanticism (NASSR) 11
Norton Anthology of Poetry 62, 71–76, 77, 79 n.
Nussbaum, Felicity 136

Odden, James 87
Ode, tradition of 172; deployed by Hemans 172; by de Staël 173
Ossian 154; *Temora* 165 n.
Owenson, Sydney. *See* Morgan, Lady Sydney
Oxford, Lady 190, 191
Ozouf, Mona 8

Paine, Thomas 89, 90, 91
Palgrave's Golden Treasury 40, 55 n. 88
Paper money 91, 195, 231–32
Park, Roy 65
Patmore, Peter 130
Paulson, Ronald 8
Percy, Bishop 264
Periodization 21–37
Perkins, David 28, 29; "The Construction of 'The Romantic Movement'" 27; *Is Literary History Possible?* 22; *Poetry of Sincerity* 22
Peterloo 86, 87, 89, 92, 93, 96, 97, 180
Petrarch, Francesco 172, 173, 183 n.
Picturesque, the: and "internal colonialism" 155–57; and literacy 155–59; and representation of labor 155; and women writers 155–59
Pindar 172, 173
Plato 119, 209
Pocock, J. G. A.: *Virtue, Commerce, and History* 227, 231, 243 n.
Polanyi, Karl 221 n.
Poovey, Mary 8, 10
Pope, Alexander 79 n., 116, 204 n.
Pratt, Mary Louise 163 n.
Priestley, Joseph 57 n.
Punter, David 8, 242 n.

Queen Caroline affair 134

Radcliffe, Ann 34, 232, 241 n.; *The Italian* 232–40; *Mysteries of Udolpho* 233, 235, 238; *Romance of the Forest* 235
Raikes, Robert 164 n.
Rajan, Tillottama 5; "Displacing Post-Structuralism" 6
Ranters 91
Raphael 177
Reddy, William: *Money and Liberty* 227
Redekop, Magdalene: "Beyond Closure" 211
Reform Act (1832) 12, 89, 108, 111
Reid, Thomas 210
Reiman, Donald: "Review" 128, 135; "Shelley as Agrarian Reactionary" 91
Rembrandt, 71
Renza, Louis 272–73
Representation, politics of 83–100, 108, 111
Restoration, as thematic 174–75
Restriction, The 232
Reynolds, Sir Joshua 65, 66, 70, 79 n.
Richard I (of England) 76
Richardson, Alan 11
Robbins, Bruce 3; "Theory and the Narratives of Professionalization" 17 n., 18 n.
Robertson, James 210
Robinson, Henry Crabb 125, 126
Rogers, Samuel 13, 40–58; *The Pleasures of Memory* 42–55, 56 n.; reviewed 48
Romantic poet, concepts of 119, 121, 124 n., 125–32, 152, 185, 225; Wordsworthian paradigm 128–29, 221 n., 225; and literary marketplace 187–200, 208, 209–10, 216
Romantic subjectivity 225–26; and post-structuralism 225; and alternative identities 226–32, 235, 237, 240. *See also* Romantic poet
Romanticism: and cultural materialism 1, 3, 8–11, 269–81; and deconstruction 1, 3, 5–8; and feminism 92, 93, 162, 187, 199–200; and historicisms 1, 8–11; and institutions 14, 21–39, 59–82, 102–103; and New Criticism 3–4; and the "non-romantic" 2, 8, 53–55, 85; and women writers 2, 93, 131–32. *See also* Romantic poet; Romantic subjectivity
Ross, Marlon 11, 78 n., 200 n.; *Contours of Masculine Desire* 10; "Troping Masculine Power" 201 n., 221 n.
Rossetti, William 183
Rousseau, Jean-Jacques 6, 188, 192, 193, 274
Royal Academy of the Arts, The 65–67, 76, 80 n.
Royal Society of Literature 180
Ruoff, Gene 128
Ruskin, John 13, 71, 81 n.; on Turner 68–69, 76
Russian Revolution 4

Rydal Mount 123 n.
Ryle, Gilbert 279
Rzepka, Charles: *Self as Mind* 221 n., 225, 241 n.

Said, Edward 8
Saintsbury, George 220
Salvesen, Christopher 134
Sampson, Martin Wright 31
Sappho 172, 174, 183 n., 184 n.
Sartre, Jean-Paul 5
Scarry, Elaine 242 n.; *Body in Pain* 237
Schiller, Johann Christoph Friedrich von 183 n.
Schor, Naomi 140 n.; *Reading in Detail* 239
Scott, Sir Walter 15, 37 n., 54, 79 n.; and Hogg 207–208; popularity 40, 41, 42; self-representations 220, 263–64, 265
—Works: *The Antiquary* 246, 248, 251–52, 254, 259–61, 263–64; *The Betrothed* 263; *Fortunes of Nigel*, 254, 263; *Guy Mannering* 248, 252, 254, 255–57, 258–59, 262; *Heart of Midlothian* 250, 252, 254, 259, 261–62; *Ivanhoe* 268; *Minstrelsy of the Scottish Border* 264; *Old Mortality* 251, 252; *Tales of My Landlord* 263; *Waverley* 246, 247–52, 254–55, 264
Scottish Society for Propagating Christian Knowledge 156
Scribner, Sylvia 163 n.
Scudéry, Madeleine de 188
Sedgwick, Eve Kosofsky 241 n.; "Character in the Veil" 238, 241 n.
Seekers 91
Sensibility, as model of identity 229
Sentimental fiction 8, 226, 234; and Byron 185–200 *passim*
Servius 107
Shakespeare, William 65, 92, 150; *Hamlet* 194–96 *passim*
Shelley, Mary 10, 187, 241 n.
Shelley, Percy Bysshe 9, 13, 40, 80 n., 171, 172, 180, 193; aesthetics 174; and femaleness 92–98; "The Mask of Anarchy" 83, 84, 85–98
Sidney, Algernon 114
Simpson, David 9, 11, 19 n.
Simpson, Kenneth: *Protean Scot* 210
Sinfield, Alan 11
Siskin, Clifford 1, 17 n., 52, 139 n.; "Wordsworth's Prescriptions" 12
Smith, Adam 113, 122 n., 123 n., 210, 231, 242 n., 262, 265, 274; *Theory of Moral Sentiments* 229; *Wealth of Nations* 232
Smith, Charlotte 10, 40
Smith, Olivia 163 n.
Soderholm, James 201–202 n.
Southey, Robert 14, 36, 40, 41, 104, 123 n., 172; account of the Staubbach Falls 157, 158, 159

—Works: *Lives of Uneducated Poets* 101–103, 111–21, 166 n.; *Tale of Paraguay* (1819) 158, 159, 165 n.
Spence, Thomas 90–91; *Rights of Infants* 92
Spencer, Jane 10
Spenser, Edmund 154
Spinoza, Benedict de 269, 274, 278–79, 281
Spivak, Gayatri 10
Stallybrass, Peter 11
Steiner, Wendy 79–80 n.
Sterne, Laurence 230; *Sentimental Journey* 241 n.
Stewart, Dugald 262
Stewart, Susan 264
Stoddert, Dr. 93
Stone, Lawrence 35
Street, Brian V. 163 n.
Studies in Romanticism 4, 22
Sublime, the 14–16, 163 n.; and counter-sublimes 248–66 *passim*; and deconstruction 5, 8; and historicism 9; as socially determined and determining 145, 160, 162, 249, 263–64; tropes of 147–53, 156–62
Sunday schools 164 n.
Swann, Karen 11
Swift, Jonathan 215

Taylor, John 101, 118
Tennyson, Alfred, Lord 52
Thelwall, John 37
Thomas, Elizabeth 203
Thompson, E. P. 8, 9, 33, 109, 129
Thomson, James 46, 154
Tieck, Ludwig 183 n.
Todd, Janet 8, 10
Tooke, Horne 195
Trapp, Joseph 106
Trimmer, Sarah 146, 151, 153, 154, 164 n.; *Reflections* 148
Turner, J. M. W. 65; critical reception 68–69, 70, 80 n.; "Interior at Petworth" 62, 63, 65, 70–78, 81 n.; "Petworth: The Old Library" 74; "Petworth: A Recital in the White Library" 73; "Petworth: The Square Dining Room" 72; "Transcept of Ewenny Priory" 81 n.

Varela, Francisco 274
Vaughan, C. E.: *Romantic Revolt* 29
Veysey, Laurence: "Stability and Experiment" 30
Vicinus, Martha: *The Industrial Muse* 124 n.
Victoria (queen of England) 76
Vienna, Congress of 171
Vietnam war 6
Vincent, David 147
Virgil 116, 122 n.; as poet of rural labor 104–11 *passim*, 118, 121

Volney, Constatin François 91

Wainwright, Clive 79 n.
Walker, Sarah 131–36 *passim*
Walpole, Horace 79 n., 232, 239, 242 n.; *Castle of Otranto* 233, 236
Warlaw, Lady 264
Warner, Michael: *Origins of Literary Studies* 31
Warton, Thomas 42
Wasserman, Earl 85; "The English Romantics" 22–23
Watercolour Society 80 n.
Waterloo 171, 172, 174
Watteau, J. Antoine 71
Webb, Robert K. 149
Weber, Max 30
Weiskel, Thomas 151, 250
Wellek, René 27, 32–33, 84; "The Concept of Romanticism" 32; *Theory of Literature* 32
Wells, David 241 n.
Wesley, John 109
West, Benjamin 80 n.
Whalley, George 27, 28; "England/Romantic—Romanticism" 22, 37 n.
Whitaker, Thomas 243 n.
White, Hayden 9
Whitman, Walt 105
Wilberforce, William 153
Wilkinson, Thomas 165 n.
Williams, John 56 n., 57 n.
Williams, Raymond 34, 280; *Keywords* 1, 8; *Marxism and Literature* 3, 17 n.
Williams, William Carlos 118
Wilson, Harriette 14, 186, 187, 197–98, 199, 200
Wilson, John 208, 212; on Hazlitt 126–27, 128; on Hogg 213
Wilton, Andrew 79 n.; "The Keepsake Convention" 76–77, 80 n.; "Picture Note" 77
Wolfson, Susan 10, 100 n., 196
Wollstonecraft, Mary 10, 92, 146, 187, 203 n.
Women writers, and romanticism 2, 161–62
Woodhouse, James 118
Wordsworth, Ann 18 n.
Wordsworth, Dorothy 10, 14, 93, 100 n., 126, 187; and romantic aesthetics 144, 146–48, 153–62, 165 n.
—*Works: George and Sarah Green—A Narra-
tive* 162–63 n.; "Irregular Verses" 153, 164 n.; *Journal of a Tour to the Continent* 157–59; *Recollections of a Tour Made in Scotland* 146, 147, 154–57
Wordsworth, Jonathan 122 n.
Wordsworth, Mary 126
Wordsworth, William 4, 5, 6, 9, 10, 13, 14, 15, 40, 41, 84, 87, 93, 103; and audience 108; and Dorothy Wordsworth 160, 161; and Hazlitt 125–27 *passim*, 131; and pastoral 107–11, 123 n.; and Rogers 43–55, 56 n.; and romanticism as presently constituted 21–39, 41, 225; authorial identity 208, 225; on patrons 115; on periodical culture 209, 221 n.; on the poet 170; reception of 37 n., 55 n., 109, 216; representation of labor 107–11, 112, 117–18; of the natural 97, 274; of women 95, 162
—*Works:* "On Approaching the Staub-Bach" 165 n.; *The Borderers* 243 n.; "An Evening Walk" 44–55, 56 n.; *Guide to the Lakes* 143–44, 146; *Home At Grasmere* 107–108; journal 159, 165 n.; "The Labourer's Noon-Day Hymn" 108–11, 124 n.; *Lyrical Ballads* 36, 100, 107, 112, 170; "Old Man Travelling" 269, 275–78; *The Prelude* 124 n., 147, 155, 225; "The Solitary Reaper" 155, 165 n.; "Tintern Abbey" 35–36, 36–37, 95, 147, 160; "Tracks let me follow far from human kind" 157–58, 165 n.
—*See also* Romantic poet; Wordsworthian poetics
Wordsworthian poetics 1–2, 16, 87–88, 97, 170
Working-class literature 8, 14, 90, 115–19

Yearsley, Ann 14, 144, 146–53, 159–62, 163 n., 187; education of 148–49, 163–64 n.; critical reception 160–61, 164 n., 165–66 n.
—*Works:* "Brutus: A Fragment" 146, 163 n.; "Clifton Hill" 147, 163 n.; "Night. To Stella" 149–50, 152; "On Mrs. Montagu" 150–51; "Remonstrance in the Platonic Shade" 152, 164 n.; "To Mr. Raikes" 146
York, Frederick, Duke of 188, 202 n.
Young, Arthur 149
Youngblood, Patrick 79 n.

Žižek, Slavoj 271